Untimely Moderns

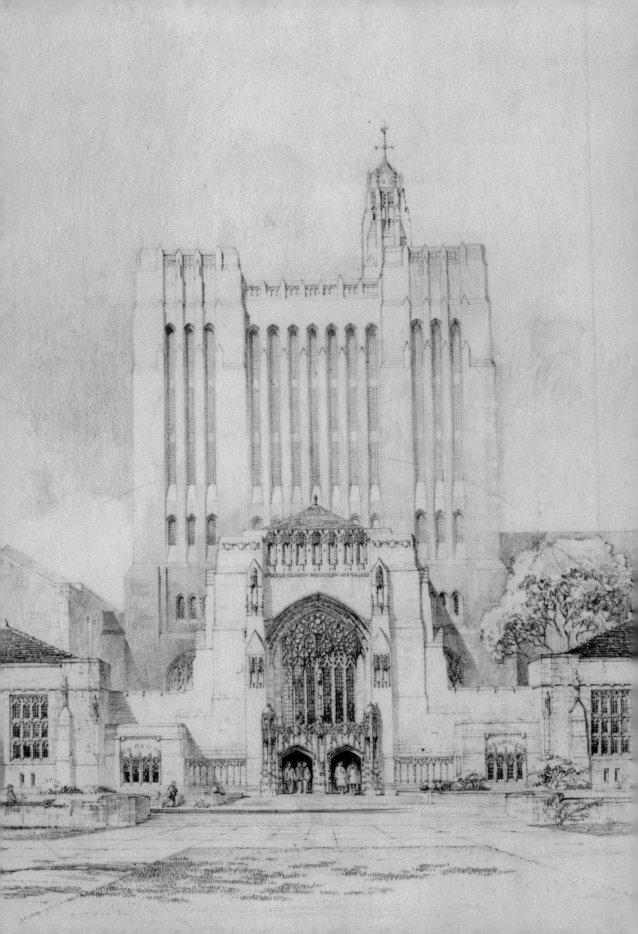

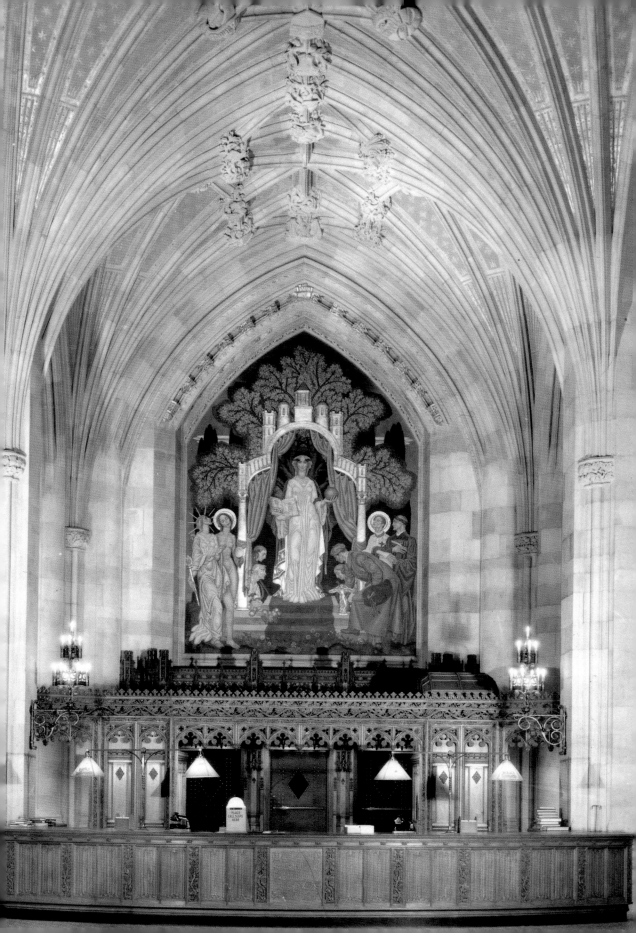

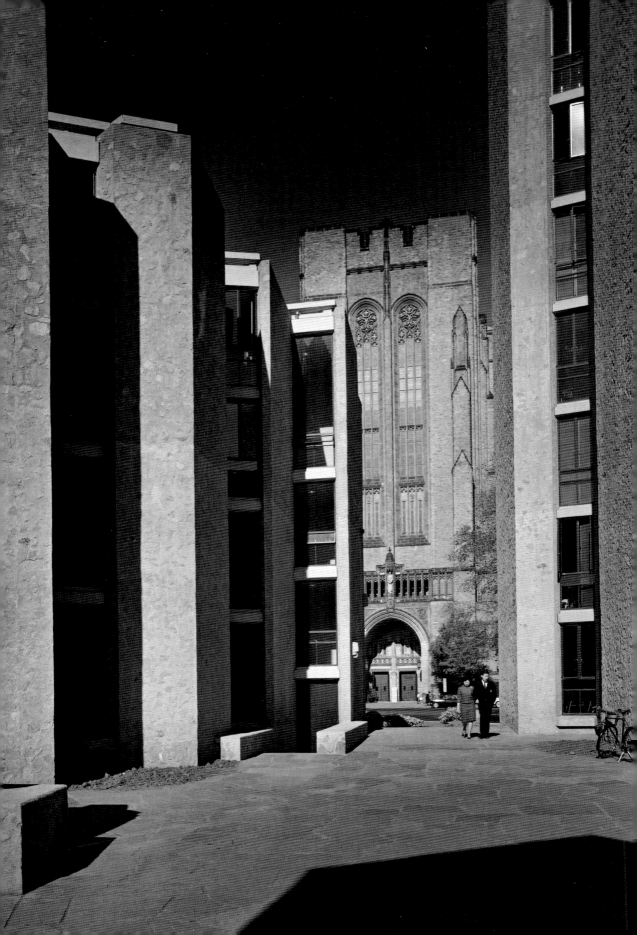

UNTIMELY MODERNS

How Twentieth-Century Architecture Reimagined the Past

EEVA-LIISA PELKONEN

Yale University Press
New Haven and London

Published with assistance from the Graham Foundation for Advanced Studies in the Fine Arts.

Graham Foundation

Published with the assistance of the Frederick W. Hilles Publication Fund of Yale University.

Copyright © 2023 by Eeva-Liisa Pelkonen.
All rights reserved.
This book may not be reproduced, in whole or in part, including illustrations, in any form (beyond that copying permitted by Sections 107 and 108 of the U.S. Copyright Law and except by reviewers for the public press), without written permission from the publishers.

yalebooks.com/art

Designed by Jeff Wincapaw
Cover designed by Jeff Wincapaw
Set in Adobe Text Pro
Printed in China by Regent

Library of Congress Control Number: 2022938410
ISBN 978-0-300-26395-4

A catalogue record for this book is available from the British Library.

This paper meets the requirements of ANSI/NISO Z39.48-1992 (Permanence of Paper).

10 9 8 7 6 5 4 3 2 1

Jacket illustrations: (front) James Gamble Rogers, Sterling Memorial Library under construction, 1929 (detail); (back) Eero Saarinen with a model and sketches of arches, ca. 1960 (detail of fig. 70).
Page ii: James Gamble Rogers, watercolor rendering of the Sterling Memorial Library main entrance (detail of fig. 30).
Page iii: James Gamble Rogers, Sterling Memorial Library (detail of fig. 28).
Frontispiece: Eero Saarinen, New Colleges (detail of fig. 80).

Contents

viii Acknowledgments

1 Prolegomenon to *Untimely Moderns*

Part One Constancy and Change

24 Chapter 1. Everett Victor Meeks: Usable Past
43 Chapter 2. James Gamble Rogers: Modern Gothic

Part Two Time and History

68 Chapter 3. Henri Focillon: Liquid Temporalities
81 Chapter 4. Josef and Anni Albers: New Beginnings

Part Three Past and Future

104 Chapter 5. Louis I. Kahn and Paul Weiss: Presence of the Past
124 Chapter 6. Eero Saarinen and George Kubler: Shaping Time
149 Chapter 7. Paul Rudolph and Sibyl Moholy-Nagy: Time Machines
168 Chapter 8. Vincent Scully: The Historian's Revenge
183 Postscript. Time Today

186 Notes
200 Index
205 Credits

Acknowledgments

Untimely Moderns bears traces of several previous research projects on individual artists and architects, which at one point began to form an intellectual group biography. The seed was planted during the "Eero Saarinen: Shaping the Future" curatorial research project in the early 2000s. I thank Robert A. M. Stern for his support throughout the process and for inviting me to give the opening lecture, "(Un)timely Saarinen," at Yale in 2010, which Cynthia Davidson generously offered to publish in *Log 19* later that year. Timothy Rohan and Stanislaus von Moos helped me expand my inquiry into American mid-century architecture to include two of Saarinen's close friends, Paul Rudolph and Louis Kahn. Brenda Danilowitz made me aware of Louis Kahn's relationship with Josef and Anni Albers, which subsequently led to my writing about their work and legacy. Thomas Weaver's invitation to write a piece, "Reading Aalto through the Baroque," for *AA Files* (2013) led to my interest in art historical formalism, which forms the intellectual backbone of this book. Eliana Sousa Santos hosted two talks, on George Kubler at the Gulbenkian Museum (2016) and on Henri Focillon at the University Institute of Lisbon (2021), which deepened my understanding of the topic. Two panels on "Time Travel" chaired with Mari Lending at the international meeting of the European Architectural History Network in Dublin in 2016 helped set the book project in motion. Paul Stirton's subsequent invitation to present a paper at the "Revivalism in the Age of Modernism" conference at the Bard Graduate Center in 2018 led me to reconsider various modalities of historical revivalism in twentieth-century architecture and, subsequently, the panel "Remembering Vincent Scully," moderated by Humberto Rodríguez-Camilloni at the Society of Architectural Historians' annual international conference in Providence in 2019, offered a platform to do a trial run of this book's last chapter, "Vincent Scully: The Historian's Revenge," which Bruno Gil and Armando Rabaça included in a special issue of *Joelho* magazine (2022) on time and memory. Finally, Jorge Mejia Hernández's invitation for a Theories of Architecture Fellowship at TU Delft in fall 2021 allowed me to get productive feedback at the very end of the writing process.

This book can be read as a meditation on the unique, time-bending architecture culture I encountered at Yale University, which has been my intellectual home for the past thirty years. Upon my arrival in the early 1990s, I found its late Gothic campus completely anachronistic, and I was equally shocked by Vincent Scully's seemingly arbitrary visual comparisons across space and time. I first learned to question my fixed ideas about what it meant to be "modern" when my thesis adviser, Karsten Harries, made

me aware that words—including the word "modern"—do a rather bad job of characterizing complex phenomena, all while three former deans, Thomas Beebe, Alexander Purves, and Robert A. M. Stern, challenged me to rethink what type of architecture should be included under that label. Friendships with three remarkable art historians I have met while teaching at Yale—Romy Golan, Nicola Suthor, and Chris Wood—have enriched my personal and intellectual life throughout the years. It is also at Yale that I met my now-husband, Turner Brooks, who occupies a dual role in this book project: daily companion and historical subject.

The intellectual journey has been less lonely thanks to conversations with many colleagues over the years, among them Tim Anstey, Tom Avermaete, Anna Bokov, Eva Branscome, Peter Brooks, Craig Buckley, Peggy Deamer, Isabelle Doucet, Kenneth Frampton, Murray Fraser, Mari Hvattum, Theodossis Issaias, Petteri Kummala, Helena Mattsson, Mary McLeod, Morgan Ng, Joan Ockman, Spyros Papapetros, Martino Stierli, Dirk van den Heuvel, Anthony Vidler, Stanislaus von Moos, Georg Vrochliatis, and Albena Yaneva.

At Yale University Press, Katherine Boller believed in the project from the very beginning, and Heidi Downey and Laura Hensley's editorial comments were always spot on. The book is supported by a grant from the Graham Foundation for Advanced Studies in the Fine Arts and published with the assistance of the Frederick W. Hilles Publication Fund of Yale University.

I dedicate this book to Turner and our two daughters, Ida and Miia Brooks.

Prolegomenon to *Untimely Moderns*

History is, in general, a conflict among what is precocious, actual or merely delayed.
—*Henri Focillon*

Without change there is no history; without regularity there is no time.
—*George Kubler*

Untimely Moderns posits that temporal disorientation was a hallmark of twentieth-century architecture, and that, while we often think that being modern means aspiring to leave the past behind with every tick of the clock, a disregard for chronological time was, in fact, an integral aspect of modernity. The title alludes to the conundrum at the heart of my inquiry: How does one conceptualize, conceive, and ultimately experience architecture that entails temporal "impurities" and contradictions?[1]

The story is centered on a group of fellow travelers, dubbed here "untimely moderns" for their shared penchant for conflating the past, present, and future in their work and words. The group includes both household names and lesser-known yet equally noteworthy figures in twentieth-century art and architecture culture: artists Anni and Josef Albers (1899–1994, 1888–1976); architects Louis I. Kahn (1901–1974), Everett Victor Meeks (1879–1954), James Gamble Rogers (1867–1947), Paul Rudolph (1918–1997), Eero Saarinen (1910–1961), and Robert Venturi (1925–2018); art historians Henri Focillon (1881–1943), George Kubler (1912–1996), and Vincent Scully (1920–2017); philosophers Ernst Cassirer (1874–1945) and Paul Weiss (1901–2002); and literary critic Harold Bloom (1930–2019). All would come into contact with Yale University and with each other. In addition to these figures, who at some point in their wide-ranging careers held teaching positions at the university, the story involves several notable visitors who gave public lectures or held brief teaching assignments at Yale: philosophers Hannah Arendt (1906–1975) and Susanne Langer (1895–1985); architectural historians Sigfried Giedion (1888–1968), Henry-Russell Hitchcock (1903–1987), Sibyl Moholy-Nagy (1903–1971), and Rudolf Wittkower (1901–1971); architects Ralph Adams

Cram (1863–1942), Le Corbusier (1887–1965), Eliel Saarinen (1873–1950), and Frank Lloyd Wright (1867–1959); as well as artist-collector Katherine S. Dreier (1877–1952) and art critic Clement Greenberg (1909–1994). This book explores a decades-long interdisciplinary conversation about architecture's relationship to time and history in which faculty, students, and visitors passionately engaged between the early 1920s and the early 1970s. While the theme was by no means unique to them or to the institution they served, the book posits that Yale's academic "biotope" and the sociocultural *topos* produced a unique *Denkkollektiv* (thought collective) that helped institute a gamut of novel temporal constructs and concepts in the architectural discourse of the period.[2] Ideas about temporal "duration" (Focillon), "new tradition" (Hitchcock and Giedion), "presence of the past" (Weiss and Kahn), "future of the past" (Moholy-Nagy), and "shape of time" (Kubler) were just some of the unique concepts that made time appear malleable or even reversible—and, above all, nonlinear and nonsynchronous. All involved shared the conviction that activating human awareness of time and history was part of the architect's craft and, to quote Michel Serres and Bruno Latour, "The past [was] no longer out-of-date."[3]

It is significant that the group includes many European émigrés and refugees embarking on a new life in the "New World." Eero Saarinen immigrated to the United States with his family in 1923 at the age of thirteen, after his native Finland was paralyzed by a post-independence economic slump; Henri Focillon died in New Haven in 1943 after a ten-year self-imposed exile from his native France. The immigration of artists and intellectuals grew exponentially at the onset of World War II. Josef Albers and his Jewish wife, Anni, were among the first to take refuge in the United States after the Bauhaus, in Berlin, closed in 1933; likewise, Sibyl Moholy-Nagy accompanied her Jewish husband, László Moholy-Nagy, to the United States in 1937. Ernst Cassirer and Hannah Arendt emigrated in 1941; the former taught at Yale for the next three years. Alvar Aalto and Sigfried Giedion—the latter also of Jewish heritage—stayed in the United States for prolonged periods during the war, lecturing and teaching at East Coast universities. Their musings about time and history cannot be separated from these complicated personal circumstances. Travel to the war-ravaged Old World often had a nostalgic tinge. Meeks, a graduate of the École des Beaux-Arts, returned to France to serve as the assistant director of the fine arts department of the Army Expeditionary Forces University in Bellevue during the final year of World War I; the closing of his Parisian alma mater motivated him to turn the Yale School of Fine Arts into an American substitute.[4] After their respective trips to Rome, Kahn, Rudolph, Saarinen, and Venturi helped turn historical European buildings and cities into new standard-bearers of post–World War II American architecture and urbanism.

While historical reflection was nothing new in architecture, the idea that the past was slipping away was a product of the turbulent twentieth century. As Alain Badiou has noted, the century was defined, on the one

hand, by an attempt to create a new society, and, on the other, by the realization that the world was changing, and not always for the better. The colossal tragedies of the two world wars dismantled, in the words of François Hartog, the "modern concept of history, based on the notion of progress" for good.[5] In a similar vein, while modern architects aspired to improve the life of the masses, they soon came to realize that their creations also deserved much of the blame for the degradation of the built environment and for societal ills. These contradictory temporal sentiments went hand in hand with the urgency to reassess the present against the past in order to imagine alternative paths for the future.

Untimely Moderns foregrounds academia's role in fostering historical reflection as a tool to gain a broader temporal perspective, even in situations when the goal is to solve present-day problems. The architects of the group benefited from academic appointments, which gave them the opportunity to take distance from the everyday grind of running a practice and reflect on architecture's deeper transhistorical purpose and meaning instead. In turn, the influx of practical, worldly concerns compelled historians to make the past resonate with the present, and philosophers to make the at times esoteric field inform daily existence. Yale University offered a perfect physical setting—a kind of ersatz reality with modified temporal coordinates—to muse about time and history, because, thanks to its deep-pocketed donors, its campus features one of the latest Gothic compounds to be completed in the country. The fact that many of the buildings were created after the style marked by labor-intensive ornamentation began to lose popularity after the 1929 stock market crash bears witness to the university's desire to at times resist change at all cost.[6]

That the style rife with Anglo-Saxon connotations was chosen in the wake of World War I when Yale, which had traditionally served a relatively narrow population of well-to-do East Coast families of Anglo-Saxon extraction, began to diversify demographically makes us aware of what Peter Osborne has called the "politics of time."[7] Indeed, when it comes to evoking the past, one must always ask whose lineage and traditions are being edified. In this case, the people behind Yale's stylistic choices clearly believed that the future would ultimately side with their social class and traditions. Alfred Granger, a prominent apologist for the use of the Gothic style on American college campuses, stated, as late as 1932, that "in spite of the 'melting pot' ours is an Anglo-Saxon civilization." He felt that Americans wanted their children to be "in surroundings which recall the glorious, even if only traditional, past of our race."[8] The so-called Federal style (also known as the "plantation style") that Yale used for several residential colleges in the early 1930s had an even more toxic racial underpinning. One of them was, in fact, named after the notorious Confederate slaveholder John C. Calhoun.[9] The students could read these cultural signs, nicknaming one of the residential areas at Pierson College as the "slave quarters" due to its humble scale and appearance. The university has only recently begun to

Fig. 1 John Russell Pope, Payne Whitney Gymnasium, Yale University, 1932.

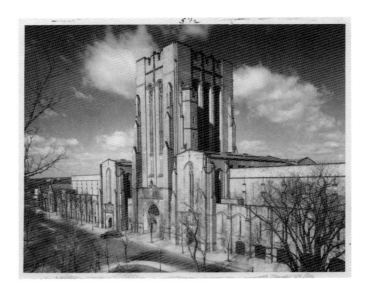

repent for those decisions and traditions.[10] At the same time, the university was cognizant that it could not afford to seem too retrograde.[11] The new, albeit old-looking campus played a significant role in defining an ambiguous middle ground by accommodating some of the technologically most novel structures of their building type in the world behind their historicist facades. Many of the most prominent structures were rife with temporal incongruities from the get-go; Harkness Tower was, upon its completion in 1922, the first *couronne* tower built in the modern era and the tallest load-bearing masonry structure of its kind in the world, while Sterling Memorial Library (1931) and John Russell Pope's Payne Whitney Gymnasium (1932) hid state-of-the-art facilities behind medievalist garb (fig. 1). The latter is still one of the largest gyms in the world.

Yale's mostly neo-Gothic central campus served also as a provocative physical backdrop and frequent topic in a decades-long debate about the validity of historical styles—one that grew heated at times as many students and leading architects considered the new campus architecture hopelessly anachronistic upon its completion. Yet, come mid-century, many began to see, once again, value in a campus that defied historical time. The noted English professor Robert Dudley French, who had served on the university's building committee in the 1920s, honored Rogers's campus architecture in 1950 based on that very premise, insisting that Yale University, "for all her Gothic towers and smokestacks, Palladian doorways and colonnades, is not living so completely under the spell of the past as some of her impatient children are inclined to believe." In his mind, the use of Gothic and other historical styles in academic settings was acceptable, because such anachronism enhanced students' ability to move fluidly across the time and space required for academic inquiry. As he put it, "The matters that concern [the university], to be sure, cover the whole space of measured and immeasurable time, and the daily fare by which she is fed comes to her from all the

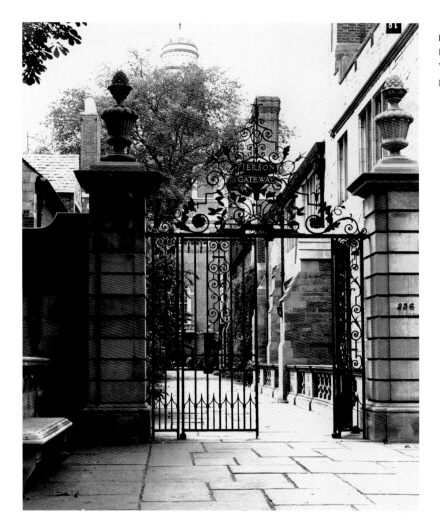

Fig. 2 James Gamble Rogers, Pierson College, Yale University, 1933, gateway from York Street.

ages men have scanned." It follows that particularly "elderly universities, in their corporate capacity, are seldom to be found leading the vanguard in the arts" because they prefer to conduct the "business of building new worlds under the shadow of towers that breathe the enchantments of ages long gone past."[12] Rogers's Pierson College (1933), which transitioned from Gothic to Federal classical along its entrance walkway, epitomized the educated mind's ability to travel through time (fig. 2).

When French wrote his ode to Yale's historicist campus architecture, the university was about to embark on its second major building boom, which yielded the first nonhistoricist (aka "contemporary") structures on campus that were equally rich with time-warping tendencies. These include two museums by Kahn—the annex to the Yale University Art Gallery (1953), which uses geometric forms toward a transhistorical effect, and the Center for British Art (1969–77); Eero Saarinen's David S. Ingalls Hockey Rink (1955–57) and New Colleges (1957–62; later named for Samuel F. B. Morse and Ezra Stiles), which, respectively, use prehistorical allusions

Fig. 3 Eero Saarinen with a scale model of the New Colleges (later named the Samuel F. B. Morse and Ezra Stiles Colleges), Yale University, ca. 1957. Photo: Charles Albertus.

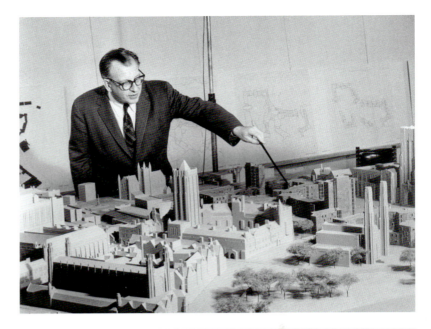

Fig. 4 Paul Rudolph, Art and Architecture Building, Yale University, 1958–63, view of the library periodical reading area, taken once the building was reopened in 1998 after remodeling.

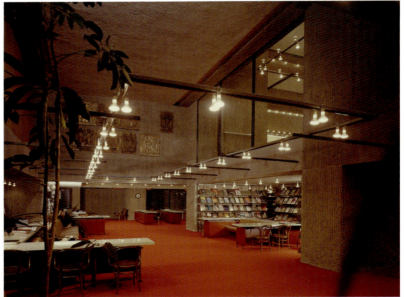

and medieval urban typology; and Rudolph's Art and Architecture Building (1958–63), whose interior containing plaster casts of ancient artworks hung in no particular chronological order, forms, to quote architectural historian Mari Lending, a "polychronic wonder" par excellence (figs. 3, 4).[13] These buildings prove that the "untimely moderns" active at midcentury shared Dudley's conviction that collegiate architecture should operate outside the confines of historical time, which translated into an interest in transhistorical forms, typologies, and urban morphologies. Their engagement with architectural history countered the increasing pressure

facing architects to address emerging problems using state-of-the-art technologies. This incongruity led to two camps: those who believed that modern architecture should be of its time and saw time as consisting of successive moments organized chronologically; and those, the untimely moderns, who embraced the nonsequential, "eternalist" version of time and considered all moments to be equally present at any given time.[14] The latter group imbued their work with forms, materials, and techniques from bygone eras, believing that architecture's main task was to offer alternative temporal realities. The structures by the "untimely moderns" still make us wonder: What period is this from?

LEARNING TO BE MODERN

Gail McDonald notes in her 1993 book *Learning to Be Modern* that American modernism was "composed by the educated for the educated" and that "learning to be modern demanded a continuous calibration of the relationship between tradition and innovation, aristocratic and democratic ideals, authority and self-determination."[15] Likewise, calibrating the relationship between historical and professional knowledge has been at the heart of debates surrounding architectural modernism, and it was for that reason that, already in the early 1920s, Yale University instituted the study of architectural history as a required component of professional architectural training. As Alina Payne has pointed out, this quest to balance historical knowledge with the demands of present-day professional practice was a central dilemma in twentieth-century architectural education.[16] This tension was acutely felt in American schools of architecture as they began to shift away from the Beaux-Arts educational model and adopt, beginning in the late 1930s, modern arts curricula, all while two domestic upstarts, Frank Lloyd Wright's Taliesin Fellowship (established 1931) and the Cranbrook Academy of Art (established 1932), followed by the arrival in the United States of teachers from the former Bauhaus (1919–33), paved the way to an alternative educational model: workshop-based, personality-driven, and iconoclastic in relation to past modes of artistic expression. Ivy League institutions, including Yale, faced a dilemma: how to stay au courant and relevant alongside these new educational trends. Holding on to the academic tradition that privileged historical knowledge became a way to distinguish university-based art and architecture training from that offered in such craft-based institutions. However, it soon became clear that even history teaching had to adapt to changing times, and subsequently conventional art historical topics, such as the study of historical styles and iconography, gradually gave way to art historical formalism, which facilitated a new discourse focused on defining aspects of past architectures that were applicable to new designs. Emphasis on form over both content or context made history resonate with architects in two ways: first, transhistorical formal elements could easily actualize their validity for contemporary

practice through new technologies and programs, and second, recurring formal motifs supported the idea of an unchanging humanist essence of art that gained currency in the aftermath of World War I. As we will learn, these formalist techniques emerged on the Yale scene in the 1920s and reached the apogee through the teachings of a group of highly visible New Critics, neo-Kantians, and formalist art historians between 1950 and 1970.

My story begins with Everett Viktor Meeks, who was acutely aware of the dilemma between architecture's practical demands and its higher purpose when, at the outset of his twenty-five-year tenure as dean of the Yale School of Fine Arts, he persuaded the university to integrate the teaching of art and architecture—fields that had previously been considered simply skill-based and nonacademic—into Yale's humanities-based liberal arts curriculum. Alarmed by what he perceived as an increasingly service-oriented approach to architecture and motivated by a desire to buck that trend, Meeks insisted that an elite university such as Yale should show the way and treat architecture as something loftier: as a field of discourse—that is, a particular branch of knowledge with its own history and set of rules that students needed to command. His solution was to follow the guidelines and principles set by the New York–based Beaux-Arts Institute of Design (BAID), which instructed students to study historical precedents even when designing for present-day programs.[17] A passage from BAID's 1934 *Bulletin* offers a delightfully matter-of-fact reasoning for why and how to collapse time during a design process: "Modern problems to be successful must have modern solutions; the proper approach to modern solutions is through a study of the solutions of the past. Good design—good proportion and composition—are the growth of past ages of art."[18] Meeks instituted the idea that Yale students be exposed to the timeless qualities of art through both standard slide lectures as well as through "art appreciation" classes in a gallery setting. We will return to the distinction drawn between two modalities of historical reflectivity—one based on passing historical knowledge, including knowledge about historical styles, and the other on personal experience and imagination—throughout this book.

One of Meeks's most consequential decisions was to hire in 1933 the Sorbonne-based French art historian Henri Focillon, who ended up spending the last ten years of his life convincing Yale students that art and architecture existed outside historical time. Focillon's 1934 book *La vie des formes,* translated into English as *Life of Forms in Art* in 1942, posits art as an internally driven formal morphology only tangentially informed by external factors.[19] The fact that the book was written during the height of a worldwide recession and the rise of National Socialism underscores the political dimension of his formalist stance that art does not and should not succumb to historical constraints. Focillon helped establish art historical formalism as a tenet of art history teaching at Yale for decades to come through his two equally influential disciples George Kubler and Vincent Scully, who taught at Yale in 1938–83 and 1947–2009, respectively. In his 1962 book *The Shape*

of Time: Remarks on the History of Things, Kubler insists that every work is part of a longer historical sequence and places an individual artist within a "galaxy" of artifacts, both old and new. Scully, for his part, teased out somewhat inscrutable formal affinities among buildings across time and space during his slide lectures, suggesting that architects resurrected past forms in their own work in a subliminal way. For all three figures, art history was never a closed chapter but rather something that was constantly revisited and reimagined by a new generation of artists and architects—an "open work" of sorts, to cite Umberto Eco.[20] This book posits that these three formidable art historians had a major impact on how architecture was discussed, designed, built, and eventually experienced at mid-century and shows that the lines of intellectual influence can often be pinned down to affinities between individuals. For example, I will draw a parallel between George Kubler's idea that every work of art is part of a longer series of historical artifacts and Eero Saarinen's discussion of how various historical arches informed his design of the Gateway Arch in St. Louis; the two were classmates at Yale College and lifelong friends. The last chapter is devoted to Vincent Scully, who urged a whole generation of architects, many of them his students, to discover architectural history as a fuel for creativity.

To further support art history education at Yale, Meeks convinced the university to build a new art gallery and turn the country's oldest university art collection into a major public art museum. During his tenure, the vast encyclopedic collection featuring objects from around the globe and across a broad temporal spectrum, in what was first called the Yale Gallery of Fine Arts, began to take shape. At the oldest end of the spectrum, the new acquisitions he helped spearhead featured a substantial collection of Egyptian archaeological artifacts from circa 1200 BCE and a lion relief that once decorated the Ishtar Gate at Babylon's main entrance from circa 600 BCE, which the gallery bought from the Pergamon Museum in the 1930s. In 1941 the arrival of the Société Anonyme Collection turned the gallery into a repository of the largest collection of European nineteenth- and twentieth-century art in the country at the time.[21] The remarkable collection includes works by key figures of the European avant-garde such as Piet Mondrian, Marcel Duchamp, El Lissitzky, Kazimir Malevich, and many others. It was also during his tenure that the Yale University Art Gallery became a frequent second stop for Museum of Modern Art exhibitions, beginning with a Le Corbusier exhibition in 1936 and *Aalto: Architecture and Furniture* in 1938.

The pedagogical function of the expansive collection was to supplement classroom teaching by making the gallery into a veritable "walk-in textbook of art history" for art and architecture students who worked in adjacent studio spaces.[22] The annex to the Yale University Art Gallery (1953), designed by Kahn in collaboration with local architect Douglas Orr and now part of the Yale University Art Gallery complex, was conceived as the Yale Design Laboratory and used primarily by the Department of Architecture, which

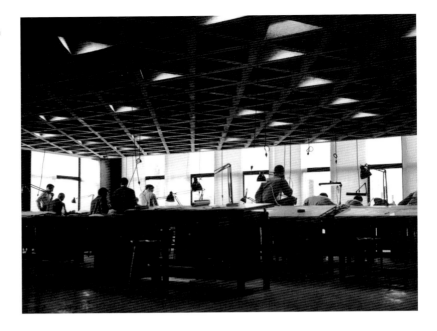

Fig. 5 Architecture studios in Louis I. Kahn's annex to the Yale University Art Gallery, photographed 1953.

housed design studios on its top floor and a space for student-curated exhibitions on the floor below (fig. 5). Art studios continued to be housed in Street Hall, which was connected to the gallery on the other side with an inhabitable bridge. The tradition of placing studio spaces adjacent to the gallery continued after the Department of Architecture moved to the Paul Rudolph–designed Art and Architecture Building, completed in 1963. To further enforce synergy between Yale's collections and studio teaching, Rudolph turned the new building into a repository of the gallery's collection of plaster casts of ancient artworks. Surrounding students with artifacts while they went about their studies spatialized the idea that artists and architects should be haunted by an archive of images and objects, past and present, during the creative process.

Furthermore, the university's large slide collection, originally housed in Street Hall, the original home of the School of Fine Arts, gave access to what the French art historian turned minister of culture André Malraux called the "*musée imaginaire*" (museum without walls). Assisted by the legendary slide librarian Helen Chillman, Vincent Scully famously spent hours in the slide library assembling images for his popular lectures that made wide-ranging formal analogies across time and space.[23] While teaching art history with lantern slides was itself nothing new—Heinrich Wölfflin had already used projection technology in the late nineteenth century—easy access to photographic imagery, due to new projection and reproduction technologies, allowed historical comparisons and contrasts to become a norm later in the twentieth century.[24] New projection and reproduction technologies made teaching and writing about art history increasingly visual, which allowed images from different periods and places to impact a new generation of architects in an almost subliminal manner.

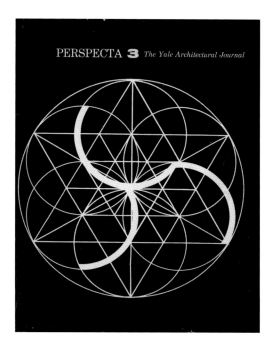

Fig. 6 Cover of *Perspecta* 3 (1954) depicting a medieval mason's mark.

While teaching architectural history in a visual manner at mid-century was not unique to Yale—Jean Labatut used a similar method at the University of Pennsylvania to draw formal comparisons between buildings across time and place—the technique was, in that particular academic setting, enhanced by lively interdisciplinary exchanges among architects, artists, anthropologists, philosophers, and literary scholars, who helped theorize and legitimize the formalist method by introducing a whole new arsenal of temporal registers, topics, and concepts into architectural discourse.[25] In addition to the three aforementioned Yale formalist art historians, who insisted that art was only peripherally motivated by external historical forces, philosopher Paul Weiss convinced architects at mid-century that architecture was to be treated as a medium of time, while Josef and Anni Albers helped emphasize the medium-specific, timeless principles of their art forms.[26] In 1951 George Howe, an influential chair of the Department of Architecture, founded *Perspecta: The Yale Architectural Journal* as a platform for interdisciplinary exchange (fig. 6). At mid-century, Yale was also a stronghold of New Criticism, which emphasized the self-contained and transhistorical dimension of the aesthetic object. Cleanth Brooks, who arrived at Yale in 1947—the same year as Weiss and Scully—insisted that art had very little to do with its historical context, and that writers should temper their desire to make their work socially relevant. Striking a metaphysical note in vogue on campus at the time, he said that the task of a writer was to instead offer a "basic interpretation of man and his relationship to the universe."[27] Literary formalism gained its most ardent and most vocal supporter of artistic autonomy in Harold Bloom. He joined the faculty in 1955 after completing his doctorate at Yale under William K. Wimsatt, Jr., who

instilled in his students the idea that the evaluation of literary work should be based solely on critical insights about literary traditions and the craft of writing. Bloom's seminal 1973 book, *The Anxiety of Influence: A Theory of Poetry,* went even further, proposing that the ability to engage and build on transhistorical themes and techniques was the hallmark of a true artistic genius and of a great work of art.[28]

UNTIMELY MEDITATIONS

The adjective "untimely" nods to the far-reaching intellectual legacy of questioning linear historical time and the impact it had on twentieth-century intellectual and artistic culture. The English language owes the nomenclature to Shakespeare, who coined the term to denote a departure from the presumably "timely," natural course of events. In *Romeo and Juliet,* Capulet states mournfully: "Death lies on her like an untimely frost." Instead of following a singular, linear path, Shakespeare suggested that time includes multiple speeds, which becomes evident when Rosalind, for example, points out in *As You Like It,* "Time travels in divers paces with divers persons." The appearance of the ghost in *Hamlet* suggests yet another temporal overlay: the past haunting the present. In *Hamlet,* Shakespeare uses a corporeal metaphor—"time is out of joint"—to provoke us to envision that time, like limbs of the body, can get disjointed to the point of obtrusiveness.[29]

In the 1870s, Friedrich Nietzsche, who was an avid reader of Shakespeare, introduced the concept of *Unzeitgemässe*—composed of the negative "*Un*," "*Zeit*" (time), and "*gemäss*" (fitting or appropriate)—as a critique of the term "*zeitgemässe*" (timely), which was then commonly used to refer to things that were presumably up-to-date and forward-looking.[30] Critical of Hegel's teleology and the historical inevitability it entailed, the famed philosopher of the future insisted on the human capacity to imagine alternative temporal horizons and outcomes. This did not mean that the march of history was completely ignored. Yet, in Nietzsche's historical schemata, the future was shaped by historical reflectivity. It was thus important to know "when it is necessary to feel historically and when unhistorically."[31] In his essay "*Vom Nutzen und Nachteil der Historie für das Leben*" ("On the Uses and Disadvantages of History for Life") published in *Unzeitgemässe Betrachtungen* (*Untimely Meditations,* 1876), he considered architecture to be an ideal medium in the effort to turn history into a generative force. In it, he wrote: "The history of the city becomes for him the history of himself; he understands the wall, the towered gate, its rules and regulations, its holidays, like an illuminated diary of his youth and in all this he finds again himself."[32] Nietzsche emphasizes that history is "useful" only when the experiencing subject becomes aware of its multivalence and incompleteness—in this case, through "the palimpsests, even polypsest" the city encompasses, and that, instead of being predestined, our individual and collective lives

follow multiple paths.[33] The present moment should thus never be considered simply an inevitable result of an accumulative past, but as something that forces us to ask: Where did we come from, and where are we heading? It followed that the measure of a true artist was to feel the weight of history in all its complexity while coming to terms with the ineffable present. The purpose of studying history was meant to be unsettling in a productive sense. Nietzsche's declaration about the value of classical studies in *Unzeitgemässe Betrachtungen* sums up his position in this regard: "I do not know what meaning classical studies could have for our time if they were not untimely—that is to say, acting counter to our time and thereby acting on our time and let us hope, for the benefit of a time to come."[34]

Nietzsche taught modernist architects such as Le Corbusier and Mies van der Rohe to think of their work as a continuum of a *longue durée* and themselves as historical agents.[35] Both used montage as a tool to underscore their historical reflectivity and agency. Corbusier's Ville Contemporaine set (1925) proposed new construction in sharp contrast with the old city, while Mies's Friedrichstrasse skyscraper project (1922) used the building's glass skin to reflect its historical surroundings. Martino Stierli has written how "Mies' [urban] montages related to the past and at the same time cast their shadow to the future,"[36] and turned the "modern metropolis" into a "palimpsest of heterogeneous historical strata."[37] The pursuit of future and novelty went, in other words, hand in hand with reimagining the past. I posit that architects became increasingly convinced about the weight and relevance of the past due to a combination of acute historical consciousness and growing dissatisfaction with the direction and speed of change after World War I. Bauhaus medievalism was just one of the many instances in which the desires to counter the negative historical and societal forces ravaging Europe at the time and to envision a different future were based on retaining the forms and material practices of a bygone era.[38]

A slew of essays and books written in the aftermath of World War I addressed the dilemma that studying the past posed for modern artists, writers, and architects: how to retain the essence of art without compromising modernity's forward-leaning thrust. In his seminal 1919 essay "Tradition and the Individual Talent," the American-born and Harvard-educated English poet T. S. Eliot argued that a modern writer needs to engage the past when creating something new. Yet, rather than adhering to inherited models in a "timid or blind" manner, a writer aspiring to being modern should engage the work of bygone writers on an equal plane, as if they were his or her contemporaries; "The Waste Land" set an example by considering Shakespeare to be as relevant and "modern" as a contemporary poet. The ability to erase temporal distance was the hallmark of what Eliot called having a "historical sense," which "involves a perception, not only of the pastness of the past, but of its presence." He continues to elaborate upon the meaning of the term as follows: "This historical sense, which is a sense of the timeless and of the temporal together, is what makes

the writer traditional. And it is at the same time what makes a writer more accurately conscious of his place in time, of his contemporaneity." In Eliot's words, "the past should be altered by the present as much as the present is directed by the past."[39] Importantly, a creative artist was expected to study precedents differently than would a scholar, who tended to treat historical objects as documents of a particular period and place, that is, without assigning them historical distance. Eliot's fellow traveler Ezra Pound made a similar point when stating that "all ages are contemporaneous," and used the river as a metaphor to convey the idea that time was a dialectical process between the flow of water, embodying the passing of traditions, and the riverbank eddies, which represent different historical moments.[40] A work of art in this schema is never a product of an isolated period and place but contains sediments from different moments in time. The aquatic metaphor captured the desire to overcome period styles in favor of the idea that at its core, art's purpose was to entail and celebrate what contemporary French art historian Georges Didi-Huberman calls "impurities of time."[41] Indeed, even figures deemed most future-orientated in the annals of twentieth-century architecture culture were implicated in this mandate. For example, in his 1923 book *Vers une architecture* (*Toward an Architecture*), Le Corbusier states that architecture—past, present, and future—should be grounded in universal formal principles, and that only material outcomes change through time, depending on available technologies. His contemporary Mart Stam believed that all noteworthy modern architects were able to establish continuity with the past "subconsciously," without hindering progress.[42] In fact, the ability both to engage and transcend a particular historical moment was considered the mark of a true artistic genius, which, as Maria Stavrinaki points out in her book *Dada Presentism* (2016), is an "ahistorical quality by definition."[43]

Untimely Moderns demonstrates that, while harnessing art's transhistorical qualities into new work was integral to modern artistic practice on both sides of the Atlantic from the 1920s onward, musings about the past gained distinctly ethical and moral tones in the early twentieth-century United States, not least because of the country's rapid pace of modernization. Think of Willa Cather's novels, which convey a sense that what had been lost might be gone for good, and of William Faulkner's depictions of how memories get transmitted and transformed through generations. The latter famously stated, "The past is never dead. It's not even past."[44] In her study of early twentieth-century American art, Wanda M. Corn detected a dominant sentiment among American modernists—that "deepening the present [required] giving it an identifiable past."[45] Many art museums founded in the late nineteenth century were expanded at that time to facilitate the increasing interest in history.

As has already been noted, art education in American universities came to play a central role in fostering historical reflectivity during the late nineteenth and early twentieth centuries. Charles Eliot Norton, the founder

of Harvard's Division of Fine Arts and the first professor of art history in the country, said, "What we learn in college is the history of man's past achievement and its bearing on the present." Well before Yale instituted art education as part of its humanities curriculum, Norton instilled in his students the idea that the past was not to be ignored and promoted the study of art as a tool to make students aware of the "history of civilization," with the purpose of guarding them from the overemphasis of present "material, economic and scientific advancement."[46] Two of these students became key figures in early twentieth-century American artistic and intellectual culture: T. S. Eliot and the cultural critic Van Wyck Brooks, whose influential 1918 essay "On Creating a Usable Past" pioneered the idea that the study of history sparks creativity. In his words, the goal is to study "our literature from the point of view not of the successful fact but of the creative impulse."[47] This mandated that studying historical precedents needed to be both intentional and selective: "For the spiritual past has no objective reality; it yields only what we are able to look for in it. And what people find in literature corresponds precisely with what they find in life," he reasoned.[48] He called the past "usable" because it is "an inexhaustible storehouse of apt attitudes and adaptable ideals; it opens of itself at the touch of the desire; it yields up, now this treasure, now that, to anyone who comes to it armed with a capacity for personal choices."[49] As historian Casey Nelson Blake has noted, "To think of the American past as 'usable,' as opposed to a dry collection of facts or a completed tradition deserving mute reverence, was to take an essentially pragmatic approach to the study of history."[50]

This book traces a parallel trajectory in American architecture culture, where rapid changes in the built environment added a level of urgency to historical introspection and to the idea that the creative act should retain the memory of the past and strive at timeless expression. Pound's river metaphor resurfaces in *American Architecture* (1928), written by architect, architectural historian, and museum director Sidney Fiske Kimball, who, echoing Pound, calls "artistic creation . . . a never-ending stream" as he continues to muse about how "among the American architects [there] are more than one who give promise of living on, not merely as the founders of great schools of the past, but as masters who can speak out of the past in the eternal language of form."[51] The reference to eternity and the timelessness of architectural form undermined the historicist idea that each period and place was supposed to have its unique artistic expression by emphasizing that truly great architecture transcends ordinary, everyday reality marked by finitude and succession.

Indeed, while Europeans tended to view the United States and its architecture as an embodiment of the "world to come," many American architects and their clients were in fact "discovering tradition" in the 1920s and '30s.[52] The fact that Americans wanted to clad their skyscrapers in historical garb baffled Le Corbusier, who in his 1935 book *Quand les cathédrals étaient blanches: Voyage au pays des timides* (*When the Cathedrals Were White: A*

Journey to the Country of Timid People) argues that Americans suffered from chronophobia marked by a combination of historical amnesia, inability to live fully in the present, and ambivalence toward progress and change.[53] Le Corbusier shared with the "untimely moderns" of this book the somewhat paradoxical idea that imagining the future required reimagining the past. "A modernist reads the past, if at all, through the lenses provided by modernism: through Freud, for example, or Benjamin," as Christopher S. Wood has noted.[54] Le Corbusier reimagined the medieval past to conceive a future path for architecture. Through such process of historical reflectivity, even "history itself, as an authorized sequence of events, multiplies from official to alternative versions," as the contemporary architectural theorist Albena Yaneva recently put it.[55]

A whole gamut of oxymoronic temporal concepts rose from the ambition to frame recent developments in historical terms, among them "new tradition" and "contemporary history," coined by Henry-Russell Hitchcock and Sigfried Giedion, respectively. It is worth discussing their work in some detail, since both insisted on placing modern architecture into a longer historical narrative, in an effort to make it gain credibility and historical gravity by understanding its formation and predicting its future development. In his 1929 book *Modern Architecture: Romanticism and Reintegration,* Hitchcock justifies the need to take a longer historical perspective toward new architecture, writing:

> The literature of the architecture of the present seems disproportionately profuse beside that of the architecture of the past. Thus the illusion is reinforced that the present is a period distinct from and opposed to the past. Historical criticism should however be able to show that as regards architecture the present is the last realized point in the dialectic of history, and that even the most advanced contemporary forms constitute no rootless phenomenon but the last phase in a long line of development.[56]

The passage reads as a not-so-veiled criticism of Walter Gropius's 1925 book *Internationale Architektur* (*International Architecture*), which presented modernist architecture as a phenomenon born ex nihilo, without connection to the past. To contrast such historical amnesia, Hitchcock argued that the modern movement was born out of two conflicting temporal trajectories: discovery of abstraction and experimentation, combined with "a sentimental desire to recall one or several styles of the far past."[57] He gave the previously mentioned designation "new traditionalist" to refer to a diverse group of architects born between the 1830s and 1870s who, in his mind, mediated successfully between the two tendencies. The group included, among others, American architects H. H. Richardson and Louis Sullivan, Dutch architect Hendrik Petrus Berlage, Viennese architect Otto Wagner, and the Finnish American architect Eliel Saarinen. Using language

rich with temporal markers, Hitchcock celebrated how these "new traditionalist" architects combined "innovation" and "experimentation" with "recall," "retention," "emulation," and "copying" of past elements.[58] Seeking to find a balance between the imitative and creative impulses, Hitchcock made sure to distinguish the works of the "new traditionalists" from nineteenth-century eclecticism, arguing that increasing formal stylization enabled "blending their borrowings so subtly and in so doing prominently incorporating with their architecture the finest craftsmanship in building, as well as to some extent contemporary methods of engineering, that the public was persuaded there was no reminiscence of the past at all."[59] Architectural historian Panayotis Tournikiotis makes a salient point, in his book *The Historiography of Modern Architecture* (1999), that the notion of "New Tradition dealt with the past as a whole, treating simultaneously all the architectural experiences of five centuries and, potentially, the experiences of every period in history," and, in an effort to legitimatize modern architecture, fused it with "elements from the styles of the entire history of architecture."[60] The ambition to embrace different historical styles indiscriminately in an effort to maximize the visual effect made the new traditionalists distinctly different from their historicist precursors as well as from their revivalist peers.

So why did Hitchcock think it was important for modern architecture to retain historical memory in the first place? His 1927 article "The Decline of Architecture" captures his concern for the speed of change. He writes: "The appearance of speed is more probably due to the fact that in the intellectual landscape of the present the smallest incidents stand clear, and rush past us with all the effect of major events of the past; and the metronome rhythm is so close to our ears that the larger and more significant rhythms of our day, which alone we retain of the past, are obscured."[61] While he was by no means against technological advancements, letting the technological imperative have a free reign would, in his mind, easily lead to "a complete cessation of all the elements that appear valuable not only to our civilization but in any civilization."[62] Two years later, he concluded his book *Modern Architecture* with a similar question: how will the present, hurried period measure within the future annals of history? He wrote:

> How long the period of development will last, how long it will be before the architecture of the New Pioneers, no longer new, reaches its climax, how long before it will be in its turn superseded, it is absurd to attempt to say. The tempo of the future escapes us more than anything else about it. The general impression of the crescendo is surely illusory and due to the fact that very minor events of the present appear to set a pace equivalent to that of the major events of the past.[63]

Sigfried Giedion appropriated the oxymoronic term "new tradition" for the title of his 1941 magnus opus, *Space, Time and Architecture: The Growth*

of a New Tradition, which grew out of the Charles Eliot Norton Lectures he gave at Harvard in 1938. Following Hitchcock's lead, he saw modern architecture as part of a longer continuum, which led him to advocate the idea of "constituent facts."[64] Building on Jacob Burckhardt's idea that certain fundamental psychological depositions and their formal manifestations have stayed the same throughout history and Sigmund Freud's idea of the "unconscious," Giedion maintained that the reappearance of these formal "constancies" could not be explained through conscious activity alone. In his Freudian formulation, "out of a forgotten strata of consciousness the elements of primitive man which are dormant in us are again brought to light, and at the same time unity is sought with the present day."[65] In a similar way, structural and formal solutions inherent in modern architecture were often already "latent in the vision of the [earlier] master."[66] Giedion must have also been familiar with Freud's term "*Latenz*," which the pioneering psychoanalyst used to refer to how unconscious drives such as sexuality guide human behavior.[67] Giedion used it to refer to certain mentalities and their formal manifestations that were "latent" but reappeared from dormancy at intermittent points, as if by their own volition.[68] Terms such as "inheritance" and "potentiality," which appeared in his Harvard lecture titles, placed modern art and architecture as part of a longer temporal frame in a manner that evoked organic life. The graphic layout of the original cover of his book supports the thesis by making the formal affinities across time and space visible from the get-go: it superimposes an arial view of an American highway overpass on top of André Le Nôtre's garden design for Versailles (fig. 7).

Since Giedion adopted Albert Einstein's concept of "space-time" for the title, it is worth reminding ourselves of the basic tenet of his theorem: time and space form a continuum, and one cannot experience one without the other. Time in this conception is not linear but consists of equal moments that can be viewed from varying vantage points. In Giedion's reading, this means that any historical artifact contains multiple time scales and temporal frameworks. It follows that, whereas Hitchcock viewed architectural history chronologically, albeit not sequentially, Giedion's temporal construct is full of repetitions, flashbacks, and afterlives of formal tropes that defy periodization. While it is hard to firmly establish whether Giedion had read *La vie des formes* prior to writing the book, he often seems to paraphrase Focillon's core ideas—for example, when he makes the point that architecture is not bound by historical time, but "has a life of its own, grows and dwindles, finds new potentialities and forgets them again."[69] Giedion stated his intellectual ambition on the eve of his first Norton Lectures, which formed the basis of the book in an interview with the *Harvard Crimson,* when he said: "[My lectures] will try to make a bridge between history and contemporary times, showing how history is dynamic, not day to day. We have no respect for our own tradition. . . . The most important thing is for those who govern to know what is happening, for them to see the unity of the past and future—the others will see it through them."[70]

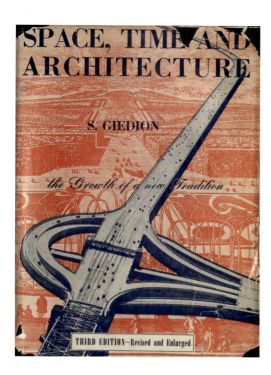

Fig. 7 Cover of Sigfried Giedion, *Space, Time and Architecture: The Growth of a New Tradition* (Cambridge, MA: Harvard University Press, 1941), showing American highway overpass juxtaposed with André Le Nôtre's garden design for Versailles.

Giedion states his desire to create a nonlinear and "dynamic" relationship to history in the beginning of the book, writing: "History is not simply the repository of unchanging facts, but a process, a pattern of living and changing attitudes and interpretations."[71] A key part of his pedagogical mission was to instill in young minds the idea that they should consider revisiting and reimagining historical architecture as an integral part of their creative process. Subsequently, he set into motion a new mode of thinking historically among a new generation of architects, one that embraced the discovery of longer historical patterns from a firmly contemporary perspective. Giedion employed yet another temporal oxymoron, "contemporary history," arguing that architectural history should be written to benefit the present so that we might "conduct our lives against a much wider historical background."[72]

In fact, many who participated in these conversations surrounding modern architecture during the 1920s and '30s had for some time preferred the term "contemporary" over the term "modern" because it implied the rejection of a linear, historicist understanding of time and embraced a more dynamic and spatial—Einsteinian—notion of time. George Harold Edgell, dean of the faculty of architecture and landscape architecture at Harvard, argues in his 1928 book *The American Architecture of Today* that "contemporary" did a better job of accommodating the diversity of the work produced at the time, writing: "At the outset, therefore, let us agree that by modern we mean contemporary. Modern American architecture includes all the architecture of America which has recently been built, or is being built today. It includes the conservative and the radical, the archaeological

and the original."[73] The designation "contemporary" was more inclusive than the term "modern" since it allows past, present, and future to coexist. Erwin Panofsky, another prominent European émigré art historian active in East Coast academia after World War II, observed that, in contrast to their European colleagues, American art historians were willing to discuss contemporary phenomena. In 1955 he noted how "in the United States such men as Alfred Barr and Henry-Russell Hitchcock, to name only two of the pioneers in this field, could look upon the contemporary scene with the same mixture of enthusiasm and detachment, and write about it with the same respect for historical method and concern for meticulous documentation, as are required of the study of fourteenth-century ivories or fifteenth-century prints."[74] Furthermore, he concluded that American universities and museums had overall more contact points with contemporary society than their European counterparts.

Untimely Moderns is organized into three parts that together cover the early 1920s to the early 1970s in a loosely chronological manner. Instead of detailing the history of architectural education at Yale, which Robert A. M. Stern and Jimmy Stamp accomplished in their book *Pedagogy and Place: 100 Years of Architecture Education at Yale* (2016), my book is conceived as an intellectual group portrait focused on decades-long interdisciplinary conversations that culminated in the 1950s and '60s centered on modern architecture's relationship to time and history.[75]

The first part, "Constancy and Change," focuses on two foundational figures: architect-educator Everett Victor Meeks, the long-serving dean of the School of Fine Arts, and architect James Gamble Rogers, the main author of Yale's neo-Gothic campus. The chapter "Everett Victor Meeks: Usable Past" discusses Meeks's attempt to moderate the impact of modernization and modernism through various modalities of teaching history. The chapter "James Gamble Rogers: Modern Gothic" charts discussions surrounding Gothic architecture during the 1920s and '30s on and off campus, highlighting Rogers's ambition to mediate between the past and present.

The second part, "Time and History," highlights the novel temporal constructs of art historian Henri Focillon, who helped establish the Department of the History of Art at Yale in 1941, and the former Bauhaus teachers Josef and Anni Albers. The chapter "Henri Focillon: Liquid Temporalities" highlights the touchstone of Focillon's simple observation that even if every art object is to a degree the product of a certain time and place, its most salient feature is that it continues to live and affect audiences beyond that date and context. Focillon's idea that time is fluid and its "duration has a plastic quality" is discussed; this means situating works of art into a complex spatio-temporal matrix and considering their wide-reaching impact and influence. The chapter titled "Josef and Anni Albers: New Beginnings" posits that the Alberses' preoccupation with repetitions (Josef) and beginnings (Anni) resisted the modernist idea of progress and change in favor of

the pursuit of art's ontological origins, which emphasized the transhistorical nature of artistic technique.

The third part, "Past and Future," features a group of architects—Kahn, Saarinen, and Rudolph—who contributed to conversations about architecture's relationship to time and history. Each chapter highlights personal and intellectual affinities between an architect and a historian or philosopher: Kahn and Paul Weiss; Saarinen and Kubler; Rudolph and Sibyl Moholy-Nagy; and Venturi and Scully. In addition to analyzing the architectural techniques that these figures used to convey their take on multi-temporal modernity, the chapters highlight the novel temporal constructs they coined and helped to propagate.

All of the people featured in this book contributed to the discussion about art and architecture's relationship to time mainly by using the tools of their respective trades—artists and architects by recycling historical styles, combining formal tropes from different times and places in a single work, and repeating age-old material techniques; educators and historians by insisting on the value of historical knowledge and teasing out temporal multivalence and instability in existent works; and philosophers by highlighting dimensions of temporal experience. This book highlights that these pursuits into multi-temporal modernity came to fruition as part of an interdisciplinary conversation and gained momentum through co-teaching, symposia, and publications under the auspices of an academic institution obsessed with its own past at a time of historical change. My effort to trace these conversations has been facilitated by the Yale University Archives as well as three publications that tracked and shaped discussions about modern architecture. The *Yale Daily News* reported on the lively interdisciplinary debates surrounding modern architecture that engaged the university at large. Who could have guessed that a college newspaper would offer such a treasure trove for an architectural scholar? The *Harkness Hoot* offered acerbic student views on Yale's Collegiate Gothic architecture, while the early decades of *Perspecta* illuminated the varied temporal constructs that emerged in the wake of interdisciplinary encounters, which included mining architecture's timeless dimension, discussing the value of tradition for the creation and experience of architecture, employing cultural memory as a social asset, considering temporal duration as a key dimension of architectural experience, and asserting contemporaneity as a new temporal marker. While the *Yale Daily News* and *Harkness Hoot* circulated mainly on campus, *Perspecta* had a national and international following among professionals and students alike, and many seminal articles were published in its pages during the 1950s and '60s. These included an excerpt, published in a 1965 issue, from Venturi's then-forthcoming book *Complexity and Contradiction in Architecture*. By the time it was published, in 1966, its main premise, that modern architecture should foster well-tested transhistorical formal qualities, had already been established as a given.

PART ONE

CONSTANCY AND CHANGE

CHAPTER 1

Everett Victor Meeks
Usable Past

An undated photograph shows the slightly stodgy Everett Victor Meeks dressed in a dapper Edwardian-style three-piece suit on the deck of an ocean liner (fig. 8). A scion of a wealthy New York family and a 1901 graduate of Yale College, Meeks represented the old Yale, which catered to the sons of old East Coast families whose bespoke traditions distinguished them from the socially and economically less fortunate. In his double duty as chair of the Department of Architecture and dean of the Yale School of Fine Arts, Meeks shepherded art and architectural education at the country's oldest art school into a new era by insisting on history lessons. The length of his tenure—twenty-five years—bears witness to his ability to lead through a period of great change.

Meeks's Beaux-Arts training shines through in the World War I Memorial he designed in 1927 for what is today called the Hewitt Quadrangle (Beinecke Plaza); this cenotaph uses classical architecture to align three historical moments—World War I, American independence, and classical antiquity—into a continuous topology (fig. 9). The base of the work features reliefs of tanks and other items of modern warfare flanked by two eagles that carry an empty coffin. Two classical columns adorned by a garland—a symbol of the afterlife—frame a black slab with the following dedication in golden letters: "In memory of the Yale men who, true to her traditions, gave their lives so that freedom might not perish from the earth." The tribute emphasizes that the fallen Yale community members sacrificed themselves for a noble cause by defending Western democracy. Lists of famous battles carved on the entablature of a Doric colonnade outside the University Dining Hall (1901) provided a resonant backdrop, associating classical architecture with democratic values. The architectural language was homologous with the project's political message: during times of individual and collective loss and struggle, people need to see their challenges as part of a larger historical project. Classical architecture was thus indicative of the desire to communicate timeless values and convey a sense of shared duty and tradition. As we will learn in this and subsequent chapters, Meeks's educational mission was shaped by his conviction that academia had a significant role in keeping those timeless values alive.

Fig. 8 Everett Victor Meeks in an undated photograph.

HUMANIZING ARCHITECTURE

Meeks's first move as a dean was to place arts education at center stage in Yale's humanities-based liberal arts curriculum. Before his tenure, architectural instruction had been conducted as a subset of engineering under the auspices of the Sheffield Scientific School, which was located outside Yale's central campus and offered instruction only at the graduate level. Meeks made it possible for Yale College students to study architecture as a major or a minor—something that he himself had not been able to do as an undergraduate; he completed his architecture studies at Columbia University for that reason.

Three years into his tenure, Meeks summarized his educational mission as "humanizing the arts and incidentally humanizing the undergraduates."[1] Arts education was a key vehicle for instilling in students the timeless values of knowledge, truth, and beauty, which had, in his mind, succumbed to materialism and greed. Calling the arts "part of a gentleman's education" underscores the elitist and gendered underpinnings of his vision; like wars, the battle for humanization was going to be won by an exemplary group of men.[2] His efforts paid off, and the following year he could already boast that "Yale's undergraduates today are awakening in no unmistakable manner to the importance of the Fine Arts. As a result, this year there have been 494 cases of election in Fine Arts courses. This figure compares with 232

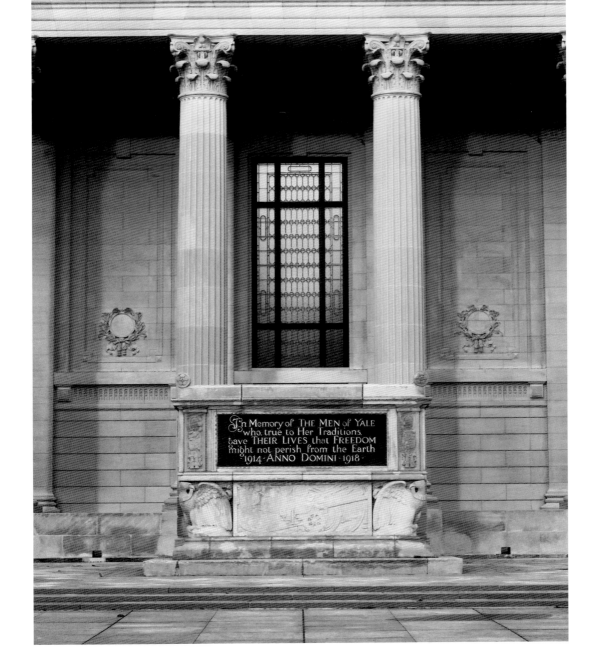

of the year previous and 141 of the year before that."[3] The number of students taking arts classes had thus almost quadrupled during the first three years of his deanship. The numbers were significant considering that Yale College was at the time an all-male institution that held athleticism in high esteem while art was considered a specialized and slightly feminine field and offered exclusively at the graduate level at the Yale School of Fine Arts, founded in 1869 and the first coeducational arm of the university.

While Meeks's "humanizing" project was rooted in the study of historical styles, his main goal was to distill from them transhistorical formal and aesthetic qualities. He set a defiant tone in 1925, declaring that "we [at the department of architecture] have one theory which we are hanging on hard and that is that a work of art must have an element of beauty. The consequence is that we steer our students along that line. If they want to do modernistic work it has to be beautiful."[4] His pedagogical method was thus based on two temporal constructs: while each style formed a historical period along a linear timeline, the idea of beauty was grounded in a nonlinear, eternalist notion of time, which viewed the present moment as part of a larger continuum. He was aware that gaining historical knowledge no longer sufficed, and that overcoming current societal ills and individual weaknesses, such as the single-minded pursuit of money and power, required transcending one's limited perspective.

The universalist underpinnings of his educational agenda reveal that the Beaux-Arts–trained Meeks was, at his core, deeply rooted in American intellectual culture. One can detect traces of transcendentalism, an intellectual and social movement that took hold in New England during the early part of the nineteenth century, in his educational program. For example, the emphasis on instituting timeless values through art can be likened to Ralph Waldo Emerson's idea that one can counter the finitude of human life with the "idea of culture" that makes evident "a relation between the hours of our life and the centuries of time." As an eternalist, Emerson believed that all moments of time are equal, and that human goodness would prevail in the end. "Hours should be instructed by the ages, and the ages explained by the hours," he wrote.[5] Meeks's humanizing effort also resembled the goals of the twentieth-century progressive education movement as formulated by John Dewey, a highly visible New York–based public intellectual and Columbia University professor around the time when Meeks began his deanship. His widely read book *Democracy and Education* (1916) argues that education should allow students to "achieve breadth and richness of experience."[6] Dewey's reasoning went that a well-rounded curriculum would lead to an emotionally and intellectually attuned public, which in turn would translate into a well-balanced society in the future. He too challenged the historicist idea of linear time and the teleological causalities it entailed. Education should not determine individual or societal outcomes but rather simply allow broader participation in the nonteleological and somewhat messily nonlinear democratic process. It is worth noting that

Fig. 9 Everett Victor Meeks, cenotaph, Yale University, 1927. Photo: Steven Sculco.

James Rowland Angell, Yale's president during much of Meeks's tenure, had studied psychology under Dewey in Chicago at the turn of the century.[7]

Meeks's educational agenda was also informed by contemporaneous conversations surrounding arts education. Here we are reminded that progressive thinkers such as Dewey were not alone in viewing art as an essential part of humanities-based liberal arts education at the time. The prominent neo-Gothic church architect Ralph Adams Cram, who founded the Medieval Academy of America in 1926 with the goal of reviving art's central role in society, was also among those who shared the sentiment that Americans were lacking time-honored, shared values. In addition to being one of the most prolific American church and campus architects of his time—the nave and north transept of the Cathedral of St. John the Divine in Manhattan and the Graduate College at Princeton, both from the 1920s, are two of his best-known works—Cram was a well-regarded public intellectual and a frequent speaker at the Yale School of Fine Arts during the early 1900s.[8] In his 1910 keynote speech at the "annual anniversary exercises," entitled "The Place of Fine Arts in Public Education," he outlined his educational vision, saying: "We study Greek and Latin, history, literature, philosophy, mathematics, not, primarily, that we may become specialists in the use of one or the other, at a given rate of pecuniary compensation, but that we may become cultivated men, and this should be our attitude toward the fine arts."[9] Cram reminded his audience that education should never aim at short-term gain and that art held a particularly important position in this regard because it was a product of the "spiritual mind" that "treasured consciousness of the innumerable æons of life that preceded this little hour of earthly habitation, and with the innumerable æons that shall succeed."[10] Akin to religion, art's function was to help humans transcend the finitude of life and gain access to the infinite, eternal realm beyond material reality. Very much like Cram, Meeks called for the "awakening of the mind[s]" of students through humanities-based arts education. In a 1925 lecture, Meeks struck a reverent note when defining the goal of the School of Fine Arts as follows: "We want our students to become more and more dignified and the work to become more and more dignified, so that the Art School shall not be an appendage but an integral part of this institution."[11] Meeks used a key concept of post-Kantian moral philosophy—dignity—to refer to a distinctly human quality worthy of universal respect, and felt that architects had lost theirs by succumbing to market forces and shortsighted profit-mongering. What Meeks, Emerson, Dewey, and Cram thus had in common was their shared desire to reassert timeless values—whether based on aesthetic, moral, or religious principles—into a world seemingly devoid of any.

Meeks's most consequential and long-lasting contribution to architectural pedagogy was to establish, in 1925, the so-called dual curriculum, which mandated that "technique[s] of various arts" were taught in tandem with "history, criticism, and appreciation of arts."[12] In an interview with the *Yale Daily News,* Meeks stated, "We do not have to choose between 'techni-

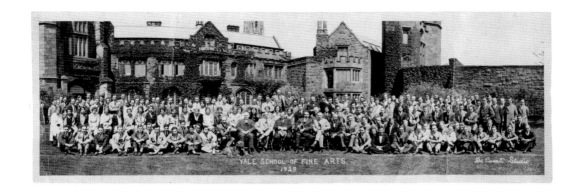

Fig. 10 Everett Victor Meeks with his students in front of Weir Hall, Yale University, photographed 1929.

cal' and 'academic' art instruction. We have no reason [to doubt] why they should not supplement each other. Here at Yale we have the almost perfect setting for completing, with little addition to our course, this dual curriculum."[13] The "setting" he referred to extended beyond drafting studios and classrooms into the "splendid art collection of pictures and drawings to frame work in architecture."[14] Access to both originals and reproductions set the new architecture program on par with that of the École des Beaux-Arts in Paris, which housed a collection of classical art on its premises. It was indeed the 1917 closure of the *école* during World War I that provided an impetus to establish at Yale, in the words of art history professor A. Kingsley Porter, an "architecture school of the very first rank in America" to compensate for that loss.[15]

To meet the standards of the French école, Meeks began to lobby for the university to expand its arts facilities into the area adjacent to Street Hall, the original home of the Yale School of Fine Arts located at the corner of Chapel and High streets. Weir Hall, designed by Meeks in the Victorian Gothic style, was completed in 1927 to house the new architecture program (figs. 10, 11). The building shared a courtyard garden named Weir Court with a new Gallery of Fine Arts, designed by Egerton Swartwout in a modified Italian Gothic style, which opened a year later along Chapel Street next to Street Hall with the goal of giving both architecture and art students easy access to the collections (fig. 12). The symbiotic relationship between the School of Fine Arts and the Gallery of Fine Arts was embodied by Meeks himself, who held a dual title as the dean of the former and the director of the latter for the next twelve years. The new arts curriculum mandated that the standard slide lectures would be complemented by "art appreciation" classes in the gallery setting, which encouraged students to "look beyond the pigment" into the "inherent quality that stamps it as a work of art."[16] The latter aspect can be traced to a key idea behind Western aesthetic thought, according to which discovering this inner core of art required transcending mere optical seeing and activating higher perceptual faculties. In Meeks's mind, the goal of these sessions was to train the observer to reach "such mental capacity . . . that what he sees speaks to him in terms far more emphatic than those with the capacity of conception,

Everett Victor Meeks 29

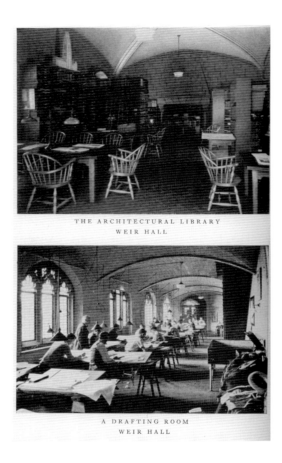

Fig. 11 Architecture library (top) and drafting room (bottom) at Weir Hall, Yale University. *Catalogue of the Department of Architecture in the Yale University School of the Fine Arts.*

founded on mere physical perception."[17] The operative goal of close observation was to distill the metaphysical essence of art and put it into use in the studio in a manner that transcends what had been traditionally at the heart of Beaux-Arts training—namely, learning by copying. The technique and subject matter were less important than the psychophysical experience delivered by the art object. Even the new gallery building was conceived as "a case study and an inspiration" rather than as an accurate representation of medieval architecture.[18]

All in all, experiential learning supported Meeks's idea of "humanization" by inserting human agency into a world that was being overtaken by forces that escaped human control. His approach to teaching art history was informed and motivated by two radically different temporal constructs: presentism, which is based on the notion that human beings have stayed essentially the same through the ages, and historicism, which assumes that the world is changing. The increasing access to visual tools allowed the emphasis on direct visual experience to inform classroom teaching as well. Here we are reminded that visual experience had emerged as a dominant epistemological paradigm within the discipline of art history in the late nineteenth century when Heinrich Wölfflin began to use the slide lecture format to highlight the "immediate experience" that a particular

Fig. 12 Egerton Swartwout, Gallery of Fine Arts, Yale University, 1926–28.

style through its characteristic forms, spaces, and materials can deliver. The idea that historical styles did not belong merely to the past but were constantly reimagined was grounded in a significant methodological provocation, which Wölfflin framed in his 1886 dissertation, "Prolegomena zu einer Psychologie der Architektur" ("Prolegomena to a Psychology of Architecture"), as follows: "A history that seeks only to ascertain the chronology of what has taken place cannot be sustained; it would be particularly mistaken if it supposed itself thereby to have become 'exact.'"[19] In similar fashion, Meeks saw the activation of "imagination" as the ultimate goal of "art appreciation" classes and mobilized the method of experiential learning to fuel the critical and creative faculties of art and architecture students. This suggests that he was at least superficially aware of what the Swiss art historian called the "imaginative beholding," which meant that experiential learning was both retrospective and projective: while learning about history, students were invited to project their own impressions and feelings onto past works.[20] As Mark Jarzombek has pointed out in his discussion of Wölfflin's art historical method, aesthetic experientialism aimed to "reawaken the living, human presence in a world stagnating in conceptual immobility."[21] This entailed ridding students of the temporal immobility by teaching them to recognize likenesses across time and space, and seeing this ability as something unique to human consciousness and thus worth fostering.

To be sure, Meeks was a keen observer and synthesizer of various intellectual and educational trends rather than a trailblazer. He was surely, for example, aware of what was happening at Harvard, where Charles Eliot Norton, informed by John Ruskin's experiential approach to art, had pioneered arts education in a gallery setting in the late nineteenth century. This so-called Fogg method, named after the art gallery where the lessons took place, put an emphasis on art's psychological effects and resonated with the

notion of "radical empiricism" put forward by Harvard's William James, which emphasized that true knowledge stems from direct sensory experience.[22] In 1928 Meeks echoed the thinking of yet another notable Harvard faculty member, the philosopher Alfred North Whitehead, when concluding his remarks on "The Place of Art in Higher Education" by stating: "Once the process of aesthetic appreciation, founded on a veritable basis of judgment, is instituted, the awakening of imagination has taken place and we have helped accomplish the ultimate object of education, not only in the highest and broadest sense."[23] Whitehead summed up his views on education in his hugely popular 1929 book *The Aims of Education:* "Fools act on imagination without knowledge; pedants act on knowledge without imagination."[24] Meeks translated these influences into an educational agenda that mandated that the goal of studying "art of the ages" was to learn the basic "grammar of art," which in turn would form the foundation for the production and experience of art.[25]

MITIGATING MODERNISM

Meeks's insistence on experiential learning reveals his ambiguous relationship to modernism and modernization. His pedagogical goal was to counter the perceived flatness of the rationalized world by investing it with "emotional authenticity," which T. J. Jackson Lears has defined as a common antimodernist tenet in early twentieth-century American culture.[26] So when Meeks began to use the words "modern" and "modernism" in his lectures and writings in the late 1920s, he did it with some trepidation, voicing excitement as well as concern that the embrace of novelty was leading students to lose sight not only of timeless aesthetic principles but also miss out on the experiential depth that could be gained by revisiting the past.

In his 1928 article "The Place of Art in Higher Education," whose title echoes Cram's 1914 essay "The Place of Fine Arts in Public Education," Meeks makes his antimodernist stance apparent when he shows concern about the "accelerating tempo" by which "virulent" forms of modernism were taking hold in young minds, which leads him to argue that it is impossible to set a standard for present and future art without visiting the "true standards of the past."[27] However, Meeks was keenly aware that forcing students to emulate past works would probably only increase the lure of new trends, which led him to envision the combination of history and studio teaching as a balancing act. His reasoning went:

> It seems fair to assume that a policy of instruction too strictly confined to the historical and critical examination of the arts may tend to train students with the idea that there is no art except of the past. Just as, on the other hand, should a curriculum offer nothing but technical instruction, the students might then tend to become too imbued with modernism, let us say, in too virulent a form.[28]

The "dual curriculum" combining the two aimed to mitigate the temporal divide between past, present, and future.

Initially, Meeks was rather positive about the new architecture emerging from Europe in the late 1910s and throughout the 1920s. The *New York Times* reported Meeks stating, in August 1930, that the emergent "new style" in architecture was a "'true one,' expressive not only of contemporary materials and methods of construction and function, but reflecting as well modern life, modern ideals and particularly latter-day conceptions of beauty of form." He cited buildings in Orly, France, and Breslau, Germany, as exemplary of the style that "gives [architects] a choice of [diverse] paths."[29] Meeks was surely familiar with the wide appeal of Le Corbusier's 1923 book *Vers une architecture* (*Toward an Architecture*) and the rise of modern abstraction, given his close ties to Paris and his friendship with Katherine S. Dreier, a major collector and promoter of modern art.[30] He must have also known that some nearby colleges had begun to offer courses on the topic; Alfred Barr, for example, had already taught a course on the topic at Wellesley College in the spring of 1927.[31] His enthusiasm was accompanied by a fear that the past was being ignored. It is also no accident that Meeks wrote "The Place of Art in Higher Education" a year after Josef Albers made a splash at the Sixth International Congress for Drawing, Art Education, and Applied Arts, organized by the League of Nations in Prague, with his lecture "Werklicher Formunterricht" ("Creative Education," 1928) and a parallel exhibit of student work from his Bauhaus *Vorkurs,* or preliminary course. A large American delegation consisting of 855 people, including Dreier, was in attendance.[32] While I have been unable to confirm whether Meeks traveled to Prague, he was surely informed about what was happening at the Bauhaus and contributed to the vivid debate about art education that followed the conference on the pages of the *American Magazine of Art* with the essay "The Place of Art in Higher Education." Echoing the foundational premise of the Beaux-Arts education—that to create something new, one must learn about the past—he wrote: "Not only, therefore, must the programme of study which the university offers keep pace with the times; it must also be prophetic, planned with a vision to meet the conditions and possibilities of the future, in so far as they may be foreseen, from a careful, analytical, and perhaps one might even say synthetical, reading of conditions of the past and of the present."[33] Acknowledging that "the older generation should not for a moment forget that the young men and women of the younger generation naturally demand to know about and understand the modern work they see going on everywhere about them," he devised a strategy to "plan and administer our instruction in art [so] that trained critical ability and trained creative ability may cope with this immanent, menacing problem and attempt clearly to solve it for the future of art." The main challenge was to hold the "accelerating tempo" of change at bay; the cure was to ground students by teaching them the "basic principles of art."[34]

In a subsequent essay on the topic, "The Responsibility of the College" (1931), Meeks continues to emphasize that "the eager young designer needs to know what the past has considered fine in order that he may build up a logical aesthetic basis for his own work." In his mind, "a fundamental insight into principles [and] a knowledge of beauty in the past [would help] counteract the vagaries that are the result of unbalanced education and judgment."[35] The urgency was accompanied by the prospect that the students were "going to be in many cases the patrons, in some cases the creators, of the art of the future."[36] He concluded his essay by making a case for Yale's "dual approach" to art education, which combined the "creative" and the "historical-critical" methods, on the grounds that "on such a programme, broad enough and elastic enough to reach all phases of mind, we may hope to build for the future."[37] Meeks stood firm in his belief that studying the past should remain a hallmark of academic arts education even after the founding of several new art schools, which rejected history teaching, among them the Black Mountain School in Asheville, North Carolina, with Josef Albers at its helm. The *New York Times* reported that in the school's "anniversary exercises" Dean Meeks asserted that "while extreme modernists deplored what they called 'academic training,' Yale took the position that it should give 'the best possible general fundamental training in the arts.'" The term "fundamental" alludes to the idea of perennial, nonstylistic aesthetic standards at the core of his educational agenda, which transcended stylistic "isms" of all kinds.[38] His 1937 article entitled "Foreign Influences in American Architecture" captured his steadfast belief that, as far as aesthetics are concerned, the principles and standards do not change over time. In his words, "there are certain 'imponderables' that breathe a living spirit into its works, certain 'immutables' that form the basis of a true aesthetic."[39]

Meeks was optimistic that modern architecture could meet the "immutable" standards. In a lecture given at the fiftieth anniversary of the Architectural League of New York in 1931, he sought a common ground between the "radical" and "conservative" factions of contemporary architecture by stating that "in all the impatience that the imaginative experimenter may have with the 'style man,' let us remember that there is a broad common ground upon which they may meet, respect one another, inspire one another. And it is the only stable ground—I venture to say—upon which either may build his philosophy of design. It is beauty."[40] He again cited French and German examples—Eugène Freyssinet's airplane hangars in Orly (1916–23) and the Werkbund exhibition buildings in Breslau (now Wrocław) (1929)—as being exemplary in this regard. These examples proved that certain "immutables" were still valid:

> I permit myself one basic principle for future architecture.... Architecture, the most formal of the arts, has an essential esthetic which is bound up with the very term "architecture." Unity, balance, proportion, rhythm and scale are fundamental and must be recognized

as such. Only on such a foundation may we raise structures, which shall have truth and character. In particular let the revolutionist remember that if his architecture is to stand, not only the test of the elements but the test of time, it must appeal not only to man's rational judgment but to his esthetic sense as well. Only when it does this can it be truly architecture. Otherwise it is mere building.[41]

His message was clear: those unable to master timeless formal and aesthetic principles could not be considered architects. By the time he wrote these words, students such as Eero Saarinen had already begun to incorporate modernist formal tropes such as flat roofs into their work, warranting Meeks's concern over proper appropriation of those tropes (fig. 13).

Meeks doubled down on his commitment to the dual curriculum after Columbia and Harvard began to modernize their curricula, arguing that the ability to produce truly "contemporary" art and architecture required that students absorb "perennial" aesthetic standards and values through their education. It is worth quoting Meeks's 1938 lecture entitled "Modern Art" at length to get a sense of the temporal construct behind his claim:

> The true art of the past is alive and perennial. The true art of today will live and endure, but only in recognizing and adhering to standards which slowly unfolding human experience has revealed and which only a continued, ordered and universal development can change. Again let us not forget that through it all has run the appeal to the aesthetic. Two decades are not going to eliminate the results of the experience of mankind.[42]

In a subsequent sentence full of rich temporal markers, Meeks made a case that to be truly "contemporary" a work must merge the past, present, and future into a continuous topology:

> Should we [not] always stress in due degree the art of the present, particularly in all curricula designed even for the layman, but we must go further and try continually to bring out the interdependence of the arts, past and present, upon each other, as well, of course, as the value of tradition as it bears on the art of the present, in an endeavor to stimulate and foster a real knowledge not only of what art was, but what it is and should be.[43]

History should thus be taught with the present in mind. The 1933–34 bulletin states accordingly that history should thus be taught with contemporary architecture in mind. For example, a survey dedicated to "the development of the elements of architecture in the historical styles" could be taught "with special reference to their use in America today."[44]

While Meeks was surely considered a relic of a bygone era within certain modernist circles, his educational mission was, in fact, based on a

relatively novel temporal construct—that is, Henri Bergson's idea of temporal *durée,* or duration, by asserting that the past, present, and future flow and interpenetrate one another through human perception. Bergson first propagated the idea in *L'évolution créatrice* (*Creative Evolution*), which was published to critical acclaim in 1907 when Meeks was studying at the école in Paris. In it, Bergson wrote: "Like the universe as a whole, like each conscious being taken separately, the organism which lives is a thing that endures. Its past, in its entirety, is prolonged into its present, and abides there, actual and acting."[45] Its English translation in 1911 was followed by a widely publicized American lecture tour that included a stop at Yale in 1913.[46] As we will learn in the third chapter, Meeks's top hire, Henri Focillon, had studied with Bergson and shared the belief that the past, present, and future organically intermingle in a truly creative mind. Like Focillon, Meeks advocated that, at their core, art and architecture transgressed time.

WHAT TIME IS MODERN ARCHITECTURE?

To battle superficial adoption of modernism among students, Meeks turned Yale into a site for active conversations about modern architecture. The roster of speakers and topics from the mid-1920s onward indicates that architecture's relationship to time and history dominated the discussions. The burning question was how to learn from the past without resorting to copying historical styles and, subsequently, how to avoid turning modern architecture into yet another style. The fact that the *Yale Daily News* covered these lectures, often on its front page, bears witness to the wide interest

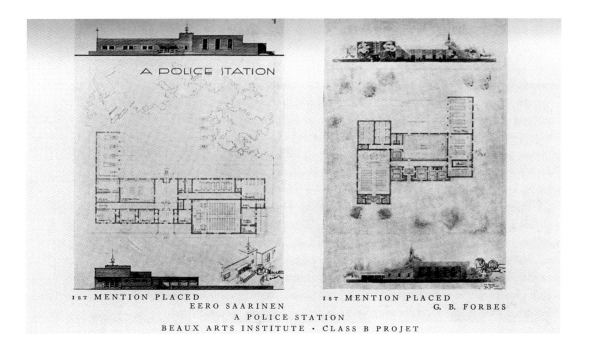

Fig. 13 Prize-winning entries by Eero Saarinen (left) and George Bartlett Forbes (right) to the Beaux-Arts Institute of Design competition, 1934. Reproduced in the *Catalogue of the Department of Architecture in the Yale University School of the Fine Arts* (1931–35).

in the topic just as buildings in various historical styles were being erected on campus.

The first series of lectures took place in the spring of 1924 under the rubric "The Trend of Architecture in America." The word "trend" suggests that the organizers felt that, while something new and exciting was in the air, the status and long-term prospects of those trends were still debatable. Meeks began the series with a lecture entitled "The Modern Trend in Architecture" in which he applauded the Finnish American architect Eliel Saarinen for his ability to lead the discipline forward without losing sight of the past. Saarinen belonged to what Meeks called the "no style school," which transcended time and place.[47] The legacy and validity of historical styles continued to dominate the discussion with the 1925 appearance of Raymond Hood, whose winning entry to the 1922 *Chicago Tribune* competition, designed with John Mead Howells in the neo-Gothic style, was about to be completed.[48] Many, including the preeminent Chicago architect Louis Sullivan, preferred Eliel Saarinen's runner-up scheme featuring abstract vertical massing that tapered off, based on the setback principle (fig. 14). While Hood remained loyal to historical styles for another decade, the criticisms against his design were certainly on his mind when he defiantly said that "modern architecture should . . . be something symbolic of our own age" and that "good architecture has always been modern."[49] He defined "modern architecture" rather broadly: it relied on the architect's ability to create rather than copy. In his words, "people who copy are not playing the game squarely. . . . It is the weak who copy and the strong who create, and who have the energy to put away the temptation to call the work of others their own."[50] He continued to note that architectures of the past should surely be studied, but only to find out applicable "methods" rather than to copy the finished results.

Literal emulation of historical styles came under increased scrutiny in the 1930s. British architect and planner C. R. Ashbee lectured in 1931 on "Gothic and Georgian Revivals and Their Meaning," maintaining that learning from historical period styles should not be excluded but simply reframed: rather than imitated, a style could be "revived" with new meaning and urgency.[51] Ashbee set the tone by insisting that historical styles could sponsor new ideas and thinking. Subsequently, starting in the mid-1930s, most of the lecturers who were brought on campus belonged to the group Henry-Russell Hitchcock had called the "new traditionalists" in his 1929 book *Modern Architecture: Romanticism and Reintegration.* Swedish architect Ragnar Östberg—responsible for the much-celebrated Stockholm City Hall, which had been completed in an early Renaissance style rather belatedly in 1923—lectured and exhibited his work at the art gallery in 1934.[52] The *Yale Daily News* captured the temporal paradox behind Östberg's most famous building by noting that his work could be read against two temporal frames: whereas many saw Stockholm City Hall as the "most perfect modern building in the world," it was "termed by others 'the last

Fig. 14 Entries to the 1922 *Chicago Tribune* competition by John Mead Howells and Raymond Hood (left), Eliel Saarinen (middle), and Bertram Grosvenor Goodhue (right). Reproduced in Talbot F. Hamlin, *The American Spirit in Architecture* (New Haven: Yale University Press, 1926), 198.

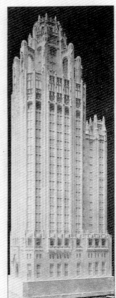
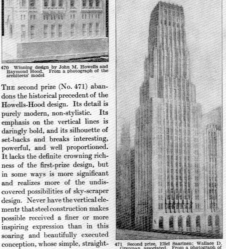
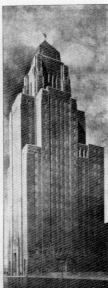

stand of the Renaissance.'"[53] In his lecture "The New Lines of Development in Architecture," Östberg voiced concern about the speed of change. It is worth quoting from his lecture at length because of its rich thematization of time from the get-go:

> The question as to which direction the building art of a new time will take has always presented itself periodically, and claimed our interest. But the intervals between the various styles were always longer in the past, and seem to have been longer, the further back our eyes rove. It is considerable time now since one particular stage in type persisted through several generations. Now rather one generation suffices for several stages, during which a distinct style

hardly has time to be achieved. This circumstance is certainly connected with the hurry of our occidental culture, which more and more feels irritation over having to remain with anything, making it fuller, or, as the Swedish poet said, "digging the dike deeper." Speed has become everything. The goal is nothing but a resting place on the way.[54]

Numerous temporal markers populate Östberg's talk: the passing of generations and "intervals between the various styles," various tempos that contrast the "speed" and "hurry" with the call to "persist" and "remain."[55] He concludes with a warning about pace of change: "The real danger by which architecture is threatened in the restless hurry of our time, is that no style is given time to mature, but in succession one unripe fruit is thrown away in the hurry to pluck the next."[56] The Swedish architect echoed Meeks's concerns when criticizing the increasingly utilitarian approach to architecture, stating that "it is necessary to maintain a bold front against the mechanical trend of the times, and in reality no influence is more beneficial in this connection than the artistic."[57]

A cluster of further talks on modern architecture was organized the following year around Le Corbusier's much-advertised American lecture tour, under the auspices of the Martin A. Ryerson Lectures on Modern Architecture between October 1935 and February 1936. At stake was the increasing prominence of Europeans in a field once dominated by American "pioneers," and tellingly the lecture series was sponsored by and named in honor of a wealthy Chicagoan lawyer, philanthropist, and art collector whose family had been a major patron of Louis Sullivan. The series featured, in addition to Le Corbusier, four architects who represented different facets of American architectural modernism: the eminent Frank Lloyd Wright, whose career was about to get a second wind; Ralph Thomas Walker, a successful New York–based art deco architect; George Howe, an early convert to international-style modernism; and architect and educator Eliel Saarinen, whose *Chicago Tribune* competition entry had become a model for new skyscrapers, among them Hood's Rockefeller Center (1931–33). Suspicion about "modern" trends emerged as a dominant theme, with Wright setting a tone and bypassing the concept of "modern" architecture altogether by focusing instead on the notion of "organic architecture." He struck a transcendentalist tone on October 16, 1935, before a packed audience at the Yale Law School auditorium. "You must learn the nature of man, the structure of life, and nature itself, always nature," he said. "The true architect expresses himself by what he has learned from nature and what he is himself."[58] Importantly, he aligned architecture with nature rather than with human history.

Le Corbusier took the stage two weeks later, on October 30, to discuss his style of architecture, which he defined as a "reflection of the modern machine age" and a "product of the development of steel, concrete and

glass."[59] The *Yale Daily News* reported that he showed drawings and movies of his own work, noting that, "unlike Wright," the eminent French architect talked about architecture's need to "pleas[e] the eye."[60] In that regard, the lecture was in line with the thesis of his, by that time, hugely influential book *Vers une architecture,* which embraced new technological and material innovations in tandem with architecture's timeless formal principles.[61] It is interesting to compare Le Corbusier's rationalist emphasis on universal formal standards with Ralph Walker's emphasis on human practical and emotional needs in his lecture "Form Follows Function."[62] Walker's functionalist criteria was certainly more relative and subject to variables such as personal preferences, local cultural norms, and climatic requirements rather than the timeless aesthetic standards promoted by Le Corbusier.

Eliel Saarinen, whose medievalist compound, comprising Cranbrook School for Boys, Kingswood School for Girls, and Cranbrook Academy of Art, had just been completed in Bloomfield Hills, outside Detroit, concluded the Ryerson lecture series on February 5, 1936, by echoing Wright's sentiment that many architects had fallen prey to "imitation," despairing that modern art was "a confusion of copies. Art schools, too, are often out of touch with the life about them." His solution struck a quasi-transcendentalist tone: instead of copying either contemporary or past work, architects should tap into the eternal creative forces around them and "turn to the universe about us, to life, and the stars and the atoms, for our artistic principles." After such cosmic evocations, Saarinen turned his attention to the present, stating, "We must realize that a man or an art is only great as it is related to the contemporary life and environment." The fundamental premise was that architecture was part of a larger totality. "Cities," for example, "should be designed as a whole, carefully organized in three dimensions. For architecture is the art of organization of everything from the individual room to the large city." He concluded, "We must keep away from preoccupation with style."[63] The lectures were hugely popular, and the presentations of both Le Corbusier and Frank Lloyd Wright had to be moved to the Yale Law School auditorium due to high attendance. The series was covered prominently on the pages of the *Yale Daily News*.

As German émigré architects Marcel Breuer, Walter Gropius, and Mies van der Rohe were appointed to positions in peer institutions, Yale engaged architects who represented more moderate, regional alternatives to high modernism. Swedish architect Gunnar Asplund was invited to give a Trowbridge Lecture in April 1934, and Alvar Aalto's work was singled out as a model of a presumably more perennial humanizing approach to architecture. His 1938 Museum of Modern Art retrospective was shown at the Yale Gallery of Fine Arts in September of that year, and he returned to campus the following April to deliver the lecture "The Problem of Humanizing Architecture," which was sympathetic to Meeks's educational goal to fight off the materialistic and technocratic imperatives imposed on architecture. In this model, architecture was to be governed by human psychophysical

needs, which did not change through time. The selection of Sigfried Giedion to deliver three Trowbridge Lectures under the title "Towards Contemporary History" in the fall of 1941 confirmed the pattern of choosing speakers who saw modern architecture as a product of longer cultural developments. The *Yale Daily News* reported how in his final talk "Giedion put forward the idea that modern architecture had its roots in anonymous inventions of the past, which he called the 'constituent factors' in our evolution."[64] Of the many European modernist artists who gravitated to the United States during World War II, the speakers who were chosen promoted the timeless essence of art. Among them was Le Corbusier's former collaborator and onetime client, the cubist painter and writer Amédée Ozenfant, who took the stage on March 15, 1939, to give the lecture "Form from Prehistoric to Modern Times," which reinforced the idea that modern art and architecture were part of a longer temporal durée rather than a fad.

Conversations about modern architecture's relationship to time and history were put on hold when the focus shifted from the quest for the soul of modern architecture toward more pragmatic and programmatic concerns in response to the Great Depression and the war. This was the mood in early 1939 when two hundred experts delivered papers at a conference titled "Yale-*Life* Conference on House Building Techniques," organized by the Department of Architecture and *Life* magazine. One of the speakers was Wallace K. Harrison, a leading American modernist who served as a "chief critic" at the Department of Architecture from 1938 until 1942 and had just helped to complete Rockefeller Center, one of the largest projects of the New Deal era. Henry R. Luce, the president of Time, Inc., delivered the closing address. Luce—a Yale alumnus and the owner of a vast media empire that included *Time, Fortune,* and *Architectural Forum* magazines—was an ardent booster of American architecture and the country's global political might.[65]

When Meeks retired in 1947, *Architectural Forum* ran an article titled "Arbiter of the Arts" that celebrated his ability to "rid[e] the tide of changing taste throughout his entire life" and how "over and over, Meeks has hit the current trend of architectural thinking at exactly the moment when his particular background and abilities were at a premium, suggesting the eerie idea that history was tailored to fit Everett Meeks rather than vice versa."[66] Meeks's ability to adapt to mitigate the impact of modernism was noted in particular:

> By the late 'thirties, when America's delayed architectural explosion became violent enough to penetrate even the ivy-clad halls of American colleges, the Dean was so thoroughly entrenched in his job that he could afford to act as a shock absorber. . . . Now, without relinquishing his own Beaux-Arts ideal, he gradually allowed the college philosophy to keep up with the changing times. . . . He [even] brought such radical lecturers as Le Corbusier, Frank Lloyd

Wright, Eliel Saarinen, Buckminster Fuller, Alvaar [*sic*] Aalto, Fernand Leger [*sic*] and Amédée Ozenfant to amaze the inmates of his Gothic catacombs. Once again, Dean Meeks had managed to ride with the tide.[67]

Indeed, while Yale's peer institutions had already begun to "loosen the hold of the Beaux-Arts system" in part due to the Great Depression, which had led architects to shift their attention from questions of style to burning social issues, Yale began the transition only after Meeks's retirement in 1947.[68] As it turned out, what motivated the transitioning to "modern" pedagogy at that historical conjuncture, in the immediate aftermath of the war, had less to do with practical problems than with the desire to revisit the transhistorical meaning and significance of architecture.

CHAPTER 2

James Gamble Rogers
Modern Gothic

When Frank Lloyd Wright and Le Corbusier lectured at Yale in 1935, the architectural setting—the eight-hundred-seat auditorium of the Sterling Law Building, executed in the highly ornate Collegiate Gothic style—was the elephant in the room. The building's completion date, 1931, made it one of the latest Gothic buildings to be erected on any American campus (fig. 15).

One can only imagine the mixture of envy, horror, and awe the two trailblazers of modern architecture must have felt at the sight of the vast new campus executed in various historical styles—mostly Gothic—during a mere fifteen-year period. Many of the new, albeit old-looking, buildings were designed by James Gamble Rogers, who was Wright's exact contemporary and a fellow Chicagoan. The two had, in fact, known each other during their early careers at the turn of the century when the city was the center of American architecture culture. When Wright's Yale lecture took place, both men were in their late sixties, and while Rogers was at the peak of his career, Wright's career had slowed but was about to regain momentum. When asked what he thought about Yale's new campus during the Q&A period, the latter was quick to respond: "I've wasted my time if you don't know the answer."[1] Le Corbusier, twenty years his junior, was equally dismissive. During his lecture on the origins of modern architecture, the *Yale Daily News* reported him making a not-so-veiled criticism: "Since we no longer are living in the Middle Ages, why should the houses in which we live be designed in a Middle Age style that handles only the problems of that period?"[2]

Yet, before we take their criticism at face value and dismiss the Collegiate Gothic style prevalent on American campuses in the early part of the twentieth century as mere anachronism, we must ask: What qualities and values were invested in the style, and what made it both so popular and controversial? Indeed, while copying stylistic traits and typologies of medieval architecture appeased mainly the traditionalist mindset, its spatial, atmospheric, and experiential qualities appealed to many, who saw value in the ability to trigger an intense sensation, in the here and now, all while evoking historical and cultural values of a bygone era. Furthermore, the

Fig. 15 James Gamble Rogers, Sterling Law Building, 1931.

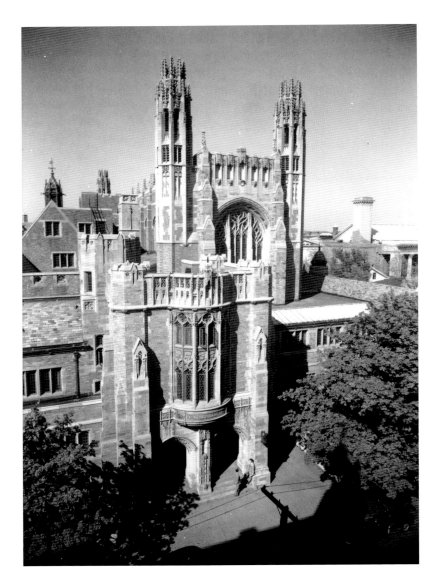

Gothic's structural audacity was lauded by traditionalists and modernists alike. As we will learn, even Le Corbusier credited Gothic builders' boldness and ambition.

GOTHIC GHOSTS

The Gothic style's unique legacy within the history of modern architecture began with Wolfgang von Goethe's 1772 ode "Von deutscher Baukunst" ("On German Architecture"), which begins with a visit to the graveside of architect Erwin von Steinbach, whose ghost subsequently guides the visitor through his masterpiece, the Strasbourg Cathedral. Apart from its nationalist fervor, the essay brought a new type of epistemological paradigm into the architectural discourse: a direct phenomenal encounter marked by a

new type of knowledge, feeling, as well as a new temporal metaphor, *Geist,* which can be translated either as a "spirit" or "ghost." The message of his ghost-infested story was somewhat paradoxical: an emotive link to the past intensified the sensation of being fully alive at the present moment. Its author despised how his French contemporaries were reducing historical architecture into theoretical and mathematical formulas. For him, architectures of the past were not mere replicable material objects, but alive, dynamic, and palpable, both animated and invested with the ability to stimulate the contemporary mind. Goethe's succinct advice to them was to "measure less and feel more."[3]

John Ruskin introduced these fundamental components of German Romantic thought—feeling and imagination—into nineteenth- and twentieth-century architecture culture with his widely read book *The Stones of Venice* (1851–53), which presents the Gothic style as a source for new types of experience marked by awareness of time. He wrote: "The vital principle [of Gothic architecture] is not the love of *Knowledge,* but the love of *Change.* It is that strange *disquietude* of the Gothic spirit that is its greatness; that restlessness of the dreaming mind, that wanders hither and thither among its niches, and flickers feverishly around the pinnacles, and frets and fades in labyrinthine knots and shadows along wall and roof, and yet is not satisfied, nor shall be satisfied."[4] Echoing Goethe, Ruskin masterfully captures the movements of his "restless mind," scanning and inhabiting the nooks and crannies of San Marco with his breathless prose; like his German predecessor, instead of treating medieval Venice as a relic of the past, the author tried to define its "nature" and "character," as if confronted with a living thing. Guided by this ambition, Ruskin set out to study the Gothic style through direct experience without being hampered by preconceived ideas and stylistic taxonomies. Like all Romantic thinkers, he insisted on direct experience. His position was firmly rooted in the intellectual and scientific culture of his time: he was an empiricist, who believed in cultivating an intimate relationship between mind and environment; and, as a realist, he believed in rendering reality as a fact without complex intellectual overlays and abstractions that turned both architecture and nature into static formulas. He said that the Gothic style, like nature, had never stopped evolving as it encountered and subsequently absorbed aspects of other styles, leaving a trail of endless regional variants, a process akin to hybridification in nature. For example, the Venetian Gothic was, to his mind, a hybrid produced by an encounter between Northern Gothic and Byzantine architecture. The title of the book's fourth chapter—"The Nature of Gothic"—was a nod to this link between architecture and nature.

The Gothic surfaces with a vengeance at the advent of the twentieth century as a model for architecture that can mediate between individual experience and large-scale historical changes. In his 1911 book *Formprobleme der Gotik* (*Form in Gothic*), the prominent art historian of medieval art Wilhelm Worringer located the birth of modern individuality in the Gothic

period, writing: "Both in religion as in all [art] . . . the individual I becomes the carrier of feeling. . . . There is no question that [the Gothic style] provides the history of modern feeling and thus of modern art."[5] In his previous book, *Abstraktion und Enfühlung* (*Abstraction and Empathy: A Contribution to the Psychology of Style,* 1908), Worringer reached a verbal crescendo when describing the complex psychological charge of Gothic architecture: "Gripped by the frenzy of these mechanical forces, that thrust out at all their terminations and aspire toward heaven in a mighty crescendo of orchestral music, he feels himself convulsively drawn aloft in blissful vertigo, raised high above himself into the infinite. How remote he is from the harmonious Greeks, for whom all happiness was to be sought in the balanced tranquility of gentle organic movement, which is alien to all ecstasy."[6]

Following in Goethe's and Ruskin's footsteps, twentieth-century lovers of the Gothic produced some of the most idiosyncratic architectural writing by mining the depth of human experience. Among the most evocative was Karl Scheffler, best known as the editor-in-chief of the influential magazine *Kunst und Künstler* (Art and artists). His 1908 book *Der Geist der Gotik* (The gothic spirit) treats Gothic architecture as the ultimate symbolic art form that culminates in a cathartic rupture: a communion with the surrounding world. On occasion, his prose reads like a Gothic novel as the animating spirit impregnates the building under scrutiny to the point of unhinging: "The stone became immaterial, the weight became lifted, as it were, the wall became erased, the spatial boundaries became invisible, and everything resolves into an atmospheric synthesis [*Stimmungssynthese*]."[7] Like his predecessors, Scheffler did not treat the Gothic as a mere historical style but as a site and symptom of transhistorical existential strife. This approach enabled him to consider a whole host of examples—the medieval cathedral in Riga, Auguste Rodin's sculptures, and Henry van de Velde's interiors—as outcomes of a shared sensibility born out of the human desire to master change. New building typologies brought on by modernization were particularly potent examples of "the restless force towards power, which governs the whole world, find[s] its fulfillment in storage buildings [*Speicherbauten*], department stores, and skyscrapers, the industrial buildings, railway stations, and bridges; in the rough functional form lies the pathos of suffering, the Gothic spirit."[8] The perennial "Gothic spirit" continued to live in the minds and bodies of the creators. When writing about Hans Poelzig's colossal theater in "Das Grosse Schauspielhaus" (The great theater, 1919), Scheffler focused on how "through the 'Gothic' in him, [Poelzig] strives for the pathos of expression and hugeness, breaking all stylistic imitation and leads towards the new."[9] Like their medieval ancestors, the twentieth-century purveyors of the Gothic style were the epitomes of intense creativity and pathos.

The reverence of medieval architecture and culture was not limited to Europe but also took firm hold in the United States, where the promi-

nent American historian Henry Adams championed the Middle Ages as a period of extreme vitality. In his widely read 1913 book *Mont-Saint-Michel and Chartres,* Adams made the period sound the most modern of all: "The nineteenth century moved fast and furious, so that one who moved in it felt sometimes giddy, watching it spin; but the eleventh moved faster and more furiously still."[10] Since Gothic architecture was a product of such a fast-moving period, it was thus particularly fitting for modern times, went the logic. Intellectual historian Michael D. Clark summed up Adams's medievalism as follows: "The Middle Ages were not, in Adams' rendition, gloomy, monkish, otherworldly, or oppressed by the weight of tradition; they were rather a time of youth, passion and dynamism. In some ways, despite Adams' anti-modern stance, they were strikingly modern."[11] The Middle Ages thus came to be seen at this time as a period of transformation, analogous to the present moment, which led to the proliferation of medieval studies in American universities. Princeton's Charles Rufus Morey pioneered medieval art and architecture as a new area of scholarship, based on the belief that, out of all historical styles, Gothic was broadly understood as offering the most viable model for American architecture during a period of rapid modernization.[12] Yale's decision to hire, in 1932, two historians of medieval art and architecture—Henri Focillon of the Sorbonne and Marcel Aubert of the École des Beaux-Arts—was indicative of this wider interest in mining the link between the medieval and modern periods at a time of great political, social, and technological change.[13]

After the 1922 *Chicago Tribune* Tower competition, the proper contemporary use of the Gothic style became a popular topic of conversation regarding the future of the most modern American building typology—the skyscraper.[14] In his 1926 book *The American Spirit in Architecture,* the Columbia University–based architect turned arts librarian Talbot Faulkner Hamlin coined the term "modern Gothic" to make a case for the continuing validity of the style on the grounds that it can continue to evolve *and* retain the aura of a bygone era.[15] In his view, its modern incarnation had to be based on the expansion of the original style rather than on its literal emulation. He had favored Saarinen's second-place entry to the *Tribune* competition because it "abandon[ed] the historical precedent of the [winning] Howells-Hood design" and was in "its detail . . . purely modern, non-stylistic [because] its emphasis on the vertical lines is daringly bold, and its silhouette of set-backs and breaks interesting, powerful, and well proportioned."[16] In Hamlin's description, Saarinen had managed the upgrade by distilling the Gothic style to its essential formal characteristic, verticality, which embodied not only the grandeur of the new skyscraper typology but also the bold and striving "American spirit." This shift from a literal adaptation of a historical style to the emphasis of its formal and symbolic essence went hand in hand with two ways of understanding how the past can be relayed to the present: historicist architecture relied on a certain level of historical knowledge and decoding, while the latter allowed the past to be

communicated to the experiencing subject in an immediate, psychophysical manner, just as it had communicated with Goethe 150 years earlier.

The conversation triggered one of the most fervently conservative and even reactionary American architects at the time, Ralph Adams Cram, to double down on his insistence that the Gothic style did not belong to the past nor did it need to be modernized. In a December 1926 issue of the newly founded *Time* magazine, he said that "Gothic restoration is neither a fad nor a case of stylistic predilections" but continued to live in sync with the "great rhythm of human life that is the underlying force of history."[17] Cram's rhetoric reveals that he was an avid reader of Henri Bergson and saw the style as a crystallization of a supernatural life force, an élan vital, that existed outside time. The issue of *Time* featured Cram on the cover—a sign that his version of the Gothic also got a stamp of approval from its publisher, Henry Luce. Cram's vitalist rhetoric surely appealed to Luce's conviction that, as a nation, the United States was full of vitality, even if its citizens were at times unable and unwilling to capitalize on its potentiality. Luce later coined the term the "American Century" and wrote that the United States was the "most powerful and vital nation in the world," invested with a special purpose and destiny to lead.[18] Giving birth to Gothic restoration would be a logical manifestation of the advent of the new superpower.

Cram found a curious bedfellow in Le Corbusier, who came to a similar conclusion that American architects could learn a thing or two from their medieval predecessors after a 1935 lecture tour that took him to the campuses of Columbia University, the Massachusetts Institute of Technology, Princeton University, the University of Michigan, Yale, Cranbrook Academy of Art in Bloomfield Hills, Michigan, and numerous other smaller colleges and cultural institutions in the East Coast and the Midwest. He chronicled his observations in his 1937 book *Quand les cathédrals étaient blanches: Voyage au pays des timides* (*When the Cathedrals Were White: A Journey to the Country of Timid People*), whose cover juxtaposed imagery from medieval France over a 1922 map of Manhattan. An image of a medieval knight placed just above the author's name presents Le Corbusier as a modern-day architect-crusader arriving in a foreign land to combat architectural heresies and introduce a new era built on lessons from the medieval past (fig. 16). The author states his mission in the book's opening pages, writing: "I wish to show only the great similarity between [the medieval] past . . . and the present day."[19] Architecture had deteriorated since the Middle Ages and needed to be set on a new path, he believed. This view had led him to propose a few years earlier that, while a large patch of central Paris should be torn down to make room for his Ville Radieuse, the remnants of the city's medieval past should be left standing as a memento of that era's soaring spirit. Now it was America's turn to learn from medieval ancestors what it meant to harness the present moment.

While Le Corbusier's relationship to history was ambiguous, to say the least, he never thought that embracing modernity's forward-leaning thrust

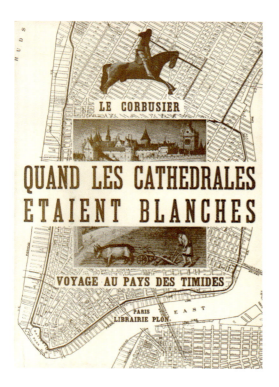

Fig. 16 Cover of Le Corbusier, *Quand les cathédrales étaient blanches* (Paris: Libraire Plon, 1937), showing imagery from medieval France juxtaposed over a 1922 map of Manhattan.

would mean leaving the past completely behind. He pointed out that he had been misunderstood in this regard during a 1929 lecture in Buenos Aires, saying, "Today I am considered a revolutionary. I shall confess to you that I have had only one teacher: the past; and one education: the study of the past. Everything, for a long time, and still today. . . . It is in the past that I found my lessons of history, of the reasons for being of things. Every event and every object is 'in relationship to.'"[20] His American travelogue reads as a crusade against what Nietzsche called the "misuse" of history, which hinders lessons from the past from being properly integrated into present-day life. Reading Nietzsche had taught Le Corbusier that the true essence of the past is accessible only to those who live courageously in the present; only then, he wrote, have we "extended our *sympathy* to all the world and to all times."[21] Using language rich with hyperbole, Le Corbusier celebrated medieval architecture as being international and "dazzling" and the medieval people as courageous, "direct and raw, frank."[22] Those who built the cathedrals had the guts to turn "their backs on 'the antique,' [and] on the stereotyped models of Byzantium," he wrote, lamenting that the Middle Ages had come to an end with the Renaissance, when erudition and copying eclipsed the dynamic life force as the primary agent of form-giving. After a tirade against how Renaissance art was being "imposed upon us in the schools by our instructors," he proposed that architects and students of architecture should follow the lead of their medieval predecessors and begin to "live intensely in the present moment of modern times."[23] Such passages suggest that Le Corbusier's love for the Gothic was both fervently

Fig. 17 Le Corbusier, sketch made during a lecture at Columbia University, October 1934, which contrasts engineering architecture (top) and academic Beaux-Arts architecture (bottom).

presentist and anti-historicist. "Everything, at every hour, is only the work of the present moment," he wrote.[24] Copying the Gothic style verbatim without inhabiting the medievalist mindset thus betrayed its very essence.

Academic adulation and replication of historical styles, which he witnessed at American architecture departments, particularly those housed at Ivy League universities, was his pet peeve. Yet, American infatuation with Gothic architecture manifest on college campuses seemed to both baffle and fascinate him. He conveyed his ambivalence when he said: "The American university is a world in itself, a temporary paradise, a gracious stage of life. . . . Often the style is Gothic—that's the way it is!—rich, luminous, well made."[25] His words echoed Ruskin's conviction that architecture was a product of the human mind and spirit and should in return activate them; in this case, "luminous Gothic" resonates with the intensity of young life during this tender period. The Collegiate Gothic style might have even reminded him of his own youthful travels to Venice and Ravenna, where he had rendered details of the Venetian Gothic, following Ruskin's lead. His verdict of the still predominantly Beaux-Arts–based American architectural education was less ambiguous. Romantic bias against overtly academic neoclassical architecture was evident in the drawing he made during a Cranbrook lecture, which depicted American architectural education as being stuck in producing neoclassical "corpses."[26] A drawing by him shown at Columbia, Vassar, and Yale contrasts products of Beaux-Arts training with the great achievements of American engineering such as the George Washington Bridge, which in Le Corbusier's words was an emblem of "daring technique" and a product of "experimentation" conducted by people who were "not fossilized" (fig. 17).[27]

In *When the Cathedrals Were White* Le Corbusier used numerous spatio-temporal metaphors to communicate that to be modern had less to do with style than with a certain disposition toward time and change. Mikhail Bakhtin's contemporaneous term "chronotopos," or "time-spaces,"[28] comes to mind when he surmised that "the spirit of the new times does not blow with the strength of the gale," and how "in the instruction at American universities I observe a sort of fear of seeing the doors open on the unknown of tomorrow."[29] In these two sentences he likens time to a windy landscape that we need to bravely inhabit, instead of hiding behind closed doors. At Cranbrook, Le Corbusier despaired about "the dramatic conflict which is strangling architecture, which causes 'building' to remain off the roads of progress, [and] architectural products [to] remain outside the frame of modern times."[30] In this instance, time is likened first to a road and then to an enclosure; the road metaphor assumes that time has a direction, and the idea of an enclosure suggests that we can choose to exist either within or outside our time. In his view, the citizens of Manhattan failed to embrace the present and strive, boldly, toward the future. All in all, Le Corbusier found Americans to be suffering from a particular kind of modern pathology: chronophobia, or a fear of time, which manifested itself as "timidity" and temporal disorientation, as Grand Central Terminal made him lament how "everything is torn apart—or at least pulled in two different directions: tradition (having existed) and the impulse to build everything in a new way."[31]

What the world's most famous modern architect had to say about America's national malaise—chronophobia—was widely covered in newspapers. Temporal metaphors are plentiful in a 1935 *New York Times* interview, which relayed Le Corbusier's characterization of himself as a "missionary of modern art in the land of the heathen inventors of that art who have not yet learned how to use it."[32] He based this on his harsh verdict that, while American architects had been trailblazers during the late nineteenth century, now "the Europeans who have taken it up have made it much more 'modern' than [the Americans] have dared or cared to make it."[33] Like Nietzsche before him, Le Corbusier viewed New York as a temporal palimpsest imbued at once with "brutal disorder and reckless lack of right direction" and potentiality, believing that Americans were nevertheless capable of "always pushing upward in the process of blasting through."[34]

Le Corbusier's book was widely read but also widely misunderstood. Most overlooked was his search for architecture's transhistorical essence. When a group of architects and architecture educators gathered at Princeton University in April 1937, shortly after the book was published in English, to evaluate the state of architectural education in the country, he was clearly the menace American architectural education had to reckon with. *Architectural Record* reported that when Mr. [Ely Jacques] Kahn—a successful New York–based architect with Beaux-Arts credentials —asked the students "whether, if Princeton's neo-Gothic campus

Fig. 18 Aerial view of the Princeton University campus. Reproduced in *Architectural Record* 82 (September 1937): 56.

was destroyed overnight, they would like to see it rebuilt by a certain internationally-known modernist," probably referring to Le Corbusier, "the yeas so drowned the nays that for a moment even Ely Kahn was nonplused" (fig. 18).[35] The enthusiasm must have come as a bitter pill for Kahn, who had fought against International Style modernism since the early 1930s. He could have found solace, even a counterargument, had he detected Le Corbusier's love for the medieval past.[36]

WHAT TIME IS GOTHIC?

As he continued to use the style throughout the 1920s and into the early 1930s on Yale's campus, James Gamble Rogers was certainly aware of the call to make the Gothic style more modern and forward-leaning. He was at the peak of his career, a hugely successful and highly influential architect and planner who had designed numerous educational, health care, residential, civic, and corporate office facilities across the country. Known as a consummate professional, he distinguished between utilitarian buildings and those of symbolic value and calibrated his stylistic choices accordingly. The Columbia-Presbyterian Hospital (1921–28) in New York exemplified the former and was, as architectural historian Gwendolyn Wright has noted, the first hospital to be designed from the inside out around its technical facilities, without overt stylistic trappings.[37] Rogers designed an elegant neoclassical mansion for Edward S. Harkness on Fifth Avenue, while choosing Gothic and Georgian for the buildings that the preeminent New York philanthropist funded on the campus of Yale, their shared alma mater. While

Yale's Sterling Memorial Library (1931) was executed in Gothic, financial constraints governed the choice of classical language for Columbia University's Butler Library (1934). For the same reason, Rogers resorted to the cheaper Georgian or Federal style for some of the ten residential colleges he designed on the Yale campus after the onset of the Great Depression. All in all, Rogers was not a stylistic ideologue.

To be sure, stylistic choice was hardly ever the only thing on Rogers's mind when he embarked on an architectural commission. Baron Haussmann comes to mind when one considers Rogers's ambitious campus plan for Yale, which required the demolition of a large swath of the existing city and included an aggressive land-acquisition program (fig. 19). It is still hard to fathom that within a mere fifteen-year period, between 1920 and 1935, the university added no fewer than thirty-seven new buildings, including ten residential colleges and the Sterling Memorial Library, Sterling Law Building, Payne Whitney Gymnasium, and University Theatre, reconfiguring a square-kilometer area as the new campus seemingly overnight with buildings that looked like they had stood there forever.[38] In the end, Rogers's campus plan helped execute a somewhat paradoxical goal: to pave the way for a new era in the institution's history by re-envisioning its historical legacy. Its centerpiece, the Harkness Memorial Quadrangle, completed in 1922 opposite the Old Campus, makes the convergence of these two temporal regimens manifest: its novel superblock typology was split into seven smaller courtyards, and façades and roofs into smaller units, to break down its massive scale to make it appear quaint. The complex was made to look instantly old by pouring acid on its stone façade and cracking windowpanes on purpose (figs. 20, 21). Furthermore, as Paul Goldberger has attested, Rogers curated an assemblage of historical periods, places, and cultures deemed significant to Yale's institutional history or legacy: Wrexham Tower (1921), based on the church of St. Gilles in the town of Wrexham in Wales—where Yale's benefactor, Elihu Yale, lies buried—sits in the northwest corner of Branford College Court (fig. 22).[39] The Harkness Tower, which hovers over the central entrance gate to the largest of the three memorial quadrangles, was modeled after St. Botolph's Church

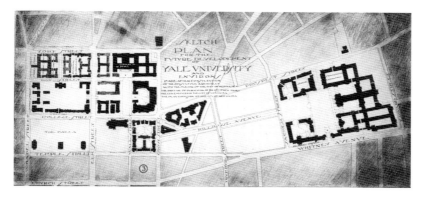

Fig. 19 James Gamble Rogers, "Sketch Plan for Future Development of Yale University and Environs," 1921.

James Gamble Rogers

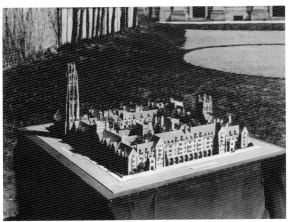

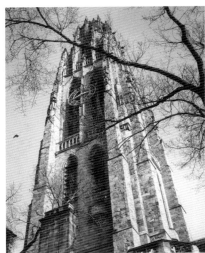

Fig. 20 James Gamble Rogers, Model of Harkness Memorial Quadrangle, Yale University, 1919.

Fig. 21 James Gamble Rogers, Wrexham Tower in the Harkness Memorial Quadrangle, Yale University, 1921.

Fig. 22 James Gamble Rogers, Harkness Memorial Quadrangle, Yale University, traceried windows above a moat wall along Elm Street. Reproduced in *Architectural Record* 50, no. 3 (September 1921): 182.

Fig. 23 James Gamble Rogers, Harkness Tower, Yale University, 1921.

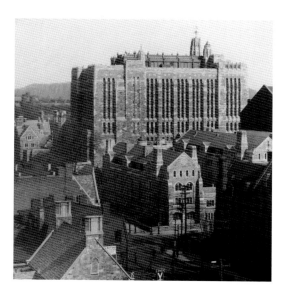

Fig. 24 James Gamble Rogers, Sterling Memorial Library, Yale University, 1931, view of the stack tower from the south.

in Boston, England. To be sure, these references to the British Gothic were motivated by the desire to anchor the institution firmly in an Anglo-Saxon cultural and ethnic lineage.

The Harkness Tower, conceived as a symbol of the university, epitomized Rogers's desire to foster both continuity and change, as it was the first *couronne* tower built during the modern era (fig. 23). The height of the structure—216 feet—represented the number of years between the founding of the university in 1701 and the start of construction in 1917. The fact that the tower was, upon its completion, the tallest masonry structure of its kind in the world made a case that the institution was by no means stuck in the past. *Architectural Record* dedicated twenty pages to the technical marvel in a 1921 issue in which, after commenting on the visual splendor of its verticality, Marrion Wilcox celebrated how the "new tower possess[es] the quality that visualizes art-tendencies of the past and present, and in its turn will affect those of the future."[40] In addition to anchoring its cultural and ethnic affinity to England, it projected the intellectual ambitions of the institution by including sculptures of key figures of Western learning, such as Plato and Homer, alongside Yale's founders. The ornamental program on the flanks of the new icon thus conveyed the coexistence of the two temporal horizons dear to the institution it symbolized: building for the future was best achieved when honoring the past.

Located a block north from the Harkness Memorial Quadrangle, the Sterling Memorial Library (1931) proved that these were not ordinary historicist buildings (fig. 24). Construction photographs reveal a modern steel structure covered with decorative stone cladding—a standard practice since the advent of the Chicago frame in the late nineteenth century (fig. 25). It featured the conventional trappings of the Gothic style: gargoyles, turrets, and pointed arch windows that took thousands of hours for skilled artists and craftsmen to execute. Yet, behind its Gothic garb lay a state-of-the-art,

Fig. 25 James Gamble Rogers, Sterling Memorial Library, Yale University, 1931, stack tower under construction.

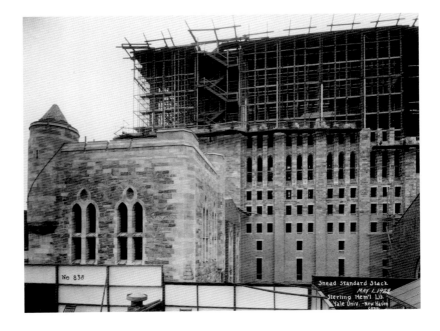

Fig. 26 James Gamble Rogers, Sterling Memorial Library, Yale University, 1931. The page contrasts the functional stack tower (top) and the highly ornamented entrance sequence (bottom). Reproduced in the *Yale University Library Gazette* 5, no. 4 (April 1931): 75.

AISLE IN THE STACKS

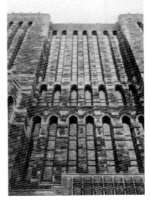

YORK STREET FAÇADE

ENTRANCE HALL

WALL STREET ENTRANCE

122,500-square-foot library the size of an urban block. The centerpiece of the composition was a vertical stack tower, which was yet another example of Rogers's ability to innovate with historical styles and typologies. The first of its kind, it accommodated eighty miles of bookshelves housing 3.5 million volumes among its seven full and eight mezzanine stories. Books were stored in a novel metal shelving system called the Snead Standard Stack, patented by Snead and Company in 1922, which allowed a large quantity of books to be arranged in a self-supporting cast-iron framework with integrated electrical wiring for lighting and floor outlets (fig. 26).[41] The tower was equipped with four elevators—two for people and two for bulk book transport, as well as a pneumatic tube system that transported call slips from the circulation desk to an army of book dispatchers who facilitated the quick retrieval of individual books by placing them on a book conveyor on sixteen landings.[42] "Expansion flexibility," "future growth," and the "centralization of books to minimize time and effort in handling" were cited as primary design principles.[43]

The first-floor plan shows that the building was composed around two temporal frameworks: the back-of-the-house featured on top of the plan was designed matter-of-factly with the sole purpose of moving books efficiently. The exposed structural grid was free of any ornamentation. In contrast, the public areas marked by thicker walls were organized akin to a typical Christian church around an east–west nave. The circulation desk area reminiscent of a church altar at the end of the nave provided a hinge between the two realms, guaranteeing that students could stay sealed off in an area of ritual and intellectual contemplation, separate from the frenzy taking place in the circulation area. The two conflicting time scales converged only when the books changed hands (figs. 27, 28). A small staircase located behind the circulation desk offered an opportunity to travel back in time to the building where Yale College was founded in 1742 and sit in the reproduction of the first college library. The Linonia and Brothers Reading Room to the right of the entrance invited students to gather around a fireplace to discuss and debate while surrounded by its collection of twenty thousand books of fiction in a quasi-domestic setting (fig. 29).

Rogers must have felt obliged to formulate his stance toward the modern, less literal interpretation of the Gothic style championed by Eliel Saarinen's entry to the 1922 *Chicago Tribune* competition, not least because of the likeness between the winning entry and the Harkness Tower, which placed him firmly in the retrograde historicist camp. He framed his position in an essay titled "Notes by the Architect," which was published in the *Yale University Library Gazette,* in which he said: "The style of the new Sterling Memorial Library is as near to modern Gothic as we dared to make it. We kept, however, sufficiently close to the sound principles and tried traditions of old Gothic to be certain that there would be no sense of freakishness and no danger of becoming, in the passing of time, a little out of style."[44] In other words, while accepting the idea that the style needed to

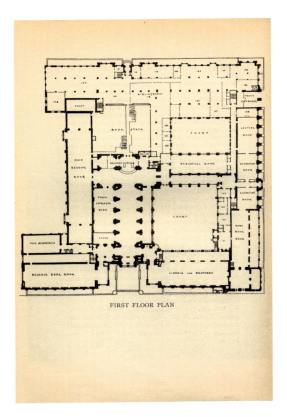 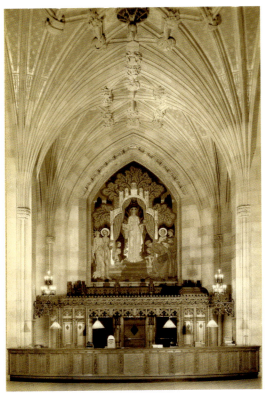

Fig. 27 James Gamble Rogers, Sterling Memorial Library, Yale University, 1931, first-floor plan. Reproduced in the *Yale University Library Gazette* 5, no. 4 (April 1931): 60.

Fig. 28 James Gamble Rogers, Sterling Memorial Library, Yale University, 1931, view of the circulation desk area with Eugene Savage's mural.

be adapted to meet new needs, he insisted that it was equally important not to lose its recognizability in the process. His reasoning went that even the most modern-looking buildings would eventually lose their novelty. It therefore made sense to rely on a "well-tested" style rather than bet on new, untested ones, which were bound to eventually fall out of style. Numerous temporal denotations populate his sentences—"modern," "old," "outdated," "tradition," "passing of time," "test of time," and "becoming"—and reveal that Rogers grounded his idea of style in the human experience of time. Yet, while insisting that the human mind craves continuity and tradition, he acknowledged that it yearns for change as well. He continued to outline various architectural strategies that aimed to mediate between the two. The watercolor rendering accompanying his essay conveyed the varied surface effects caused by the decision to "change the kind of stone from time to time" (fig. 30).[45] On the inside, the goal was to choreograph a sequence of varied spaces and atmospheres by contrasting the "imposing" entrance hall with the "homelike and sociable" reading room to the right of the entrance, culminating it with a "practical" reserve book room. Each space was carefully calibrated according to the pace and speed of its use. The architect noted how the architecture of the vaulted exhibition rooms "in itself will be enough to invite passers-by to stop."[46]

Rogers's ambition had less to do with re-creating the past than with the idea that belonging through shared traditions could be fostered while

students went about their daily business. According to architecture critic Aaron Betsky, Rogers's desire to use architecture as a tool for calibrating human experience can be traced to ideas put forward by a group of pragmatist philosophers, sociologists, and anthropologists active in his hometown of Chicago at the turn of the century. These included the sociologist George Herbert Mead and the psychologist John Dewey, for whom Rogers designed two buildings—the University of Chicago's School of Education and the Laboratory School.[47] Their primary mission was helping individuals relate to their physical environments and their fellow citizens to form a mutually respectful, healthy community. Mead talked about "the social

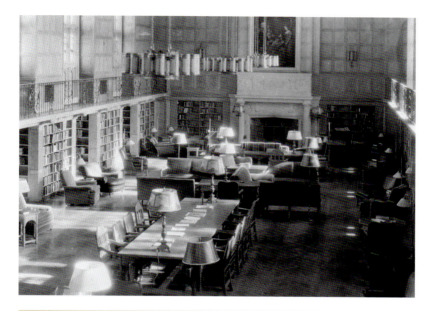

Fig. 29 James Gamble Rogers, Sterling Memorial Library, Yale University, 1931, Linonia and Brothers Reading Room.

Fig. 30 James Gamble Rogers, watercolor rendering of the Sterling Memorial Library main entrance viewed from across the campus, accompanying his article "Notes by the Architect," *Yale University Library Gazette* 3, no. 1 (July 1928): 3.

character of the self."⁴⁸ Rogers surely was familiar with their work and research focusing on how communities and societies function. Parallels can be drawn between Dewey's ambition to counter the anonymous processes and protocols of modernization by fostering communal traditions and Rogers's use of architecture as a tool to introduce students to institutional traditions. He was less interested in the historical accuracy of the chosen architectural style. Rogers's 1919 letter to Yale's secretary, Anson Phelps Stokes, who helped mastermind the university's expansion, reveals his pragmatist leanings in this regard:

> As far as traditions go, I hope that the only traditions governing us will be Yale traditions and our country's tradition. Architecturally we will, I know, keep our effects as essential and not the traditions. Of course we will have to have architectural traditions because in most cases there is no other way of getting the desired effect except by employing the traditions, which we use only because in these

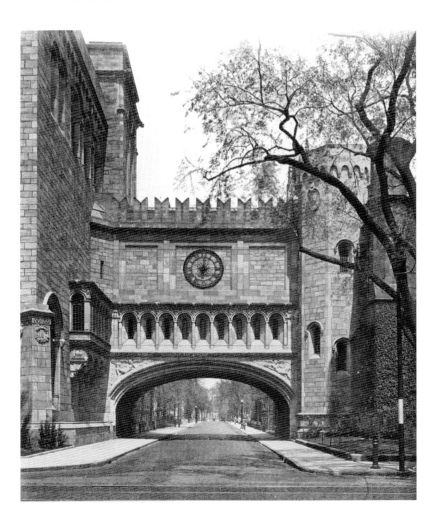

Fig. 31 Edgerton Swartwout, bridge connecting the Yale University Art Gallery to the existing Street Hall housing at the School of Fine Arts, photographed 1929.

60 Constancy and Change

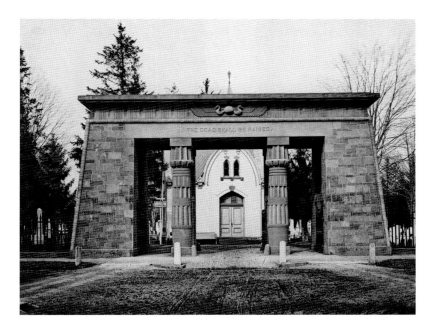

Fig. 32 Henry Austin, gate to the Grove Street Cemetery, New Haven, 1848.

cases they are necessary to get the effect. It does seem awfully hollow and servilely cringing to use a tradition that means nothing to us.[49]

The idea that the Gothic style could be "employed" for a desired effect indicates that Rogers was less interested in being truthful to past models than in having an impact on the minds of the student body. Ultimately, the appropriateness and effectiveness of the style could be judged only phenomenally by the eyes and bodies of the user. Following the same logic, the Gothic style could be unmoored from its historical and cultural origins and meanings and adapted to new contexts and programs.

Rogers's desire to use architecture as a tool to mediate the experience of time becomes evident as one walks along High Street—the south–north axis of the central campus—which is invested with myriad temporal markers, metaphors, and riddles. The journey begins by entering from commercial Chapel Street under the Yale University Art Gallery bridge, which has a clock on its front; the original idea was to get students and faculty to attend classes on time (fig. 31). Harkness Tower on the left has four blue clocks placed on its four flanks that chime every hour, while a carillon bell organ on top plays contemporary tunes each day at noon and at six in the evening. The Old Campus, situated opposite the main gate on the right, houses the freshman class. The journey ends at the Egyptian Revival gateway to the historic Grove Street Cemetery, the final resting place of many faculty members, which welcomes visitors with this inscription: "THE DEAD SHALL BE RAISED" (fig. 32). The two libraries one traverses along High Street—the Sterling Memorial Library and the Lillian Goldman Law Library—continue to pass historically accumulated knowledge from generation to generation, year after year.

James Gamble Rogers

DEBATING THE GOTHIC

While widely heralded as the most modern and most emulated library at the time, after its completion in 1931 the Sterling Memorial Library triggered a lively debate about the appropriateness of the Gothic style for modern times.[50] A new student-run magazine called the *Harkness Hoot,* which had been established in 1930 as an alternative to the official university paper, the *Yale Daily News,* served as a platform for the debate. In a 1930 article titled "Art vs. Yale University: Challenging Yale's Girder Gothic and Its Builders," one of the magazine's founding editors, William Harlan Hale, claimed that a "survey of the university's new buildings gives a pang of disappointment" and deemed Yale's new structures a "stale copy of the Gothic of the Thirteenth Century" (fig. 33). The university had "forgotten art, and become obsessed with archeology," while "no man, no nation possessed with life-giving creative sense would ever dream of copying a previous age." In a text full of pointed sarcasm, he criticized both the client and its architect, saying: "It seems almost incredible. When the world is witnessing a sweeping rebirth of genuine architecture and when every clear-headed designer who is not bound to copies and formulas is envisioning a new order of forms and masses and relationships, then the builders of Yale join the tripe of impotent imitators who grind out their lifeless plagiarisms."[51] The contrast between "impotent imitator" and "clear-headed

Fig. 33 William Harlan Hale, "Art vs. Yale University: Challenging Yale's Girder Gothic and Its Builders," *Harkness Hoot,* November 15, 1930, 27–28. The spread contrasts a dark dorm room at the Harkness Memorial Quadrangle with a modernist, light-filled interior.

62 Constancy and Change

designer" drew a parallel between copying and the inability to conceive and to create something new. "Is the Sterling Library beautiful? Is anything admirable in a highly functional building which dresses up like a cathedral?" Hale asked. He then summarized his criticism by lampooning Yale's motto, "*Lux et Veritas*" (light and truth), when he wrote: "There is not one suggestion of Veritas in the Sterling Library;—and for that matter there is precious little of Lux." Construction site photos were accompanied with the title: "IT MIGHT HAVE BEEN" and "YALE'S ONLY ATTEMPT AT LIVING ART," suggesting that the building looked better unfinished than when finished (figs. 34, 35).[52] The article was republished in the *New Republic, American Architect, Creative Art,* and *New Freeman,* among others, and several notable figures such as Wright, Henry-Russell Hitchcock, Ely Jacques Kahn, and Frederick Kiesler promptly voiced their support for Hale's criticism.[53]

The university responded swiftly to the criticism by inviting Ralph Adams Cram to lecture on the benefits of the Gothic style. A caption on the front page of the *Yale Daily News* captures the argument: "Foremost Authority on Gothic Architecture Discusses Significance of Its Modern Use." The reasoning went as follows: in contrast to the stagnantly perfect and thus stiffening style of classicism, the Gothic was by its nature versatile and perennially evolving, and thus adaptable to new programmatic needs. The article continues to report that Cram had attested the superiority of the Gothic over classical by stating that "There was nothing complicated, nothing elaborate about the old Grecian structures. Their architects knew their limit and realized when they had reached it. The Gothic architects knew no limits. Theirs was a boundless vision, a soaring imagination. Hence they failed to achieve the ultimate in structural perfection. This very reason lends greater glory to their failure than the Greeks' success. Their noble efforts deserve greater praise because of the limitless scope of their vision."[54] The idea that the Gothic style embodies "boundless vision" and "soaring imagination" made the case that the style was future-bound and particularly suitable for educational institutions because "education, like religion, is everlasting. It is not the product of any one epoch, or any one civilization. Therefore it is wholly appropriate and logical to house a college in a beautiful and significant Gothic structure. . . . The beauty of Gothic architecture not only enhances the intrinsic beauty of education, but it also indicates continuity, the soul of education."[55] Gothic architecture was homologous to a young, evolving mind—always striving and curious—whereas classical architecture was presumably a product of, and thus better suited to, a settled and slightly stale older mind. It followed that an institution invested in the future should stick with the time-tested, open-ended Gothic style. There was thus no reason to gamble with passing stylistic trends. Earlier, in a 1924 article "The Value of Precedent in the Practice of Architecture," Cram explained his own reasoning for choosing Gothic for an American university by using a troublesome racial analogy: "When working at an old university . . . I know that my business is to subordinate my own fads and

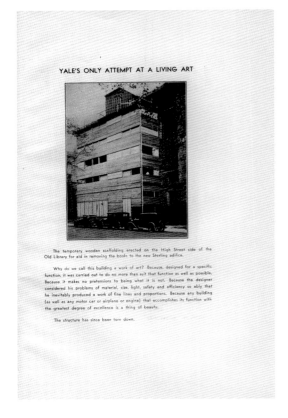

Fig. 34 William Harlan Hale, "Art vs. Yale University: A Discussion of Yale's Physical Expansion, and an Arrangement of Its Buildings," *Harkness Hoot*, November 15, 1930, 29–30. The spread contrasts a photograph that depicts the underlying steel structure of the Sterling Memorial Library stack tower with the finished building with its Gothic cladding.

Fig. 35 William Harlan Hale, "Art vs. Yale University: A Discussion of Yale's Physical Expansion, and an Arrangement of Its Buildings," *Harkness Hoot*, November 15, 1930), 31. The photograph shows part of the Sterling Memorial Library clad in scaffolding with a caption that suggests the outcome was less appealing.

fancies to this dominating influence, to pick up the old tradition of college architecture that belongs to our race."[56] He ends with a reverent mode by stating that architecture's role was

> not to invent some new thing like a carburetor or a religion or a philosophy or a new architectural style, but to recover the truths of old arts from their forms and the spiritual radiance that emanates from them and modestly, humbly, try to re-create these forms, not as final ends in themselves, but as recovered truths after a long night, facts to hold to, foundations to build upon, landmarks in the great adventure wherein we, even we, may play our part in recovering right values for the world and bringing it about that in the end they shall prevail.[57]

In Cram's treatment, the goal of Gothic architecture was not only to foster educational traditions but also to help maintain the cultural and social status quo. Yet, due to the sheer labor invested in elaborately decorated Gothic buildings, the style was no longer a feasible choice after the economic crisis unfurled in the United States following the 1929 stock market crash. As it turned out, Yale did not commission another Gothic building after these debates took place. Times had changed.

PART TWO

TIME AND HISTORY

CHAPTER 3

Henri Focillon

Liquid Temporalities

Around the time that Yale's last neo-Gothic buildings were being completed, the university hired two prominent French scholars of medieval art, Henri Focillon of the Sorbonne and Marcel Aubert of the École des Beaux-Arts in Paris, to teach a two-year course at the Yale School of Fine Arts on the "history and criticism of art."[1] Aubert stayed for five years, while Focillon, whose arrival on campus was announced in the *Yale Daily News* on March 28, 1933, remained on the faculty until his death in 1943 and built a lasting intellectual legacy that culminated in the founding of the Department of the History of Art in 1940 (fig. 36).[2]

One cannot help but wonder what an expert of medieval art from the land of cathedrals thought about the American obsession with Gothic architecture, and whether Focillon was aware of William Harlan Hale's article that deemed Sterling Memorial Library anachronistic. While no written record exists of his response to Yale's brand-new Gothic campus, the following passage from *La vie des formes* (*The Life of Forms in Art*), published a year into his tenure at Yale, indicates he probably did not view its architecture as being hopelessly out of sync with its time. He wrote:

> The spiritual instant that is our life does not necessarily coincide with a historical urgency; it may indeed even contradict it. We have no right to confuse the state of the life of forms with the state of social life. The time that gives support to a work of art does not give definition either to its principle or to its specific form. It is quite capable of slipping back into the past or forward into the future. The artist inhabits a country in time that is by no means necessarily the history of its own time.[3]

Focillon could even have had architects James Gamble Rogers or Ralph Adams Cram in mind when he pointed out that an artist living in a particular time and place may "be thoroughly contemporary with his age and may even, because of this fact, adapt himself to the artistic activities going on around him. With equal consistency he may select examples and models from the past and create from them a new and complete environment. He

Fig. 36 Henri Focillon, photographed March 3, 1932, at the Sorbonne.

may, again, outline a future that simultaneously strikes into the present and the past."[4] Americans' affinity with traditions and historicist architecture might have prompted him to conclude that "a sudden shift in the equilibrium of [an artist's] ethnic values may bring him into violent opposition with his environment and hence with the moment, and arouse a nostalgia in him that is highly revolutionary."[5] This chapter explores Focillon's unique historical method of unmooring works of art from fixed spatial and temporal coordinates. I will focus on his use of liquid metaphors as a means to emphasize that an object of art never belongs to a single period or place. Art should instead remain a site for imagining alternative realities and expanding our geographic and temporal horizons.

LIQUID METAPHORS

Focillon's statement that "we have no right to confuse the state of the life of forms with the state of social life"[6] set a defiant tone in the early 1930s, an era already marked by the rise of totalitarianism, which had begun to constrain artistic freedom in the birthplaces of the modern movement. He supported his thesis by pointing out that art rarely aims at the social status quo, with artists striving more often to create new realities. The fact that past works of art continue to live in the minds of future artists and audiences, and even to influence future works, proved his point that it made no sense to confine an object of art to a particular period and place. Architecture offered a prime example in this regard. He said, "No one can predict what environments architecture will create. It satisfies old needs and begets new ones. It invents a world all its own."[7] The very title of his book, *La vie des formes,* underscores that art forms are alive and invested with an inherent volition that allows them to chart their own unpredictable evolutionary course. With animated prose, he talked about the "mobility of form"[8] that manifests itself in the "ability to engender so great a diversity of shapes" and "almost fantastic wealth of variations and of metamorphoses."[9] Focillon grounded his thesis on the concept of élan vital, which he borrowed from his former teacher Henri Bergson, who had coined the term at the turn of the century to indicate that the evolution of species was fueled by an inherent "life force" rather than being determined by external conditions.[10] This antiempiricist and vitalist notion of evolution, applied to the discipline of art, gave him the conceptual armature for the idea that objects of art were first and foremost products of internal morphological processes rather than of external constraints. True art did not carry fixed meanings but was ingrained with the mystery of life.

Focillon was particularly worried about the rise of nationalism and the idea of national art and architecture. In this biological-cum-philosophical art historical schemata, an object of art was never a product or a particular period, place, or race but fueled by a shared genetic pool of forms and techniques that traverse through time and space. What Focillon called "families of forms" and "families of minds" underscore that art belonged to all of humanity.[11] The political implications of this universalist ideal were already explicit in the 1929 conference "Art Populaire," which Focillon helped organize in Prague under the auspices of the International Committee on Intellectual Cooperation (ICIC) with the aim of countering rising nationalism by using craft practices as proof of art's transhistorical and transcultural essence.[12] In his introduction to the accompanying publication, Focillon urges his fellow art historians to learn from "observational sciences" like "ethnography, folklore studies, linguistics, sociology, and human paleontology," which had proven that "racial and ethnic scopes" are constantly evolving and "unstable" and that "civilizations are enriched from the outside, or else they perish." He exclaims: "To define is not to separate; even to isolate

a phenomenon or a fact, we need to acknowledge that it is by comparing that we can define."[13] As the son of a printmaker and as an accomplished watercolorist in his own right, he taught students to pay particular attention to technique in an effort to reveal the "interaction of traditions, influences, and experiments" across time and space, and he gravitated toward artists who extended the possibilities of these art forms.[14]

True to his belief that art of all periods and places shared common traits, his scholarship was not limited to a single period and place; prior to arriving at Yale, he had written books on the Japanese printmaker Katsushika Hokusai, the French caricaturist Honoré Daumier, and the Italian architectural engraver Giovanni Battista Piranesi, among others.[15] Focillon's art historical schema was equally multifocal and anti-teleological, as he was adamantly opposed to the idea of historical destiny, which was being deployed to promote nationalist and racial theories of art at the time. "History is not unilinear; it is not pure sequence," he writes. "[It] is, in general, a conflict among what is precocious, actual or merely delayed."[16] He continues by describing how "the history of art displays, juxtaposed within the very same moment, survivals and anticipations, and slow, outmoded forms that are the contemporaries of bold and rapid forms."[17] Like life, art does not follow a predestined, linear path but rather traverses through time and space in a more unpredictable and nonlinear manner. It follows that rather than forcing art objects into narrow historical taxonomies such as "Italian Renaissance" or into teleological meta-narratives based on the idea of progress, it is better to work outward from individual works of art and let them reveal analogies across periods and places. Viewed from such an inductive perspective, each object of art forms a kind of mini-world, or "monad," that exists in dynamic relationship with other monads—past, present, and future.

Focillon used the words "actual" and "non-actual" to celebrate how a single work of art could offer a window to an expansive sensation of time and space. His idea that a work of art should contain multiple temporal strata and enhance our horizons beyond the here and now can be traced to one of the founding fathers of modernist poetry, Charles Baudelaire, who in his 1846 essay "De l'héroïsme de la vie moderne" ("On the Heroism of Modern Life"), wrote: "All forms of beauty, like all possible phenomena, have within them something eternal and something transitory—an absolute and a particular element. Absolute and eternal beauty does not exist, or rather it is nothing but an abstract notion. . . . The specific element of each type of beauty comes from the passions, and just as we each have our particular passions, so we have our own type of beauty."[18] He continued to develop the concept of beauty in experiential terms in the chapter "La Modernité" ("Modernity") in his 1863 book *Le peintre de la vie moderne* (*The Painter of Modern Life*), writing, "Beauty is made up of an eternal, invariable element, whose quantity it is excessively difficult to determine, and of a relative, circumstantial element, which will be, if you like, whether

Fig. 37 Henri Focillon, untitled ink drawing, ca. 1936. Collection Baltrusaitis, Paris. Reproduced in *Henri Focillon: Textes et dessins d'Henri Focillon* (Paris: Centre Georges Pompidou, 1986), 243.

severally or all at once, the age, its fashions, its morals, its emotions."[19] For him, modern art could both be grounded in and be a product of a singular moment in time and place even as it transcended those coordinates. Similarly, Focillon believed that art's function was to break the mental barriers that confine us to a single historical place and time. Furthermore, echoing the French poet's emphasis on the transitoriness of all phenomena, he saw success in "rework[ing] our monumental concept of time into that of a fluid time, or, one whose duration [that] has a plastic quality."[20]

The idea of fluid time also referenced the notion of temporal durée, a term that Bergson coined to capture the temporal expansiveness of lived experience. Focillon went even further by likening time to a liquid mass that was multidirectional and oceanic, which countered the misconstrued notion of linear clock time. He emphasizes the nonlinearity of his temporal conception when he suggests that "the moment is not simply any point along a line; it is rather a node [*nœud*], a protuberance [*renflement*]. Nor is it the sum total of the past, but instead the meeting point of several forms of the present."[21] Rather than using the common metaphor of time operating like a river flowing in one direction, he construes it as a malleable substance invested with qualities such as bending and bulging. Albert Einstein's space-time model comes to mind as Focillon proposes that time consists of "nodes" that form an interconnected spatio-temporal network rather than isolated moments. The idea of a "protuberance" suggests that, much like the famed theoretical physicist, Focillon imagined that even the smallest art object or event—like a pebble being dropped on the surface of the water—engages a larger spatio-temporal totality. The emphasis on liquidity shows that art acquires its meaning through both intentional and unintentional cross-temporal formal relationships and extensions. It follows that, rather

Fig. 38 Henri Focillon, *Embouchure de l'oder à quimper,* n.d., mixed media. Collection Baltrusaitis, Paris. Reproduced in *Relire Focillon: Principes et théories de l'histoire de l'art* (Paris: Musée du Louvre and École nationale supérieure des Beaux-Arts, 1998), 12.

than being a singular object produced by a single individual at a particular place and time, art is by its essence a synergetic transhistorical event. Focillon reveals his view of art's ontological essence and epistemological premise by stating that "flowing together within [a work of art] the energies of many civilizations may be plainly discerned."[22] He adds: "A work of art is immersed in a whirlpool of time; and it belongs to eternity."[23] Rather than trying to explain the meaning of an individual work of art through its subject matter or artistic intentions, art historians should learn from philosophers and begin considering each sign as being in a dynamic interaction with other signs. It is thus natural that seas and rivers featured prominently in his artworks, as water has always been a facilitator of global connectivity (figs. 37, 38).[24]

Using liquid metaphors to conceptualize the genesis and meaning of art was shared by his friend and contemporary Walter Benjamin, who in his *Ursprung des deutschen Trauerspiels* (*The Origin of German Tragic Drama,* 1925) refers to a work of art as "a whirlpool in the river of becoming [that] pulls the emerging matter into its own rhythm."[25] The German word for "origin" in the original German title, "*Ursprung,*" consists of "Ur," or "origin," and "*springen,*" or "jump," and suggests an autopoietic flow and energy.[26] In this formulation, art, like a river, traverses through time and is shaped by and, in turn, shapes history. Like Benjamin, who defined "aura" as "a strange tissue of space and time: a unique apparition of distance, however close it may be,"[27] Focillon used the term to convey the idea that each work comes into being and gains its meaning through other works by evoking an ephemeral vision of sorts when he writes,

> Form is surrounded by a certain aura: although it is our most strict definition of space, it also suggests to us the existence of other

Henri Focillon 73

forms. It prolongs and diffuses itself throughout our dreams and fancies: we regard it, as it were, as a kind of fissure through which crowds of images aspiring to birth may be introduced into some indefinite realm—a realm which is neither that of physical extent nor that of pure thought.[28]

Their descriptions of auratic experience—one that entails associations and flashback to other forms—suggests that art and thought are born when an individual gains access to an expansive notion of time and space, beyond the here and now. Both men had probably read Sigmund Freud's 1930 book *Das Unbehagen in der Kultur* (literally "The Uneasiness in Civilization," translated and published as *Civilization and Its Discontents*), in which the famed psychoanalyst uses the term "oceanic feeling" to describe the "oneness with the universe" that often accompanies religious feelings, and cites how one of his patients felt a "sensation of 'eternity,' a feeling as of something limitless, unbounded—as it were, 'oceanic.'"[29] Against this background, art could play a significant role also in mediating the uneasy relationship between the individual and society.

It is perhaps no accident that Focillon wrote *La vie des formes* while making frequent trips across the Atlantic on ocean liners—a primary means of travel at the time (fig. 39). His first crossing, which occurred in March 1933, might have even provided the original impetus for using liquid temporal metaphors. The sight of New York appearing on the horizon after a weeklong trip made a big impression on him. He depicted the scene in a 1935 drawing titled *USA* (fig. 40) and describes the experience of arriving to New York harbor in a 1937 essay, titled "À nos amis d'Amérique" (To our friends in America), as an auratic event as follows:

Fig. 39 Henri Focillon (left) aboard the SS *Paris*, March 15, 1935. Reproduced in *Relire Focillon: Principes et théories de l'histoire de l'art* (Paris: Musée du Louvre and École nationale supérieure des Beaux-Arts, Paris, 1998), 123.

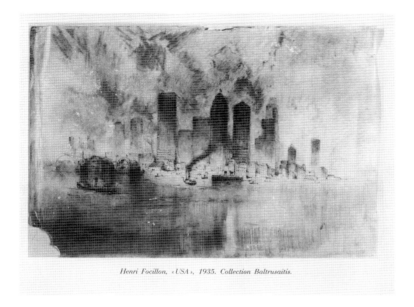

Fig. 40 Henri Focillon, *USA*, 1935. Collection Baltrusaitis, Paris. Reproduced in *Henri Focillon: Textes et dessins d'Henri Focillon* (Paris: Centre Georges Pompidou, 1986), 227.

> Every time the ship enters the waters of New York, I see, rising through the sea-mist, this colossal romantic painting, this New Sidon. Let us praise this ancient civilization for remaining resolutely modern; for worshipping the momentary gods . . . while letting time with historical consciousness and knowledge of the past cast its light on the present. . . . May the genius of Time watch over this fresh and tranquil force, necessary to the American culture, necessary for the life of our spirit.[30]

The passage conveys how the phenomenal encounter with the Manhattan skyline activated an image of the ancient city of Sidon in his mind, with the sea mist acting as a mediator. Marcel Proust's notion of "involuntary memory" (*mémoire involontaire*) comes to mind as one contemplates how an image confronted in the past returns at an opportune moment to haunt and animate the present. Focillon's description of the event shows that seeing should never be reduced to a mere optical encounter with an empirical fact, as the act always involves complicated psychological processes, including memory. He makes his case by emphasizing the *impression* that the sight of New York produced in his mind's eye rather than describing the actual view in front of his eyes in detail. For him, art existed in the realm of experience and included the effect it produced in the observer's mind, which was the loci where the "space of life" and the "space of art" converge and merge. The biographical nature of his account reveals the significance of being an embodied as well as environmentally embedded interpreter rather than a quasi-objective witness.

Focillon can be placed amid a group of historians who began to reconsider the historical method from such a phenomenological perspective. In

addition to Walter Benjamin, the German philosophers Wilhelm Dilthey and Siegfried Kracauer insisted that, unlike natural science, history writing requires a combination of feeling and thought. In a similar vein, Focillon grounded his art historical method in moments of phenomenological encounter when meanings get teased out from impressions, associations, and effects that an artwork triggers in the mind's eye. These flashbacks to the past marked moments when the psychophysical "self" discovers his or her own historicity. While teaching at the Sorbonne, Focillon came into contact with the group of historians that in the 1920s formed the so-called French Annales school. A parallel can, for example, be drawn to the intellectual project of his fellow medievalist Marc Bloch, who insisted that material objects allow access both to the "mentality" and temperament of a particular historical setting as well as to longer social and transhistorical patterns.[31] Focillon's experience at the sight of the New York skyline echoes Bloch's 1929 description of collective memory, which links our "most intimate thought processes" to larger "spiritual" groups. Bloch's words that "two types of collective presentations—the past and the present—do not, as many authors have argued, exist in opposition to each other; on the contrary, they exist only in reference to each other, as societies can interpret the past only through the present, and the present becomes meaningful only through the lens of the past"[32] could have been written by Focillon. Both men opposed rigid temporal markers. Focillon shunned historical periodization; Bloch criticized those who considered time a "a mere abstraction" and wanted to "chop it up into arbitrarily homogeneous segments." He too used a liquid metaphor to capture time's dynamic presence when stating that "historical time is a concrete and living reality with an irreversible onward rush. It is the very plasma in which events are immersed, and the field within which they become intelligible."[33] In his posthumously published book *Apologie pour l'histoire ou métier d'historien* (*The Historian's Craft,* 1949), Bloch quotes the following passage from *Le vie des formes* to indicate an intellectual affinity: "At any given date, the political, the economic and the artistic do not occupy the same position on their respective curves."[34] Human societies are shaped by various activities, which do not necessarily evolve in a synchronized manner. Among them are the various arts, which are each entitled to their own temporal rhythms and speeds.

BAROQUE EONS

As already established, Focillon was adamantly against historical periodization—the nineteenth-century construct based on the notion that objects and events can be organized chronologically into a timeline that forms a logical sequence of events. He was particularly opposed to the idea of national styles and used the phrase "the life of styles" to emphasize that historical styles such as classicism and the Gothic had evolved during prolonged periods through traversing various geographic locales, while retain-

ing some recognizable formal and structural characteristics in the process.[35] When discussing style, Focillon focused on discovering parallels rather than on drawing distinctions, and he accused his fellow art historians of isolating the high moments of any given style from what he called the "*déchets*"—that is, the kind of surplus of less notable projects that fluctuate between convention and innovation.[36] The Gothic style was particularly exemplary in this regard: an open-ended system that developed around a few key formal elements through centuries, even millennia, that was constantly "in the process of self-definition, that is, defining itself and then escaping from its own definition."[37] Furthermore, he reminds readers that historical styles exist in reciprocal relationship to other styles. The Gothic style, for example, absorbed columnar elements from classicism, and in return introduced vaulting into classical language, which led to the evolution of the baroque. Focillon went so far as to suggest that Gothic tracery had its origin in the archaic snake motif and its symbolic meanings.[38] Such a prolonged evolutionary process enabled the Gothic style to imbue diverse cultural contexts, social structures, and "psychological landscapes," which made it richer and more versatile than any other style.[39] Furthermore, the ability of the Gothic style to retain these diverse layers of evolutionary strata helped it to manifest a "transfinite," rather than a "finite," dimension of time and reality.[40]

The baroque occupies an equal, if not more important, position in Focillon's book, not least because of the versatility and vitality of its signature curvilinear form. He describes how baroque forms "live with passionate intensity a life that is entirely their own: they proliferate like some vegetable monstrosity. They break apart even as they grow; they tend to invade space in every direction, to perforate it, to become as one with all its possibilities," matching his style of writing with the virulence of the artistic style in question.[41] It is worth pursuing the notion of a "virulent" baroque in more detail because it suggests that, like viruses, certain formal tropes and sensibilities can remain latent through time and resurface at opportune moments without human intervention. It follows that Focillon treated the baroque as an autotelic and recurring event rather than a historical period.

The idea that the baroque is perennially latent and ready to reemerge at opportune moments and locales can be traced to an observation Nietzsche made in his 1878 essay "Vom Barockstil" ("On the Baroque"): "The Baroque in its unique splendor . . . has often recurred since the time of ancient Greece: in poetry, in oratory, in prose, in sculpture, and—as is well known—in architecture."[42] In a similar vein, the renowned Spanish philosopher Eugenio d'Ors, Focillon's contemporary and fellow member at the ICIC, referred to the baroque "eon" that was derived from the Greek word "*aeon*" to denote not only that the baroque embodied a geological or cosmological timescale, but that the baroque mentality was invested with its own agency. In d'Ors's treatment, a baroque "eon" moves and transfers across time and space, resembling what Arthur Schopenhauer called the "world of will"—that is, an aspect of reality that defies representation and

meaning and presents itself as pure force and energy. D'Ors talked about the pantheistic telos of the baroque, which manifests itself with "*dynamism*" and "*movement,*" enabling its forms to migrate between different media and styles to reach the status of what d'Ors refers to as a "cosmic sensibility," one that is able to challenge boundaries between cultures and intellectual positions.[43] In 1931, he presented his theory of the baroque at a conference he helped organize on the topic in Pontigny, France, and published it in Paris a few years later as a book titled *Du Baroque* (Baroque, 1936).

It followed that neither Nietzsche nor d'Ors considered the baroque to be a product of a particular period and place, but rather saw it as a prevalent and recurring mentality marked by longing. D'Ors referred, for example, to the "*Sehnsucht baroque dans l'art modern,*" or "baroque longing in modern art."[44] This curious temporal convergence between the modern and baroque suggests that, in their minds, a baroque sensibility existed where two temporal vectors—one pointing to the past and the other to the future—intertwined. To be sure, d'Ors was not talking about the desire to copy or revive a historical style when referring to a complex emotional state that lacks resolution. This aspect of the baroque ethos was poignantly captured in the words of another fellow traveler, Walter Benjamin, who concluded that "there is no baroque eschatology."[45] A perennial incompleteness made this modern incarnation of the baroque into the ultimate assault on Hegel's philosophy of history and the idea that humanity was evolving toward some predestined goal or destiny. Furthermore, due to its incomplete and inconclusive nature, the baroque defied the idea of cultural or national purity pursued by National Socialist politicians and architects and became the ultimate avatar of a more dynamic and hybrid version of the human race. In d'Ors's mind, "classicism is inherently intellectual . . . normative and authoritarian . . . [while] Baroque is vitalist, it is freedom-loving."[46] Regarding their respective historical origins, d'Ors wrote: "If the precursor of classicism is called antiquity, the precursor of the Baroque could be called prehistory."[47] While the former was ruled by geometry, the "primitive" mind was presumably ruled by pure "instinct," unbound by human reason and control.[48] Focillon had witnessed the interest in prehistory rise during his lifetime; this new temporal construction had opened, since its "invention" in the nineteenth century, not only a whole new immeasurable timescale but also new frontiers of human knowledge and imagination. The link Focillon makes between prehistory and the deep layers of human psyche was a typical concern among artists and scientists alike.[49]

Sigfried Giedion picked up on the idea of a transhistorical and transnational baroque in his landmark book, *Space, Time and Architecture: The Growth of a New Tradition* (1941), calling it a "specific kind of universality" that aimed to reintegrate art and science, reason and feeling, after centuries of disintegration.[50] The undulating wall, which he traced to Francesco Borromini's church San Carlo alle Quattro Fontane, occupies a particularly important role in Giedion's thesis as an embodiment of such a synthesizing

impulse, as it allows the interior and exterior to merge in a manner analogous to an empathetic human mind. Rather than attempting to revive the baroque as a historical style, he treated it very much in the same manner as d'Ors and Focillon—that is, as a latent "method of thinking and of feeling" ready to emerge at opportune moments.[51] He saw in Lansdown Crescent (1793) in Bath, England, for example, a fulfillment of Borromini's undulating wall. Like Focillon, Giedion insisted that an artist was never constrained to his or her own time but able to draw from the endless reservoir of previous forms. He could have well been reciting Focillon when he wrote: "This living from day to day, from hour to hour with no feeling for relationships, does not merely lack dignity; it is neither natural nor human. It leads to a perception of events as isolated points rather than as parts of a process with dimensions reaching out into history. . . . Present-day happenings are simply the most conspicuous sections of a continuum."[52]

Giedion lectured at Yale on several occasions during Focillon's tenure: in January 1940, when he spoke about the interrelations among "art, architecture, and construction," and in October and November 1941, when he returned to give a series of three consecutive lectures on his newly published book.[53] It is thus very likely that the two men met in person. In turn, Focillon was also surely aware of Giedion's various activities and of his leading role within the network of artists, architects, and historians who formed the modern movement. The two men were certainly of the same mind regarding the historian's task. Very much in the spirit of Focillon, Giedion noted that "history is not static but dynamic" and called on every new generation to rediscover the past anew. Calling himself a "contemporary" historian, he underlined the embodied, phenomenological perspective to past events when he wrote: "To turn backward to a past age is not just to inspect it, to find a pattern which will be the same for all comers. The backward look transforms its object: every spectator at every period—at every moment, indeed—inevitably transforms the past according to his own nature. Absolute points of reference are no more open to the historian than they are to the physicist; both produce descriptions relative to a particular situation."[54]

To be sure, neither Focillon or Giedion wrote about history for the sake of archaeological knowledge, but rather to detect larger cultural patterns that carried over to the present moment. For both, history writing was, in a way, a radically ahistorical act. Indeed, Giedion acknowledged that it was possible, even desirable, for a historian to feel completely at odds with one's own time, as he did when writing his book during World War II; he felt affinity with the Swiss art historian Jacob Burckhardt, who "had no love for his own time: he saw during the [eighteen] forties an artificially constituted Europe which was on the verge of being overwhelmed by a flood of brutal forces."[55] He continued to note that Burckhardt did not simply study history for the sake of historical knowledge, but rather used the Renaissance as a model for the "regeneration" of his own age.[56] Similarly, Giedion used

the historical baroque as a foil to express his dissatisfaction with the current era and saw the reoccurrence of the baroque's signature architectural element, the undulating wall, as a beacon of hope for a new era marked by the synthesis of reason and feeling. Furthermore, like Focillon, Giedion around 1930 had begun to shift his attention away from the centers of high modernism to what he called "border regions" (*Randstaat*), which in his mind possessed a capacity for "independent development" and an innate creative impulse, or "*Gestalltunskraft.*" This led him to celebrate Romanian sculptor Constantin Brancusi, Alsatian artist Hans Arp, and Finnish architect Alvar Aalto as agents of a brighter future due to their ability to merge heteronomous cultural impulses and artistic forms, both past and present, into a new synthetic whole.[57] In Giedion's mind, at that particular historical conjuncture, the future was in the hands of those who were positively out of sync with their times.

CHAPTER 4

Josef and Anni Albers

New Beginnings

The 1933 headline announcing the arrival of two German artists, Josef and Anni Albers, in North Carolina read: "Germans on Faculty at Black Mountain School; Josef and Frau Albers Named Instructors in Art There."[1] The Alberses had been invited to teach at the newly founded Black Mountain College shortly after the Nazis had closed the Bauhaus. They were the first Bauhaus teachers to immigrate to the United States (fig. 41).[2]

The United States offered both artists a new beginning. Anni reinvented herself as a quintessentially modern artist and held her first retrospective at the Museum of Modern Art in 1949 at the age of fifty; it was the first exhibition in the museum's twenty-year history to be dedicated to a female artist and the first to feature textile arts. While Josef had never been a full "master" at the Bauhaus, his reputation as a teacher began to rise after he joined Black Mountain College at the age of forty-five. His teaching career culminated when he was hired by Yale as a full professor at the ripe age of sixty-two. It was also during this period at Yale that his artistic career began to gain full momentum, and he held his first major retrospective at New York's Metropolitan Museum of Art in 1971, at the age of eighty-three. During these second and third acts the two played a significant role in launching a new era in American art, as a roster of their former students, including John Cage, Eva Hesse, Sheila Hicks, and Robert Rauschenberg, helped turn New York into the new center of the art world during the 1950s and '60s.[3] Yet, as this chapter will demonstrate, neither their own work nor their approach to art education was motivated by the pursuit of novelty. Following the well-rehearsed Bauhaus methodology, both taught their students to work with basic forms, common materials, and age-old techniques, insisting that artistic innovation comes from going back to foundations and beginnings, again and again.

MODERNIST "INVASION"

As has already become evident, Yale University was hardly an educational trailblazer when it came to the arts. Indeed, while students at Black Mountain College were conducting open-ended artistic experiments during the

Fig. 41 "Germans on Faculty at Black Mountain School; Josef and Frau Albers Named Instructors in Art There," *Asheville Citizen*, December 5, 1933.

1930s and '40s, their Yale peers were still following the Beaux-Arts curriculum, which dictated that they study historical styles in the classroom and draw plaster casts of ancient sculptures in the gallery (fig. 42).

Change was on the way starting in the mid-1930s when Henri Focillon began offering a course on nineteenth- and twentieth-century "modern art." Around the same time, the Yale Gallery of Fine Arts received, as a gift, its first collection of late nineteenth-century art and hired Focillon's doctoral student George Heard Hamilton as a curator in that area. Under Hamilton's leadership, the gallery began to play a significant role in introducing the Yale community to modern art, first by becoming a frequent stop for exhibitions organized by the Museum of Modern Art, starting with the 1936 *Color Reproductions: Modern Watercolors and Pastels,* which had been curated in 1934 by the museum's first director, Alfred H. Barr, Jr.[4] New signs of receptiveness might have played a role when Katherine Dreier, Marcel Duchamp, and Man Ray decided in 1941 to gift to Yale about four hundred drawings, paintings, prints, and sculptures that included works by Archipenko, Duchamp, El Lissitzky, Ernst, Giacometti, Gris, Kandinsky, Klee, Léger, Malevich, Miró, Moholy-Nagy, Mondrian, Picasso, Ray, and others from the collection of the Société Anonyme: Museum of Modern Art—an organization the three of them had founded in New York in 1920 with the mission of collecting and exhibiting modern art. The gift made the university the somewhat unlikely home of the largest collection of twentieth-century European art in the country, surpassing the holdings of the Museum of Modern Art at the time.[5]

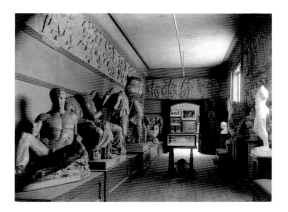

Fig. 42 Plaster casts on display in the 1920s at Street Hall, the home of the Yale School of Fine Arts.

Fig. 43 Katherine S. Dreier in the Société Anonyme exhibition at the Yale Art Gallery, 1942. Photograph courtesy Beinecke Rare Books and Manuscript Library. Katherine S. Dreier Papers / Société Anonyme archive.

A photograph of Dreier, taken at the opening of the first exhibition of the collection in January 1942, shows her standing in the middle of a top-lit gallery near her own painting *Zwei Welten* (1930) and El Lissitzky's *Proun 99* (ca. 1923–25); the latter hangs on a freestanding panel as if to distance itself from its neo-Romanesque architectural container (fig. 43). The reception to the exhibition was mixed, to say the least. The *Yale Daily News* declared on the eve of the event: "MODERN ART ... comes to Yale, but try to figure out some of its subjects." The image caption stated mockingly: "This is the 'King of Insects' by Peter [sic] Klee."[6] The opening was accompanied by a two-day symposium, whose goal, in Hamilton's words, was to explain to the public the "significance of the new acquisitions and their significance for the modern world." Referring indirectly to the German Nazi Party's notorious 1937 *Degenerate Art* exhibition, Hamilton struck a combative tone when declaring that the art on view "does not represent the degeneration of art, but its antithesis;—intellect and progressiveness."[7] Modern art gained a new geopolitical subtext—and the gallery a new mandate as the

Josef and Anni Albers 83

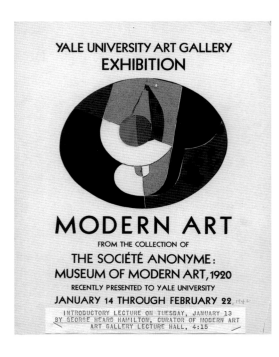

Fig. 44 Poster for the exhibition *Modern Art from the Collection of the Société Anonyme: Museum of Modern Art*, 1942. Featuring *Still-Life: Tapestry Design, No. 13* by Enrico Prampolini.

guardian of a threatened artistic legacy—as the Nazi terror spread across Europe. Indeed, by the time the opening celebrations ended, modern art had turned into treasured "heritage" and even the *Yale Daily News* reporter had come around, announcing that "the exhibition is a challenge to the imagination and sensitivity of the University community . . . [but] those not bound by conventional tastes and prejudices will find in these pictures excitement and stimulation, and the promise of enduring joys throughout the future during which the entire collection will remain as the permanent heritage of the University."[8]

The agreement between donors and the university dictated that the Société Anonyme would help arrange regular exhibitions based on the new collection in order to expose the public to nonfigurative modern art (fig. 44). The Yale University Gallery of Fine Arts dropped the word "Fine" from its name around the same time to embrace the synergy between visual arts, architecture, and design at the heart of the modern movement, and many subsequent exhibitions began to embrace the socio-aesthetic ideals behind this new totality. The 1943 *Modern Exhibition—Painting and Architecture* promoted the idea that "contemporary culture also has a definite form; that there is unity in all phases of human endeavor today, and that the true artist is sensitive to the new direction."[9] Models of Le Corbusier's Villa Savoye (1932), Mies van der Rohe's Villa Tugendhat (1928–30), and Paul Nelson's Suspended House (1936–38) borrowed from the collection of the Museum of Modern Art were prominently displayed on pedestals and surrounded with works by Calder, Gris, Klee, Léger, Lipchitz, Mondrian, and Picasso from the Société Anonyme collection; they were placed casually on easels in the gallery's sculpture court, where they shared a space with the statue of

Minerva from the museum's plaster cast collection (figs. 45, 46). The Gesamtkunstwerk was completed with sound recordings, which included readings by James Joyce and Darius Milhaud and music by Duke Ellington, Igor Stravinsky, Paul Hindemith, and others. Music by Hindemith—who had just been hired as a visiting professor of the theory of music at Yale and was best known for his collaborations with Hans Richter and Oskar Schlemmer—made, in the words of student-curator Henry Kibel, the "*esprit du temps*" manifest.[10] To convey the idea that a shared "modern" sensibility penetrated all aspects of culture and society, the exhibition featured not only objects of art and architecture but also models of molecules from Yale's scientific collections as well as technical items, such as propellor blades used by the technical officers at the Army Air Forces Technical Training Command (AAFTTC) facility on campus.[11] The curious blend of art, science, and military equipment underscored that at this particular historical conjuncture, modern art and architecture stood for a higher purpose—namely, intellectual and artistic freedom—and that the United States was fighting for that noble cause, both on the battlefield and at home. The invitation to the opening of the exhibition included a quote from Sigfried Giedion's

Fig. 45 *Modern Exhibition—Painting and Architecture*, Yale University Art Gallery, 1943. Installation view with Paul Nelson's Suspended House (1936–38) on the right next to a painting by Piet Mondrian.

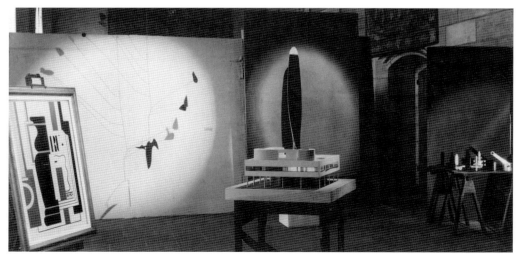

Fig. 46 *Modern Exhibition—Painting and Architecture*, Yale University Art Gallery, 1943. Installation view depicting Le Corbusier's Villa Savoye (1932) in the middle with a painting by Fernand Léger and a mobile by Alexander Calder.

1941 epoch-defining book *Space, Time, and Architecture*: "A thoroughly integrated culture produces a marked unity of feeling among its representatives" (fig. 47).[12] Importantly, Giedion did not define modern architecture as a project with a concrete, quantifiable aim, but as a fulfillment of a transhistorical and transcultural aesthetic sentiment. He was among the many European expatriates who attended the opening.

European high modernism momentarily eclipsed from sight in December 1945, when the gallery hosted an exhibition of Russian architecture from "the earlier pre-medieval days to the cataclysm brought on by the present war," which was organized by the Architects Committee of the National Council of American–Soviet Friendship in New York. The exhibition bore witness to a short-lived cultural collaboration between the two allies in the wake of their mutual victory over Nazi Germany. Hamilton had even taught Russian art history to army trainees on campus during the war. An awareness of the massive loss of historical heritage during the war might have played a role in the audience's receptiveness to the large-scale urban projects, such as the Moscow subway system, which had been executed in the so-called Socialist Realist style. The *Yale Daily News* lauded how "Soviet architects sought a synthesis of modern techniques and forms and the old cultural heritage of the past."[13] The architectural legacy of the Soviet avant-garde was considered a mere aberration in the centuries-long architectural tradition. We are reminded that several Yale art history faculty members had been members of the famed "Monuments Men," charged with the mandate of preserving significant architectural sites from Allied bombings and that the year 1945 marked the end of the war and the beginning of the herculean task of rebuilding.

Fig. 47 Invitation to *Modern Exhibition—Painting and Architecture*, Yale University Art Gallery, 1943.

Time and History

Fig. 48 *The Modern House Comes Alive* exhibition, Yale University Art Gallery, 1948.

Tempering the notion that to be modern meant leaving the past behind was also on display at the touring exhibition *The Modern House Comes Alive,* which promoted "lived, inhabited modernism" based on the idea that modern art and architecture can serve as a "satisfying background" for age-old daily rituals, as *New York Times* critic Mary Roche put it (fig. 48).[14] The 1948 exhibition highlighted recent American achievements in modern art, architecture, and design by featuring paintings by Marsden Hartley, Lee Krasner, and others; models of private houses by upcoming young architects, including Edward Durrell Stone and Philip Johnson; furniture by Wharton Esherick and Jens Risom; and sculpture and fabrics by Michael Lekakis, Grete Franke, and Emily Belding. Architectural models were displayed on classical pedestals and many of the designs had pitched roofs—a stark rebuttal of the so-called International Style modernism. Architectural critic Peter Blake heralded the age-old collaborative artistic spirit of the American scene in the exhibition catalogue as follows: "The final test of true collaboration of artists will come if the work of one of the collaborators is removed. If there remains a complete, unified composition, then there has been no collaboration in the true sense; but if there remains an unmistakable, irreplaceable aesthetic void, then the collaboration has been complete, and we shall approach again the spirit of great collaborators of the past."[15] Evoking the Gesamtkunstwerk legacy shared by the English Arts and Crafts movement, the French art nouveau, and the German Bauhaus would make American homes join the pantheon of great domestic architectures of the past.

The reception to the 1948 exhibition featuring Man Ray's *Silent Harp* (1944) and Marcel Duchamp's *In Advance of the Broken Art* (1915) from the Société Anonyme collection proved that the postwar atonement of the past had made the most provocative and iconoclastic European avant-garde art a hard sell. The *Yale Daily News* reported in bafflement: "Modernists

Invade Yale Art Gallery; Exhibit Includes Harp, Snow Shovel." The short review used the Société Anonyme's provocative mantra—"Traditions are beautiful—but to create, not to follow"—to remind its readers that much of collection amounted to an assault on traditional art.[16] After the publication of a catalogue of the collection in 1950, the Société Anonyme dissolved and curated no further exhibitions.

ART EDUCATION GOES MODERN

The quest to balance traditional and new art forms took center stage when the newly appointed dean of the Yale School of Fine Arts, Charles H. Sawyer, an art historian by training, began to phase out the Beaux-Arts curriculum and shepherd Yale into a new "modern" era in its art education after his appointment in 1948. Although Sawyer had first been ready for a total overhaul of the curriculum, he ended up taking a more gradual approach and his first years on the job were marked by the coexistence of both old and new educational models. As one architecture student noted at the time: "We got the best of both old and new. The first year we were given projects like mausoleums and temples. I took Shepherd Steven's course on the Renaissance.... We were the last class to do renderings in multiple layers of Chinese ink."[17]

Indeed, institutions don't change overnight, and Sawyer sounded very much like his predecessor, Everett Victor Meeks, when he proclaimed in his 1948 inauguration speech that "the two apparently diverse approaches to the arts, the creative or practical and the theoretical or historical, are woven inextricably in the same pattern and should enrich each other" and urged students to "have sufficient insight and confidence in [themselves] to enjoy the original and creative work of [their] own time as well as the accepted idioms inherited from the past."[18] Here we are reminded that Yale's two peer institutions, Harvard and Columbia, had retired the Beaux-Arts method of teaching architecture already in the late 1930s and that leading European modernist architects had begun to land jobs stateside; Walter Gropius and Marcel Breuer joined the Harvard Graduate School of Design (GSD) faculty in 1937 and Mies van der Rohe took the helm at IIT the following year.[19] Indeed, Yale was more than ten years behind the curve when it hired the former Bauhäusler Josef Albers into the faculty in 1950 to modernize the curriculum. Yet, lateness was hardly the only determining factor for the future of art education at Yale; the decision to hire an artist rather than an architect was based on a different take on what aspect of European modernism was worth building upon. Indeed, while Harvard's and Columbia's decision to "go modern" was triggered, in part, by the worldwide economic depression, which had sponsored an interest in European functionalism, Yale's choice to bring Albers on board took place during a postwar atonement and was grounded in the school's long-lasting legacy of fostering art as a high-minded and slightly noble pursuit. Originally, Gropius had hoped

to bring Albers along with him to Harvard's GSD, but the appointment never came to fruition because Dean Joseph Hudnut was suspicious about the benefits of a design fundamentals course taught by a nonarchitect in a professional school setting.[20] To be sure, Albers was a better fit for Yale, where art and architecture were still taught under the shared institutional umbrella of the Division of the Arts. As we are to learn, choosing an artist rather than an architect to spearhead the transition to a modern arts curriculum had a profound impact on how architecture was taught and discussed at Yale for years to come, namely as art, fulfilling a symbolic, rather than practical, role in society.

Yale was certainly a better fit for Albers as well. At Harvard, he would have worked in the shadow of his former boss, while at Yale he was able to define a new curriculum from the ground up and on his own terms. His main contribution was to replace Meeks's dual model, which combined history and studio teaching, with one that invested the creative act with the capacity to access the foundational premise of art. Albers's voice shone through the 1948 report by the committee put in charge of the transition to the new curriculum, which was addressed to Sawyer. The report suggested: "The purpose of the curriculum would be to develop an understanding of the visual media by free manipulation of their basic materials and tools. No artistic formulas, present or past, would be presented for the student to copy; rather he would be encouraged to develop his own procedures and judgments from direct personal experience."[21] In an act of iconoclastic defiance, Albers subsequently ordered that the art gallery's collection of plaster casts be stored in the basement before his arrival.[22] The intent to foster "personal experience" was based on the idea that the ability to reenact the origin of art and to access art's perennial genetic code and meaning lay dormant in each individual. The creative act could activate that intelligence. History, criticism, and art appreciation were thus replaced by a "Basic Course" modeled after the Bauhaus *Vorkurs,* some version of which Albers had taught almost continuously between 1923 and 1948, first at the Bauhaus and then at Black Mountain College. The report continued to state that, through the course on design fundamentals, a student "would acquire the self-confidence that comes only through elementary knowledge, and realize gradually the design powers resting within himself. His method of attack would be individually developed; he would learn to think in situations, not by predigested theory. The curriculum would give the student a thorough, personal grounding in visual fundamentals, as a secure base for his professional training and later work, and as a common language for communication with his fellow students and future clients."[23] The emphasis on "elementary knowledge" and "visual fundamentals" revealed Albers's distaste for historical knowledge and what he called "predigested theory." There is, in fact, no mention of teaching art history in the report; the assumption was that students would discover the transhistorical essence of art through their own work by first learning "visual fundamentals," which

would spark innovation without compromising art's timeless principles down the road.[24]

To be sure, bringing a teacher who despised conventional teaching methods into an academic setting was a risky move. Albers had formulated his defiance of forcing historical knowledge upon students already in a 1924 essay "Historisch oder Jetzig?" (Historical or contemporary?), in which he stated "that historical knowledge inhibits production; and that listening to teachers without being allowed to forget amounts to taking nourishment without the subsequent bowel movements, and that the alternative, vomiting it up in an examination, is unhealthy."[25] The analogy Albers drew between a mind bombarded with historical information and a clogged digestive system underlined that, in his mind, such an antiquated teaching method hindered creativity. His chosen temporal indicators—"*jetzig*" from "*Jetz*" (German for "now"), and "*heutig*" from "*Heute*" (German for "today")—offered an alternative by being based, respectively, in eternalist and historicist temporal constructs. The former embodied the idea that the intensity of an artistic act allows a person to gain access to the timeless wisdom that each such moment contains, while the latter was based on the notion that an artist conducts such acts here and now, as part of the surrounding world. Albers articulated the latter idea when he stated that the "goal of Bauhaus training was to bring art, hitherto isolated from practical life into harmony with the demands of contemporary [*heutigen*] life."[26] Yet, as his 1928 lecture "Werklicher Formunterricht" ("Creative Education") at the Sixth International Congress for Drawing, Art Education, and Applied Arts in Prague demonstrates, Albers was not against learning from history altogether but insisted rather on the difference between conventional, knowledge-based education and hands-on learning, which allowed passing on age-old material techniques and hand skills from previous generations to students more organically. He explained: "The productive handling of materials is established through long tradition. The technical education is therefore based on adopting already established working methods." Yet, he also warned that "such education alone would make one creatively constrained [*unfrei*], [as] it hinders discovery [*Erfindung*]."[27] The role of an educator was to unleash "unhindered [*ungestörtes*], influence-free [*unbeeinflusstes*], and unprejudiced [*vorurteilfreies*] experimentation."[28]

Albers continued to declare his opposition toward conventional history teaching during his tenure at Black Mountain College. His 1935 text "Art as Experience" leaves no doubt where he stood: "If art is an essential part of culture and life, then we must no longer educate our students either to be art historians or to be imitators of antiquities but for artistic seeing, artistic working, and more, for artistic living."[29] John Dewey's idea of "learning by doing" as well as aspects of various life philosophies, including Henri Bergson's vitalistic belief in a mysterious life essence and Nietzsche's celebration of lived experience, resonate in Albers's words, written while teaching at Black Mountain: "Life is more important than school, the student and the

learning more important than the teacher and the teaching. More lasting than having heard and read is to have seen and experienced."[30] Upon his retirement from Yale, Albers summarized his pedagogical approach: "The main principle of my teaching is to force the student not to apply rules—I put them in a vacuum and help them discover how to breathe."[31] The metaphor suggests that the minds of the students be stripped bare of all prior images and information—vacuumed out, as it were—in order to allow space for "breathing," the most basic bodily function, without which life ceases. The statements, made twenty years apart, uphold an anti-authoritarian political stance by implying that traditional education aims to control students. The difference between top-down "teaching" and self-governed "learning" was thus nothing less than a matter of life and freedom triumphing over death and confinement. Albers captured the essence of his pedagogical strategy with the somewhat paradoxical maxim: "The more one is taught the less can one learn."[32]

In the end, Albers's Yale tenure turned out to be a great success, not least because, despite his iconoclastic rhetoric, he valued the core idea behind a humanities-based liberal arts education—namely, that the goal of education is to help students discover timeless qualities and values to guide their actions. Nor was he opposed to students being exposed to historical art; on the contrary. He concludes "Art as Experience" by encouraging readers to discover the "connection between a modern picture and music by Bach."[33] He ended up having an almost cult-like following among undergraduate and graduate students alike. Tellingly, he was lauded for continuing Meeks's educational legacy and, in so doing, safeguarding the quality of American architecture and design for years to come. Four years into his tenure at Yale, the Committee of the Division of the Arts reported: "Never before has there been such a shouting need for the humanizing affect which the basic principles of painting and sculpture—color, line and form—can give to the increasingly machine-made environments in which Americans must live." The report went on to claim that "young designers properly trained in the ageless visual disciplines are desperately needed by today's society."[34] The statement allied with what had become the dominant ethos of arts education at Yale, namely that present problems can be solved only by unmooring the creation and experience of art from historical time.

DISCOVERING THE VIRTUAL

Albers's call for "ageless" visual principles raises the question: What, if anything, was new in his educational and artistic vision? His 1928 lecture "Werklicher Formunterricht" offers some insights into his thinking about how to approach this temporal paradox, as it defines what was "new" in somewhat surprising terms: "Perhaps the only entirely new and probably the most important aspect of today's language of forms [*heutigen Formabsichten*] is the fact that 'negative' elements (the remainder, intermediate,

Fig. 49 Josef Albers, *Structural Constellation: Transformation of a Scheme No. 12*, 1950. Machine-engraved and sandblasted plastic laminate mounted on wood, 17 × 22½ in. (43.2 × 57.2 cm). Collection of Tate Modern, London.

and subtractive quantities) are made active."[35] His *Structural Constellation* series, begun in the late 1940s, demonstrates that Albers was still exploring how to make nonvisible "negative" elements "active" some twenty years later (fig. 49). These works consist of white geometric lines etched on black laminated plastic plates, which form overlapping cubic volumes set against a black background, creating multiple coexisting spatial illusions.[36] The etchings function as chiaroscuro in reverse, culminating in the moment when the seemingly empty black background transforms the two-dimensional figure into gaining spatiality and depth in the viewer's mind. Importantly, the virtual space was created in the viewer's mind through a perceptual act.

The emphasis on imagination and the imaginary translated into an educational mantra, "to open eyes," which is how Albers defined his pedagogical objective upon his arrival in the United States in 1933. The idea that most people were incapable of fully "seeing" contrasted optical and empirical "outer sight" and the somewhat mystical notion of "inner seeing." The former was based on registering a material fact somewhat mechanically, while the latter called for "imagination and vision" to supplement that process.[37] The invitation to mine the "discrepancy between the physical fact and the psychological effect" struck a chord, and Albers became one of the most popular teachers at Yale shortly after his arrival, as students from different majors flocked to his "Basic Drawing" and "Interaction of Color" classes.[38] All architecture students were required to take both courses during their first year. His message to students was that they and the world around them evolve in fluid space-time and that everybody sees things differently depending on physical vantage point and mental disposition. A film recording made by John Cohen in the mid-1950s depicts Albers as a

modern-day magus, demonstrating how to turn a circle into an ellipse and back again using a hinged moving panel to change the angle from which students perceived the circle.[39] The temporal aspect is notably present in the studies Sheila Hicks conducted in the "Basic Drawing" course in the mid-1950s, which depict an envelope rotating in an illusionary space (fig. 50). The ultimate task was to be able to conduct the exercise in one's mind without moving or rotating the prop. In philosophical terms, to really "see" meant transcending the thing as it appears to us (noumena) by focusing on appearances (phenomena), including the mental effects produced by the thing in our mind's eye. The tension between the two modes of seeing was rooted in a long tradition of German aesthetic theory, since Kant distinguished between the actual or factual form (*Daseinsform*) and perceptual form (*Wirkungsform*), which prioritized the phenomenal attributes and psychophysical effects of the perceptual act.

Albers's aversion to objectified historical knowledge did not translate to a distaste for historical artifacts, though. Following in Nietzsche's footsteps, he insisted that we engage history from our present-day perspective with new tools for the benefit of the present and future life. Both Alberses collected ancient Mesoamerican artifacts, and, as curator Lauren Hinkson has suggested, Josef Albers's photo-collages of the historical sites from the region, exemplifying graphic abstractness, might have even been intended to locate the "origin story" of modern abstraction in pre-Columbian Mexican art and craft.[40] Josef's photo-collages of Gothic architecture demonstrate that he liked to use the then still relatively new media of 35mm film photography to make us see historical architecture in a new light (fig. 51). For him, objects made a long time ago do not reside in the past but continue to activate our imaginations. In return, we continue to activate them from new perspectives, using new technologies.

Navigating the gap between the "physical fact" and the "psychic effect" aligned him with other German expatriate intellectuals with anti-positivist and anti-materialist neo-Kantian leanings prevalent within the American academic community after World War II. These intellectuals believed that human ability to transcend the physical world with the power of imagination is what distinguishes human beings from other living creatures, and that only humans are able to reconfigure their temporal and spatial coordinates and imagine new realities, all while being anchored in a particular place and time. Among them was the German philosopher Ernst Cassirer, who taught at Yale between 1941 and 1943, and subsequently at Columbia until his death in 1945. In his landmark book *Philosophie der symbolischen Formen* (*The Philosophy of Symbolic Forms*, 1923–29), the author argued that our experience of the world is mediated through symbolic systems, such as language and art. Time too is a symbolic language, which means that there is no time as such, only various systems of conceptualizing and assigning meaning to the passage of time. Cassirer captured the mind's ability to shift temporal frameworks when referring to "the immanent recall

Fig. 50 Sheila Hicks, drawing of envelopes for Josef Albers's "Basic Drawing" course, Yale University, ca. 1954–56. Pencil and colored pencil on newsprint, 11 × 17 in. (27.9 × 43.2 cm). Courtesy of Josef and Anni Albers Foundation.

Fig. 51 Josef Albers, *Paris, Notre Dame, 16.V.55*, 1955. Gelatin silver print mounted on cardboard, 8 × 12 in. (20.3 × 30.5 cm). Josef and Anni Albers Foundation.

of the consciousness"[41] and acknowledging the existence of the "mythical (and religious) feeling of time."[42] The power of imagination gives human beings the ability to exist within multiple temporal frameworks at once.

By the time Albers joined the Yale faculty in 1950, Cassirer's theory of symbolic form had been popularized by philosopher Susanne Langer, whose 1941 book *Philosophy in a New Key: A Study in the Symbolism of Reason, Rite and Art*. It is worth discussing Langer—one of the most celebrated public intellectuals in America at the time—in detail because her ideas about the symbolic dimension of art and architecture played an important role in making artists and architects pay attention to how their respective media shaped the human experience of reality. She gave a much-anticipated Martin A. Ryerson Lecture, "Art Symbol and Symbolism in Art," at the uni-

Fig. 52 Article reporting on Susanne Langer's lecture titled "Art Symbol and Symbolism in Art," published in the *Yale Daily News,* May 7, 1954.

versity art gallery on May 6, 1954, to a "full capacity" audience (fig. 52).[43] While it is hard to determine whether Josef and Anni Albers were in attendance, they shared Langer's emphasis on the metaphysical, nonmaterial, and even time-bending essence of art.

What gave Langer's writings wide appeal was her ability to ground complex philosophical ideas in everyday life. For example, she concretized the idea that human beings exist simultaneously between material and nonmaterial worlds with a commonsensical example that, as human beings go about their daily lives, they surround themselves with a virtual reality consisting of mental images. She wrote: "We can call up images and let them fill the virtual space of vision between us and real objects, or on the screen of the dark, and dismiss them again, without altering the course of practical events."[44] Importantly, the idea of "virtual space" did not refer to an actual physical space or to a purely illusionary pictorial space, but to the human ability to move fluidly between real and imaginary worlds. Her notion of the "virtual" introduced a third category into Kant's aesthetic schema that relied on the distinction between actual form (*Daseinsform*) and perceptual form (*Wirkungsform*), which Albers had reframed by arguing that cognition is based on a constant struggle between the duality of "physical fact" and the "psychic effect." In the context of this book, is it worth highlighting the temporal dimension of Langer's argument, which suggests that this

ability to augment reality with virtual phenomena allows human beings to extend their spatio-temporal framework beyond the linear clock time and experience time as something malleable and expandable. Langer believed that the visual arts in particular have an ability to expand our experience by allowing us to operate outside the linear language-based learning and knowledge, as she continued to posit that "*visual forms are not discursive. They do not present their constituents successively, but simultaneously, so the relations determining a visual structure are grasped in one act of vision.*"[45] She continued to criticize the "language-bound theory of mind" for "rul[ing] [visuality] out of the domain of understanding and the sphere of knowledge."[46] When visual thinking is given free rein, the human brain gains the agility to handle a complex set of ideas and imagery, past and present, simultaneously in a manner superior to the slowness of linear verbal reasoning. Langer was interested in the arts exactly because they defy the "language-born thought" that reduce human experience into linear duration. Importantly, the nonlinear visual experience always extends into the environment and occurs within the constantly shifting framework of space-time.

Art's ability to make time gain plasticity is the theme of her subsequent 1953 book, *Feeling and Form: A Theory of Art,* in which she wrote: "Experience of time is anything but simple. It involves more properties than 'length,' or interval between selected moments; for its passages have also what I can only call, metaphorically, *volume.* Subjectively, a unit of time may be great or small, as well as short or long."[47] Music, in particular, was able to activate coexistent temporal registers. In her words, "musical time . . . serves to develop the temporal realm in more than one dimension" because "it is thoroughly 'virtual,' i.e., unrelated to the space of actual experience."[48] In the chapter titled "The Modes of Virtual Space," she makes a case that "architecture is a plastic art." The comment foregrounds architecture's ability to modulate human experience of space and time.[49] Again, she keeps her argument grounded on concrete examples; in her words, architecture "expresses the characteristic rhythmic functional patterns which constitute a culture. Such patterns are the alternations of sleep and waking, venture and safety, emotion and calm, austerity and abandon; the tempo, and the smoothness or abruptness of life."[50] In Langer's treatment, architecture ceases to be a mere physical container of predetermined programs—as walls, floors, and ceilings gain both spatial and temporal depth.

The idea that when people go about their daily routines, they can inhabit temporalities that defy linear "clock time" was influenced by Henri Bergson, who introduced imagination as a third category between representation and reality into philosophical and artistic thought. As we have already learned, Bergson considered time an extension of human imagination and a medium through which human beings exercise their freedom to imagine new ideas and realities. Unmooring art and architecture from historical clock time was one of the key by-products of the anti-materialist

stance Josef and Anni Albers shared with him. The goal was not to represent reality as a given, but rather to use art as a tool to open up new realities and potentialities.

UNLEASHING POTENTIALITY

The most salient manifestation of Josef Albers's anti-materialist stance can somewhat paradoxically be found in the material exercises he conducted with his Bauhaus students in the "Werklicher Formunterricht" course. In one famous assignment, he asked his students to work with a sheet of paper, a simple and readily available material, and overcome its most common treatment as a flat, nonstructural material in order to discover new properties. Students would subject the paper to a series of operations, such as cutting and folding until the seemingly flat material gained complex and often surprising formal, structural, and even sculptural qualities. The exercise taught the profound lesson that imagination is never bound or dictated by material realities and limitations. In his 1936 lecture at Black Mountain College, Albers referred to "*Material-Eingenschaften*" (material qualities), "*Materialgerecht*" (doing justice to a material), and "*Material Kapazität*" (material capacity) to emphasize that the ultimate act of "form-giving" is based on a balance achieved between respecting the material on its own terms and helping it unleash its hidden potentiality by making it perform in unexpected ways.[51] The process harks back to the old Greek concept of *aesthēsis,* which occurs when the interaction between material object and sensing subject releases potentiality in both.[52] Albers summed up this generative form-giving process in his 1934 essay "Concerning Art Instruction," writing that the "relationship between effort [*Aufwand*] and effect [*Wirkung*]" determined the ultimate success of a creative act.[53]

Josef Albers's approach to material experimentation developed in tandem with Anni Albers's exploration into the techniques that define her medium, weaving. In her 1938 article "Work with Material," Anni Albers insisted that being a "creator" required obeying the "set of irrevocable laws" within the medium at hand. In the case of weaving, the basic "operation" of interlacing longitudinal and lateral threads, warp and woof, establish "stability and order" and open a vast space for innovation and experimentation at the same time—a potentiality waiting to be unleashed.[54] Anyone who has seen her work can attest to the amazing spatial and textural richness that she created by manipulating the analogue technique of making the woof thread alternate over and under the warp in various ways (figs. 53, 54). More overtly than her husband, Anni believed that creativity could benefit from historical research, which led her to assemble a vast collection of ancient South American textiles and subject them to careful formal and technical analysis; she dedicated her 1965 book *On Weaving* to "my great teachers, the weavers of ancient Peru."[55] She believed that the techniques

Fig. 53 Anni Albers card-weaving at Black Mountain College, 1937. Josef and Anni Albers Foundation.

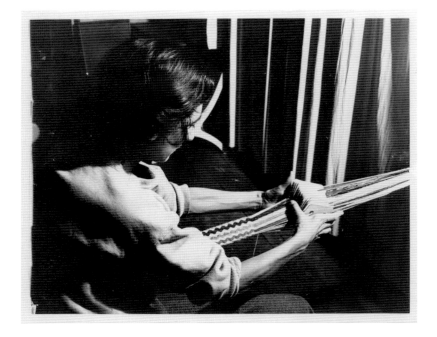

Fig. 54 Anni Albers, *Open Letter,* 1958. Cotton, 23 × 24 in. (58.4 × 61 cm). Josef and Anni Albers Foundation.

Fig. 55 Anni Albers, diagram showing modified and composite weaves, ca. 1965. Black masking tape and pencil on gridded paper, 8 9/16 × 11 in. (21.7 × 27.9 cm). Reproduced in Anni Albers, *On Weaving* (Middletown, CT: Wesleyan University Press, 1965), plate 18.

and laws of weaving had stayed constant through the millennia and that future work—including her own—should occur within the parameters inherited from generations of weavers (fig. 55). Authorship and dates were irrelevant to her. In a 1947 article titled "Design: Anonymous and Timeless," she went so far as to celebrate weaving for being governed by the medium rather than by an individual creator; in her words, a "good designer is an anonymous designer . . . the one who does not stand in the way of the material." An artist should simply be a medium through which the material makes its way into a realized work. She continues to link anonymity with timelessness as follows:

> The more we avoid standing in the way of the material and in the way of tools and machines, the better chance there is that our work will not be dated, will not bear the stamp of too limited a period of time and be old-fashioned someday instead of antique. The imprint of time is unavoidable. It will occur without our purposely fashioning it. And it will outlast fashions only if it embodies lasting, together with transitory, qualities.[56]

It is perhaps no accident that the leading art critic at the time, Clement Greenberg, defined painting in similar terms—that is, as a medium governed by internal rules rather than by an individual creator. Importantly, Greenberg did not define "modernism" as a historical "movement," but rather as an artistic mindset motivated by an "exacerbated concern with esthetic value."[57] What was new in modernism, if anything, was this heightened disciplinary introspection. Greenberg delivered a Ryerson Lecture titled "Abstract and Non-Abstract Painting and Sculpture" at the Yale University

Josef and Anni Albers 99

Art Gallery on May 12, 1954, six days after Langer's talk. Quotations from the lecture cited in the *Yale Daily News* the next day reveal that, very much like Anni Albers, Greenberg did not believe that modern abstract art was in any way different than old representational art. He emphasized that "every work of art is a law unto itself. Every work must be judged with an open mind whether abstract or not." Highlighting the medium over subject matter helped erase the artificial distinction between old and new, figurative and nonfigurative art. The reporter noted: "No full appreciation of the medium can be achieved until the common ground between the world of the abstract and the world of the Old Masters is recognized."[58] It is worth quoting Greenberg's essay "Modernist Painting" (1960), which popularized the concept of medium specificity because it addresses the issue of time and history in a manner that resonates with Anni Albers's desire to define a productive relationship between the present and past art. Greenberg wrote: "And I cannot insist enough that Modernism has never meant, and it does not mean now, anything like a break with the past. It may mean a devolution, an unraveling of tradition, but it also means its further evolution. Modernist art continues the past without gap or break, and wherever it may end up it will never cease being intelligible in terms of the past."[59]

Echoing Greenberg's idea of medium specificity, Anni Albers called for identifying foundational techniques of her medium and using them as tools of innovation. Her essay "Early Techniques of Thread Interlacing" starts with the provocation that "beginnings are usually more interesting than elaborations and endings. Beginning means exploration, selection, development, a potent vitality not yet limited, not circumscribed by the tried and traditional. For those of us concerned in our work with the adventure of search, going back to beginnings is seeing ourselves mirrored in others' work, not in the result but in the process."[60] Importantly, in her usage, the word "beginning" does not refer exclusively to a historical past, but to a locus of inquiry into the foundational techniques of a particular medium, which were timeless. Furthermore, the idea of "mirroring" oneself into the work of those who came before suggests that an artist working in the present must always position him- or herself within the history of the chosen medium. T. S. Eliot's "Tradition and the Individual Talent" comes to mind as Albers continues to define her relationship to the past, writing: "Therefore, I find it intriguing to look at early attempts in history, not for the sake of historical interest, that is, of looking back, but for the sake of looking forward from a point way back in time in order to experience vicariously the exhilaration of accomplishment reached step by step."[61] It is also very likely that Albers had read Gottfried Semper's discussion of the "technical" and "historical" aspect of textiles, as she identified the initial medium-specific techniques such as "knotting," "netting," "looping," and "twining" in a manner that had been outlined by the influential architect-historian in the mid-nineteenth century.[62] Like Semper, she believed that art is born of technical mastery, and she wrote her book so that future weavers could

learn to unleash the transhistorical intelligence of these age-old techniques through their own creative process.

Anni Albers insisted that each new work built on age-old material techniques could simultaneously hold the intelligence of all past works and the potential for future development. She summarizes her approach toward history in her 1946 essay "Constructing Textiles" as follows: "Retrospection, though suspected of being the pre-occupation of conservators, can also serve as an active agent. As an antidote for an elated sense of progress that seizes us from time to time, it shows our achievements in proper proportion and makes it possible to observe where we have advanced, where not, and where, perhaps, we have even retrogressed. It thus can suggest new areas for experimentation."[63] Each work was to be a palimpsest of a longer development.

PART THREE

PAST AND FUTURE

CHAPTER 5

Louis I. Kahn and Paul Weiss

Presence of the Past

When asked in 1946 to comment on the state of architectural education at Yale, Charles H. Sawyer, the leading candidate to succeed Everett Victor Meeks as dean of the School of Fine Arts at that time, offered his verdict in no ambiguous terms:

> The School of Architecture has not developed or materially enhanced its reputation during the past ten years. In a time of drastic changes in the building profession and in the whole role of the architect in connection with it, it would seem as if the Yale School has adjusted itself less successfully than some of the others to the problems of new materials and structural principles. One feels a survival of Beaux-Arts principles and practices that have, in some measure at least, outlived their usefulness.[1]

The "drastic changes" included a whole gamut of new programmatic needs and technologies that had emerged in the wake of World War II. In his mind, there was no ambiguity about the next step: it was time to wean from the Beaux-Arts system.

Yet, once Sawyer, a former museum administrator, was appointed dean the following year, he retained many aspects of the system he had deemed out of date, including the so-called collaborative project between students of architecture, painting, and sculpture, which had been the staple of the Beaux-Arts curriculum.[2] Using the Yale University Art Gallery as a site for collaboration and debate was paramount to his vision, as it had been for Meeks. As we will learn, fostering a link between architecture and the visual arts came to have a long-lasting impact on Louis I. Kahn, one of the most enigmatic figures of twentieth-century American architecture, who came on board as a visiting critic at Yale in 1947 as a last-minute replacement for Brazilian architect Oscar Niemeyer (who was declined a visa on the grounds of his leftist views) and stayed on the faculty for the next ten years. It proved to be the most significant of a series of architecture faculty

appointments for a reason Sawyer could not have foreseen: Kahn's cryptic statements about architecture's timeless essence helped launch a uniquely philosophical chapter in American architectural discourse. Neither could Sawyer have anticipated that a year into his new job, Kahn would gain a commission to design an annex to the art gallery—a stroke of luck for an architect who had yet to design a major institutional building.[3] The austere, brick-clad concrete structure became the first nonhistoricist-style building on Yale's campus, albeit one that challenged expectations of what the alternative should look like.

TOWARD COGNITIVE ARCHITECTURE

Kahn was impacted by the many ideological transformations that shaped American architecture during the first half of the twentieth century. Following his studies under the notable French American Beaux-Arts architect Paul Philippe Cret at the University of Pennsylvania in the early 1920s, Kahn became an early convert to the socio-aesthetic agenda behind European modernism and, together with the French-born Dominique Berninger, founded the Architectural Research Group in 1932 to promote new models of social housing. He subsequently collaborated with the pioneering American modernists George Howe and Oscar Stonorov on several housing projects in the Philadelphia area.[4] By the time he arrived at Yale, Kahn was also a highly visible member of the short-lived American Society of Planners and Architects, a professional advocacy group promoting architects' involvement in urban planning that had been initiated by architect-educator Joseph Hudnut, who in 1938, as a newly appointed dean, had brought three prominent members of the European modernist movement, Walter Gropius, Marcel Breuer, and Sigfried Giedion, to teach at Harvard's Graduate School of Design.[5] Professional expertise in the area of housing and urban planning made Kahn a perfect candidate to teach upper-level studios in a school looking to update its position.

Those behind Kahn's hiring might also have been aware of his contribution to the symposium "The New Architecture and City Planning" at Columbia University, which had been published in 1944 as a book featuring Kahn's essay "Monumentality." His paper, along with four others dedicated to the topic, were fueled by the quest to counter Lewis Mumford's controversial 1938 statement that "if it is a monument, it is not modern, and if it is modern, it cannot be a monument."[6] The paper boosted Kahn's academic credentials by bringing forth his budding interest in the aesthetic dimension of architecture, which had surely been noticed by the organizer of the symposium, German architect-historian Paul Zucker, who had been vocal about his dissatisfaction with the state of American architecture and planning, on the grounds that it failed to fulfill the psychophysical needs of those who "look at and walk through the buildings."[7] For Zucker, the duality between the functional and aesthetic dimensions was the inherent

"paradox" of modern architecture.[8] Yet, as Sarah Williams Goldhagen has noted, it is unclear why he invited Kahn to contribute a paper on monumentality rather than on social housing or urban planning, given Kahn's expertise in those areas.[9]

It is equally difficult to determine what triggered Kahn to forgo topical functional and social concerns and charge architecture with an ability to transport humans to a contemplative mental state. His definition of "monumentality" suggests that he had at least some familiarity with art history and aesthetic theory. In his essay "Monumentality," Kahn wrote: "Monumentality in architecture may be defined as a quality, a spiritual quality inherent in a structure which conveys the feeling of its eternity, that it cannot be added to or changed."[10] As Joan Ockman has pointed out, Kahn's ideas about the topic echo Alois Riegl's 1903 essay "The Modern Cult of Monuments: Its Essence and Its Development" and the quasi-mystical notion of *Kunstwollen,* or a "will-to-art," which assumes that art is born out of a perennial existential urge that manifests itself in recurring formal motifs.[11] Furthermore, in "Monumentality," Kahn adopts Riegl's idea that the actual historical age and original intent of a monument is secondary to its ability to make the passing of time palpable in the mind of the beholder. The latter called it "age value" and asserted that the quality depends on "our appreciation of the time which has elapsed since [the work] was made and which has burdened it with traces of age."[12]

While it is quite unlikely that Kahn ever read Riegl, it is possible that he was aware of Henri Focillon, whose book *La vie des formes* had been published in English in 1942 as *The Life of Forms in Art.* Focillon's idea of "living forms" comes to mind when reading Kahn describe how formal and structural tropes from the past continue to "reappear" in new works. He

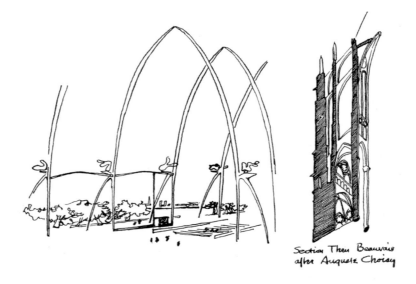

Fig. 56 Louis Kahn, illustration accompanying his essay "Monumentality" (1944) depicting a section of Beauvais Cathedral after Auguste Choisy and a pointed arch of his own design. Reproduced in Paul Zucker, ed., *New Architecture and City Planning* (New York: Philosophical Library, 1944), 582.

wrote: "The influence of the Roman vault, the dome, the arch, has etched itself in deep furrows across the pages of architectural history. Through Romanesque, Gothic, Renaissance, and today, its basic forms and structural ideas have been felt. They will continue to reappear but with added powers made possible by our technology and engineering skill."[13] By placing a series of slim, pointed arches of his own design alongside a section of Beauvais Cathedral drawn by the nineteenth-century French architectural historian Auguste Choisy, Kahn demonstrated what this meant in practice: his design took on a perennial structural problem (how to span an opening) and a solution (an arch) from his medieval predecessors, while tackling it with the new material of steel (fig. 56). The perennial architectural element embodied both continuity and change through its form and structure.

Kahn's ten-year tenure at Yale occurred during a period of intense soul-searching among early converts to modernism among the American architectural community as it began to reassess the legacy of the modern movement after World War II. In 1948 Kahn attended a symposium at the Museum of Modern Art called "What Is Happening to Modern Architecture?," the title of which captures the common sentiment that modern architecture had betrayed its original premise. Memories of the 1932 *Modern Architecture: International Exhibition* loomed large, with both Alfred H. Barr, Jr., and Henry-Russell Hitchcock present. Walter Gropius captured the sentiment by drawing a parallel between architecture and human life stages when stating: "Our life is not yet settled, so modern architecture is not yet settled. It is in the making. Instead, the flow of continuous growth, the change in expression in accordance with the change in life, should be underlined."[14] Echoing the title, which captured the unpredictable situation, Lewis Mumford compared modern architecture to a rebellious teenager, stating: "I don't think that anything more serious is happening to modern architecture at the present moment than that it is growing up. You do not expect an adolescent to wear the same clothes as he did in babyhood."[15] While various remedies were proposed, the symposium failed to arrive at a consensus as to what the future of modern architecture might entail.

Kahn's first studio briefs indicate that he too was wondering where modern architecture was heading and whether its success should be measured in social or aesthetic terms. The first two assignments he gave to his Yale students—a "suburban shopping center" in the fall of 1947 and a "suburban residence" in the fall of 1948—explored building types that were keeping mid-century architects busy. Kahn's description of the latter studio indicates that he had no qualms about the new way of living. He wrote: "The grownups respect but do not live in the past. They try to understand our present mode of living, thinking, and methods of doing things."[16] Yet, his next studio the following spring, titled "National Center for UNESCO," shifted the focus from basic programmatic needs—housing and shopping—to the quest for monumentality. A photograph shows Kahn with a student

Fig. 57 Louis Kahn (right) working with his student Bliss Woodruff on a student assignment for the UNESCO headquarters at Yale University, fall 1949.

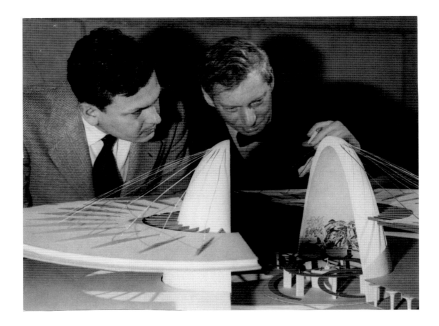

in front of a model in which the historical arch motif makes a reappearance as a space-defining element for a rotunda housing a UNESCO-themed mural (fig. 57).

Kahn's interest in architecture's perennial formal and aesthetic dimensions became amplified after he was assigned to co-teach a Collaborative Design Problem with Josef Albers in December 1949. Kahn served as the "chief critic and coordinator" and Albers as an "in-house critic." The two had probably first met at Zucker's symposium, and Kahn had traveled in the fall of 1949 to Cincinnati, where Albers was teaching at the time, to deliver the invitation to join the Yale faculty. The studio gave Albers a preview into the current state of arts education at Yale. Kahn created the studio brief, called "An Idea Center for Plastics," and the studio took place in two three-week segments in late 1949 and early 1950, just prior to Albers's appointment as a full professor and chair of the newly established Department of Design. Before looking at the studio in detail, we must remember that plastic was a trendy new material backed by a whole new industry at the time the theme of the studio was chosen. In a letter to the faculty in July 1949, Dean Sawyer had embraced the importance of forming an alliance with the new industry following an educational model set by László Moholy-Nagy at the New Bauhaus in Chicago. Sawyer made a direct reference to the Container Corporation of America—which had, under the leadership of its chairman, Walter Paepcke, funded Moholy's efforts—when he wrote: "Lou [Kahn] and I are especially anxious to see if the program can be written this year which would suggest to the participants the growing opportunities now developing in all the arts in Design for industry. We would propose using as a model for study and consultation some firm which has done pioneering work in the field such as the Container Corporation."[17] Yet,

Fig. 58 Newspaper article entitled "Retiring Yale Professor Honored by Colleagues at Party" from the *New Haven Register*, January 27, 1954. Louis Kahn (far right) is presenting a *Structural Constellation* by Josef Albers as a gift to George Howe.

somewhere along the way, Kahn came to frame the assignment and its objective in very different terms—that is, as a "laboratory of visual ideas (images) for a plastics manufacturer"—in effect, undermining practical applications and emphasizing the material's ability to trigger visual effects instead.[18] The overall goal was to provide "a setting of the demonstration of the effect of light, space, distance on a new material" and "create 'experiences' in form, space and architecture."[19] "Principles of optics are of primary importance," the brief states.[20] Kahn's description made it clear that by this time his pedagogical interests had shifted from designing functional objects to mining cognitive processes and aesthetic ideas.

It is very likely that Kahn had seen Albers's etchings on Plexiglas during his visit to Cincinnati and discussed their curious perceptual effects with him. There is even evidence that Kahn was impressed by what he saw: a 1954 photograph in which he holds a piece from Albers's *Structural Constellation* series as a gift to the departing dean, George Howe (fig. 58). Furthermore, his increasing interest in the aesthetic experience can be credited at least in part to his exposure to conversations about modern art during his weekly teaching trips to New Haven. As discussed in the previous chapter, the Yale University Art Gallery had begun to host frequent exhibitions and lectures on modern art and architecture from the late 1930s onward.[21] The genesis and meaning of modern art emerged as a focal point in various lectures during the late 1940s. Kahn might, for example, have been in attendance in March 1948 when Katherine S. Dreier gave a lecture titled "'Intrinsic Significance' in Modern Art," in which she stated: "We of today look upon Art with totally different eyes from those of 35 years ago, because

Fig. 59 *Plastics in Art and Industry* exhibition at the Yale University Art Gallery, December 1949.

our eyes have grown accustomed to a larger conception of vision. It is not only the physical eye which sees, but the mind or inner-eye." She continued to emphasize the aesthetic dimension as follows: "Art is a visual experience which does something to one through the combination of the physical and inner eye."[22] Whether or not Kahn was in attendance, he started to see painting as a new standard-bearer and encouraged his students in the plastics studio to learn from the "experience and instruments of design used by the painter,"[23] especially the ability to apply "pigments or color of light and the effect on shades and shadows."[24]

Albers visited New Haven in mid-December 1949 to review the outcomes displayed in the exhibition *Plastics in Art and Industry,* which featured work by him, Alexander Archipenko, and Naum Gabo (fig. 59).[25] The exhibition was curated by Eliot Noyes, who had recently been appointed jointly by the Department of Architecture and the Yale University Art Gallery after a seven-year tenure at the Museum of Modern Art. Despite its high stakes—a new material with industrial prospects, a world-famous educator as an external critic, and a capstone gallery show organized by a renowned curator—the studio produced uneven results, not least because plastic proved to be a challenging material for students to manipulate without proper tools. It therefore comes as no surprise that Albers, who favored ordinary methods and materials, was not happy with the outcome. Kahn was surely aware of Albers's distaste for novelty based on the paper the famed arts educator delivered at Zucker's symposium, "The Educational Value of Manual Work and Handicraft," which made a case for the persistence of traditional craft techniques and manual labor, using architecture and his wife's artistic medium, weaving, as examples of media resistant to change. Since Albers's essay is the final one in the book, he got the last word with his concluding statement: "One thing seems sure, the more new archi-

tecture gains the quality of old handicraft, the more it will fulfill its task, the more it will contribute and lead to better living."[26] Albers's words charged post–World War II architecture with a temporal paradox: old rather than new techniques and materials would enhance future ways of living.

BACK TO THE BASICS

Josef and Anni Albers's singular impact on Kahn's artistic and intellectual development can be detected in the elemental forms and medium-specific techniques that dominate his first major institutional commission, the annex to the Yale University Art Gallery, which launched him to international fame at the age of fifty-two upon its completion in 1953. As noted earlier, he was a somewhat unexpected choice for such an important commission, considering his lack of designing large institutional buildings. He had gained the commission in 1950, after the appointed architect, Philip J. Goodwin, resigned for health reasons, and after Eero Saarinen declined the offer due to other commitments and recommended Kahn for the job.[27] The project got off to a challenging start: the client preferred a "contemporary" addition, while the vocal alumni wanted the building to match its Gothic-Romanesque neighbor. A 1953 memorandum signed by Goodwin traces the sequence of events that followed: at one point the committee behind the new building "abandon[ed] all efforts toward a contemporary design, and a new, simplified addition to the old wing [was] planned." Goodwin, whose credentials included the 1929 building for the New York Museum of Modern Art, continues to criticize his successor's design as a "spineless glorification of the 12th century with sort of a dim trailer in a fashionable 1952 model" (figs. 60, 61). He concludes by disparaging how "Yale see-saws between fear of its graduates and a desire to be very up-to-date."[28] Goodwin failed to notice that Kahn's design, which blended still relatively new curtain-wall technology and a tetrahedral ceiling structure with elemental forms and materials, defied periodization. Kahn found an ally in the American innovator and futurist Buckminster Fuller, who was constructing a cardboard dome with a group of art students on top of Weir Hall next door in the fall of 1952 (fig. 62). Both structures expanded architecture's temporal scope into the past and the future by recycling architecture's perennial formal tropes and typologies through a combination of new and old materials and techniques. The triangle motif dominated both structures.

Anni Albers's weavings offered another reference point and might have even informed the way Kahn chose to feature the building in *Perspecta* 3 in 1955: each individual element of the ceiling structure—the tetrahedral concrete slab, air-conditioning ducts, heating, and lighting—was printed in a different color on separate sheets of Mylar, so that when the sheets were placed on top of each other they produced an overlapping weave of vertical and horizontal lines (fig. 63). Kahn's "pictorial essay" might have, in turn, inspired Anni Albers to write the essay "The Pliable Plane: Textiles

Fig. 60 Louis I. Kahn, Yale University Art Gallery, perspective drawing, ca. 1951.

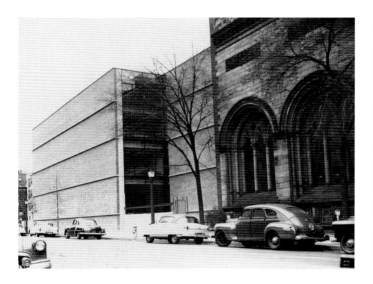

Fig. 61 Louis I. Kahn, Yale University Art Gallery, façade facing Chapel Street.

Fig. 62 Unidentified art student constructing a geodesic dome out of cardboard on top of Weir Hall under R. Buckminster Fuller's guidance, Yale University, November 1952.

in Architecture" (1957), in which she drew a parallel between architecture and weaving as follows: "Both construct a whole from separate parts, a manner of proceeding fundamentally different from that of working metal, for instance, or clay, where parts are absorbed into an entity." Her statement that "both are ancient crafts" implies that architects and textile artists should obey the age-old rules and principles of their respective mediums.[29] Kahn's call to resist "emotional whims" and to let the logic of construction guide the process[30] echoed Anni Albers's 1938 essay "Work with Material," in which she warned against "the *hubris* of creative ecstasy" in order to "get

Fig. 63 Series of ceiling elevations depicting integrated environmental systems within the tetrahedral ceiling of the annex to the Yale University Art Gallery, printed on layers of semitransparent trace paper. Reproduced in Louis Kahn, "Order and Form," *Perspecta* 3 (1955): 49.

Louis I. Kahn and Paul Weiss

from materials the sense of directness, the adventure of being close to the stuff the world is made of."[31]

By the mid-1950s, Kahn had begun to absorb concepts and ideas, often verbatim, from both Alberses. Kahn seems to have been particularly fond of their idea that the purpose of design is to introduce "order," stability, and permanence into a world seemingly devoid of any. Compare, in particular, the following two passages. The first was written by Josef Albers and published in the *Yale Alumni Magazine* in 1950:

> To design is
> to plan and organize,
> to order, to relate
> and to control.[32]

This next quote is from the short text "Order and Form," which Kahn published in a 1955 issue of *Perspecta:*

> **Order is**
> **Design** is form-making in order
> Form emerges out of a system of construction
> Growth is a construction
> In **order** is a creative force
> In **design** is the means—where with what when with how much.[33]

Kahn repeats not only Josef's words ("order" and "design") and his message (design is ordering) but also the rhetorical device of the simple present tense, which both men chose over the more commonly used historical or narrative present. Indeed, neither frame the condition of "order" as being conditional to a prior event or action; nor did either of them state, for example, "I propose that order is necessary," or "architecture should have order." They simply consider the idea of order as being both essential and unchanging.[34]

In his 1957 article "Architecture Is the Thoughtful Making of Spaces," Kahn continues to insist on eliminating functional instrumentality and letting architecture's timeless, medium-specific qualities shine through, as he wrote:

> Reflect on the great event in architecture when the walls parted and columns became. It was an event so delightful and so thought wonderful that from it almost all life in architecture stems. The arch, the vault and the dome mark equally evocative times when they knew what to do from how to do it and how to do it from what to do. . . . Spaces transcend function.[35]

Kahn did not define the outcome in programmatic terms but used the ineffable concept of "space" to characterize the nonmaterial essence of

architecture and to introduce yet another temporal horizon: potentiality for undetermined future actions. Fittingly, for the Art Gallery Annex, Kahn was in this case given the mandate to design a multifunctional, flexible loft that could hold varied programmatic tasks—with the assumption that those changed over time. He met the challenge by reducing his design to an open rectangular space defined by two parallel brick walls, a glass curtain wall, and a series of tetrahedral ceiling slabs. A cylinder housing the stairs and a rectangular elevator core break the otherwise open space in the middle. The ambition to highlight the intrinsic spatial quality is apparent as soon as one enters the building: the low ceiling height, dim lighting, and materiality of the enclosing surfaces make the space uniquely visceral and palpable. Kahn might have had Josef Albers's words in mind: the goal of all non-representational art is to celebrate "presentationalism . . . as an immediate perception of all cognitive realities."[36] The statement captures their shared belief that art and architecture should not try to keep up with the pace of change but offer a respite from hectic clock time by emphasizing art's ability to provide unique temporal experiences and realities. A 1957 letter Kahn wrote to the couple confirms his adoration: "I can think of nothing but delight in your personalities and your great art."[37]

THE PRESENCE OF THE PAST

There is no question that the ten years Kahn spent teaching at Yale between 1947 and 1957 played a significant role in his intellectual and artistic development and led to a turning point in his professional career. He in turn helped shape the intellectual culture of what was at that time called the Department of Architecture in many ways: in addition to helping bring Josef Albers into the faculty, he convinced sixty-four-year-old George Howe to leave his comfortable semiretirement at the American Academy in Rome and spend his remaining years as the department chair.[38] Albers helped realign architectural education with the arts, while Howe helped realign architectural education away from narrowly defined professionalism toward the humanities after the unsuccessful two-year tenure of Harold D. Hauf, an engineer by training. Time was ripe to begin an ontological quest for architecture's transhistorical essence.

One of Howe's first acts as dean was to launch *Perspecta: The Yale Architectural Journal* as a platform for interdisciplinary exchange among students, faculty, and the profession at large. The magazine was itself a Collaborative Design Problem of sorts, as the first issues were designed by a faculty member at the newly established Department of Graphic Design, at this time Norman Ives—a still-existent tradition.[39] In his inaugural speech in September 1951 titled "Training for the Practice of Architecture," which was published in the first issue of the magazine a year later, the new chairman encouraged architecture students to take courses in a variety of subjects, such as "music, philosophy, science, or the law" and develop "not

so much a *knowledge* . . . but a *feeling* for other subjects, a consciousness of their existence, an insight into their relation to architecture," which he believed would set them on a path for discovering architecture's "objective, a high purpose."[40]

Howe's hiring coincided with the appointment of a new university president, Alfred Whitney Griswold, who believed that the goal of all education, especially higher education, was to prepare students to sustain the values of free democratic society, which, in his mind, required critical thinking that only a liberal arts education could provide. His mission to turn Yale into a bastion against specialized, skill-based education put pressure on programs such as architecture, engineering, and nursing to revise their curricula accordingly. In Griswold's words, at worst "vocational studies induce a kind of neutralism, a passive tendency to accept things as they are and conform to them, that is dangerous to freedom."[41] To avoid overt specialization, Griswold instituted philosophy as a core discipline around which other disciplines revolved and founded the still-existent Directed Studies program as a stronghold of his educational mission. Yale's mid-century building boom, which took place during Griswold's twelve-year tenure from 1951 to his early death from cancer in 1963, is a testament to architecture's central role in his educational vision.

Howe began the process of opening architecture up to interdisciplinary intellectual exchange in his inauguration speech, which included multiple references to aesthetic and cultural theory, semiotics, and philosophy. He began by paraphrasing Geoffrey Scott's idea that architecture is first and foremost art, saying, "without the ordering and imaginative control of art building can never be architecture."[42] Scott's book *The Architecture of Humanism: A Study in the History of Taste* had, since its publication in 1914, been an essential read for those, like Howe, who were concerned that the essence of architecture had been compromised by an overemphasis on programmatic and technical factors. Aware that professional practice can easily lead to compromise in architectural quality, he warned students to "never . . . be product-minded, process-minded, money-minded, standard-minded" and summarized his maxim as follows: "We shall strive, as we go along, to consider the material, economic and technical aspects of building always in the light of significant form."[43] The reference to Clive Bell's concept of "significant form" made the point that certain formal properties have an ability to evoke aesthetic experiences that arouse emotions, including moral feelings. A quote from John Ruskin—"We require from buildings, as from men, two kinds of goodness: first, doing their practical duty well; then that they be graceful and pleasing in doing it"—underlined the need to balance professionalism with higher aesthetic ideals.[44]

Howe aligned his overall pedagogical position with Alfred North Whitehead, the Harvard-based mathematician, who began his 1916 essay "The Aims of Education" with a discussion on how to elevate "expert knowledge" to the level of "culture," which Whitehead defined as follows:

> Culture is activity of thought, and receptiveness to beauty and humane feeling. Scraps of information have nothing to do with it. A merely well-informed man is the most useless bore on God's earth. What we should aim at producing is men who possess both culture and expert knowledge in some special direction. Their expert knowledge will give them the ground to start from, and their culture will lead them as deep as philosophy and as high as art.[45]

One cannot overstate the transformative influence Whitehead's musings about the importance of transcending the confines of our material, everyday existence had on many other figures labeled as "untimely moderns" in this book as well, both directly and indirectly. In addition to passing on an interest in the symbolic dimension of art and architecture to his doctoral student Susanne Langer, he had a profound impact on Sigfried Giedion, Whitehead's colleague at Harvard, who in *Space, Time and Architecture* perpetuated the idea that architecture's purpose was nothing less than to save culture at large.

Furthermore, Whitehead helped spearhead a reassessment about the value of historical knowledge for educational purposes. Echoing Nietzsche, he believed that "the only use of a knowledge of the past is to equip us for the present."[46] Whitehead's scorn for standard history teaching is evident in the following words:

> No more deadly harm can be done to young minds than by depreciation of the present. The present contains all that there is. It is holy ground; for it is the past, and it is the future. At the same time it must be observed that an age is no less past if it existed two hundred years ago than if it existed two thousand years ago. Do not be deceived by the pedantry of dates. The ages of Shakespeare and of Molière are no less past than are the ages of Sophocles and of Virgil. The communion of saints is a great and inspiring assemblage, but it has only one possible hall of meeting, and that is, the present; and the mere lapse of time through which any particular group of saints must travel to reach that meeting-place, makes very little difference.[47]

Indeed, since Nietzsche wrote his essay "Vom Nutzen und Nachteil der Historie für das Leben" ("On the Uses and Disadvantages of History for Life") in 1874, philosophers have kept reminding artists and architects of their ability to revisit the past for the benefit of the present.

Kahn also answered the philosopher's call to rethink architecture's relationship to time and fell under the spell of the charismatic young philosophy professor Paul Weiss—yet another student of Whitehead—shortly after his arrival at Yale. Both arrived at Yale in 1947, and Weiss subsequently became a frequent visitor to the Department of Architecture after Howe's

appointment. An iconoclast by nature, the new hire turned Yale's Department of Philosophy not only into an exception but also a top department in the field by championing large metaphysical issues, such as "immortality" and "time and eternity," that had been overlooked in philosophy departments across the English-speaking world, which were at the time dominated by analytical philosophy.[48] His contribution to the first issue of the *Review of Metaphysics*—a journal he founded upon his arrival at Yale—gives an idea of the *Denkstil* Kahn might have been exposed to at Yale. Weiss's 1947 essay "Being, Essence and Existence" reads:

> Thesis: Whatever is, in thought or fact, has an essence.
> Definition: An essence is a meaning, a structure, the character, the nature of an entity, "what" it is.[49]

Weiss's subsequent writings mined various dimensions of time under titles such as "The Past: Its Nature and Reality" (June 1952); "The Past: Recent Discussions" (December 1953); "On the Difference between Actuality and Possibility" (September 1955); and "Historic Time" (June 1962). In them, Weiss identifies time as an essential aspect of being human, and one that was being overlooked by the "moderns," all of whom, according to him, were suffering from chronophobia—that is, a fear of time. He had already addressed this issue in his 1935 essay "Time and the Absolute" when he stated his main premise as follows: "Time is no phantasm. It is not a form of intuition, an abstraction, or a measure; it is integral to the real, and is to be abandoned only at the price of losing the world."[50] He continued to argue it was time to come to terms with the idea that we never exist in a singular moment:

> The moderns, in their anxiety to take time seriously, have committed *the fallacy of essential completeness*. They suppose that there can be but two kinds of objects—those which persist because they have non-temporal boundaries, and are thus eternal, and those which have temporal boundaries, and thus must perish with the passing moment. They do not and cannot admit a persistent, which is in time. But it is of the essence of an object not to be exhausted by being present. This is not a world of momentary absolute beings, each complete and self-sufficient, whose essential boundaries are marked by the end of the present moment. It is a world of interdependent beings, each incomplete, *persisting because insufficient.*[51]

Kahn might have in turn inspired Weiss's interest in architecture and how buildings, and the act of building, mediate the human experience of time. He discussed the topic in his October 1951 lecture "Philosophy and Architecture," which he delivered at the Yale University Art Gallery to a packed audience. The main message was that architecture's task was

to help overcome modern chronophobia, which he saw as plaguing modern society. Kahn might well have been in the audience hearing Weiss say that "architecture is a reservoir of time" and insist that "architecture must incorporate the past, present, and future." The *Yale Daily News* reported the following day that Weiss blamed modern architecture for "putting a stop to time and holding on to the present," and modern architects for "unconsciously operating under the Cartesian philosophy which says that the only thing that is real is the immediate" (fig. 64). The article quotes Weiss stating in his lecture: "Such arguments as, 'the past is a nothingness,' 'the present is always moving on,' and 'the future exists only in the imagination' find no place in art." Good architecture, he said, should combine all these, because the "past has the monuments; the present has the process; and the future has the planning." The same article reported that "in a final plea, Professor Weiss asked artists of all kinds to take the good aspects of the past and integrate them into the future."[52]

Both Weiss and Kahn were present at one of the "studio discussions" that was transcribed in *Perspecta* 2 in 1953 under the title "On the Responsibility of the Architect: Roundtable Discussion with Philip Johnson, Louis Kahn, Vincent Scully, Pietro Belluschi and Paul Weiss." In their introductory note, the student editors expressed their concern that architects were losing sight of architecture's symbolic function when lamenting that "in the everyday hurry of our extroverted age we seldom have a chance to stop and reflect upon the basic things in life."[53] After hearing the architects go back and forth about whether an architect is an artist or a provider of a service, Weiss provoked his fellow panelists to take a broader view and engage broader philosophical questions by asking: "What evidence is there, in architecture, of the great change which has recently occurred in the outlook of artists, philosophers, and scientists towards the idea of time?"[54] Weiss could have named several sources to prove his point that time was one of the central topics of twentieth-century intellectual and artistic thought. His message was clear: It was time to start asking profound ontological

Fig. 64 Article reporting on Paul Weiss's lecture at the Yale University Art Gallery, published in the *Yale Daily News*, October 3, 1951.

questions as he continued to posit that if modern architects were to engage in an inquiry about architecture's temporal dimension, they would have to take into consideration something that they had preferred to ignore so far—namely, the past.

It is worth quoting Weiss's musing about the past at length because the topic had preoccupied Kahn for some time:

> Architecture, in particular, is determined by the past. Almost more than any other enterprise it makes use of the past and tries to achieve a release from it. It seeks to achieve a present in the face and against the drag of the past. Architecture, more conspicuously perhaps than anything else, offers the present the very meaning of the past. It shows us the past as a finished fact. Another way in which the past is relevant to architecture is implied in the fact that architecture is a temporally accumulative art. It incorporates what was done in order to achieve it. . . . Architecture accumulates the past in its product. Architecture is a saving of the past; its product is the absorption of all the steps gone through in order to produce it. To build a building you take first this brick and then that brick and so on. Each brick remains as part of the final result. But in music this is not true; there you have to take the note away to be able to enjoy the next. It might thus be said that music and poetry are more spiritual, more humanistic, but that architecture is more metaphysical, for it preserves the past in the object.[55]

Weiss summarizes his point by stating that "the past is one dimension of time. A second obviously is the present" and continues to drive home the idea that time is an integral part of human experience as follows:

> All activity is in the present. We live in the present; though this present has a kind of stretch to it, a stretch in which creative activity occurs. The architectural object, you might say, is the present. You live in the present and architecture is the dimension of your present, a spatially defined present with a forward, a back and a side to it. Architecture also cuts you off from the present, from the presence of others.[56]

Weiss insisted that architects could never escape the passing of time, since all their actions were governed by the flow of time. This entailed that, more than any other professions, architects were "bothered by a more distant future than almost anyone else."[57]

This meant that architects should be firmly grounded in the present, with one eye glancing at the past, and the other at the future. In one of the most provocative comments, Weiss objected to Yale's Gothic architecture on the grounds that "it has the wrong date, because it tries to be something

Fig. 65 R. Oshkosh, cartoon accompanying the transcript of the panel "On the Responsibility of the Architect" from *Perspecta* 2 (1953): 51. The caption reads: "He looks not with too studious an eye at what others have done."

Fig. 66 R. Oshkosh, cartoon accompanying the transcript of the panel "On the Responsibility of the Architect" from *Perspecta* 2 (1953): 54. The caption reads: "Time constipation."

other than it is. They are modern buildings for a university that imitate ancient ones; the buildings should have been dated as of today."[58] Two cartoons accompanying the transcript illustrated the dilemma this posed for modern architects: how to avoid a situation in which longing for the past turns into a temporal paralysis. The first drawing features an elderly gentleman wearing a bowtie pointing to a postcard of a historical Avignon and has a subtitle: "He looks not with too studious an eye at what others have done" (fig. 65). The other depicts an amorphous figure with its head stuck in the upper part of an hourglass with the caption: "Time constipation" (fig. 66). A modern architect was faced with the dilemma of how to find the right balance between the past and the future. Kahn had by that time begun to engage with architectural history in ways that underscored how historical artifacts and forms continue to vitalize the present. The paintings and pastels he made during his travels in Italy and Egypt in the spring of 1951 pay homage to the elemental formal language of ancient architecture and emphasize their visual effects, in the here and now. Shortly after his European sojourn he designed the Trenton Bath House (1953–55) in Ewing Township, New Jersey, which invested a transhistorical plan type— the Greek cross—with a new program. These early buildings bear witness to

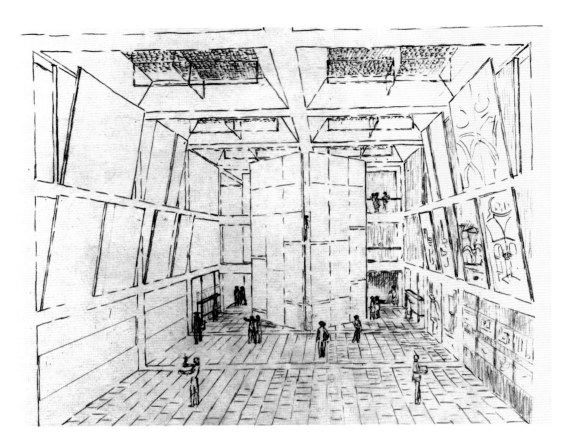

Fig. 67 Louis Kahn, Yale Center for British Art, perspectival drawing of the courtyard, n.d.

the fact that by the early 1950s Kahn had become convinced that architecture never changes at its core.

An interior perspective of the large reception room at the Yale Center for British Art, which Kahn drew some twenty years later, demonstrates that he never shed the Beaux-Arts idea that each new design should begin with the study of historical precedents (fig. 67). Our attention is drawn to the series of pictures placed on the right wall of the room, which, rather than depicting paintings from Paul Mellon's collection, which was to be housed in the building, depict historical buildings. The one closest to the viewer features the arched ceiling of the narthex of the twelfth-century Gothic-Romanesque cathedral of Casale Monferrato, which Kahn might have visited during one of his many trips to Italy. It is strikingly similar to a photograph of a building that had been published in Sibyl Moholy-Nagy's provocatively titled 1961 *Perspecta* article "The Future of the Past," which Kahn must have read (fig. 68). His willingness to identify a specific historical precedent affirms Moholy-Nagy's thesis that the future of architecture would continue to be discovered through the past.

By the time he finished designing the Center for British Art in 1972, Kahn had begun to develop a temporal construct that echoed Weiss's idea that the present moment is in fact not distinct, but rather pregnant with and born out of the past. Speaking at the Aspen Design Conference the

Fig. 68 Duomo of Casale Monferrato. Reproduced in Sibyl Moholy-Nagy, "The Future of the Past," *Perspecta* 7 (1961): 67.

same year, Kahn uttered enigmatically: "What was has always been. What is has always been. What will be has always been."[59] Indeed, the words echoed Weiss's 1945 article titled "History and the Historian," which begins with the assertion: "Every existence has a past. All have come to be. Every existence has its effect on future. All make some difference to what will be."[60] As has already become clear, Kahn was by no means the only person musing about the relationship between the past, present, and future. Besides participating in interdisciplinary conversations that took place at Yale, his ideas contributed to a wider debate about modern architecture's relationship to time and history, which gained traction in the early 1950s among the second-generation modernists behind the formation of Team 10, a successor group of the Congrès Internationaux Architecture Moderne, or CIAM. Kahn was an invited keynote speaker at the 1959 Otterlo meeting in the Netherlands, where one prominent member of the group, Aldo van Eyck, presented his "Otterlo Circles," which depict the synthesis of classical, early modern, and vernacular traditions as a basis of design. In fact, when Sigfried Giedion, Jaqueline Tyrwhitt, and Josep Lluís Sert first met at Sert's house in Cambridge, Massachusetts, in May 1953 to prepare for the last old-guard-led CIAM meeting in Aix-en-Provence, one of the proposed topics was finding "means of discussing the continuity with the past."[61] It was through their deeply existential mode of inquiry that Kahn and Weiss made their mark in the conversation that dominated post–World War II architectural discourse for decades to come.

CHAPTER 6

Eero Saarinen and George Kubler
Shaping Time

Eero Saarinen's winning entry to the Jefferson National Expansion Memorial design competition in 1948, titled "Gateway to the West," launched his independent career in a spectacular manner: the thirty-eight-year-old architect's team beat his seventy-five-year-old father, Eliel Saarinen, in the final round by proposing a 560-foot-high weighted parabolic arch clad with shining stainless steel built on the left bank of the Mississippi River, where Lewis and Clark had embarked on their expedition with President Thomas Jefferson's blessing in 1803. The structure, now commonly known as the Gateway Arch, took almost twenty years to be built and is now one of the most recognizable urban icons in the world. Its author, who died in 1961 at the age of fifty-one, never saw it completed.

Saarinen's use of a perennial formal motif—a parabolic arch—aligns with the formalist schemata of his two close contacts: his father, Eliel, who in his 1948 book, *The Search for Form in Art and Architecture,* proposed that forms of art and architecture can travel through time and space to new uses and contexts; and his Yale classmate George Kubler, who in his 1962 book, *The Shape of Time: Remarks on the History of Things,* posited that every art object should be considered as part of a longer historical sequence. Viewed through these related exegeses, Saarinen's Gateway Arch gains kinship with all previous, present, and future arches—an idea that its author fully embraced. Had he lived, he would have enjoyed the afterlife of his design.

FORMS IN THE PUBLIC DOMAIN

When Saarinen chose the arch motif for his entry to the Jefferson National Expansion Memorial competition in 1947, he had plenty of precedents, old and new, to study. He was familiar with Eugène Freyssinet's airship hangars at Orly Airport outside Paris (1923) and had probably driven by the Municipal Asphalt Plant (1943), designed by Ely Jacques Kahn and Robert Allan Jacobs, along Roosevelt Drive on Manhattan's Upper East Side; both were dominated by parabolic reinforced-concrete ribs. Working together with

his father, he had already deployed wooden structural arches to carry the roof of the Berkshire Music Shed in Tanglewood, Massachusetts, completed in 1940. We can also assume that he was familiar with Louis Kahn's 1944 proposal to rework the historical arch motif with new materials and with his argument that modern monumentality was to be grounded in recognizable forms; they were close friends.

Despite the prevalence of the arch motif in various cultures throughout history, soon after the results of the competition were announced, the chairman of the New York Commission of Fine Arts, Gilmore D. Clarke, accused Saarinen of citing one singular arch—namely, Adalberto Libera's unexecuted memorial arch for the twentieth anniversary of Italian fascism from 1938. In a letter dated February 24, 1948, addressed to the chairman of the competition jury, William W. Wurster, Clarke summed up his condemnation, saying: "The pertinent question is not whether or not the design was plagiarized; rather it is whether or not, in the circumstances, it is appropriate to perpetuate the memory of Thomas Jefferson and to memorialize the Louisiana Purchase by constructing a monument similar in design to one originally created to glorify twenty years of Fascism in Italy!"[1] The situation intensified on February 26, 1948, when the *New York Herald Tribune* published a front-page story headlined "St. Louis Arch for Memorial Called Fascist," and presented two oblique views of seemingly identical super-sized parabolic arches that dwarfed their respective urban contexts to demonstrate the point.[2] The debate gained national traction when *Life* magazine picked up the story shortly afterward (fig. 69).[3]

Likenesses between a monument dedicated to a founder of the world's oldest democracy and one celebrating the anniversary of a fascist state were troubling, to say the least. The architect rushed to declare that neither he nor any of his collaborators had seen or heard about Libera's arch until the accusations broke out.[4] The *New York Herald Tribune* came to the architect's rescue a day after it published Clarke's claim, noting that "the symbols of architecture, as of all art, belong to those who succeed in appropriating them. The runic form of Hitler's swastika, equally a device of our own Indians, is an instance."[5] The competition jury released a statement shortly afterward, which discredited the plagiarism accusations on the same grounds that an arch was a perennial architectural motif without fixed cultural or political meanings. It is worth quoting the statement at length, as it resonates with the formalist stance that forms are born from preceding forms:

> The jury welcomed the fact that the outline given to the great arch was one which, while of a general type going back many centuries, was not an adaptation of classical or historical motifs, but one especially characteristic of modern architecture and engineering.
>
> Arches of this general type are extremely old as an architectural form. One closely similar in effects is the immense arch of the royal

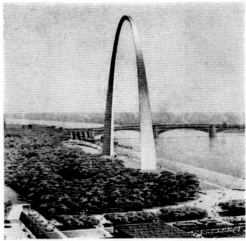

Fig. 69 "Arch Argument: St. Louis Memorial Starts Architectural Squabble," *Life*, March 8, 1948, 113.

palace at Ctesiphon, built by Chosroes the Great, King of Persia, in the 6th century.

In recent times the parabolic and the hyperbolic arch, with their structural advantages, have become characteristic forms of functional modern architecture ... in bridges, and in structures where a clear span of great height is important, like the great hangar at Orly near Paris. The form is in the public domain; it was not invented by the Fascist.[6]

The signees shielded Saarinen's design from association with Libera's arch on three grounds: Saarinen's arch was based on a "general type" rather than on "historical adaptation"; modern architects had often used the form as a structural rather than as a symbolic element; and the form belonged to the "public domain," therefore, it could not be claimed by a single individual or political entity.

Saarinen told his side of the story in the article "Saarinen Tells How 'Gateway' Was Conceived" in the *St. Louis Post-Dispatch* two weeks after the scandal broke. In it, the architect answered the question at the heart of the matter—namely, how he came up with the arch motif—by recalling his design process, step by step:

> We thought of a huge concrete arch. Such a shape was in no way unfamiliar to us. There are the dirigible hangars in Orly, France, designed by the engineer Freyssinet that really gave a sense of monumentality. There are the arched concrete bridges that were built by the Swiss engineer, [Robert] Maillart. There is also the arch that the great French architect, Le Corbusier, incorporated in his design for the Palace of the Soviets sometime in the '20s. My father [Eliel Saarinen] and myself had used some large exposed wooden arches to hold up the roof to the summer opera house we built at the Berkshire Music Center a few years ago. All these things came to one's mind when we struggled to make an arch made out of pipe cleaners stand upright on the plan on the living room rug.
>
> Then we thought maybe an arch is a good idea, but we began to wonder whether one leg should not be placed on each shore of the river, thus forming sort of a great symbolic arch bridge that tied together the two sides of the Mississippi. No, there seemed to be enough bridges, and placing a symbolic bridge between two useful bridges didn't seem right. Maybe the arch should be parallel with the levee but placed right in the Mississippi. Then we came back to the thought that placing it on the west bank was not bad at all. It seemed like sort of a modern adaptation of a Roman triumphal arch.[7]

According to this narrative, Saarinen and his collaborators were first drawn to the structural qualities of the arch motif before discovering its historical and symbolic associations. Calling the outcome "a modern adaptation of a Roman triumphal arch" indicates that the team deemed it possible to appropriate a symbolically laden historical motif into new uses and invest it with new meanings, all while holding on to the old ones. A subsequent headline spoofed Gertrude Stein's 1913 line "Rose is a rose is a rose is a rose" by stating "An Arch, Is an Arch, Architects Archly Agree."[8] The tongue-in-cheek tone conveyed a profound message: every concept or image carries a whole slew of historical and cultural associations, and Saarinen's arch cannot therefore be attached to a singular political meaning.

The debacle led to a broader conversation about the value of using historical precedents as a basis of design, with Kenneth K. Stowell, the editor-in-chief of *Architectural Record* leading the way by dedicating his editorial in the April 1948 issue to the topic. Entitled "Precedents, Prototypes and Plagiarism," it begins: "Architecture has amassed an unprecedented amount of

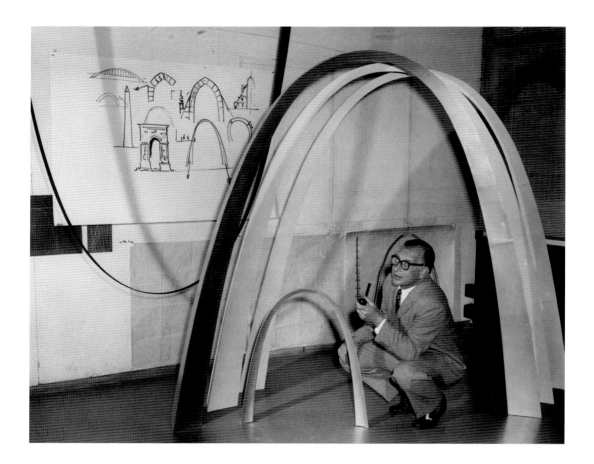

Fig. 70 Eero Saarinen with a model and sketches of arches, ca. 1960.

precedent. If one cares to probe into the past, he probably can find a precedent or a prototype for the form of each and every part of any structure." Without directly referring to Clarke's plagiarism accusation, Stowell posits that "it is therefore beside the point to criticize or cast aspersions on the use of a particular form just because it, or a similar form, has been used before for a particular purpose. Such natural and traditional use of precedent is inherent in architectural development, and it should not be implicated that plagiarism is involved." "Plagiarism" means "copying of prototypes without any significant contribution, modification, or improvement on the part of the design," according to Stowell.[9] Saarinen's design could thus be deemed innovative not despite, but because of, it being a novel adaptation of a historically recognizable form.

A photograph taken around 1960, when the project was heading for construction, depicts Saarinen kneeling in front of the model of the slightly revised, final version of the arch with sketches of various historical arches pinned to the background; twelve years after the debacle he could openly celebrate that his arch was generated from and gained its meaning against a plethora of historical precedents (fig. 70). By the time the photograph was taken, the original structural catenary arch had been replaced with a weighted catenary arch, which underscored that twentieth-century

Fig. 71 Eero Saarinen, sketch depicting a weighted catenary arch juxtaposed with Leonardo da Vinci's Vitruvian Man, early 1950s.

structural arches were no longer the primary reference point. The shift from structural to formal imperative aligned with an increasing interest in Renaissance architecture following the publication of Rudolf Wittkower's *Architectural Principles in the Age of Humanism* in 1949, which helped spread an interest in proportional geometric systems. It is likely Saarinen revised his design shortly after attending the symposium "Il Primo Convegno Internazionale sulle Proporzioni nelle Arti" (The first international conference on proportions in the arts) in October 1951, where Wittkower was a featured speaker.[10] He was probably in the audience when the renowned British architectural historian posited that the Renaissance architect Palladio's villas did not carry over the pagan function of ancient temples, even when copying their plan form. One can only imagine how vindicated Saarinen must have felt after listening to the esteemed scholar posit that a form can free itself from unwanted historical meanings, given that his arch had just a few years earlier been deemed fascist! An undated pencil sketch that depicts Leonardo da Vinci's Vitruvian Man inside the arch was probably drawn sometime soon after the Milan conference (fig. 71). The drawing offered a final rebuttal against plagiarism accusations by highlighting its connection to Renaissance proportional systems. Even if Saarinen expressed his weariness about the stifling effect proportional and geometric systems have in the unpublished essay "Golden Proportions" (1953), the idea of architecture being a transhistorical formal language devoid of fixed historical associations gave him license to apply lessons from the past to his future designs.[11]

SEARCH FOR FORM

While it is hard to confirm whether Eero Saarinen had read Henri Focillon's *La vie des formes,* he was surely familiar with his father's 1948 book, *The Search for Form in Art and Architecture,* which made a similar argument: forms of art and architecture are able to travel through time and space into new contexts and acquire new meanings. Indeed, so similar are the two books in their thematic content and structure, even down to the chapter titles, that it is hard not to assume that the elder Saarinen had read Focillon's book—either in French (he was fluent in that language) or in its 1942 English translation. It is also likely that the elder Saarinen and Focillon had met in person in February 1936, when Eliel lectured at Yale.[12]

The elder Saarinen's main contribution to formalist art history was to expand its geographic and temporal scope beyond Europe and into periods where no written records exist to explain the meanings of artworks. Chapter titles such as "The Primitive African Negro Form," "The Mayan Form," and "The Egyptian Form" suggest that each culture has its unique formal language. While many of the objects featured in the book had lost their legibility over time, in Saarinen's mind they still communicate the "thoughts, feelings, and aims of our forebears" through the "silent language of form."[13] Like Focillon, Saarinen believed that forms of art provide a unique bridge between past and present, because even when original meanings get lost, forms retain their psychic effect. Due to this psychic bridge, past art never loses its allure. A photograph taken by his twenty-seven-year-old son, Eero, during a 1937 trip to the Yucatán Peninsula, titled "The Mayan Form: Temple of Warriors, Entrance, Chichen-Itza, Yucatan," proved the point (fig. 72). The choice of destination was indicative of the growing interest in pre-Columbian art after Edward Herbert Thompson's archaeological digs at Mayan sites in the late nineteenth and early twentieth century, and after the subsequent rediscovery of Machu Picchu in today's Peru by the Yale historian Hiram Bingham in the 1910s. Many pre-Columbian artifacts found their way to the natural history museums at Yale and Harvard, where they continued to baffle historians and fascinate wider audiences. Eero's photograph depicts one of the most enigmatic structures on the Mayan site—the serpent columns of the Toltec Temple of Warriors that epitomize the challenges much of pre-Columbian art poses to conventional art history: it is difficult to date and decipher because so little is known about the culture that produced it, due to the lack of written documents. In his popular 1932 memoir *People of the Serpent,* Thompson points out that scholars indoctrinated in conventional ways of writing about history, based on isolated periods and places, could not understand the layered symbolic language of ancient Mayan culture, which, according to his findings, had reached its highest level of development through communication among different ethnic groups within a wider region during a prolonged period of time.[14] Understood this way, prehistoric and pre-Columbian art challenges the

Fig. 72 Entrance to the Temple of Warriors, Chichén-Itzá, Yucatán. Reproduced in Eliel Saarinen, *The Search for Form in Art and Architecture* (New York: Dover, 1948), n.p. Photo: Eero Saarinen.

notion that each period and place has its own distinct style by promoting a global, *longue durée* approach to writing art history that challenges conventional temporal and geographic markers.

Eliel Saarinen was intrigued by what he called "form-migration" between different cultures over periods of time and observed that the phenomena had recently increased due to advanced travel and communication tools. He writes in a chapter dedicated to the topic: "The present age is eager to spread ideas about. When a novel form appears—and is found strong and expressive—in a short time it is published, described, analyzed, criticized, exhibited, and advertised everywhere and in every way."[15] How increased intercommunication impacts the creative process is at the heart of his inquiry.[16] The elder Saarinen's answer to the question reveals the humanist underpinnings of his thesis. It states: "[There are] two different types of mind. One type absorbs facts, digests them, and makes them creatively fertile. The other type absorts [*sic*] facts, sterilizes them, and uses them as such. The former is the creative mind. The latter is the parasitic mind—a 'parasitic,' for after all it lives on food digested by others."[17] Somewhat serendipitously, *The Search for Form in Art and Architecture* came out the year his son was accused of plagiarism. The book left no doubt that adaptation and appropriation of external influences were an inherent part both of the individual creative process and of cultural development at large. Likewise, increased internationalization of culture was an "opportunity," yet one with a caveat: "The more slowly form develops towards international expression, the safer the development."[18] The challenge is how to avoid superficial fads and let external influences settle more deeply, but slowly, into the culture.

Time is an essential component of the elder Saarinen's inquiry into the process of form migration, one that led him to embrace the vitalist notion of

temporal durée, which was both intuitive and nonlinear. The chapter titled "Form and Time"—note the resemblance to the last chapter in Focillon's book, "Forms in the Realm of Time"—offers an enigmatic assessment of such temporal phenomena: "TIME is that endless something which surrounds us. It moves forward, seemingly. Behind is the past, gone forever. The present is a ceaseless passing of the future into the past. Ahead is that unknown future."[19] The statement echoes Henri Bergson's notion that subjective temporal intuition, rather than historical change, propels the arrival of the future. The elder Saarinen continues: "During his long journey of evolution, man has passed through all the stages of the past. He is kindred with them, physically and spiritually. The forms of the past, therefore, are to man like an atavistic echo once experienced—and he understands them. But in the long course of time the divergences of the details wane, and so much the more distinct appear the contours of the whole. Man discerns the fundamental form of the past."[20] The idea of an "atavistic echo" suggests that the author believed that repetition of past forms was inevitable and even desirable; we rely on them for our survival, since only "past and present can be understood, not future." In his historical schemata, the creative mind, imbedded in a time continuum and receptive to the flow of forms, "gives birth to [new] form[s]."[21] Like life, art is constantly reborn from preexisting matter.

When it was time for Eero Saarinen to define his own theory of form creation, he too referred to it as an open-ended "search." As we have already learned from his retelling of the design process of the Gateway Arch, this entailed exploring various precedents and distilling from them possible solutions to the problem at hand. In his posthumously published article in *Perspecta* 7 (1961), Saarinen acknowledged his generation's indebtedness to the modern masters, Frank Lloyd Wright, Le Corbusier, and Mies van der Rohe, writing:

> These are the great leaders, especially Corbu and Mies, and these three made the great principles which together form our architecture. Mixed together, they make the broth which is modern architecture. In different parts of the world, the ingredients of the broth have different proportions. For instance, architecture in South America and Italy is primarily made up out of the fundamental principles plus Corbu. This forms a different product than that of the U.S. which has primarily Mies, comparatively little Corbu, and FLW as a spice.[22]

The passage suggests that an architect operates like an information processor, shifting through past and present models and letting them guide the design outcome. Saarinen then continues to acknowledge that the field was ripe with new opportunities and that his generation "refused to stop" and accept modern architecture as a fait accompli. "We," he continues, "felt that there must still be time for search . . . the challenges of the great variety of problems to be solved seemed to indicate a greater variety of answers

Fig. 73 Eliel Saarinen, Cranbrook Academy of Art and School for Boys, Bloomfield Hills, Michigan, 1925–32. Model by Loja and Eero Saarinen, 1925.

than such [modern] 'style' [originally] tolerated."[23] The use of a culinary metaphor—a broth—captures the idea that, like chefs, architects create by studying precedents. The metaphor also allowed him to note that architects with different cultural backgrounds tailored their work to local tastes. The parallel between architecture and cooking assumes that architects don't invent but appropriate and tweak preexisting models. Novelty, if any, is a matter of finding the right combination.

FOLDING THE PAST INTO THE FUTURE

Eero Saarinen's all-too-brief life and career challenged the linear timelines in many other ways as well. He spent his childhood and youth in two magnificent Arts and Crafts Gesamtkunstwerk environments designed by his architect father in collaboration with his textile designer mother, Loja Saarinen: his first ten years were at Hvitträsk, a medievalist granite fortress outside Helsinki in his native Finland, and his teens on the Cranbrook campus in Bloomfield Hills, outside Detroit.[24] These two cloistered compounds allowed the family to live in a time warp, as if the twentieth century were yet to arrive. The younger Saarinen began to develop his own budding historical imagination in his mid-teens by participating in the design of the Cranbrook campus as an ersatz sort of reality (fig. 73).[25] The Gateway Arch

Eero Saarinen and George Kubler 133

Fig. 74 Eero Saarinen, Gateway Arch, St. Louis, under construction in 1965. Photo: Louis Pavledes.

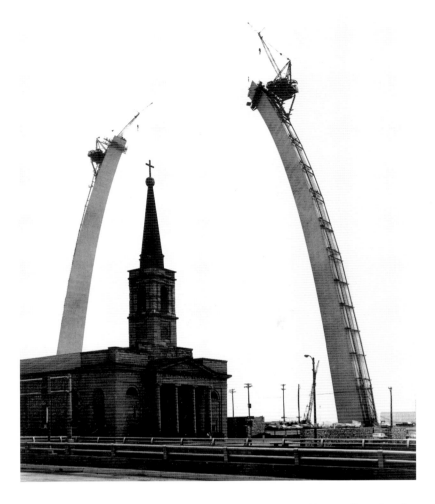

proves that sourcing historical motifs remained part of his toolkit when he embarked on his independent career. This went hand in hand with the belief that architecture was never meant to merely reflect existing realities but to provide alternative ones. Many of his independent projects highlighted the contrast of their respective contexts by extending their temporal imagination both backward and forward in time. If this required, as in the case of the Gateway Arch, clearing swaths of historical urban fabric to make way for a new structure, so be it (fig. 74).

Saarinen's arrival at Yale College in the fall of 1931 coincided with Harlan Hale's tirade that deemed the Sterling Library hopelessly anachronistic. While we can only speculate where Saarinen stood in the debate that butted historicism against modernism, in all likelihood he did not agree with Hale's critique that Gothic was anathema to modern times. Saarinen had studied historical styles with great gusto in the classroom.[26] His knowledge is manifest in a series of illustrated letters featuring examples of Early Christian, Byzantine, and Romanesque architecture he sent to his childhood friend Florence Schust (later Knoll) during a trip he took after grad-

134 Past and Future

uation between 1934 and 1936, under the auspices of the Charles Arthur and Margaret Ormrod Matcham Traveling Fellowship (fig. 75). His travel itinerary reveals his historical and stylistic range. Apart from seeing ancient architecture in the Mediterranean region and Mexico, Saarinen visited several notable examples of recent architecture in Northern Europe, including Holland, which was one of the birthplaces of the modern movement. Here we are reminded of the stylistic range of buildings constructed during the 1920s and '30s. In Hilversum, Saarinen saw both Jan Duiker's Zonnestraal Sanatorium (1925–31) and W. M. Dudok's Town Hall (1928–31), which, despite being completed in the same year, were completely different. In a 1936 letter to Everett Victor Meeks, Saarinen reported that the latter made a particular impression.[27] It is worth noting that Dudok had appeared in Henry-Russell Hitchcock's 1929 book *Modern Architecture: Romanticism and Reintegration* as Eliel Saarinen's fellow "modern traditionalist"—that is,

Fig. 75 Eero Saarinen, sketches depicting the history of architecture, from a letter sent to Florence Schust (later Knoll), 1935.

Eero Saarinen and George Kubler

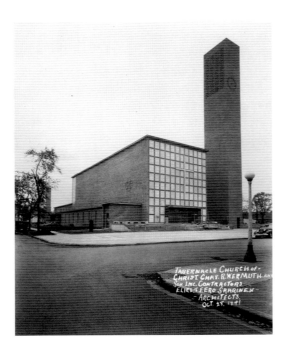

Fig. 76 Eliel and Eero Saarinen, First Christian Church, Columbus, Indiana, 1942.

as somebody able to distill formal motifs from the past without resorting to direct copying. One can detect Dudok's influence in the collaborative work Eero did with his father during the late 1930s and early 1940s, especially in the First Christian Church in Columbus, Indiana (1942), whose asymmetrical massing, light-colored brick walls, and exquisite detailing echo Hilversum Town Hall, and which, like its predecessor, was celebrated for its ability to mediate between modern and traditional sensibilities (fig. 76). Subsequently, *Time* magazine heralded the outcome as "the costliest modern church in the world, planned by Europe's most famous modern architect and his son," which provided their client "a pair of modernists whom even conservative architects respect."[28]

Eero's career took a sudden turn in 1950 when his father died curled up in the Womb Chair (1948)—a fitting tribute to the passing of generations, making the son solely responsible for a plum commission to design what became the largest and most expensive construction project of its time: the General Motors (GM) Technical Center in Warren, Michigan. The compound of twenty-four elaborately crafted buildings, housing various research, management, and design facilities around a reflecting pool, was dubbed the "Versailles of Industry" upon its completion in a 1956 *Life* article with the time-bending title "Architecture for the Future: GM Constructs a 'Versailles of Industry'"—a testimony that the most forward-looking work benefits from a historical reference point to make it resonate with a contemporary audience.[29] In a brochure published for the opening, the client used the slogan "Where Today Meets Tomorrow" to suggest that GM calibrated its products and new facilities in a manner that blended innovation with the familiar (fig. 77). Indeed, that was often Saarinen's modus operandi:

Fig. 77 Cover of "Where Today Meets Tomorrow," *GM Annual Report,* 1956.

he made the old feel new. For example, at the GM Technical Center, he appropriated neoprene caskets from the auto industry for architectural use to improve the performance of a preexisting curtain wall glazing system. Likewise, Saarinen and his team updated familiar architectural imagery—Mies van der Rohe's, to be specific—by giving old materials and techniques a new twist (e.g., colored bricks with ultrathin glazing) and by using slick detailing and integrated artworks to invest the industrial compound with a luxurious exuberance in a manner that harked back to the Arts and Crafts tradition. The strategy paralleled GM's ambition of turning the car, a familiar product, into a fashionable object of desire through design. To meet this goal, the compound included a "styling department"—the first of its kind in the automotive industry—which, like the fashion industry, introduced new shapes and colors on an annual basis. Indeed, as far as the client was concerned, the future could not arrive early enough; to accelerate its arrival, the then-CEO, Alfred P. Sloan, came up with the idea of "dynamic obsolescence" to speed up consumers' appetite for new styles by replacing their otherwise perfectly functioning vehicle with a new one simply in pursuit of novelty and change.

The high visibility of the project—President Dwight D. Eisenhower opened the building in May 1956—cemented the younger Saarinen's fame, and *Time* magazine placed him on the cover of its July 2, 1956, issue with the plan of the Tech Center in the background. This made him only the fourth architect to gain that distinction, following Ralph Adams Cram (1926), Frank Lloyd Wright (1938), and Richard Neutra (1946). The article, titled "The Maturing Modern," conveys Saarinen's belief that the future development of modern architecture relied on the architect's ability to draw from a whole range of historical sources. He said: "When you do a job like this, your mind goes back to Versailles, the Tivoli Gardens, San Marco, the way Italians used pavements. And you think, 'Boy! Let's do that!'" The implication was that a "mature" modern building needed to

look both forward and backward in time, depending on its client and program.[30] Indeed, while the GM Tech Center built on the legacy of twentieth-century European and American architecture, the Massachusetts Institute of Technology (MIT) Chapel, which was completed the same year, harked back to much earlier times and drew its cylindrical shape from the Castel Sant'Angelo (also known as Hadrian's Tomb), which Saarinen had probably already seen during his 1935 trip. Saarinen calibrated the new and the old on a case-by-case basis: a building for a car manufacturer should embrace the arrival of the future; a monument or a chapel should retain historical memory; and buildings for academic institutions needed to balance continuity and change.

MITIGATING CHANGE

To be sure, the future did not move at the same pace in every location, even during the fast-changing mid-century period in the United States. Yet, change was evidently in the air, even within the parochial confines of Yale, when forty-four-year-old Alfred Whitney Griswold was appointed its sixteenth president. He too made it on the cover of *Time* magazine, which heralded him as a reformer in an enclave resistant to change. Yale's Gothic architecture looms behind his youthful face, and the magazine captures the eerie ennui prevailing on campus, saying: "Yale's newest buildings appear to be the oldest, for their antiquity was planned in advance and custom-made. Upperclassmen eat in baronial halls, may sit under imposing chandeliers or by an imported Burgundian fireplace, use silver sugar bowls. Yale's Divinity School looks as if it might have been moved up from Williamsburg; the university library looks like a cathedral . . . ; its main power plant is clothed in stone to look like a Gothic tower."[31] Yale was also notoriously insular at the time: 55 percent of the faculty were alumni of Yale College when Griswold took office. Aware that rebooting Yale's image required convincing his tradition-bound constituency, Griswold demonstrated his political shrewdness by incrementally introducing nontraditional-looking buildings by some of the hottest new names in American architecture without causing a total overhaul of the existing campus. This involved inserting twenty-six new buildings into the existing fabric and a few into the surrounding urban areas, while leaving the twenty-year-old Gothic campus nearly intact. After Griswold's untimely death in 1963 at the age of fifty-six, the campus he helped upgrade was the envy of its peers. In 1964, the *Columbia Daily Spectator* heralded Yale's campus as the "veritable museum of buildings by contemporary architectural giants."[32]

Saarinen received several commissions from Yale, two of which were built: the David S. Ingalls Hockey Rink (1955–57) and the New Colleges (1957–62), later named the Samuel F. B. Morse and Ezra Stiles Colleges. He was, in many ways, a natural choice: like Griswold, he was a graduate of Yale College and had served on many university committees, including

the Committee of the Division of the Arts charged with the task of modernizing Yale's arts curriculum in the late 1940s; the GM Technical Center had established him as one of the hottest young architects who designed with the future in mind; and the MIT Chapel had proven his ability to work with a top-tier institution known for sponsoring modern architecture, albeit by designing a building based on a historical precedent, namely Castel Sant'Angelo in Rome. Subsequently, the two buildings he designed for Yale featured a curious blend of historical evocations and new technology in a manner that ended up confusing modernists and traditionalists alike.

The first of them, the David S. Ingalls Hockey Rink, located just north of the central campus, recycled a familiar historical motif: an arch, which spans across the ice longitudinally with a cable roof suspended on both sides (fig. 78). Recalling the Gateway Arch, the hockey rink used the motif in ways that blended structural and programmatic reasoning with the symbolic. Like the Gateway Arch, the building became controversial as soon as the plans were revealed, and it probably never would have been built had it not been for Griswold's shrewdness in harnessing institutional history to his support. It was namely Griswold who garnered support from a group of prominent Yale art historians to convince the disgruntled alumni that the mostly underground, oval-shaped building dominated by a hung cable roof could be labeled as Gothic.[33] The letter helped convince the building's main donor, Louise Hale Harkness—a daughter of William L. Harkness—to let the university move forward with the plans. The historians had proven that without a historical echo chamber modern architecture remained illegible. Yet, the outcome continued to bewilder many, largely because the building's shape triggered so many myriad associations: "a capsized Viking

Fig. 78 Eero Saarinen, original pencil sketch for the David S. Ingalls Hockey Rink, Yale University, 1956.

Eero Saarinen and George Kubler 139

Fig. 79 Eero Saarinen, New Colleges (later named the Samuel F. B. Morse and Ezra Stiles Colleges), Yale University, site plan, 1960.

vessel," "[a] reproduction of the pre-historic monster," "a king-sized helmet from the War of the Roses," were just some associations the building triggered after its completion.[34] The interior space was another matter, as it did not seem to match any known precedent. One critic even reported a feeling of nausea upon entering, due to the combination of curved ramps and slanted retaining walls. Even those who considered the "revolutionary" building a "wonderful vision of the future" were concerned that its enticing, futuristic allure would eventually feel outdated.[35]

The powerful donor behind the New Colleges, Paul Mellon, requested that they be based in the same Oxbridge model that James Gamble Rogers had used for his college typology. Resistance to his previous Yale project might have prompted Saarinen to pay more respect to the existing campus architecture; this time, he used towers to echo those spread around the neo-Gothic campus and tucked his buildings carefully between Rogers's Hall of Graduate Studies (1930–32) and John Russell Pope's Payne Whitney Gymnasium (1932) (fig. 79). Yet, in his customary manner, Saarinen extended his references beyond the immediate physical and historical context, with a nod to medieval Italy, by crafting narrow walkways and piazzas between buildings; the one facing the gymnasium is an exact replica of the Piazza del Campo in Sienna.[36] Saarinen's ambition to re-create the look and feel of medieval Italy is best captured in the stepped passage located between the two colleges (fig. 80).

It is important to note that Saarinen used historical reference points in his designs radically differently than Rogers, who applied stylistic features to convey cultural and ethnic affinities between two loci. In contrast, Saarinen's main motive was to enrich the language of modern architecture beyond the functional and structural imperative by investing it at times with multiple historical and cultural touchpoints. Like so many of his contem-

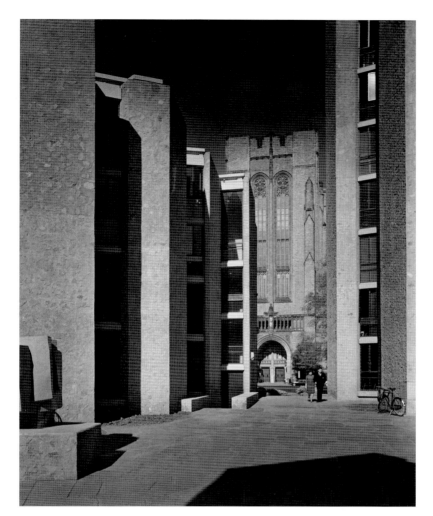

Fig. 80 Eero Saarinen, New Colleges (later named the Samuel F. B. Morse and Ezra Stiles Colleges), Yale University, 1957–62, view to the Payne Whitney Gymnasium. Photo: Joseph Molitor.

poraries, Saarinen had fallen in love with Italian historical cities during his 1951 trip and there was no ideological subtext behind his choices beyond the fact that he must have found them pleasing. He addressed his take on architecture's relationship to time and history in 1959 upon the unveiling of the design, by stating that his goal was to "create a new vocabulary or add to the vocabulary of modern architecture." The outcome was conceived to be "of our time, but also timeless."[37] When describing the technique called "masonry without masons," which involved adhering rocks by placing them in a formwork with liquid concrete without the need for labor-intensive assembly, he argued that modern architecture would benefit from expanding its material palette to include masonry (fig. 81). He wrote: "One of the reasons why the general vocabulary of modern architecture does not usually include masonry walls is that these require handicraft methods which are anachronistic in our time. But an entirely new technological method will be used for the stone walls of these colleges so that for the first time a stone wall will be as 'modern' as a curtain wall of panels." He continued

Eero Saarinen and George Kubler

Fig. 81 César Pelli looking over a stone wall during the full-scale model construction of the New Colleges (later named the Samuel F. B. Morse and Ezra Stiles Colleges), Yale University, n.d.

by describing how the walls of Yale's New Colleges "will be somewhat like old Pennsylvania houses, where worn plaster reveals the stone-work, or the stone walls of the Cotswolds in England."[38] Echoing his father's thinking, Saarinen determined that appropriating forms and techniques from the different cultures and eras guaranteed that a new building would become part of the culture of its time; there was no culture without cultural memory. It is very likely that he had also read Sibyl Moholy-Nagy's 1957 book *Native Genius in Anonymous Architecture,* in which the author discusses Pennsylvania's stone building tradition (fig. 82).[39] Inspiration from stone structures in Italy, England, and the United States turned the aggregate of rocks into a trans-geographical and multi-temporal atlas of sorts.

Due to his untimely death in 1961, Saarinen missed the opportunity to respond to Reyner Banham, who condemned the buildings upon their

Fig. 82 Double House, New Hope, Pennsylvania. Reproduced in Sibyl Moholy-Nagy, *Native Genius in Anonymous Architecture* (New York: Horizon, 1957), 96.

completion in 1962 on the grounds that the compound looked like a stage set for medievalist plays, while its interior "f[e]ll below even the medieval standards." In other words, it failed to meet both the historicists' and the modernists' criteria of success. Feeling that the building was indicative of a broader institutional malaise and hopelessly out of sync with the times, the well-known British historian exclaimed: "Yale is a very sick place."[40] Saarinen's colleges continue to trouble many students even today, albeit for the opposite reason, that is, for being too modern and thus somehow less true to the presumably more "authentic" Yale experience of living in the early twentieth-century neo-Gothic colleges down the road. Their verdict offers an eerie echo of Rogers's prediction that architecture that steers too far from a traditional style will soon fall out of style.

THE SHAPE OF TIME

Art historian George Kubler shared Saarinen's conviction that historical artifacts continue to gain new meanings in the mind of the onlooker. The two men's intellectual affinity can be traced to the early 1930s, when they had been classmates at Yale College (class of '34). Saarinen's frequent visits to their shared alma mater, where Kubler had begun to teach after completing his PhD under Henri Focillon in 1940, allowed them to stay in touch.[41]

Both men found their own voices through strong and influential father figures. While Eero Saarinen began his career working closely with his biological father, Kubler's first accomplishment as a young faculty member was to carry on the intellectual legacy of his "*Doktorvater*" Henri Focillon by translating *La vie des formes* into English under the title *The Life of Forms in Art*. The book came out in 1942, one year prior to Focillon's death, and a revised second edition was published in 1948. Notes that Kubler made during the translation process capture the core idea of the book, namely,

method. HF. January 26

Genesis of style

Autonomous character of work of art, independently of historical data.
 All facts of art tend to group themselves in styles. Tendency to homogeneity, to
 organic condition, constitutes style, by principles of series.
A. Style means column: in ancient bldg, style of column is relation diameter to
 height: hence style/column = symbol for coherence of phenomena.
Style in the abstract is quite different: everything that has form is style.
 a state of conscience defined by choice of certain forms. = style.
How is a style born or formed; how does it develop [genesis & evolution]
Object of study is to define constant principles in this process:
✱ Tradition, influence, experiment are the critical phases
Formerly, everything was explained by means of tradition: Romsque as
 decline of Roman tradition: Baroque as "decadence of Renaissance".
Influence is often made to explain everything: Lambert on French Gothic in Spain
   ~~~~~~~~ This principle is at heart of comparative studies
Experiment: the diagnostic trait of the artist's psychology.

Tradition: term signifies movement or phenomenon of collective
   memory. Relation to individual memory is interesting. Humanity
   never forgets. Tradition is also a technical habit; supplanting the
   need always to invent anew. Cp. Maestri commacini.
[We need to write history as layer-cake history: successive phases, super-
imposed.]
Bergson: memory is a machine for forgetting the unnecessary.

**Fig. 83** George Kubler's notes on the Focillon method, January 26, 1940, page 1.

that art exists outside historical time (fig. 83). He wrote: "Both the New Deal and Radio City are historical facts. But the former is a memory, like very h.f., and it demands reconstruction by aid of documents. But the latter is an *object,* forever present, incorporating a creative force, for as long as it is visible. Each generation brings its own new sensibility to the work of art created prior to its time."[42] An art object should thus never be reduced to a product of a particular historical moment, but considered a historical agent in its own right, capable of carrying traces of past works and influencing future work. Kubler notes how, in Focillon's art historical schemata, "tradition" and "influence" form the two dominant ways an artist relays past forms; the former entails both collective and individual memory, while the latter bares traces of a more concrete lineage that moved in the opposite direction over time.[43] When Kubler made these notes, his own research had begun to focus on Mesoamerican art, which required deciphering artifacts without the help of written documents by mapping out formal, material, and technical affinities to similar objects across time and space. He considered each object a product of a transhistorical and transcultural effort, which meant that each artist had many fellow travelers who had worked, and continued to work, with similar problems, forms, and ideas.

Kubler summarizes his own thoughts about the genesis and meaning of art in his influential 1962 book *The Shape of Time: Remarks on the History of Things,* which built on Focillon's thesis by expanding the notion of art to include a wider range of objects. The opening sentence gives a vivid impression of the totality of objects—past and present—that surround us at any given moment: "Let us suppose that the idea of art can be expanded to embrace the whole range of man-made things, including all tools and writing in addition to the useless, the beautiful, and poetic things of the world."[44] To get a fuller picture of what he called the "shape of time," historians should open their inquiries to include a whole range of objects—high and low, old and new—and begin to trace the affinities and vectors of influence through an expanded space-time matrix.

A key methodological difference from standard art history is evident in the title of the book, which replaces the word "history" with "time." The statement that "without change there is no history; without regularity there is no time" suggests that, while the term "history" denotes differentiation, "time" presumes continuity between events.[45] Kubler uses the analogy between "arts and stars" to illustrate this temporal turn: "Many historical events, like astronomical events, also *occur* long before they *appear.*"[46] His pet peeve was social art history, which considers artworks as "historical objects" that could be deciphered through archival evidence. In contrast, following Focillon, Kubler was interested in how objects of past art continue to be used, experienced, and interpreted in the present by proposing that historical events and objects send signals across time to form "clusters of actions here and there [that] thin out or thicken sufficiently to allow us with some objectivity to mark beginnings and endings. Events and the

intervals between them are the elements of the patterning of historical time." The original meanings and uses are insignificant since "knowing the past is as astonishing a performance as knowing the stars. Astronomers look only at old light. There is no other light for them to look at. This old light of dead or distant stars was emitted long ago and it reaches us only in the present. . . . Hence astronomers and historians have this in common: both are concerned with appearances noted in the present but occurring in the past."[47] Some objects, like certain planets, shine more brightly than others in these clusters. Kubler calls them "prime objects."[48] These gain visibility and significance over time as models that get emulated and copied across generations. It is worth noting that Kubler's Yale colleague Paul Weiss had used a celestial metaphor in his 1952 article "The Perception of Stars" to capture the idea that historical objects do not reside in the past but continue to inform and illuminate present objects as well. Kubler could easily have written these words:

> The objects we perceive in the far distance are as contemporary as those nearby. Just as the nose is co-present with the finger, just as our shoes are contemporary with our socks, so our eyes are contemporary with the stars we see at night. This assertion is not incompatible with the truth that it takes time for a physical action begun at one point of space to be effective at another. We feel the effects of causes which have long passed away, but we feel them in the present. The effects of those causes, no less than the world which those effects stimulate us to observe, are contemporary with us. Only the causes are separated from us in time as well as in space.[49]

It is hard to attest to the conversations Saarinen and Kubler might have had during their meetings, but Kubler's dictum that "everything made now is either a replica or a variant of something made a little time ago" could well be illustrated by the photograph of Saarinen sitting in front of a model of the Gateway Arch with sketches of different historical arches pinned in the background (see fig. 70).[50] Kubler might even have given Saarinen the idea of how to respond to the plagiarism accusations: since the arch belonged to what Kubler called a "form-class," it had to be evaluated as part of a series of previous arches, where "advances obey a rule of gradual differentiation because they must remain as recognizable variations upon the dominant memory image."[51]

In turn, Saarinen might have kept Kubler informed about conversations surrounding modern architecture and about his own distance-taking from the modernist form-follows-function dogma. Unfortunately, he was no longer around to read his art historian friend's criticism of the "purists," both artists and architects, who had the arrogance to think they could reinvent everything anew. In the final pages of *Shape of Time,* Kubler wrote:

Purists exist by rejecting history and by returning to the imagined primary forms of matter, feeling, and thought.... Among these last, men like Walter Gropius took on the old burden of their purist predecessors. They sought to invent everything they touched all over again in austere forms which seem to owe nothing to past traditions. This task is always an insurmountable one, and its realization for all society is frustrated by the nature of duration in the operation of the rule of series. By rejecting history, the purist denies the fullness of things. While restricting the traffic at the gates of perception, he denies the reality of duration.[52]

The ideas of the "fullness of things" and the "reality of duration" capture Kubler's central argument: each instant was ripe with "signals" that traverse across time and space.[53] It followed that each new object was born out of previous works. The book became widely read among the up-and-coming younger generation of artists and architects, which included John Baldessari, who in his 1968 artwork *Painting for Kubler* encouraged artists to engage "prior inventions" and "former work," and Robert Smithson, whose 1967 article "Ultramoderne" celebrated the "trans-historical consciousness" of 1930s American art deco architecture, which challenged the modernist idea that architecture should be of its time.[54] The title was clearly a provocation, as Smithson considered architecture based on preexisting work to be somehow more radical and extremely modern than European high modernism, because in his mind being truly modern meant being able to embrace the multiplicity of time.

Had Kubler ever visited Saarinen's Victorian house in Bloomfield Hills, Michigan, he would have been pleased with its eclectic mix of objects from different periods and places, in a manner that gained popularity among the cognoscenti of modern art and architecture during the 1950s and '60s. The house was featured in *Vogue* magazine in 1960 under the title "A Modern Architect's Own House: The Eero Saarinen Remade House, Victorian Outside, Modern Inside" (fig. 84). The caption accompanying a pair of interior images declares that "Inside the architect's Victorian house: the dining room, on pedestal, a polychrome wood Garuda bird from a temple of Bali; the purple and yellow 'Homage to the Square' by Josef Albers. In sparse living room, 'Dusk,' a large painting by the young Japanese artist, Ohashi; on the high white pedestal, a Cambodian bronze Buddha mask; on the table with Finnish glass vase and Tiffany glass sauce, a small bronze by Jack Squier." All this amid Saarinen's own furniture, including the 1941 Organic Chair designed with Charles Eames, which *Vogue* dubbed as an "antique" piece of modern furniture.[55] Kubler could have well been referring to the interior of Saarinen's home in a 1973 interview in *Art Forum,* in which he talked about the "collapse of boundaries" between different categories of objects, saying: "Now, I think it is happening: everything has come into

Fig. 84 "A Modern Architect's Own House: The Eero Saarinen Remade House, Victorian Outside, Modern Inside," *Vogue*, April 1, 1960, 174.

the domain of sensibility. Everything has come to be intelligible as esthetic experience. All experience is undergoing what one might call 'esthetization.'"[56] In this revisionist account, *The Shape of Time* was less about the history of objects than about the history of human sensibility.

CHAPTER 7

# Paul Rudolph and Sibyl Moholy-Nagy

*Time Machines*

When considering Paul Rudolph's meteoric rise to fame, one thinks of George Kubler's statement that "without a good entrance, [an artist] is in danger of wasting his time as a copyist regardless of temperament and training."[1] Rudolph graduated from the Harvard Graduate School of Design (GSD) in 1947, launched an office the following year, began teaching at Yale in 1955, and was named the chairman of the Department of Architecture three years later, at age forty. This amounts to a mere eleven years between graduation and becoming the head of one of the preeminent architecture schools in the country.[2] The same year he completed his first major institutional commission, the Jewett Art Center for Wellesley College, outside Boston (1958); this revealed a time-bending approach to its architectural context by completing the existing Collegiate Gothic quadrangle with a building that bore a resemblance to the Doge's Palace in Venice, with its arcaded screen façade (fig. 85).

Rudolph had by then become one of the most vocal critics of the historical amnesia plaguing modern architecture, something that the faculty at his alma mater, among them Walter Gropius, the chair of the Department of Architecture at the GSD, had come to exemplify for many. Yet it was actually at Harvard that Rudolph first developed an interest in architectural history. Indeed, while Gropius did guard younger students' access to architectural history—convinced that "when the innocent beginner is introduced to the great achievements of the past he may be too easily discouraged from trying to create for himself"—he exempted "older students who have already found self-expression" from such restrictions.[3] In his contribution to the first issue of *Perspecta* in 1952, Rudolph praises his former teacher for making him "see in traditional architecture principles still valid today." He continues by noting that "once principles were seen, one could unleash the imagination without fear of producing 'Googie' architecture, if the disciplines of the ages were observed." For him, "new directions" of modern architecture did not reside in the quasi-futurist architecture of the 1950s but in lessons from the past.[4]

Fig. 85 Paul Rudolph, Jewett Art Center, Wellesley College, Massachusetts, perspectival rendering, n.d. Courtesy of Library of Congress, Washington, DC.

To be sure, Gropius did not oppose teaching architectural history and can, in fact, be credited for convincing the GSD's dean, Joseph Hudnut, to hire the prominent architectural historian Sigfried Giedion to the faculty along with him in 1938. While Rudolph never got to take a class with the famed Swiss professor, he read *Space, Time and Architecture: The Growth of a New Tradition* with gusto and later called it the "single most influential book in my professional life."[5] Its central idea—that present-day architecture recalls past forms—might have given Rudolph an incentive to forge transhistorical formal analogies in his own work. Furthermore, Giedion's idea that the goal of modern architecture was to strive toward the synthesis of "thinking" and "feeling" must be kept in mind when we consider that psychophysical experience was at the heart of Rudolph's own historical and theoretical inquiry.[6] Dean Hudnut echoed these sentiments when writing in his 1938 article "Architecture Discovers the Present" that a time would come "when we will value such emotions 'for their own sake,' unassociated with the time and circumstance which has occasioned them; when the totality of architecture as a phenomenon embracing both matter and spirit is overcome by an architecture of ritual."[7] As we will see, Rudolph thought along these same lines, insisting that the most important lessons of the past were to be experienced and emulated through the sentient body in the present.

Indeed, while Rudolph never took any architecture history classes as a student, Harvard instilled in him a lifelong passion for architectural history, which developed into a habit of citing his favorite buildings and books in his own works and words. While he was by no means the only architect to embrace architectural history at the time, he was far more adamant and polemical than most in his conviction that modern architecture and urbanism suffered from historical amnesia, and that the time was ripe for reversing this omission for good. This chapter takes a closer look at his attempt to channel history into contemporary use, and considers the influence of the self-taught architectural historian Sibyl Moholy-Nagy, who wrote Rudolph's

first biography in the early 1970s.[8] Her paradoxical temporal construction "the future of the past" captures their shared intellectual ambition and iconoclastic mindset.[9]

## ALL ROADS LEAD TO ROME

After graduating from Harvard, Rudolph had an opportunity to travel in Europe thanks to a coveted Wheelwright Fellowship. The year-long trip convinced the budding architect that old European towns should become the new standard-bearers for modern architecture and urbanism as he considered Italian cities and towns to be the epitome of a livable, human-centered environment that was lacking in the United States at the time. In 1952 he lamented the deplorable state of architecture and urbanism of his home country, writing: "With notable exceptions I was impressed much more by the great architecture of the past than by the contemporary efforts. I returned to this country with the reinforced conviction of the necessity of regaining the 'form sense' which helped to shape Western man's building until the nineteenth century. Other periods have always developed means of tying their architecture to previous works without compromising their own designs. This is also our task."[10]

He borrowed the term "form sense" from Geoffrey Scott's exegesis *The Architecture of Humanism: A Study in the History of Taste* (1914), which highlighted a particular aspect of Renaissance architecture—namely, perceptual and bodily experience.[11] Scott's book was reprinted several times in the late 1940s and '50s and, together with Rudolf Wittkower's book *Architectural Principles in the Age of Humanism* (1949), ignited a renewed interest in Renaissance architecture among young architects, albeit by proposing two completely different approaches to the material. Rudolph certainly took notice of Wittkower's ability to reduce Renaissance architecture to "syntactic relationships, the geometric grids, the emphasis on structure," which came to define his design method from the outset of his independent career.[12] Yet, he also took to heart Scott's dictum that the main lesson to be learned from Renaissance architecture was how to produce visual and sensory "delight."[13] Subsequently, Scott's idea that a city should have a unified "form sense" guided Rudolph's critique of post–World War II American urbanism, which, in his mind, had failed to allow various historical layers to merge into a continuous urban fabric. Changes in historical conditions, functional demands, and technological advancements were deemed irrelevant, since all great architecture spoke through the perennial language of form and was able to trigger "direct appeal"[14] and "immediate emotion."[15]

The talk Rudolph delivered at a panel titled "The Changing Philosophy of Architecture," at the 1954 American Institute of Architects conference in Boston, called for a renewed emphasis on architecture's perennial qualities. The call for the rediscovery of architecture's age-old values and principles offered a somewhat counterintuitive take on the panel topic by

proposing that "changing philosophy" required looking backward, not forward, in time. Referring to the dismal state of American cities and modern urbanism, Rudolph began his presentation by simply stating, "We still have many lessons to learn from Rome."[16] He was surely aware that elevating the Eternal City to a gold standard countered Le Corbusier's famous statement that "Rome is the perdition of those who don't know much. To put architecture students in Rome is to wound them for life."[17] Their differing opinions were founded on opposite epistemological models: Le Corbusier condemned Rome's urbanism as the antipole of reason and knowledge, while Rudolph believed the Eternal City could only be understood through a direct, multisensory, psychophysical experience. In philosophical terms, the former followed Descartes's dictum "I think, therefore I am," while the latter emphasized the extended nature of the human mind, based on the idea that the mind does not reside solely in the brain, nor even in the body, but rather extends to the whole environment—in this case to the built environment—promoted by Goethe. The contrast between reason and feeling entails a temporal subtext: whereas the rational mind projects into the future, the romantic mind tends to linger in the past. Subsequently, where Le Corbusier saw a glimpse of order and reason in individual buildings defined by geometric forms and volumes, such as the Pantheon, Rudolph praised the visual and kinetic pleasure of wandering along Rome's meandering streets and irregular squares. In the same vein, while Rome made Le Corbusier long for the straight avenues of Paris, the experience of the Eternal City made Rudolph detest the "tyranny" of wide-open streets in his own country.[17] Rudolph acknowledged the need to accommodate the automobile, but insisted that architects and planners also learn from how historical cities succeed in "manipulating the approaches and sequences of space" in a manner that was more conducive to the pace of the human body.[18] For Rudolph, as for Scott, the human experience of space constituted the ultimate test of good architecture and urbanism.

Rudolph saw in the work of nineteenth-century Viennese urbanist Camillo Sitte an alternative to Le Corbusier's urban ideals; Sitte's 1889 book *Der Städtebau nach seinen künstlerischen Grundsätzen* was published in English as *The Art of Building Cities* in 1945 with a foreword by Eliel Saarinen. The book offers a stark rebuke to Vienna's Ringstrasse on similar grounds that Rudolph used to criticize the UN area: the wide, circular road lined with isolated buildings compared unfavorably to the scale and feel of the medieval town it circumscribed. Rudolph cited Sitte's words to make a case against freestanding buildings that were destroying the traditional urban fabric in the modern United States as follows: "Of the two hundred and fifty-five churches in Rome, forty-one are set back with one side against other buildings; ninety-six with two sides against other buildings; one-hundred and ten with three sides against other buildings. Only six stand free."[19] Following Sitte's lead, he identified the freestanding glass skyscraper as the main culprit for the dismal state of American architec-

ture and urbanism, as exemplified by three landmark buildings of the era: Harrison and Abramovitz's UN Building in New York (1947), Gordon Bunshaft's Lever House in New York (1949), and Mies van der Rohe's Lake Shore Drive Apartments in Chicago (1951). While many considered such curtain-wall-clad towers to be a symbol of American economic prowess and a sign of technological progress, Rudolph criticized his contemporaries for creating "isolated buildings with no regard to the space between them, monotonous and endless streets, too many goldfish bowls, too few caves."[20] By evoking bowls and caves, Rudolph made the point that modern architecture should be conducive to a whole range of emotions, existential states, and temporal frameworks. It is worth quoting his 1954 lecture at length, since it is surely one of the most eloquent attempts to track how the human mind responds to the built environment in different temporal modalities. Rudolph stated:

> We need desperately to relearn the art of disposing of buildings to create different kinds of space: the quiet, enclosed, isolated, shaded space; the hustling, bustling space, pungent with vitality; the paved, dignified, vast, sumptuous, even awe-inspiring space; the mysterious space; the transition space which defines, separates, and yet joins juxtaposed spaces of contrasting character. We need sequences of space which arouse one's curiosity, give a sense of anticipation, which beckon and impel us to rush forward to find that releasing space which dominates, which acts as a climax and magnet, and gives direction. For instance, the Duomo in Florence is a magnet, which dominates the whole city and orientates one.[21]

The words echoed Scott, who proposed that one had to hark back to the fourteenth and fifteenth centuries to find buildings where the "centre of that architecture was the human body; its method, to transcribe in stone the body's favorable states; and the moods of the spirit took visible shape along its borders, power and laughter, strength and terror and calm."[22] Rudolph had probably also read Susanne K. Langer's 1953 book *Feeling and Form,* in which she posits that art and architecture are able to provide "a source of experiences not essentially different from the experience of daily life—a stimulus to one's active feelings."[23] The idea that they help trigger complex psychological processes and make sense of the world complemented Scott's aestheticism.[24]

Upon his appointment as chairman of the Department of Architecture at Yale, Rudolph amplified his criticism of modern architecture when he began his January 1958 inauguration speech, "Architecture: The Unending Search," by stating that modern world architecture was "probably lower than mankind has ever seen." With his characteristic fervor, Rudolph continued that "we, in truth, do not know how to do many other things, which the great periods of architecture have known."[25] His charge was that modern

architects were simply oblivious to "many of the basic principles of architecture such as scale, proportion, the relationship between parts, and most important of all, how to create living, breathing dynamic spaces of varying character, capable of helping man to forget something of his troubles."[26] The subtitle of the lecture—"The Unending Search"—hinted at the hermeneutic underpinning of his claim, according to which architecture, unlike science, could not be reduced to unambiguous, teachable formulas. Rather, it called for an architect to employ all cognitive faculties during design. Elsewhere Rudolph encouraged architects to search within themselves and learn to embrace "our own passion for certain forms today."[27] In other words, history was at the architect's disposal, not the other way around. Rudolph conveyed his fluid temporal imaginations in 1977 as follows: "Our perceptions of architecture change more than our perceptions of other arts, in spite of architecture's permanence. This is because we must use architecture, and the conditions of our use are constantly modified by the weather; the time of the year; our own particular time of life; our personal activities; our fate; economic, political, philosophical twists and turns; and, most of all, our particular reading and rereading of history."[28] For Rudolph, the peripatetic experience of his own body provided the ultimate testing ground for what was to be included in such operative "rereading."

**PRECEDENTS AND CLICHÉS**

Rudolph's generation of architects was drawn to a new type and style of history writing, one that aimed to help architects find historical models to guide them during the design process. As mentioned, Wittkower's *Architectural Principles in the Age of Humanism* (1949) was a must-read for Rudolph's generation of architects because it was written with a practicing architect in mind. The book ignited lively debate over what, if any, lessons could be found in the book for designers.[29] Reassessing the moment a decade later, Alison and Peter Smithson stated that interest in Palladian buildings ignited by Wittkower's book gave young architects who began their careers in the immediate aftermath of the war "something to believe in . . . something that stood above what they were doing themselves."[30] Wittkower had no patience for the genius cult that fueled much of early twentieth-century art and architecture and went so far as to insist that the study of great buildings of the past was a prerequisite for architectural quality. Rudolph cites him in "The Six Determinants of Architectural Form" (1956), saying: "When architects depend on their sensibility and imagination architecture has always gone downhill."[31] Already in "The Changing Philosophy of Architecture" (1954), he had argued, "One does not understand why the sensitive, traditional architect who 'goes modern'—to use that detestable and revealing phrase—usually forgets all principles of architecture, which indeed do not change."[32] Architectural historian Alina Payne has noted that while Giedion, Hitchcock, and Wittkower all helped legitimize mod-

ern architecture by "embedding it in history,"[33] Wittkower had the most direct impact on how architecture was designed and discussed during the 1950s due to his emphasis on proportional systems and geometric schemes, which gave architects direct compositional guidance—despite the fact that, unlike Hitchcock's and Giedion's, his book lacked any overt references to twentieth-century architecture.[34]

The impact of history on individual creativity also took center stage in André Malraux's *Les voix du silence* (1951), a landmark book of the era, which was published in English in 1953 as *The Voices of Silence* to much critical acclaim. Malraux's quest was to build on Nietzsche's idea that the ultimate challenge for an individual is to avoid being burdened by the past, using history as a fuel to propel positive future outcomes instead. Echoing Henri Focillon's idea that forms of art have their own volition, Malraux talked about "the persisting life of certain forms, emerging ever and again like specters from the past."[35] As noted earlier, the analogy Focillon drew between art and biological processes guarantees that past forms continue to evolve and gain new meanings in each new context. A special issue of *Yale French Studies* in 1957 is indicative of the impact Malraux's book had on fostering Focillon's legacy of liberating art from history and, in so doing, turning forms into a generative force. However, somewhere along the way the humanist underpinnings had gotten lost; in his essay entitled "The Taming of History," Yale English professor Geoffrey Hartman reframes Malraux's thesis as follows:

> The artist must come to terms with an infinite variety of artifacts, each simultaneously symbol and broken sign of man's creative powers. And the artist has, in the last hundred years, begun to counter the stony magic of history. He has accepted a "museum without walls" and striven to resuscitate in his art the creativity latent in the whole world's past. Deprived of most cultural aides to order, the artist has assumed complete autonomy. He has made the locus of the work of art not a specific culture, or a habit like psychology, but the realm of art itself, independent of both world and abstract beauty, formed and transformed by each work of genius entering in.[36]

Malraux's book makes a case that increased access to photographic reproductions had turned the past into a vast archive and that it was now up to artists, historians, critics, and curators to make it their own. What Hartman referred to as the "master-menace" of history is captured in the famous 1953 photograph published in *Paris Match:* it depicts Malraux at home amid hundreds of photographic reproductions of historical artworks spread across the floor in seemingly random order as he chose images for his book, *Le Musée imaginaire* (*The Imaginary Museum*). The image also hints at a solution: every artist, curator, and art historian should curate and represent history in new ways by choosing, combining, and categorizing

Fig. 86 Page from Paul Rudolph's article "The Six Determinants of Architectural Form," *Architectural Record* 120, no. 4 (October 1956): 185, showing the campanile of Siena, the Hagia Sophia in Istanbul, Mont Saint-Michel in France, and a roof detail of the buildings on Mies's Illinois Institute of Technology campus (top half of the page), and Palladio's San Giorgio Maggiore in Venice, a Japanese temple, the supporting columns of Le Corbusier's Unité d'Habitation, Frank Lloyd Wright's Taliesin West, and medieval fortifications.

images according to his or her own criteria. Access to reproductions facilitates the process.

Rudolph's photographic essay "The Six Determinants of Architectural Form" suggests a similar approach, as it capitalizes on the power of using photographs to access and process historical material. The graphic layout echoes Malraux's process of forging affinities between art objects from different periods and geographic locations based solely on predetermined architectural and aesthetic criteria. For example, one of the spreads draws affinities between a Japanese temple, the campanile of Siena, Hagia Sophia in Istanbul, Mont Saint-Michel in France, and a roof detail of one of the buildings on Mies's Illinois Institute of Technology campus in Chicago to demonstrate how buildings met the sky in various situations (fig. 86). The captions indicate an emphasis on the transhistorical formal and emotive qualities of architecture: "the sense of quiet repose"; "the corners are important"; "the role of various buildings is clear, primarily because of the relationship to the sky."[37] The accompanying text makes a case for studying historical precedents by citing the Polish American architect and urban planner Matthew Nowicki, best known for his structurally expressive buildings: "We cannot keep on pretending that we solve our problems without precedent in form."[38] A quotation from British architecture critic J. M.

Richards's 1953 article "In Defense of the Cliché" went even further by suggesting that the closer modern architects stuck to preexisting models, the better: "At this moment architecture so sorely needs its plagiarists that the value of not being a genius needs stating afresh."[39] Rudolph continued to echo Richards when he summarized the benefit of historical models for the design process as follows: "Clichés, in their proper role, are not merely a means of appearing up-to-date, but a means of insuring a civilized standard of design—even in the absence of genius—by providing the architect with a range of well-tried, culturally vital forms and motifs to convert the passive act of plagiarism into the creative act of building up and systematically enriching architectural language appropriate to our times."[40] Rudolph's attitude toward historical change is evident in this statement. While he strongly dismissed the idea that each new period should invent new architecture, he still believed that the march of history should go on, albeit in an incremental, nonlinear manner. This meant that even a "passive act of plagiarism" should be converted to an "architectural language appropriate to our times." The use of "vital forms and motifs" was thus paramount to his vision.[41] Historical precedents should never simply be copied but studied with a particular aesthetic effect and emotive impact in mind.

**ANNEXING THE PAST INTO LIFE**

The autodidact architectural historian Sibyl Moholy-Nagy shared Rudolph's distaste for modern urban planning, love for historical cities, and acerbic style of criticism. She too lamented the "boredom of the skyscraper box"[42] and, much like Rudolph, did not mince her words when exclaiming that "the technocratic illusion that a man-made environment can ever be the image of a permanent scientific order is blind to the historical evidence that cities are governed by tacit agreement on multiplicity, contradiction, tenacious tradition, reckless progress, and limitless tolerance for individual values."[43] Like Rudolph, she was an iconoclast at heart and saved some of her harshest words for Mies van der Rohe, who had gained demigod status among young architects. Her European background gave her words extra authority.

Moholy-Nagy's message was unambiguous and aligned with Rudolph's: most mid-century American architecture had failed to address even the most basic human psychophysical needs. She coined the term "matrix of space" to emphasize that individual and collective human actions and experiences, rather than walls, create space. The concept was built on Plato's dictum "Space is the logical condition for the existence of bodies," which Moholy-Nagy repeated in capital letters in her essay "Environment and Anonymous Architecture" (1955).[44] Her rebuke of modern architects' inability to create livable environments led her to turn the "anonymous architecture" into the "counter-image" of modern architecture.[45] Connection to the larger man-made and natural environment as well as concern

for human psychological needs are paramount. After tracing the origins of architecture to the "primordial" times, when our hunter-gatherer ancestors sought shelter in caves, she states: "The history of man as a seeker of shelter is the history of his relationship to the environment."[46] She was deeply influenced by Malraux's 1950 book *La monnaie de l'absolu* (*The Twilight of the Absolute*)—a riff on Nietzsche's *Twilight of the Idols*—which posits that neither art nor life is headed toward some ultimate teleological goal and uses it to back up her argument that modern architects should begin learning from sound traditions. The creative process, she quotes Malraux, is "that never ending process of transmutation, running parallel to history."[47] Moholy-Nagy concludes her article by stating: "The purpose of living is strictly non-progressive. It has not changed since the day the first settler staked out a piece of land and constructed a permanent shelter that was to meet his needs, including his need for identity with the group without which the average man does not want to live."[48] She ends it with a transcendentalist credo: "Settl[ing] on the surface of the earth is a testimony to infinity expressed through the temporal."[49] The idea that a finite experience of inhabiting a particular place and time could make one aware of a larger, infinite existence and reality echoed Ralph Waldo Emerson's notion of the temporal sublime.[50] Her landmark book *Native Genius in Anonymous Architecture* (1957) was based on the same premise that the built environment should enhance continuity between past, present, and future. "Buildings are transmitters of life. They transmit the life of the past into the lives of the future—if they are more than mere shelter and more than borrowed form," she wrote.[51] Being "more than mere shelter" means that a structure does not serve mere material but also spiritual needs. There was no ambiguity in Sibyl Moholy-Nagy's mind that modern architecture had failed in this regard.

Her subsequent *Perspecta* article, "The Future of the Past" (1961), strikes a more hopeful tone; she observes a new interest in architectural history among the second generation of modern architects, which included Kahn, Rudolph, and Saarinen, who had, in her mind, "in some gratifying instances discovered a harmonic triad of contemporaneousness, projection into the future, and responsibility towards the past, that expresses not feelings of superiority but an appealing cultural pride."[52] She sums up their contribution as follows: "Saarinen's Romanesque inspiration, Johnson's classicism, Rudolph's American community consciousness, and Kahn's magisterial magic—all of it points to a reevaluation of architectural tradition for the sake of the future." She compliments their ability to absorb historical knowledge into their designs but ends with a wary note that while "the reevaluation of the past might indicate a genuine revolution—it might also indicate no more than a fad for want of better copy."[53] In an effort to avoid the latter scenario, she reminds her readers that the ultimate measure of good architecture is its ability to meet human psychophysical needs. It follows that since the human brain has evolved over a prolonged period

of time, people tend to respond positively to familiar formal tropes and spatial patterns.

## THE CITY AS A HISTORICAL PALIMPSEST

As has been noted, Moholy-Nagy shared Rudolph's distaste for modern urban planning and subsequently coined the term "architectural urbanity" to propose a more integrated approach to designing cities. The title of her 1968 book, *Matrix of Man: An Illustrated History of Urban Environment,* captures her desire to envision a complex, spatial interplay of buildings, streets, parks, and squares that together create a livable totality that she deemed lacking in most contemporary cities. Two years later she published *The Architecture of Paul Rudolph*—the first monographic study on the architect—in which she embraced Rudolph's New Haven projects for their sensitivity to the urban context.

Her positive assessment is intriguing if we consider that when Rudolph arrived in New Haven in the late 1950s, the city was a center of so-called urban renewal, which was championed by the city's newly elected mayor, Richard C. Lee. This involved the erasure of large swaths of the city's historic urban fabric that had been deemed a socially undesirable and anachronistic hindrance for a new era of car-orientated urbanization. A publicity shot depicts Mayor Lee at the helm of a bulldozer gleefully leveling the downtown for new construction just south of Yale's central campus (fig. 87).[54] An aerial view depicts the outcome: blocks and blocks of empty land with a few new freestanding buildings (fig. 88). Two urban realities thus existed side by side: Yale's Gothic campus consisting of perimeter block buildings, narrow streets, and cozy courtyards, and a city dominated by

**Fig. 87** Mayor Richard C. Lee on a bulldozer in downtown New Haven, ca. 1960.

Fig. 88 Photograph of New Haven showing the Oak Street connector with parking lots in the front and Yale University in the background, ca. 1959. Photo: Charles B. Dunn.

highways, parking garages, malls, and other freestanding, late-modernist buildings built in the name of progress. Rudolph had a habit of bringing up Rogers's campus architecture to students and, while he never publicly criticized Lee's urban renewal efforts, he surely viewed the results of Lee's actions as one of the most potent misadventures of American urbanism to that date.[55]

Considering Rudolph's preference for traditional urbanism over such misadventures of modern urban planning, it comes as a surprise that he became one of Lee's most trusted architects. His first commission from the city of New Haven was a 760-foot parking structure called the Temple Street Garage along Route 34 (1958–63), which connected the city's downtown to the new highway network (fig. 89). The building was a cornerstone of Lee's bold, car-centered urban vision, whose goal was to offer commuting suburbanites easy access in and out of the city to work and shop. Rudolph's biographer Timothy Rohan notes how the garage's "powerful, elongated concrete arches [give] it an ancient and rhythmic quality that observers likened to Roman structures," as if to make the new and old infrastructures resonate with one another.[56] Indeed, while both the garage's purpose and location suggested that it was primarily an appendix to the highway network, Rudolph managed to nestle the giant, two-block-long edifice amid the few remnants of the city's historical fabric by including an arcade with shop fronts on the street level (fig. 90). Moholy-Nagy called the parking garage "an anonymous background structure, a new version of the urban ligament—the street," and valued how "the orthogonal grid of the historical city plan has been maintained by running an existing street through the garage, producing still another version of the building as

Past and Future

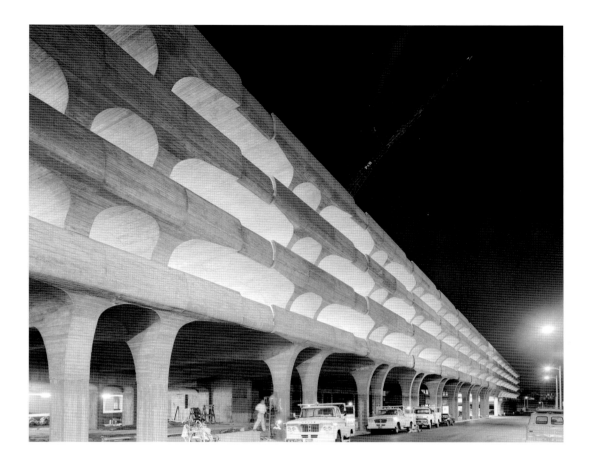

Fig. 89 Paul Rudolph, Temple Street Garage, New Haven, 1958–63. Photo: © Ezra Stoller/Esto.

gateway." Calling the building "a bridge from old to new," Moholy-Nagy praised how "the emphatic bid for duration in time is Rudolph's refutation of the artificial-obsolescence theory held by the planners of disposable cities." She also took note of Rudolph's ability to modulate speed, writing: "On both the pedestrian and the motor rate of movement, the long vistas and light-contrasted turns combine the continuity of a multilevel road system with a dynamic space experience." She even admired the "timeless solidity" of the protruding "concrete shelves."[57] Overall, the building was a testament to Rudolph's idea that cities should embrace different scales, speeds, and historical layers.

Rudolph also received several commissions from Yale's president, Whitney Griswold, whose approach to modernizing the university and its facilities was tempered by his respect for the university's neo-Gothic campus and the traditions it evoked.[58] As already noted, Griswold generally chose to locate new buildings along the perimeter of the existing campus, and most of them, except for Saarinen's hockey rink, were conceived as part of an integrated urban ensemble based on the principles set in place by James Gamble Rogers's campus plan in the late 1910s. Furthermore, masonry and concrete were favored over glass. Rudolph's Art and Architecture Building at Yale (1958–63; fig. 91), located at the southwestern corner of the central

Fig. 90 Paul Rudolph, Temple Street Garage, New Haven, 1958–63.

Fig. 91 Paul Rudolph, Art and Architecture Building, Yale University, 1958–63. Photo: © Wayne Andrews/Esto.

campus next to the Yale University Art Gallery, exemplified Griswold's vision in many regards. Its design put into practice Rudolph's dictums, outlined in "The Six Determinants of Architectural Form," that architecture should "be related to its neighbors in terms of scale, proportions, and the space created between the buildings," and that each new building should

162    Past and Future

Fig. 92 Paul Rudolph, Art and Architecture Building, Yale University, site plan, 1961. Reproduced in Paul Rudolph, *The Architecture of Paul Rudolph* (New York: Praeger, 1970), 121.

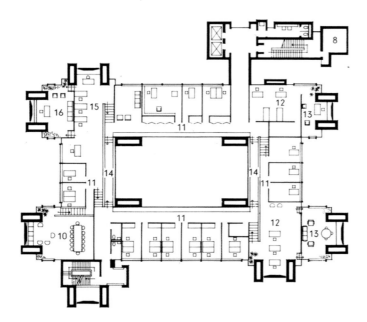

Fig. 93 Paul Rudolph, Art and Architecture Building, Yale University, third-floor plan, 1961. Reproduced in Paul Rudolph, *The Architecture of Paul Rudolph* (New York: Praeger, 1970), 127.

be conceived as part of a "city scheme" rather than as an isolated object.[59] When viewed along Chapel Street, the highest part of the building acts as an urban marker at the corner of York Street (fig. 92). Rudolph adjusted the pinwheeling layout to the existing streets and housed the main public functions —the auditorium, gallery, and review "pits"—in the middle (fig. 93). The gallery on the second floor is reminiscent of the central hall of Frank Lloyd Wright's Larkin Building in Buffalo, New York (1906), which had been demolished in 1950, much to the chagrin of the architectural community. Rudolph destabilized the static centralized plan and the absolutism it represented by introducing level changes—some thirty in all—into the pinwheel plan, which charges the building with multiple speeds. The coexistence of

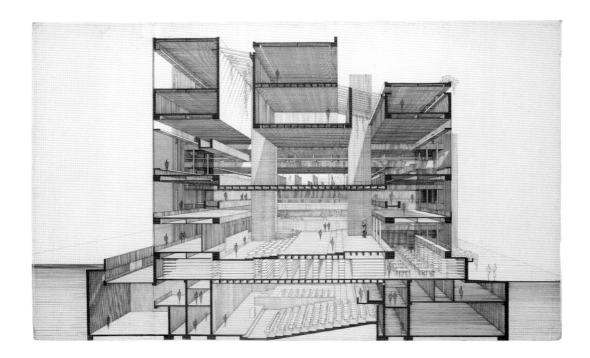

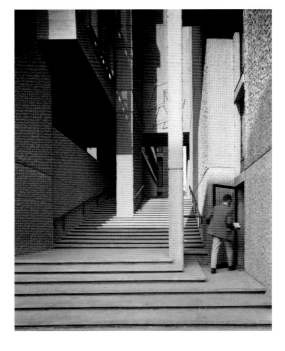

Fig. 94 Paul Rudolph, Art and Architecture Building, Yale University, section, 1958.

Fig. 95 Paul Rudolph, Art and Architecture Building, Yale University, 1958–63, entrance with Josef Albers's sculpture in the background. Photo: © Ezra Stoller/Esto.

two spatial concepts—the open plan combined with room-like enclosures—adds to this temporal complexity. The former embraces movement and interconnectivity, while the latter spaces are conducive to sedentary activity and concentration.

Rudolph's hand-drawn section perspective captures the complex interiority (fig. 94). The labyrinthine spatial effect recalls the famous Carceri prison series by Piranesi, whose etchings Rudolph collected. Following Piranesi's lead, Rudolph charged his building with the power to expand human experience beyond the real into the imaginary, which meant that instead of providing continuity with the surrounding reality, the building offers a fortress-like parallel reality. Moving up the gradually narrowing exterior stair between two high concrete walls, one feels like entering into an "irreality opened up inside the world" (fig. 95).[60] *Alice's Adventures in Wonderland,* where the endless rabbit holes provide alternate temporal and spatial realities, comes to mind; very much like Lewis Carroll, Rudolph saw "problems of temporality as fundamental" to the creation of "possible worlds."[61] In similar fashion, Rudolph sees bodies' relationships to space as unstable and approximate. For example, visitors are never fully cut off from their surroundings while inside the building, but are invited to observe city life from extreme angles and throughout the building—in one case, spying seven floors down at those entering the building. At several loci Rudolph re-presents the city that has been left behind by providing vistas through interconnected interior spaces, juxtaposing layers of simultaneous activity both inside and outside along the way.

The plaster casts of ancient artifacts placed throughout the interior add yet another temporal stratum to the building. They had originally been displayed at the art gallery, until Josef Albers required them to be stored in the basement after his arrival in 1950. Among the moved objects was the statue of Minerva, which gained a prominent position in the central fourth-floor studio (figs. 96, 97). Rudolph found some of them in their original shipping containers—time capsules from an era when plaster casts were coveted possessions for private and public collections as well as art schools around the world. Yet, after giving them a new life, he made sure that the casts operated differently in the nonmuseum setting by dispersing them throughout the building in unpredictable places—above doorways and in hallways, even in bathrooms—in a manner that ignored standard display practices of labels, taxonomies, and chronologies of any kind. Casts from various periods and places were often placed side by side: a Louis Sullivan frieze from the Chicago Stock Exchange was located next to the Parthenon metopes on the third floor next to the dean's office (fig. 98). Rudolph made sure that the encounters were surprising; walking up the main stairwell, over the span of a few floors one can still encounter a relief of the Assyrian King Ashurbanipal II and get an oblique view of a Gothic saint. A few seashells are embedded into the concrete walls to remind students that their historical imaginations should not stop with antiquity, but rather extend

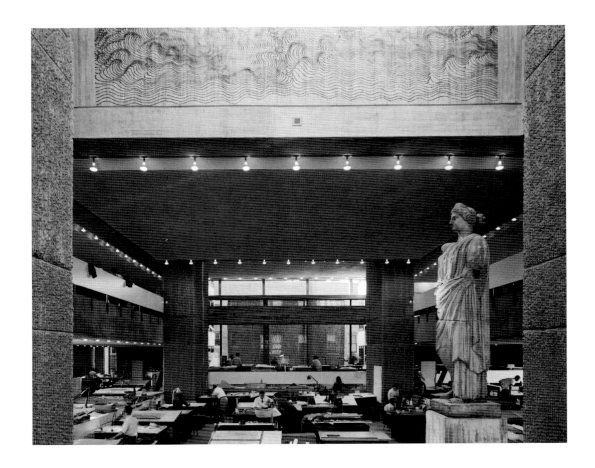

Fig. 96 Paul Rudolph, Art and Architecture Building, Yale University, 1958–63, fourth-floor architecture studios with the statue of Minerva. Photo: © Ezra Stoller/Esto.

Fig. 97 Statue of Minerva being moved from the Yale University Art Gallery to the Art and Architecture Building in 1963.

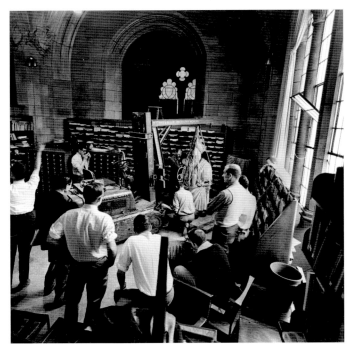

Fig. 98 Paul Rudolph, Art and Architecture Building, Yale University, 1958–63, with plaster casts on the third floor: Louis Sullivan's ornamental relief is on the left, and Pantheon metopes are on the right. Photo: © Ezra Stoller/Esto.

all the way back to the beginning of evolution. In Mari Lending's words: "Rudolph's mounting was polychronic, not chronological."[62]

Rudolph's goal was to make history part of everyday activity through such multi-temporal chance encounters. One can indeed interpret the building as an attempt to re-create the richness of temporal modalities Rudolph had discovered in Rome, where history is an integral part of the everyday environment and in constant conversation with the new. This layered approach to history led Sibyl Moholy-Nagy, in a 1964 *Architectural Forum* review, to laud the Art and Architecture Building as a "splendid achievement, crystallizing potential solutions for some of the most vexing propositions facing architecture today."[63] She compares Rudolph's eclectic approach favorably to "Kahn's medievalism, Philip Johnson's Cinquecento, and the Moorish Dixieland charm of [Edward Durrell] Stone," then compliments Rudolph's ability to integrate various historical sources of inspiration for his design from Wright, Bernini, and Piranesi, and for turning the building into a tool for "learning-in-motion . . . as old as Aristotle's peripatetic method."[64] Even "his favorite proportion unit of 40 inches" turns out to be a "standard shared with the great masters of the past."[65] Making the case that the Art and Architecture Building was an open love letter to history, she concludes her assessment of Rudolph's ability to find his own voice as follows: "Historical continuity had never bothered his teachers, but Rudolph accepted it as an architectural responsibility."[66]

CHAPTER 8

# Vincent Scully
*The Historian's Revenge*

Known for his animated—and animating—lecture style, architectural historian Vincent Scully spent his career finding traces of the past in modern architecture. After gaining both his bachelor's degree (1940) and PhD (1949) from Yale, he was retained as a faculty member of the newly founded Department of the History of Art, whose legacy of art historical formalism aligned with him intellectually—even though he never took a course with its founding father, the formidable Henri Focillon, as a student. Scully summarized his intellectual affinity at the end of his life, saying: "Iconologists of the period tended to trace forms to their original appearances, but for Focillon it all swept forward, and meaning changed as society changed, so the forms were alive, living their own life and creating a history of their own, sometimes shaping families across time. Anything was possible. I suppose I've been trying to be a *Focilloniste* all my life."[1] He criticized those obsessed with "find[ing] a written record," on the grounds that "they are reductionists who insist upon finding a single meaning that diminishes the multiplicity."[2]

Scully's remarkable rhetorical skills made his lectures into blockbuster events that often culminated in a standing ovation. One of his most popular lecture courses was "History of Art 112a," which covered material from prehistory to the present by forging visual connections among structures across time and space based on formal and symbolic likenesses. In his treatment, the tetrahedral ceiling slab of Louis Kahn and Douglas Orr's Yale University Art Gallery building resonated with an Aztec temple simply because of their shared triangular formal trope and what he perceived to be their shared symbolic meaning: the search for unity among the earthly, human, and divine realms. Scully's lecturing style was highly theatrical and choreographed; he used a long wooden pointer stick to guide the audience's eyes as he intermittently shouted orders to his teaching assistants, who operated two projectors for 35mm slides and two projectors for large-format lantern slides in tandem (figs. 99, 100). Following Focillon's lead, Scully favored poetic license over positivist factuality when evoking the past. In his buoyant manner, he claimed: "Everything in the past is always waiting, waiting to detonate."[3]

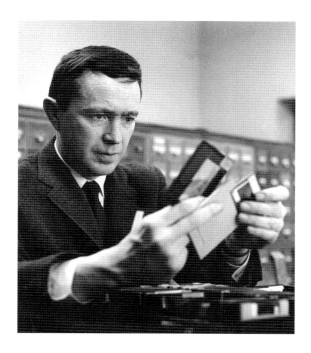

While such freewheeling visual associations might seem both unconvincing and unscholarly from a contemporary perspective, they were based on by-then well-rehearsed formalist art historical schemata: since the essence of architecture operated outside linear historical time, the original intentions and meanings behind the artworks at the time of their creation were irrelevant; each era had a license to discover history on its own terms. Increased access to photographic reproductions gave Scully and his devotees a tool to reduce history into a visual archive, which could be analyzed according to chosen criteria. The latter group included members of a new generation of American architects, who began to source historical motifs into their own work. Among them was Philip Johnson, who in 1959 gleefully declared: "Hurrah for history. Thank God for Hadrian, for Bernini, for Le Corbusier and for Vince Scully."[4] This essay takes a closer look at the intellectual roots of Scully's brand of art historical formalism, which invests both the historian and the architects he admired with a new sense of historical agency.

Fig. 99  Vincent Scully selecting images in the slide room at Street Hall, Yale University, 1950s.

Fig. 100  Vincent Scully lecturing at the Sterling Law School Auditorium, Yale University, ca. 1955.

## REENACTMENTS AND RECURRENCES

In the spring of 1953, Scully remained uncharacteristically quiet during the roundtable discussion "On the Responsibility of the Architect" at the Department of Architecture. Only after Paul Weiss began to muse about architecture being a medium of time did Scully speak up: "It's a question of time, of our relationship to these things in time."[5] The comment reflected Scully's methodological conviction that past architectures should be assessed through the feelings and associations they trigger in the mind of

the viewer, rather than by their original meanings and contextual historical evidence. While his position was firmly grounded in Focillon's art historical formalism, it was equally informed by his growing interest in psychoanalytic theory, which gained traction in the 1950s as an alternative to the traditional historical scholarship that had proven inadequate in addressing the trauma caused by the two world wars. Understandably, providing information about historical events would not console the victims of those wars, as the focus shifted to analyzing the impact those events had on current lives. As already mentioned, Freudian psychoanalysis gave twentieth-century historians license to write history from the perspective and for the benefit of the present and future. At mid-century, the focus increasingly shifted toward the individual's experience of the past as a crucial part of the healing process. In his 1986 essay "Psychoanalysis and Time," the noted American psychoanalyst Jacob A. Arlow underlines the temporal dimension of his craft: "Psychoanalysis is fundamentally related to time because it is an effort to understand how disturbances in the present are determined by events in the past." He sums up his thesis by stating that "more than any other discipline [psychoanalysis] sheds light on the coexistence of past, present, and future, as influenced by unconscious fantasy thinking. . . . Basically, the self is a time-bound concept."[6]

Scully found his voice in the late 1950s and early 1960s, around the same time that psychoanalysis reached its apogee in American culture. Carl Jung was particularly popular among the country's educated elite in the decades following World War II, largely due to the efforts of the Bollingen Foundation, which had been established in 1945 by the prominent Yale alumnus and donor Paul Mellon and his first wife, Mary Conover Mellon, with the mission of publishing the Swiss analyst's complete works in English.[7] The two subsequently hired the influential British art historian Herbert Read to edit the series. Engaging an art historian was not an accident: the creation and experience of art occupied a central role in Jung's writings. The idea that art contains traces, not only from the individual's past, but also from a distant collective past, had a profound impact on Read's philosophy of art after he began to attend Jung's annual conference, Eranos Tagung, in 1946. According to the late British art historian Andrew Causey, exposure to Jung led Read to consider art as an essential component of human evolution and to emphasize its "enduring cross-cultural and trans-historical properties."[8] He also inherited Jung's idea that the patterns of thinking that go into making art have persisted across ages, meaning an individual artistic act has its roots in transhistorical humanity.

It is hard to overestimate Read's role in steering discussions about the social role of art and architecture during the 1940s and 1950s through his numerous publications and through the Institute of Contemporary Arts (ICA) he helped found in 1946. His interest in prehistoric art culminated in the provocatively titled exhibition *Forty Thousand Years of Modern Art: A Comparison of Primitive and Modern,* which took place at the ICA

between December 1948 and January 1949. Read's inaugural lecture highlighted the "universality of art" and the "eternal recurrence of certain phenomena in art" as he proposed that modern and prehistoric artists shared the same existential "conditions." He continued to define the term "modern" psychoanalytical terms as follows:

> Modern, in this sense, is not a comparative term—we are not contrasting the modern with the ancient, present with past, or individual talent with tradition. Rather we are suggesting that like conditions produce like effects, and, more specifically, that there are conditions in modern life which have produced effects only to be seen in primitive epochs. To define these conditions would be a vain exercise of dogmatism, for they are archetypal, and buried deep in the unconscious. But generally they can be described as a vague sense of insecurity, a cosmic anxiety (*Angst,* as the Existentialists call it), feelings and intuitions that demand expression in abstract or unnaturalistic forms.[9]

It followed that "the mammoth ivory Venus from the caves of the Dordogne" appeared in the words of Read to be "the most modern in conception."[10] Giedion delivered his first talk on prehistoric art toward the end of the exhibition's run along the same lines. The lecture was titled "Art[,] a Fundamental Experience" and used prehistoric art as a model for restoring form and space to its original symbolic function of communicating complex human feelings and emotions.

Added to the list of thinkers linking artistic production to perennial existential questions was Susanne Langer, who in her 1942 book *Philosophy in a New Key* saw art and religion as keys to the irreducible human condition and granted epistemological validity to the feelings from which both sprung.[11] While Scully never cited Jung, Read, or Langer in his writings, he clearly shared their conviction that art's primary function was to mediate the relationship between an individual and the world at large. He might have even attended their lectures at Yale. He was an undergraduate when Jung delivered the Terry Lectures in 1937, during which the eminent Swiss psychoanalyst presented the idea that the unconscious operates like a volcano waiting to release traces of hidden mental processes through art. While a graduate student in 1946, Scully might have witnessed Read delivering four consecutive lectures under the title "Social Aspects of Art in an Industrial Age,"[12] which emphasized the importance of intuitive artistic processes as a means of overcoming an overtly material and rational modern worldview. As a junior faculty member in 1954, he might have heard Langer deliver a lecture titled "Art Symbol and Symbolism in Art," which advocated art's ability to communicate complex ideas and emotions rather than mere meaning.[13] Subsequently, Scully developed his own highly idiosyncratic brand of art historical scholarship, with the goal of helping

mankind overcome contemporary ills by reverting modern art and architecture back to this original function of reconnecting humans to life's transcendent purpose.

Exposure to Jung's theories is evident in Scully's 1954 essay "Archetype and Order in Recent American Architecture" in *Art in America*. Its title sums up his thesis: architecture has evolved through millennia and stems from primeval human instincts, such as fear and longing, and original human spatial imagination, which, combined, have produced a series of reoccurring metaphors and archetypes in their wake. Their reappearance in "recent American architecture" proved that a new generation of architects, such as Johnson, Kahn, Rudolph, and Saarinen, had the license to engage history on their own terms. Scully commented on how the latter two "felt 'the uses of history' to be both the liberating and the solidifying factor in [their] growth. Imbued with the sense of pure form and precise control which the work of Mies possesses, these architects felt in a sense liberated from the clichés of the 'modern movement,' from the psychological blocks concerning the 'past' which had been one of the Bauhaus legacies, and, consequently, from the expedients of fashionable change." Scully continued to disparage "the anti-historical attitude of the thirties [that] has thus given way to a more civilized awareness of the unity of all architecture, as of all human experience. Like Wright and Le Corbusier, and unlike the Bauhaus group, the present generation is prepared to learn from the architecture of all periods and places."[14] While his Bauhaus caricature is somewhat surprising considering he must have been well aware of the interest of his colleagues Josef and Anni Albers in Mesoamerican art and architecture, it was symptomatic of the wider vilification of European, particularly German, early modernism during the decades following World War II—which in Scully's case went hand in hand with an effort to promote the new generation of American architects, among them Johnson, Kahn, Rudolph, and Saarinen, who in his mind were "liberated" from the "psychological blocks" pertaining to historical memory.

Scully's words echoed the basic tenet of psychoanalytical theory established by Freud at the beginning of the twentieth century: since repression of the past signified pathology, history writing could help expose and eventually overcome this pathological state. His 1954 article revealed the most salient feature of this psychoanalytical turn: writing history in reverse and working like an analyst, treating traces of the past in present architecture both as a symptom and as a cure. In the words of contemporary literary scholar Jason B. Jones, psychoanalysis "is fundamentally a theory of temporality and history," albeit one that rejects standard historical inquiry that focuses on "common experiences of the past," in favor of one that allows "future events [to] control the meaning of the ones in the past." As Jones succinctly puts it: "Within psychoanalysis, effects frequently determine their course, rather than the other way around." Many consider the method fundamentally ahistorical, even hostile to history for that reason.[15]

Jungian themes and methodology also help explain the most anachronistic feature of Scully's historical scholarship: his obsession with the figure of the individual heroic male architect, whose creative process is fueled by a subliminal search for identity, culminating in the ability to act on history rather than allowing history to act on him. In this construction, the creation of an architectural object was dependent upon the individual's ability to reenact and reinterpret a set of inherited spatial conceptions, again and again. In his 1954 article, Scully grants the honor of first architect to Emperor Hadrian, who in the Piazza d'Oro, at his villa in Tivoli, made the recurrence of historical "archetypes" visible: an open, rectangular portico or pavilion and a closed, rounded cave. Scully celebrates how the architect "evoked Greek, Etruscan, and Roman archetypes in the service of his own longing. One may feel that basic archetypes of human experiences of the world are here as well, created by the metaphors of architecture. That is: the defined plain of the courtyard, the forest of the colonnade, the cave of the dome, the light that bursts through the cave, and the sound of water." Scully detected their recurrence in Philip Johnson's recent Wiley House in New Canaan, Connecticut (1953), which was treated as proof that "it is the primary characteristic of the architects of the present movement that they appear to express, with a similar sense of memory and of the uses of metaphor, the same clear archetypes of plain, pavilion and cave" (fig. 101).[16] Only those architects whose work featured such archetypical forms and spatial motifs made his list of noteworthy contemporary architects. However, copying forms was never enough; only those who were able to fully internalize the perennial existential battle that gave birth to them counted as truly great.

A full-page photograph of the lobby of the recently completed annex to the Yale University Art Gallery by Kahn and Orr opens the *Art in America*

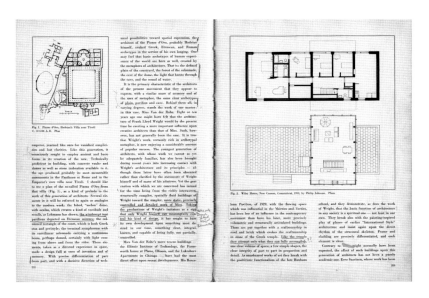

**Fig. 101** Piazza d'Oro, Hadrian's Villa (left), and Philip Johnson's Wiley House, New Canaan, Connecticut, 1953 (right). Reproduced in Vincent Scully, "Archetype and Order in Recent American Architecture," *Art in America* (December 1954): 252–53.

Vincent Scully 173

article (fig. 102). The image features a dark space tucked below the ground, with a glimpse of sky above the garden patio in the background, which make palpable the primal elements of life—earth and sky, darkness and light. Thinking of the recent discovery of the Lascaux cave, Scully proposed that the architect had reenacted the same archetypical psychological needs and spatial impulses that had given birth to a set of spatial archetypes ages before: hence the evocation of dark, cave-like space and the outside world.[17] Kahn's tetrahedral ceiling thus represented the most recent evolution of the space-spanning architectural elements that began with the cave. The idea that his design "reveals the yearning of a complex age for direct and simple experience, deeply felt and presented as general truth, without rhetoric" captures the main premise of architecture's psychoanalytical turn: architecture's task is to translate our perennial existential anxieties into direct experience.[18] In this schema, a noteworthy architect is equipped with an innate formal and spatial imagination, which allows him to draw from a series of *ur*-forms and spatial tropes stored in the collective unconscious through a process of subliminal recall. For Scully, architecture resonated with big, existential questions and, since continuity between the past, present, and future is the defining aspect of human experience, an ability to spatialize the experience of time is a key characteristic of all great architects.

Scully believed that Frank Lloyd Wright was the most quintessential architect in this regard, one who was able to sublimate his own emotions and urges into spatial archetypes like caves. In his words: "Wright is driven by his compulsion toward movement. Only the complete continuities of the circle can answer his need, and his poetic imagery remains close to the great nineteenth-century symbols of the road, the sea, and the river. The human observer is pulled inexorably into a current. This sweeps him under water into a cave which opens up into a pool. He is compelled to undergo the rite, as of immersion and purification."[19] Wright's creativity corresponded with what Jung called "individuation"—that is, a process whereby the self emerges out of the amorphous, cosmic subliminal unconscious to reach a state of individuated conscious activity. Scully capitalized on what Mikhail Bakhtin called "chronotopes," or spatio-temporal tropes of nineteenth-century literature such as the road, the sea, and the river, to show that Wright's architecture operated like a *Bildungsroman* and culminated in individual self-discovery and atonement. It is worth noting that Scully had studied literature as an undergraduate at Yale and had a habit of lacing his lectures and writings with references to great American novels such as *Moby-Dick* and *The Adventures of Tom Sawyer,* which are laden with liquid temporal metaphors.[20]

The idea that architects of all periods were governed by shared subliminal urges led Scully to redefine one of the key concepts of art historical inquiry—namely, style. He wrote: "Slogans, tags, and verbal formulas are useful, but in the end they cannot define modern architecture.... True definition, for any period, can only come when the nature and objectives of the

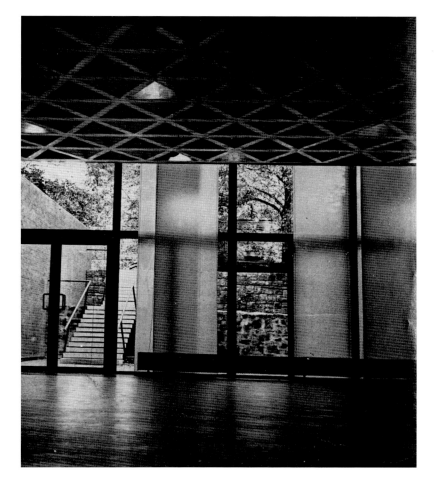

Fig. 102 Louis I. Kahn and Douglas Orr, annex to the Yale University Art Gallery, 1953, interior. Reproduced in Vincent Scully, "Archetype and Order in Recent American Architecture," *Art in America* (December 1954): 250.

self—with its present, its hopes, and its memory—are truly identified and humanly defined. Out of such definition arises that sense of identity which is style."[21] Style is an outcome of the battle for a "sense of identity" rather than a product of historical constraints. For example, although Hadrian's Piazza d'Oro and Johnson's Wiley House were built more than two millennia apart, they could be considered the same style because they express similar emotional states through timeless formal and spatial tropes. Tellingly, Scully capitalized on the psychoanalytical method and historicized modern architecture against a new temporal construct—the past—that was conceived as an amorphous totality rather than a linear sequence. Whereas historical knowledge can be accessed through documents and books, excavating the past involves a hermeneutic process that grants agency to the interpreter.

## OVERCOMING CHRONOPHOBIA

In his 1955 lecture titled "Four Kinds of Time in Contemporary Architecture," Scully proposed that "at the present there is a very vast attempt to mingle

the sense of intensity of the present with the openness of the past." The four kinds of time "related by Mr. Scully were those of recollection, the willed primitive, that of willed continuity, and that of action and memory."[22] His effort to invest modern architecture with a historical echo chamber culminated in the 1961 book *Modern Architecture,* which he concluded by writing:

> My own belief... the meaning of modern architecture can be properly understood only in the light of all the architecture ever conceived by man, and that it can hardly be written about without reference to one or another of those architectures. I do not suggest that Jung's concept of "collective unconscious" should be thought to apply here. It is true that when similar themes are handled, many unconscious parallels will appear. At the same time, the most creative architects since the late eighteenth century, with the whole past open to them, have consciously dealt with the problems of existence, and thus of expression, through their view of history and their consequent sense of personal mission as modern man. Indeed, the greatest of them, such as Wright and Le Corbusier, have been doubly conscious of the layer upon layer of meaning implicit in their sources of inspiration, and of the timeless implications of their large, few, and simple themes.[23]

Architecture's relationship with the past operates thus on two levels: through the study of historical precedents and through the engagement with perennial existential themes.

The human experience of time and history had come to dominate intellectual conversations by then. Martin Heidegger's *Sein und Zeit* (1927; published in English as *Being and Time* in 1962) and Hannah Arendt's *Between Past and Future* (1961) were some of the landmark books of the era. Heidegger insisted that one needs to go back to the origins to understand the meaning of various human endeavors, and he provided a method of exposing accumulated layers of meanings through close reading. Arendt, following in her former teacher's footsteps, suggested that humanity is a product of accumulated human actions. She captured the key tenet of her historical philosophy in her 1955 Yale lecture titled "Origins of History," positing that, unlike science, which could be studied as a distinct body of knowledge, the study of history is to be conceived of as a mode of collective self-reflection and inquiry into "the origins of things that owe their existence to man."[24] Gaston Bachelard's 1958 book *La poétique de l'espace* (*The Poetics of Space*) and Frances Yates's *The Art of Memory* (1966) were widely read among architects and consider how individual and "collective memory" —a term originally coined by Maurice Halbwachs in his 1925 book *The Social Frameworks of Memory*—determine how people relate to their environments. Siegfried Kracauer's *History: The Last Things before the Last* (1969) captures the dominant tenet of post–World War II historical

thought with a provocation we have already encountered almost verbatim through Sibyl Moholy-Nagy's 1961 article, namely, that the future is always "the future of the past—history."[25] Around the same time, from the 1950s onward, George Kubler and Clement Greenberg began to supplement the dominant art historiographical model that placed an emphasis on how art reflects historical change with the idea that art is a product of—and gains its meaning through—a system of accumulated images and objects, which get constantly reconfigured and reorganized in the hands of historians and curators. In this new art historical schema, an artist is defined by inherited patterns and modes of thinking rather than by the historical conditions in which the subject finds himself or herself.[26] Scully subscribed to the idea that architecture of all periods yields an extended visual archive and that the task of the historian is to help architects discover the perennial forms and themes that matter.

*Perspecta* 9/10 (1965) registers the interest in studying and analyzing past architectures in a manner that yields design tools by focusing on formal motifs and conceptual themes. The issue was edited by then-third-year architecture student Robert A. M. Stern and begins with an extract from Robert Venturi's forthcoming book, *Complexity and Contradiction in Architecture* (1966), which made it clear that the young, up-and-coming architect was more intent on defining his discursive stance through past objects than in solving present-day social or functional problems. At the same time, while intently ahistorical in his approach to form-giving, in the essay and subsequent book Venturi makes a historical argument by positing that the dominant "less is more" approach to architecture attributed to Mies van der Rohe and his followers does not appropriately reflect the "richness and ambiguity of modern experience."[27] A complex society calls for "complex and contradictory" architecture, albeit one "based on the need to consider the richness of experience within the limitations of the medium."[28] In light of this statement, architecture should embrace the pulse of lived experience, here and now, and relay historical motifs in tandem. In addition, referring to Yale English professor Cleanth Brooks, Venturi saw that the task of architecture was to make perennial psychological themes manifest through formal "ambiguity," "complexity," and "contradiction." It's worth noting that Venturi worked as Paul Rudolph's studio assistant while writing the book and had probably become interested in the New Criticism during his frequent visits to New Haven. All in all, the book attests that dates are deemed irrelevant, since the task of architecture is to mine transhistorical themes. One page of the book invites the reader to draw parallels among Granada Cathedral, Foligno Cathedral, John Vanbrugh's Eastbury Park in Dorset, England, Peabody and Stern's Black House in Manchester-by-the-Sea, Massachusetts, the Church of the Holy Sepulcher in Jerusalem, and Jasper John's *Three Flags* painting from 1958 (fig. 103).[29]

Predictably, the issue of *Perspecta* that features a sample chapter of Venturi's landmark book also includes essays by both Kubler and Scully,

**Fig. 103** Page from Robert Venturi, *Complexity and Contradiction in Architecture* (New York: Museum of Modern Art, 1966), 59, showing Granada Cathedral, Foligno Cathedral, John Vanbrugh's Eastbury Park in Dorset, England, Peabody and Stern's Black House in Manchester-by-the-Sea, Massachusetts, the Church of the Holy Sepulcher in Jerusalem, and Jasper Johns's painting *Three Flags*.

who had, by that time, played a major role in sparking students' interest in history. Scully begins his contribution, titled "Doldrums in the Suburbs," by crediting fellow art historian Rudolf Wittkower for inspiring a new generation of architects to be open to history after decades of self-initiated blindness with his 1949 book *Architectural Principles in the Age of Humanism*. He ramps up his explosive rhetoric against the historical amnesia of the previous generation by arguing that nothing less than the "expansion of our faculties of perception and comprehension" is at stake:

> *In the '40s our minds were small, our perceptions limited by iconoclastic dogma, our comprehension shriveled thereby. None of that is any good. Instead, we are obliged to open eyes and minds in all our fields. Chandigarh, Ronchamp, and the Greek temple came to us together, as did Rome, Tuscany, Mies, and Kahn. Beyond the individual building, the true scale of architecture, which is that of all structures in relation to each other and to the land, is opening now before us.*[30]

Following the thinking of his dissertation adviser, Henry-Russell Hitchcock, Scully had by that time become convinced that the art historian's role was to shape architectural discourse, and that only historical knowledge could rescue modern architecture from succumbing to economic and technocratic forces. Following the formalist-cum-psychoanalytical model, he believed that every relevant piece of architecture could be placed within

a historical chain of buildings with similar formal and spatial traits. "It is impossible to look at the [Richards Medical Research Laboratories by Kahn] without thinking of [Wright's] Larkin Building [or the Italian hill town] San Gimignano," he claimed.[31] Scully was preaching to the choir for whom affinity to the past had already become an accepted norm.

George Kubler went even further in his contribution "What Can Historians Do for Architects?" by arguing that architects needed art historians to rescue their discipline from the self-destruction caused by a combination of individualism and historical amnesia. He did not mince words when blaming the previous generation of architects; Walter Gropius was, he felt, the main culprit, for detaching architecture from history and thus from its disciplinarity. He begins the essay with a stark rebuke: "In this country the disastrous attempt for twenty years to banish all historical studies for architects clarified the question for nearly everyone more than a decade ago. There is now no question that historical studies of his craft are useful to the practitioner of any art." He continues by declaring that "the self-evident truth, as we now see it, is that all good architects have been saturated with the history of their profession: only the Puritans and the second-rate designers and the peripheral people ever can afford the self-mutilation of ignoring the history of architecture."[32] Through this constant re-reading of history, architects participated in crafting the "shape of time."[33] Historians' task was to impart an expanded historical vision and educate a new type of viewer-subject capable of navigating an archive of past works rather than re-create the original meaning of a work of art. Nothing less than expanding the perceptual faculties of practicing architects was at stake. He wrote: "By rejecting history, the purist denies the fullness of things when he restricts the traffic at the gates of perception. He denies the reality of duration, while the historian affirms it."[34]

## "THE HISTORIAN'S REVENGE"

While Kubler and Scully shared a conviction that art historians play an important role in deepening the temporal horizon of architects, there was a crucial difference in their approaches to the question of how past works impact the creative process of an individual artist. In Kubler's cybernetic model, an individual artist is bombarded with images to the point that his or her only role is simply to relay them further without being aware of their influence. In contrast, in Scully's psychoanalytical model, an individual artist is always fighting to maintain individuality and stake his or her historical role. Tellingly, Kubler's scholarship often focuses on anonymous Iberian and Mesoamerican art, while Scully's writings, even those including examples of vernacular or prehistoric architecture, are centered mostly on heroic male architects.

After reading Harold Bloom's 1973 book *The Anxiety of Influence: A Theory of Poetry,* Scully took on the perennial art historical question of artistic

**Fig. 104** Cover of Vincent Scully, *The Shingle Style Today: Or, The Historian's Revenge* (New York: George Braziller, 1974), Charles McKim's William G. Low House in Bristol, Rhode Island (1887), and Robert Venturi and Denise Scott Brown's Trubek and Wislocki houses in Nantucket Island, Massachusetts (1972).

influence. Bloom was a professor of English at Yale and a good friend, who, following a long legacy of literary formalism, insisted that art forms a self-referential aesthetic system and was adamantly against using art as a tool to address contemporary societal ills. The combination of the words "anxiety" and "influence" alludes to the psychoanalytic underpinnings of his thesis: being aware and under the influence of towering predecessors is an anxiety-inducing activity, and only the strongest of poets are up to the task. Bloom treated "poetic history" as "indistinguishable from poetic influence, since strong poets make that history by misreading one another, so as to clear imaginative space for themselves." In other words, the history of art is, in his mind, fueled by artistic influence rather than by external societal factors. Art, in other words, makes its own history. Bloom distinguished between "strong poets, major figures" who have the guts and the talent to "wrestle with their strong precursors, even to the death," and "weaker talents," who tend to "idealize" their predecessors.[35] Bloom's emphasis on the Western, primarily British, literary canon made him a lightning rod of the 1960s culture wars. Yet, he refused to budge, insisting that Shakespeare was never out of date.

Scully's 1974 book *The Shingle Style Today: Or, The Historian's Revenge* is based on Bloom's idea that only architects able to wrestle and "swerve" with influence are worth discussing. Scully felt that this ability to battle influence and come into one's own was a particularly American trait, and it thus comes as no surprise that he chose to discuss buildings that were all

located in New England, the home of Emersonian "self-reliance." The cover conveys the formal resemblance between Charles McKim's William G. Low House in Bristol, Rhode Island, and Robert Venturi and Denise Scott Brown's Trubek and Wislocki houses in Nantucket Island, Massachusetts, built, respectively, in 1887 and 1972 and marked by their shared wide, frontal roof gables (fig. 104). The title suggests that up-and-coming American architects such as Venturi continued to operate under the influence of turn-of-the-century architects who had produced large, ebullient houses covered in wood shingles from Rhode Island to Maine, which constituted what Scully had in his dissertation labeled the "shingle style." He returned to the Jungian idea that the architects of those houses were motivated by transhistorical urges and referred to the roofline of the Low House, forming a "crescendo of diagonal lines of force," as a "fundamental act" and "archetypical."[36] He assumed that all great architecture resulted from a mythic creative act, most often conducted by heroic male architects, which produced such archetypical forms. The list of living architects who met Scully's criteria included members of the recently founded New York Five group of architects, such as Charles Gwathmey and Peter Eisenman, as well as some of Scully's former Yale students who had just begun their careers by designing private houses in New England. The idea that a single building can absorb multiple references from the past, be it the European high modern architecture of the 1920s or the American vernacular from the turn of the century, was key. Scully interpreted Turner Brooks's Glazebrook House in Starksboro, Vermont (1973), which absorbs into its humble balloon-frame structure evocations of local building traditions and 1930s industrial design, as well as 1960s pop art, as a sign of the new generation's ability to expand its historical horizons even deeper into the American soil by "beginning to extract a new richness and solidity of expression from that vernacular" (fig. 105).[37]

Scully acknowledges Bloom's influence in the introductory pages of the book and notes that he chose to focus on single-family houses because they "most openly mirror the character and feelings of their architects and so most directly reflect the influence of those architects upon each other. In them, history can be seen being made, where young architects wrestle with their precursors in order to find a way to find openings for themselves to make a contribution."[38] One could add that designing an individual house comes closest to writing a novel, since both can be accomplished by a single author. Following Bloom, Scully focused on the artistic influence at the heart of the creative act, writing that "the strong young architect, no less than Bloom's 'strong poet,' inevitably fastens on work of his chosen precursor, purposely 'misreads' it, and finally 'swerves' from it to create a new field of action for his own design."[39] The strongest ones are those "who seem to have sought out the most forceful of the precursor-architects to emulate and to outdo, and who have focused with what now begins to appear an almost fanatic intensity upon their strongest and most directly symbolic

Fig. 105 Turner Brooks, Glazebrook House, Starksboro, Vermont, 1973. Reproduced in Vincent Scully, *The Shingle Style Today: Or, The Historian's Revenge* (New York: George Braziller, 1974). Courtesy of Turner Brooks.

forms." Like Bloom, Scully distinguished between "influence" that is an outcome of a "conscious" act, and "tradition," which he defined "as those influences which are so pervasive in any historical situation that the human beings who are involved in them are not consciously aware of them at all."[40]

The subtitle of the book—*The Historian's Revenge*—suggests that Scully no longer resorted to simply imparting historical knowledge to his audience, but saw that his role was to determine the historical significance of a particular architect based on the educated, yet highly interpretative, act of establishing formal and intellectual genealogies to past works. As James Ackerman has noted, compared to the more conscious application of historical antecedents within the Beaux-Arts tradition, the notion of artistic "influence" suppresses cited models until "a work has been completed and made accessible." In his words: "Influence, in a way, moves backward."[41] This brings us back to Scully's brand of history writing, which he tailored to shape the future course of the discipline. To meet this goal, his writings often disregard scholarly conventions, such as footnoting, in favor of a more literary style, based in part on the realization that, to serve this purpose, history writing had to transcend expert knowledge and be accessible to varied audiences. As a result, his rhetorical skills and ability to trigger the historical imagination often trump his historical acumen. While Bloom never referred to Scully's writings or expressed what he thought of Scully as a scholar, he could well have been writing about Scully when he stated: "All of Freud's copious writing is intensely metaphorical, very little of it is verifiable, and much of it is devoted to what cannot be described. . . . [He] was certainly the most suggestive myth maker of the last century." Like the work of Freud, Scully's oeuvre might be "more important as literature" than as art history.[42]

# Postscript
## *Time Today*

Sigfried Giedion captures the dilemma at the heart of twentieth-century architecture—how to balance continuity and change—in his 1957 book *The Eternal Present: The Beginnings of Art. A Contribution on Constancy and Change* as follows:

> The pattern of human life is composed of threads leading from the past, interwoven with others formed by the present. Strewn between these—still invisible to us—lie those of the future. The character of a period depends upon the degree to which different threads come uppermost. This determines whether the period is conservative, sterile, in equipoise—or revolutionary. It is this question of comparative degrees of importance which raises the problem of constancy and change. No period escapes this problem. It is eternal. Constancy does not imply just direct continuation, but rather a quality of the human mind which leaves things slumbering for long ages, suddenly to awake to new life.[1]

This inability to master life's multi-temporal weave led Giedion to despair that "at the present time the problem of constancy is of special consequence, since the threads of the past and tomorrow have been brought into disorder by an incessant demand for change for change's sake. We have become workshipers [sic] of the day-to-day. . . . This has led to an inner uncertainty, to extreme shortcomings in all essential phases of life: to what Heidegger calls 'a forgetfulness of being.'"[2]

As the book at hand has shown, the fear that the past is fading away was a concern for artists, architects, architectural historians, and philosophers alike throughout the twentieth century. Writing this book has made me wonder, how does architecture of our own time measure up in this regard, if we take into account how the built environment is changing faster than ever? The global building stock is expected to double by 2060 to accommodate the pace of population growth; China alone builds what amounts to a "new London" every year.[3] Indeed, what value, if any, do temporal concepts such as past, present, and future have when the future seems to be rolling in faster than ever? Even architectural preservationists seem to lack a sensitivity to the passing of time, to the point that it has become increasingly difficult to tell if something is old or new—or just fake. French historian François Hartog has pointed out the confusion caused by buildings and environments that are so extensively remodeled that distinctions between

old and new are blurred.[4] That Yale's Pauli Murray and Benjamin Franklin Residential Colleges, executed in the neo-Gothic style by Robert A. M. Stern Architects, failed to create a stir among students and faculty at the School of Architecture upon their completion in 2018 offers a further sign that architecture has shunned stable temporal markers for good.[5] It has become equally difficult to identify and name architectural trends since 2000, as no new building or exhibition—and there have been plenty of both—seems to have had a singular impact or caused much debate among the architectural community.

While contemporary architecture seems to be plagued by temporal ennui and blurring, there is increasing pressure to engage in hot-button topics like race and challenge standard art historical narratives. Yale's Department of the History of Art canceled its popular "Introduction to Western Art History" course in 2020, opting to tell a more transcultural and non-teleological story that spans the globe.[6] I found myself implicated in these debates while teaching the course "Architecture and Modernity" to the incoming master's students at the Yale School of Architecture in the fall of 2021, while I was putting the final touches on this manuscript. The course got off to a turbulent start when a group of students criticized its temporal framing around "modernity" as hopelessly Eurocentric. After reflecting on the issue for several months, I would still attest that it might not be possible—or even desirable—to jettison the concept of modernity from the annals of art history, and that the issues the concept brings to bear are still valid. Yet, to borrow Frederick Cooper's words, it is important at the same time to "advocate a historical practice sensitive to the different ways people frame the relationship of past, present and future."[7] Here we are reminded that most Eastern religions such as Buddhism consider distinctions among the past, present, and future to be an illusion, and prioritize an infinite, circular concept of time instead.

One lesson we all have certainly learned is that history needs to be constantly rewritten with fresh eyes and from multiple perspectives. The award-winning 1619 Project, initiated by Nikole Hannah-Jones on the pages of the *New York Times Magazine*, does exactly that by aiming to "reframe the country's history by placing the consequences of slavery and the contributions of Black Americans at the very center of our national narrative."[8] The Black Lives Matter movement, ignited by George Floyd's murder at the hands of white policemen in 2020, invigorates one of the most provocative temporal constructs of the recent past—namely, Afrofuturism, which proposes that for African Americans to imagine their future requires reimagining of the Black experience of the past. In her book *Afrofuturism: The World of Black Sci-Fi and Fantasy Culture* (2013), Ytasha L. Womack entices the reader to imagine an alternative version of both the past and future, writing: "Maybe you'll hop into a parallel universe with a past that reads like a fantasy or a future that feels like the past."[9] The idea that it is impossible to write African American history without speculating about what *could have*

*happened* rather than settling into established historical narratives is on full display in the Afrofuturist period room that opened in the American Wing of the Metropolitan Museum of Art in November 2021. Based on Seneca Village, a nineteenth-century community of predominantly Black landowners and tenants that was taken over by Central Park, the exhibition contains a modest clapboard dwelling that houses both historical artifacts and works by contemporary artists, underscoring the fact that those who once lived in the area were not permitted full control of their destinies. As its title, "Before Yesterday We Could Fly: An Afrofuturist Period Room," suggests, we cannot rely on standard historical methods or temporal constructs when evoking the African American experience, because too many Black lives never reached their full potential due to systematic racism. The curatorial statement discusses that experience in a manner evoking a poly-temporal weave—which might have pleased many of the untimely moderns discussed in this book:

> Unlike [the other period rooms at the Met] this room rejects the notion of one historical period and embraces the African and African diasporic belief that the past, present, and future are interconnected and that informed speculation may uncover many possibilities. Powered by Afrofuturism—a transdisciplinary creative mode that centers Black imagination, excellence, and self-determination—this construction is only one proposition for what might have been, had Seneca Village been allowed to thrive into the present and beyond.[10]

It is my hope that this book has conveyed that we need to reinvent the past to imagine alternative futures. This process requires that we acknowledge that history writing benefits from different voices and vantage points. Indeed, there is no doubt that in today's increasingly fragmented and environmentally fragile world, imagining an alternative future will require not only a profound reassessment of inherited historical frameworks and narratives but listening to those who will be affected the most, namely the young. Questions such as "Whose past?" and "What kind of future?" seem more potent than ever.

# Notes

**PROLEGOMENON TO *UNTIMELY MODERNS***

Epigraphs: Henri Focillon, *The Life of Forms in Art* (New York: Zone Books, 1992), 140. George Kubler, *The Shape of Time: Remarks on the History of Things* (New Haven: Yale University Press, 1962), 72.

1. Georges Didi-Huberman, *The Surviving Image: Phantoms of Time and Time of Phantoms. Aby Warburg's History of Art* (University Park: Pennsylvania State University Press, 2017), 44.

2. The concept of "Denkkollektiv" was introduced by Ludwik Fleck in his 1935 book *Entstehung und Entwicklung einer wissenschaftlichen Tatsache; Einführung in die Lehre vom Denkstil und Denkkollektiv* (Genesis and Development of a Scientific Fact: Introduction to the Study of Thought Style and Thought Collective) (Chicago: University of Chicago Press, 1979).

3. Michel Serres with Bruno Latour, *Conversations on Science, Culture, and Time*, trans. Roxanne Lapidus (Ann Arbor: University of Michigan Press, 1995), 48.

4. The Army Expeditionary Forces university was established in 1917 with the help of the YMCA.

5. Alain Badiou, *The Century* (2005; repr., London: Polity, 2007). François Hartog, *Regimes of Historicity: Presentism and the Experience of Time* (New York: Columbia University Press, 2003), 5.

6. The Gothic style became popular on American college campuses in the late nineteenth century. Princeton commissioned its first Gothic building in 1896 and completed most of the rest during the 1910s and '20s. The University of Pittsburgh's Cathedral of Learning (completed in 1937) culminated the Gothic Revival style. By the 1930s, with the onset of the Great Depression, the Gothic style had become too expensive to execute for most institutions.

7. See Peter Osborne, *The Politics of Time: Modernity and Avant-Garde* (London: Verso, 2011).

8. Alfred [Hoyt] Granger, *Chicago Tribune,* April 10, 1932. Quoted in Katherine Solomonson, *The Chicago Tribune Tower Competition: Skyscraper Design and Cultural Change in the 1920s* (Chicago: University of Chicago Press, 2001), 194.

9. Sarah Maslin, "In Pierson's Lower Court, a Tainted History," *Yale Daily News,* September 23, 2013.

10. Calhoun College was renamed Grace Hopper College, after the pioneering female computer scientist Grace Murray Hopper, in 2017.

11. See chapter "Buildings for Yale" in Aaron Betsky, *James Gamble Rogers and the Architecture of Pragmatism* (New York: Architectural History Foundation, 1994), 103–38.

12. Robert Dudley French was a member of the planning committee during the early 1930s when the university instituted the undergraduate college system based on English precedents. He published *The Memorial Quadrangle: A Book about Yale* (New Haven: Yale University Press, 1929). Quotations from French, *The Yale Scene* (New Haven: Yale University Press, 1950), viii.

13. Mari Lending, *Plaster Monuments: Architecture and the Power of Reproduction* (Princeton: Princeton University Press, 2017), 211.

14. For further discussion about these different temporal constructs, see Natalja Deng, "Metaphysics of Time: The A-Theory and the B-Theory," in *Routledge Encyclopedia of Philosophy*, https://www.rep.routledge.com/articles/thematic/time-metaphysics-of/v-3.

15. Gail McDonald, *Learning to Be Modern: Pound, Eliot, and the American University* (Oxford: Clarendon, 1993), xii.

16. History did not officially become a required part of professional architectural training across the country until the 1970s. For more on teaching architectural history in the architecture school setting, see Alina A. Payne, "Architectural History and the History

of Art: A Suspended Dialogue," *Journal of the Society of Architectural Historians* 58, no. 3 (September 1999): 292–99; and Gwendolyn Wright, "History for Architects," in *The History of History in American Schools of Architecture*, ed. Gwendolyn Wright and Janet Parks (New York: Princeton Architectural Press, 1990), 13–52.

17. The BAID was founded in 1916, the same year Meeks began teaching at Yale.

18. *Bulletin of the Beaux-Arts Institute of Design* (September 1934): 20. Quoted in Joseph Esherick, "Architectural Education in the Thirties and Seventies: A Personal View," in *The Architect: Chapters in the History of the Profession*, ed. Spiro Kostof (Berkeley: University of California Press, 1977), 241.

19. Henri Focillon, *La vie des formes* (Paris: Leroux, 1934). Published in English as *The Life of Forms in Art* (New Haven: Yale University Press, 1942). A revised edition was published by Zone Books in 1992.

20. Umberto Eco's book *Opera Aperta* (The Open Work) was published in 1962, the same year as George Kubler's *The Shape of Time: Remarks on the History of Things* (New Haven: Yale University Press, 1962). The first English edition came out in 1972.

21. Susan B. Matheson, *Art for Yale: A History of the Yale University Art Gallery* (New Haven: Yale University Press, 2001). The chapter "The Gallery of Fine Arts" discusses Meeks's involvement in the gallery in more detail.

22. Christopher S. Wood used the expression to describe how the Kunsthistorisches Museum in Vienna became such a "supplement to the lecture courses offered at the Institute of Art History." Christopher S. Wood, *A History of Art History* (Princeton: Princeton University Press, 2019), 253.

23. Yale made its visual collections part of the arts library in 1955. See Jesse Vestermark, "History of the Rise and Progress of the Robert B. Haas Family Library at Yale University," *Art Libraries Journal* 36, no. 2 (2011): 5–11.

24. For more discussion about Wölfflin's pioneering use of projection technology, see Zeynep Çelik Alexander, *Kinaesthetic Knowing: Aesthetics, Epistemology, Modern Design* (Chicago: University of Chicago Press, 2017), 92–96.

25. Venturi taught at the University of Pennsylvania between 1957 and 1965. See Lee Ann Custer, "Teaching Complexity and Contradiction at the University of Pennsylvania, 1961–65," in *Complexity and Contradiction at Fifty: On Robert Venturi's "Gentle Manifesto,"* ed. Martino Stierli and David B. Brownlee (New York: Museum of Modern Art, 2019), 30–47.

26. For more discussion about a tenseless experience of time, see Heather Dyke, "Metaphysics of Time," in *Routledge Encyclopedia of Philosophy*, https://www.rep.routledge.com/articles/thematic/time-metaphysics-of/v-2. Weiss taught at Yale from 1946 to 1969, and Josef Albers from 1950 to 1957. Both retired—Weiss somewhat reluctantly—due to the obligatory retirement age.

27. Cleanth Brooks quoted in "Brooks States Authors Not Obligated to Crusade Against Evils of Society," *Yale Daily News*, October 9, 1951.

28. See W. K. Wimsatt, Jr., and M. C. Beardsley, "The Intentional Fallacy," *Sewanee Review* 54, no. 3 (July–September 1946): 468–88. See also Harold Bloom, *The Anxiety of Influence: A Theory of Poetry* (New York: Oxford University Press, 1973).

29. William Shakespeare, *Romeo and Juliet* (London: Macmillan, 1893), 72. William Shakespeare, *As You Like It: A Comedy* (London: S. Gosnell, 1810), 43. William Shakespeare, *Hamlet* (London: Cambridge University Press, 1904), 33.

30. Nietzsche frequently commented on Shakespeare's plays in his writings, and one of the chapters of *Die fröhliche Wissenschaft* (The Gay Science) was written "In Honour of Shakespeare."

31. Friedrich Nietzsche, "Foreword," in *Untimely Meditations*, trans. R. J. Hollingdale (Cambridge: Cambridge University Press, 1997), 73.

32. Ibid.

33. Ibid.

34. Ibid., 60.

35. For more on Nietzsche and modern architecture, see *Nietzsche and "An Architecture of Our Minds,"* ed. Alexandre Kostka and Irving Wohlfarth (Santa Monica, CA: Getty Research Institute, 1999).

36. Martino Stierli, *Montage and the Metropolis: Architecture, Modernity, and the Representation of Space* (New Haven: Yale University Press, 2018), 143.

37. Ibid., 144.

38. Maria Stavrinaki, "Dry Time—Anni Albers Weaving the Threads of the Past," Bauhaus Imaginista, http://www.bauhaus-imaginista.org/articles/6262/dry-time.

39. T. S. Eliot, "Tradition and the Individual Talent," *Perspecta* 19 (1982): 37. The essay was originally published in *The Egoist* in 1919 and a year later in the volume titled *The Sacred Wood*.

40. Ezra Pound, "Praefatio ad Lectorem Electum," in *The Spirit of Romance* (1910). Quoted in Reto Geiser, *Giedion and America: Repositioning the History of Modern Architecture* (Zurich: gta, 2018), 350. For further discussion about how academia fostered the emphasis on tradition, see McDonald, *Learning to Be Modern*.

41. Georges Didi-Huberman talked about "impurities of time" when discussing Aby Warburg's theory of "afterlife" and "survival" in his book *The Surviving Image: Phantoms of Time and Time of Phantoms,* trans. Harvey Mendelsohn (University Park: Pennsylvania State University Press, 2017).

42. See the discussion of Mart Stam's "Holland und Die Baukunst unserer Zeit" published in *Schweizerische Bauzeitung* in Geiser, *Giedion and America*, 155.

43. Maria Stavrinaki, *Dada Presentism: An Essay on Art and History* (Stanford: Stanford University Press, 2016), 50.

44. William Faulkner, *Requiem for a Nun* (1951; repr., New York: Random House, 2011), 73.

45. Wanda M. Corn, *The Great American Thing: Modern Art and National Identity, 1915–1935* (Berkeley: University of California Press, 1999), 298.

46. Charles Eliot Norton quoted by Charles Rufus Morey in *Boston Evening Transcript,* December 30, 1926. Quoted in Sybil Gordon Kantor, *Alfred H. Barr, Jr. and the Intellectual Origins of the Museum of Modern Art* (Cambridge, MA: MIT Press, 2002), 35.

47. Van Wyck Brooks, "On Creating a Usable Past," *The Dial* (Boston, 1918), 337.

48. Ibid., 338.

49. Ibid., 339.

50. Casey Nelson Blake, "The Usable Past, the Comfortable Past, and the Civic Past: Memory in Contemporary America," *Cultural Anthropology* 14, no. 3 (August 1999): 423.

51. Sidney Fiske Kimball, *American Architecture* (Indianapolis: Bobbs-Merrill, 1928), 227.

52. For further discussion about European perceptions of American architecture, see Jean-Louis Cohen, *Scenes of the World to Come: European Architecture and the American Challenge* (Paris: Flammarion, 1995). My discussion about the American obsession with tradition is influenced by Michael D. Clark, *The American Discovery of Tradition, 1865–1942* (Baton Rouge: Louisiana State University Press, 2005). Clark describes this American paradox, saying: "Although Americans retained their reputation as a people oblivious to the past, a sense of tradition had gained enough of a foothold by the beginning of the twentieth century to play a significant part in shaping the modern American self" (3).

53. Le Corbusier, *Quand les cathédrales étaient blanches: Voyage au pays des timides* (Paris: Libraire Plon, 1937). Translated into English as Le Corbusier, *When the Cathedrals Were White: A Journey to the Country of Timid People,* trans. Francis E. Hyslop (New York: Reynal and Hitchcock, 1947).

54. Wood, *History of Art History,* 404.

55. Albena Yaneva, *Crafting History: Archiving and the Quest for Architectural Legacy* (Ithaca, NY: Cornell University Press, 2020), 31.

56. Henry-Russell Hitchcock, *Modern Architecture: Romanticism and Reintegration* (New York: Payson and Clarke, 1929), xv–xvi.

57. Ibid., xvi.

58. Ibid., 91.

59. Ibid., 92.

60. Panayotis Tournikiotis, *The Historiography of Modern Architecture* (Cambridge, MA: MIT Press, 1999), 119.

61. Henry-Russell Hitchcock, "The Decline of Architecture," *Hound and Horn: A Harvard Miscellany* (September 1927): 28.

62. Ibid., 35.

63. Hitchcock, *Modern Architecture,* 219.

64. Sigfried Giedion, *Space, Time and Architecture: The Growth of a New Tradition,* 2nd ed. (Cambridge, MA: Harvard University Press, 1949), 7. Reto Geiser has attested that Giedion owned Hitchcock's book; see Geiser, *Giedion and America,* 151.

65. Giedion, *Space, Time and Architecture,* 567.

66. Ibid., 38.

67. For further discussion of the topic, see *Latenz: Annäherungen an einen Begriff,* ed. Stefanie Diekmann and Thomas Khurana (Berlin: Kulturverlag Kadmos, 2007).

68. Giedion, *Space, Time and Architecture,* 18.

69. Ibid., 24.

70. "Giedion," *Harvard Crimson,* November 15, 1938. An article in the previous day's issue of the same magazine entitled "Siegfried [sic] Giedion to Give the Norton Lectures. Begins Series on Art and Architecture Tomorrow with Historical Slant in Fogg Museum" lists the four lectures that formed the basis for his magnus opus *Space, Time and Architecture: The Growth of a Tradition* (1941) as follows: "The Role of History Today," "Architectural Inheritance: Early Renaissance and Late Baroque," "Architectural Inheritance: The Organization of Outer Space," and "New Potentialities: Architecture and Construction."

71. Giedion, *Space, Time and Architecture,* 5.

72. Ibid., 8.

73. George Harold Edgell, *The American Architecture of Today* (New York: Scribner, 1928), 3. Quoted in Anthony Alofsin, "Tempering the École: Nathan Ricker at the University of Illinois, Langford Warren at Harvard," in Wright and Parks, *History of History in American Schools of Architecture,* 84.

74. Erwin Panofsky, "Epilogue: Three Decades of Art History in the United States. Impressions of a Transplanted European," in *Meaning in the Visual Arts: Papers in and on Art History* (Woodstock, NY: Overlook Press, 1974), 328–29. The text was originally published as "The History of Art" in *The Cultural Migration: The European Scholar in America,* ed. W. R. Crawford, (Philadelphia: University of Pennsylvania Press, 1953).

75. See Robert A. M. Stern and Jimmy Stamp, *Pedagogy and Place: 100 Years of Architecture Education at Yale* (New Haven: Yale University Press, 2016).

## CHAPTER 1
### EVERETT VICTOR MEEKS

1. "Lecture Meeks, Everett V., 1925," School of Art and Architecture, records, Manuscripts and Archives, Yale University Library, RU189, Acc 1973-A-001, Box 13.

2. Ibid.

3. Everett V. Meeks, "Introduction," *Bulletin of the Associates in Fine Arts at Yale University* 1, no. 1 (March 1926): 1.

4. Everett Victor Meeks, stenographer notecard dated December 4, 1925, Manuscripts and Archives, Yale University Library, RU 189, Acc 1973-A-001, Box 12.

5. Ralph Waldo Emerson, "History" (1841), in *Self-Reliance and Other Essays* (Mineola, NY: Dover, 1993), 1–2.

6. John Dewey, *Democracy and Education* (1916; repr., New York: Free Press, 1944), 248. For more on Dewey and his impact, see Thomas Bender, *New York Intellect: A History of Intellectual Life in New York City from 1750 to the Beginnings of Our Own Time* (New York: Knopf, 1987).

7. Angell served as president of Yale from 1921 to 1937.

8. Cram lectured at Yale in 1907, 1909, 1910, 1914, 1915, and 1931.

9. Ralph Adams Cram, "The Place of Fine Arts in Public Education" (1910), in

*The Ministry of Art* (Boston: Houghton Mifflin, 1914), 70.

10. Ibid., 79–80.

11. "Lecture Meeks, Everett V., December 4, 1925."

12. Everett V. Meeks quoted in "Extension of Curriculum Planned by Art School; Courses in History, Art and Criticism to Be Added and Graduate School Will Revise Degrees Accordingly," *Yale Daily News*, November 4, 1925.

13. Ibid.

14. Everett V. Meeks quoted in "School of Fine Arts May Be Visited by Graduates," *Yale Daily News*, February 23, 1920.

15. A. Kinsley Porter quoted in Stern and Stamp, *Pedagogy and Place*, 27.

16. Everett V. Meeks, "The Place of Art in Higher Education," *American Magazine of Art* 19, no. 10 (October 1928): 548.

17. Ibid.

18. Matheson, *Art for Yale*, 72.

19. Heinrich Wölfflin, "Prolegomena to a Psychology of Architecture," in *Empathy, Form, and Space: Problems in German Aesthetics, 1873–1893*, ed. and trans. Harry Mallgrave and Eleftherios Ikonomou (Santa Monica, CA: The Getty Center for the History of Art and the Humanities, 1994), 184.

20. Heinrich Wölfflin, *Principles of Art History: The Problem of the Development of Style in Later Art* (New York: Dover, 1950), vii.

21. Mark Jarzombek, "De-Scribing the Language of Looking: Wölfflin and the History of Aesthetic Experientialism," *Assemblage* 23 (April 1994): 31.

22. See William James, "World of Pure Experience" (1904). Quoted in Richard Grusin, "Radical Mediation," *Critical Inquiry* 4, no. 1 (Autumn 2015): 126. I thank Francesco Cassetti for bringing this article to my attention.

23. Meeks, "Place of Art in Higher Education," 547.

24. Alfred North Whitehead, *The Aims of Education and Other Essays* (1929; repr., New York: Free Press, 1967), 93.

25. Everett V. Meeks, "Introduction," in *Art and Nature Appreciation*, by George H. Opdyke (New York: Macmillan, 1932), ix.

26. See T. J. Jackson Lears, *No Place of Grace: Antimodernism and the Transformation of American Culture, 1880–1920* (New York: Pantheon, 1981), 13. Quoted in Michael D. Clark, *The American Discovery of Tradition, 1865–1942* (Baton Rouge: Louisiana State University Press, 2005), 5.

27. Meeks, "Place of Art in Higher Education," 547.

28. Ibid.

29. "Sees a New Architecture; Dean Meeks Says Trend Is for It to Reflect Modern Life," *New York Times*, August 10, 1930.

30. In 1913 Dreier organized the *International Exhibition of Modern Art* (also known as the Armory Show) and in 1920 founded, with Marcel Duchamp and Man Ray, the Société Anonyme for the "study and promotion of modern art." In 1923 she published the book *Western Art and the New Era: An Introduction to Modern Art*, the first book dedicated to the European avant-garde to be published in the United States.

31. See Sybil Gordon Kantor, "Barr as Teacher, 1925 to 1927," in *Alfred H. Barr, Jr. and the Intellectual Origins of the Museum of Modern Art* (Cambridge, MA: MIT Press, 2002), 91.

32. "Sixth International Congress for Drawing, Art Education, and Applied Arts" (Prague, 1928). Katherine S. Dreier Papers/Société Anonyme Archive, Beinecke Rare Books Library, Yale University, Box 62/Folder 1681.

33. Meeks, "Place of Art in Higher Education," 544.

34. Ibid., 547.

35. Everett V. Meeks, "The Responsibility of the College," *American Magazine of Art* 23, no. 4 (October 1931): 307.

36. Ibid.

37. Ibid.

38. "Yale School of Art Bars 'Ism' in Teaching," *New York Times*, June 14, 1935, 19.

39. Everett V. Meeks, "Foreign Influences in American Architecture," *Octagon* 9, no. 7 (July 1937): 42.

40. Everett V. Meeks quoted in "Architects' League Has Golden Jubilee; Dean Meeks Says Beauty Is Only Stable Ground for a Philosophy of Design," *New York Times*, April 25, 1931, 7.

41. Ibid.

42. Everett V. Meeks, "Modern Art" (1938), in *Historical Aspects of the Fine Arts*, by Rhys Carpenter et al. (Oberlin, OH: Oberlin College, 1938), 79.

43. Ibid., 83.

44. *Bulletin of the Yale University School of the Fine Arts: Department of Architecture* (1933–34): 39. School of Art and Architecture, Manuscripts and Archives, Yale University Library, RU 189.

45. Henri Bergson, *Creative Evolution*, trans. Arthur Mitchell (1907; repr., London: Electric, 2001), 14.

46. *Creative Evolution* was the first of Bergson's books to be translated into English. See Larry McGrath, "Bergson Comes to America," *Journal of the History of Ideas* 74, no. 4 (October 2013): 599–620.

47. The lecture took place on February 22, 1924. Everett V. Meeks, "The Modern Tradition in Architecture" (1924). Quoted in Stern and Stamp, *Pedagogy and Place*, 47.

48. Katherine Solomonson gave a thorough analysis of the *Chicago Tribune* competition and its aftermath in *The Chicago Tribune Tower Competition: Skyscraper Design and Cultural Change in the 1920s* (Chicago: University of Chicago Press, 2001).

49. Raymond Hood quoted in "Raymond Hood Says That Modern Architecture Should Be Representative of Our Own Age," *Yale Daily News*, February 28, 1925.

50. Ibid.

51. See "Trowbridge Lecture 1931, December 4, Ashbee, C.R.," School of Art and Architecture, records, Manuscripts and Archives, Yale University Library, RU 189, YRG 18-A, Series 11, Box 13.

52. The lecture coincided with the award ceremony of the prestigious Howland Memorial Prize the architect had received four years prior and an exhibition of his work, which highlighted the glorious edifice at the heart of Stockholm. The prize was awarded annually to "a citizen of any country in recognition of any achievement of distinction in the field of literature and the arts." Östberg had received the prize in 1930 but could not travel to the United States until four years later. See "Ostberg Will Visit Yale; Noted Swedish Architect Will Receive Howland Prize

from Pres. Angell," *Yale Daily News*, April 28, 1934.

53. Ibid.

54. Ragnar Östberg, "The New Lines of Development in Architecture." Undated lecture manuscript, Manuscripts and Archives, Yale University Library, RU 189, Acc 1973-A-001, Box 14, n.p.

55. Ibid.

56. Ibid.

57. Ragnar Östberg quoted in "Noted Swedish Architect Receives Howland Medal," *Yale Daily News*, May 8, 1934.

58. Frank Lloyd Wright quoted in "Wright Decries Lack of American Culture; Organic Architecture Seen Salvation of Individuality and U.S. Culture," *Yale Daily News*, October 17, 1935.

59. Le Corbusier quoted in "Le Corbusier Shows Origin of Modernism," *Yale Daily News*, October 31, 1935.

60. Ibid.

61. Much has been made about Frederick Etchells's mistranslation of the title into *Toward a New Architecture* in 1927. A new translation of the book, *Toward an Architecture*, was published by the Getty Research Institute in 2007. Jean-Louis Cohen discussed the prior mistranslation of the title as *Toward a New Architecture*, when the first English version came out. See Jean-Louis Cohen, "Introduction," in Le Corbusier, *Toward an Architecture* (Santa Monica, CA: Getty Research Institute, 2007), 49.

62. Ralph Walker quoted in "Modern Architecture Is Walker's Subject," *Yale Daily News*, November 14, 1935.

63. Eliel Saarinen quoted in "Saarinen Criticizes Artistic Imitation; Calls Modern Architecture Stylistic Stock Market," *Yale Daily News*, February 6, 1936.

64. "Giedion Discusses American Future," *Yale Daily News*, November 11, 1941. Giedion gave three lectures in October and November 1941: "Changing Aspects of Our Culture," "Lines of Research into Contemporary History," and "American Development."

65. Frank Lloyd Wright appeared on the cover of *Time* in 1938.

66. "Arbiter of the Arts," *Architectural Forum* (June 1947): 74.

67. Ibid., 74–75.

68. The idea that the Great Depression expedited the shift away from Beaux-Arts education has been put forward in Jill Pearlman, *Inventing American Modernism: Joseph Hudnut, Walter Gropius, and the Bauhaus Legacy at Harvard* (Charlottesville: University of Virginia Press, 2007), 51.

## CHAPTER 2
## JAMES GAMBLE ROGERS

1. Frank Lloyd Wright quoted in "Wright Decries Lack of American Culture," *Yale Daily News*, October 17, 1935.

2. "Le Corbusier Shows Origin of Modernism," *Yale Daily News*, October 31, 1935.

3. Johann Wolfgang von Goethe, "On German Architecture" (1772), in *Goethe: Essays on Art and Literature*, ed. John Gearey (New York: Suhrkamp, 1986), 4.

4. John Ruskin, "The Nature of Gothic" (1853), in *Works* (New York: J. B. Alden, 1885), 214. Italics in the original.

5. Wilhelm Worringer, *Formprobleme der Gotik* (1911; repr., Munich: Piper, 1927), 123–24. Translation my own.

6. Wilhelm Worringer, *Abstraction and Empathy: A Contribution to the Psychology of Style* (1908; repr., Chicago: Ivan Dee, 1997), 113.

7. Karl Scheffler, *Der Geist der Gotik* (1908; repr., Berlin: Insel, 1917), 92. Translation my own.

8. Ibid., 107. Translation my own.

9. Karl Scheffler, "Das Grosse Schauspielhaus," *Kunst und Künstler* (1920): 232. Translation my own.

10. Henry Adams, *Mont-Saint-Michel and Chartres* (1913; repr., New York: Doubleday, 1959), 37. Quoted in Michael D. Clark, *The American Discovery of Tradition, 1865–1942* (Baton Rouge: Louisiana State University Press, 2005), 134.

11. Michael D. Clark, "Ralph Adams Cram and the Americanization of the Middle Ages," *Journal of American Studies* 23, no. 2 (August 1989): 197.

12. I owe this information to Sibyl Gordon Kantor, *Alfred H. Barr, Jr. and the Intellectual Origins of the Museum of Modern Art* (Cambridge, MA: MIT Press, 2002), 20. For more discussion of the early studies of medieval architecture in the United States, see Peter Ferguson, "Medieval Architectural Scholarship in America, 1900–1940: Ralph Adams Cram and Kenneth John Conant," *Studies in the History of Art* 35 (1990): 127–42.

13. Yale eventually established an interdisciplinary Medieval Studies program in 1962.

14. For more discussion of the *Chicago Tribune* competition, see Katherine Solomonson, *The Chicago Tribune Tower Competition: Skyscraper Design and Cultural Change in the 1920s* (Chicago: University of Chicago Press, 2001).

15. Talbot Faulkner Hamlin, *The American Spirit in Architecture* (New Haven: Yale University Press, 1926), 198–99.

16. Ibid., 169.

17. Ralph Adams Cram quoted in "Skyward," *Time*, December 13, 1926, 21–22.

18. Henry R. Luce, "The American Century" (1941), in *Diplomatic History* 23, no. 2 (Spring 1999): 165.

19. Le Corbusier, *Quand les cathédrales étaient blanches: Voyage au pays des timides* (Paris: Libraire Plon, 1937). Translated into English as Le Corbusier, *When the Cathedrals Were White: A Journey to the Country of Timid People*, trans. Francis E. Hyslop (New York: Reynal and Hitchcock, 1947), 4.

20. Le Corbusier, "To Free Oneself Entirely of Academic Thinking" (1929), in *Precisions on the Present State of Architecture and City Planning* (Cambridge, MA: MIT Press, 1991), 33.

21. Le Corbusier, *When the Cathedrals Were White*, 6.

22. Ibid., 5.

23. Ibid., 6.

24. Ibid.

25. Ibid., 135.

26. Le Corbusier quoted in Mardges Bacon, *Le Corbusier in America: Travels in the Land of the Timid* (Cambridge, MA: MIT Press, 2001), 75.

27. Le Corbusier quoted in ibid., 229.

28. See Bakhtin's 1937 essay "Forms of Time and of the Chronotope in the Novel," reprinted in English in Mikhail Bakhtin, *The Dialogic Imagination: Four Essays* (Austin: University of Texas Press, 1981), 119–293.

29. Le Corbusier, *When the Cathedrals Were White*, 140, 142.

30. Ibid., 168.

31. Ibid., 122.

32. Le Corbusier quoted in H. I. Brock, "Le Corbusier Scans Gotham's Towers," *New York Times,* November 3, 1935.

33. Ibid.

34. Ibid.

35. "Premises and Conclusions at the Princeton Architectural Round Table," *Architectural Record* 82 (September 1937): 59.

36. See chapter 7, "The 1930s: New Challenges and Opportunities," in Jewel Stern, *Ely Jacques Kahn: Beaux-Arts to Modernism in New York* (New York: W. W. Norton, 2006), 174–93.

37. Gwendolyn Wright, *USA: Modern Architectures in History* (London: Reaktion, 2008), 105–6.

38. For more discussion of the history of James Gamble Rogers and his buildings at Yale, see Aaron Betsky, *James Gamble Rogers and the Architecture of Pragmatism* (New York: Architectural History Society, 1994).

39. Paul Goldberger, "James Gamble Rogers and the Shaping of Yale in the Twentieth Century," in *Yale in New Haven: Architecture and Urbanism,* by Vincent Scully, Catherine Lynn, Erik Vogt, and Paul Goldberger (New Haven: Yale University Press, 2004), 271.

40. Marrion Wilcox, "The Harkness Memorial Quadrangle at Yale," *Architectural Record* 50, no. 30 (September 1921): 162.

41. For more on the Snead and Company shelving systems, see Lydia Pyne, "How One Company Designed the Bookshelves That Made America's Biggest Libraries Possible," Slate, February 1, 2016, https://slate.com/human-interest/2016/02/how-snead-bookshelves-made-america-s-biggest-libraries-possible.html.

42. For full information about the complicated systems, see William S. Snead, "The Bookstack Tower," *Yale University Library Gazette* 5, no. 4 (April 1931): 77–80.

43. Ibid.

44. James Gamble Rogers, "Notes by the Architect," *Yale University Library Gazette* 3, no. 1 (July 1928): 3.

45. Ibid.

46. Ibid., 3–7.

47. I owe the biographical information to Betsky, *James Gamble Rogers*. Betsky's book led me to inquire about the role customs played in pragmatist philosophy.

48. George Herbert Mead, "1914 Lectures in Social Psychology," in *The Individual and the Social Self: Unpublished Essays by G. H. Mead,* ed. David L. Miller (Chicago: University of Chicago Press, 1982), 102.

49. Letter from James Gamble Rogers to Anson Phelps Stokes, October 23, 1919. Quoted in Betsky, *James Gamble Rogers,* 55.

50. I learned from Katherine Kuenzli that Henry van de Velde emulated its novel tower typology in his Ghent University Central Library shortly afterward. See Katherine M. Kuenzli, *Henry van de Velde: Designing Modernism* (New Haven: Yale University Press, 2019), 162–64.

51. William Harlan Hale, "Art vs. Yale University," *Harkness Hoot,* November 15, 1930, 21. The debate surrounding Yale's neo-Gothic style was widely quoted and discussed at the time—for example, on the pages of the *Harvard Crimson,* which announced, "Harkness Hoot Denounces Yale's New Million-Dollar Gothic Buildings—Attacks 'Bogus Elizabethan Mansions' on Campus," *Harvard Crimson,* November 4, 1930.

52. Hale, "Art vs. Yale University," 21.

53. "Two Magazines Republish 'Art vs. Yale University,'" *Yale Daily News,* December 3, 1930.

54. Ralph Adams Cram quoted in "Foremost Authority on Gothic Architecture Discusses Significance of Its Modern Use," *Yale Daily News,* January 6, 1931.

55. Ibid.

56. Ralph Adams Cram, "The Value of Precedent in the Practice of Architecture," *American Architect and the Architectural Review* (December 17, 1924): 567.

57. Ibid., 569.

## CHAPTER 3
## HENRI FOCILLON

1. "Two French Scholars Appointed as Members of Art School Faculty," *Yale Daily News,* March 4, 1932. The article reports that the two were to teach in alternate semesters.

2. "Dr. H. Focillon Arrives at Yale from Sorbonne," *Yale Daily News,* March 28, 1933.

3. Henri Focillon, *La vie des formes* (Paris: Leroux, 1934). Published in English as Henri Focillon, *The Life of Forms in Art* (1942; repr., New York: Zone Books, 1992), 152–54. Yale University Press published the first English edition in 1942. All my citations are from the revised edition published by Zone Books in 1992.

4. Ibid., 154.

5. Ibid.

6. Ibid., 98.

7. Ibid., 149.

8. Ibid., 41.

9. Ibid.

10. Focillon attended Bergson's lectures at the Collège de France.

11. Focillon, *Life of Forms in Art,* 133.

12. The ICIC was conceived after World War I to foster cultural exchange and understanding and included notable people such as Focillon, Henri Bergson, Albert Einstein, and Paul Valéry as members.

13. Henri Focillon, "Introduction," in *Art Populaire* (Paris: Éditions Duchartre, 1931), x. I thank Theodossis Issaias for sharing his translation of the text with me.

14. Focillon quoted by his student George Kubler, "History—or Anthropology—of Art?," *Critical Inquiry* 1, no. 4 (June 1975): 758.

15. For more on Focillon's relation to modern art, see Pierre Vaisse, "L'art du XXe siècle d'Henri Focillon," *La vie des formes: Henri Focillon et les arts* (Lyon: Éditions Snoeck, 2014), 205–16.

16. Focillon, *Life of Forms in Art,* 133.

17. Ibid., 140–41.

18. Charles Baudelaire, "On the Heroism of Modern Life" (*Salon,* 1846), in *Baudelaire: Selected Writings on Art and Artists,* trans. P. E. Charvet (Cambridge: Cambridge University Press, 1972), 104–5.

19. Charles Baudelaire, "The Painter of Modern Life" (1863), in *The Painter of Modern Life and Other Essays* (London: Phaidon, 1964), 3.

20. Focillon, *Life of Forms in Art,* 139.

21. Ibid., 152.

22. Ibid., 31.

23. Ibid., 32.

24. For the full range of Focillon's artwork, see André Chastel et al., *Pour*

*un temps / Henri Focillon* (Paris: Centre Georges Pompidou, 1986).

25. Walter Benjamin in *The Origin of German Tragic Drama* (1925). Quoted in Georges Didi-Huberman, "The Supposition of the Aura: The Now, the Then, and Modernity," in *Walter Benjamin and History,* ed. Andrew Benjamin (London: Continuum, 2005), 4.

26. For more discussion of Benjamin's approach to history, see Wood, *History of Art History,* 339.

27. Walter Benjamin, "Little History of Photography" (1929), in *The Work of Art in the Age of Its Reproducibility and Other Writings on Media,* ed. Michael W. Jennings et al. (Cambridge, MA: Harvard University Press, 2008), 285.

28. Focillon, *Life of Forms in Art,* 34–35.

29. Sigmund Freud, *Civilization and Its Discontents* (1930; repr., New York: Norton, 2005), 36.

30. Henri Focillon, "À nos amis d'Amérique," *Revue de l'Art ancien et modern* 81 (1937): 299. Quoted in George Kubler, "L'enseignement d'Henri Focillon," in *Relire Focillon* (Paris: Musée du Louvre and École Nationale Supérieure des Beaux-Arts, 1998), 19–20. I thank Theodossis Issaias for helping with the translation.

31. For further discussion of the parallels between Focillon and Bloch, see Walter Cahn, "L'art francais et l'art allemande," in *Relire Focillon,* 36–37.

32. Marc Bloch, "Mémoire collective, tradition et culture: À propos d'un livre récent" (1929), in *The Collective Memory Reader,* ed. Jeffrey K. Olick and Vered Vinitzky-Seroussi (Oxford: Oxford University Press, 2011), 151–52.

33. Marc Bloch, *The Historian's Craft* (1949; repr., Manchester: Manchester University Press, 2004), 23.

34. Henri Focillon quoted in Bloch, *Historian's Craft,* 127.

35. Ibid., 50.

36. For more discussion of Focillon's theory of style, see his 1933 essay "Sur la notion de style," in *Actes du XIIIe Congrès international d'histoire de l'art,* ed. Johnny Roosval (Stockholm: Comité Organisateur de Congrès, 1933), 300–302.

37. Focillon, *Life of Forms in Art,* 47.

38. Focillon put forward this theory in his 1940 lecture "Préhistoire et Moyen Age," at Dumbarton Oaks, which was published in *Dumbarton Oaks Papers,* vol. 1. *Dumbarton Oaks Inaugural Lectures, November 2nd and 3rd 1940* (New York: Johnson Reprint, 1941).

39. Ibid., 60–61.

40. I have borrowed these concepts from Nathan A. Scott, who used them in his book *The Broken Center: Studies in the Theological Horizon of Modern Literature* (New Haven: Yale University Press, 1966). Quoted in Alexander Nagel, *Medieval Modern: Art out of Time* (London: Thames and Hudson, 2012), 151.

41. Focillon, *Life of Forms in Art,* 58.

42. Friedrich Nietzsche, "On the Baroque" (1878), in *Baroque New Worlds: Representation, Transculturalism, Counterconquest,* ed. Lois Parkinson Zamora and Monika Kaup, trans. Monika Kaup (Durham, NC: Duke University Press, 2010), 45.

43. Eugenio d'Ors, "The Debate on the Baroque in Pontigny" (1936). Reprinted in *Baroque New Worlds: Representation, Transculturation, Counterconquest,* 82. Italics in the original.

44. Ibid., 121.

45. Walter Benjamin, *The Origin of German Tragic Drama* (1925). Quoted in Andrew Benjamin, "Benjamin and the Baroque: Posing the Question of Historical Time," in *Rethinking the Baroque,* ed. Helen Hills (Burlington, VT: Ashgate, 2011), 163.

46. Eugenio d'Ors, "The Debate on the Baroque in Pontigny," trans. Wendy B. Faris, in *Baroque New Worlds: Representation, Transculturation, Counterconquest* (Durham, NC: Duke University Press, 2010), 82.

47. Ibid., 92.

48. Ibid.

49. See Maria Stavrinaki, *Transfixed by Prehistory: An Inquiry into Modern Art and Time* (New York: Zone Books, 2021). Originally published in 1919 in France as *Saisis part la préhistoire: Enquête sur l'art le temps des modernes* by Les presses du reel.

50. Giedion, *Space, Time and Architecture,* 109.

51. Ibid., 156.

52. Ibid., 7.

53. "Prominent Scholars Will Lecture Today; Ore and Giedion to Speak on Mathematics, Art," *Yale Daily News,* January 30, 1940.

54. Giedion, *Space, Time and Architecture,* 5.

55. Ibid., 3.

56. Ibid., 4.

57. Sigfried Giedion, "Über Finnische Architecture," *Bauvelt* 21 (1931): 34. Giedion added a chapter devoted to Aalto for the second edition of *Space, Time and Architecture* (1949).

# CHAPTER 4
## JOSEF AND ANNI ALBERS

1. "Germans on Faculty at Black Mountain School; Josef and Frau Albers Named in Art There," *Asheville Citizen,* December 5, 1933.

2. For more details about their arrival at Black Mountain College, see Brenda Danilowitz, "Teaching Design: Short History of Josef Albers," in *Josef Albers: To Open Eyes: The Bauhaus, Black Mountain College, and Yale,* ed. Frederick A. Horowitz and Brenda Danilowitz (London: Phaidon, 2006), 8–71.

3. For more information on Josef Albers's career as a teacher, see Horowitz and Danilowitz, *To Open Eyes.*

4. For more about Hamilton's early years, see Elise K. Kenney, "From the Archives," *Yale University Art Gallery Bulletin* (2005): 130–33.

5. For more about the gift, see Susan Matheson, "Katherine Dreier and the Société Anonyme," in *Art for Yale* (New Haven: Yale University Press, 2001), 123.

6. "Famed Collection of Modern Art Goes on Exhibition in Yale Gallery; Hamilton Will Discuss Important Presentation of K. Dreier, Duchamp," *Yale Daily News,* January 13, 1942.

7. George Hamilton Heard quoted in "Hamilton Speaks at Art Exhibit; Dreier-Duchamp Group Largest Ever Assembled," *Yale Daily News,* January 14, 1942.

8. "Hartt Emphasizes Scope, Importance of Gallery's Modern Art Exhibition," *Yale Daily News,* January 15, 1942.

9. Henry Kibel quoted in Cy Blas, "Yale Has Exhibition of Art and Science: Show Is Based on Thesis That Mechanization Age Has Influenced Man's Approach to the Fine Arts." Unidentified newspaper

clipping. Courtesy of Yale Art Gallery Archives.

10. Henry Kibel quoted in Robert A. M. Stern and Jimmy Stamp, *Pedagogy and Place: 100 Years of Architecture Education at Yale* (New Haven: Yale University Press, 2016), 67.

11. AAFTTC began its training program on campus on December 22, 1942.

12. Invitation to the opening of *Modern Exhibition–Painting and Architecture*, 1943. Courtesy of Yale University Art Gallery Archives.

13. "Exhibition on Russian Architecture Now on Display in Yale Art Gallery; 200 Photographs, Maps Cover Major Trends, Including Present Plans," *Yale Daily News*, December 14, 1945.

14. Mary Roche, "Background for Living," *New York Times*, October 2, 1948. Quoted in Emily S. Warner, "Abstraction Unframed: Abstract Murals in New York, 1935–1960" (unpublished diss., University of Pennsylvania, 2017), 162. The exhibition originated from a 1948 exhibit at the New York–based Bertha Schaefer Gallery.

15. Peter Blake, "The Interrelated Arts," in *The Modern House Comes Alive, 1948–49* (New York: Bertha Schaefer Gallery, 1948), n.p. This exhibition catalogue is in the collection of the Yale Art Gallery Archives.

16. "Modernists Invade Yale Art Gallery; Exhibit Includes Harp, Snow Shovel; Duchamp Dangles Work from Ceiling Position to Create Traditions," *Yale Daily News*, March 11, 1948.

17. "Reminiscences of Hugh Moore," School of Architecture, Memorabilia, Manuscripts and Archives, Yale University Library, RU 925, Acc 2004, A 120. Quoted in Stern and Stamp, *Pedagogy and Place*, 67–68.

18. Charles H. Sawyer, "The Arts in a Liberal Education," February 23, 1948, unpublished typescript. Quoted in Brenda Danilowitz, "Teaching Design: A Short History of Josef Albers," in Horowitz and Danilowitz, *To Open Eyes*, 44.

19. See Jill Pearlman, *Inventing American Modernism: Joseph Hudnut, Walter Gropius, and the Bauhaus Legacy at Harvard* (Charlottesville: University of Virginia Press, 2007).

20. Ibid., 81.

21. University Council, "Report of the Chairman of the Committee on the Division of the Arts (Architecture, Sculpture & Painting), May 1948," 1. Eero Saarinen Papers, Manuscripts and Archives, Yale University Library, Group 593, Series II, Box 17, Folder 16.

22. Albers's aversion toward plaster casts was confirmed by Dean Charles H. Sawyer in an interview with Frederick A. Horowitz. See Horowitz Papers, Josef and Anni Albers Foundation, Bethany, CT, Box 1.

23. University Council, "Report of the Chairman," 1.

24. Ibid.

25. Josef Albers, "Historisch oder Jetzig?," was originally published in *Junge Menschen* magazine in 1924. An English translation by Russel Stockman, "Historical or Contemporary?," appeared in *Josef Albers: Minimal Means, Maximum Effect* (Madrid: Fundación Juan March, 2014), 208. I thank Brenda Danilowitz for making both the German and English versions of the text available to me.

26. Ibid.

27. Josef Albers, "Werklicher Formunterricht," *Bauhaus* 2, nos. 2/3 (1928): 3. Translation by the author.

28. Ibid.

29. Josef Albers, "Art as Experience," *Progressive Education* 12 (October 1935): n.p.

30. Josef Albers, "Concerning Art Instruction," *Black Mountain College Bulletin*, 2 (1934): 7.

31. Josef Albers quoted in Richard Rhodes, "Josef Albers, Teacher and Artist," *Yale Daily News*, April 5, 1958.

32. Ibid.

33. Albers, *Art as Experience.*

34. "Addendum: 1954 Report of Committee on the Division of the Arts," Eero Saarinen Papers, Manuscripts and Archives, Yale University Library, MS 593, Series II, Box 17, Folder 16.

35. Josef Albers, "Creative Education" (1928), in *The Bauhaus: Weimar, Dessau, Berlin, Chicago*, ed. Hans Wingler (Cambridge, MA: MIT Press, 1993), 142–43. The lecture was published as "Werklicher Formunterricht" (Practical form instruction) in the journal *Bauhaus* 2, nos. 2/3 (1928); and again, in Gothic script, in the journal *Die Arbeitschule*, no. 45 (1929): 32–36.

36. We can assume that these pieces were well known to Albers's students at Yale; several of them were in an exhibition that took place in the common room of Jonathan Edwards College in 1954.

37. Josef Albers, "One Plus One Equals Three and More: Factual Facts and Actual Facts," *Re-Search; Three Lectures by Josef Albers at Trinity College, April 1965* (Hartford, CT: Trinity College Press, 1969), 17.

38. David R. Slavitt, "Psychological Concept of Art Shown in Albers Exhibition," *Yale Daily News*, December 1, 1954.

39. See the video clip entitled "Josef Albers Teaching at Yale by John Cohen ca. 1955," Josef and Anni Albers Foundation, https://albersfoundation.org/teaching/josef-albers/introduction/.

40. See Kyley Warren, "Questions for Lauren Hinkson, Associate Curator of Collections for the Guggenheim," *Arizona Foothills Magazine*. https://www.arizonafoothillsmagazine.com/art/art-galleries/10127-q-a-a-lauren-hinkson-associate-curator-of-collections-for-the-guggenheim.html.

41. Ernst Cassirer quoted in Ernst Wolfgang Orth, "Zum Zeitbegriff Ernst Cassirers," in *Phänomenologische Forschungen*, vol. 13, *Studien zum Zeitproblem in der Philosophie des 20. Jahrhunderts* (Leipzig: Felix Meiner, 1982), 74. Original reads: "immanenten Widerspruchdes Bewußtseins selbst."

42. Ibid., 81. Original reads: "mythischen (und religiösen) Zeitgefühl."

43. Langer gave the lecture in connection with the exhibition *Symbol and Image in Modern Art and Poetry*. Clement Greenberg followed with "Imagery and Symbol," which accompanied the same exhibition.

44. Susanne Langer, *Philosophy in a New Key: A Study in the Symbolism of Reason, Rite and Art* (ca. 1942; repr., Cambridge, MA: Harvard University Press, 1951), 144.

45. Ibid., 93. Italics in the original.

46. Ibid.

47. Susanne K. Langer, *Feeling and Form: A Theory of Art* (New York: Scribner, 1953), 112. Italics in the original.

48. Ibid., 117.

49. Ibid., 93.

50. Ibid., 96.

51. Josef Albers, "Vortrag III," July 29, 1936, given at Black Mountain College on the subject of "Konstruktion- oder Material-Übungen," unpublished manuscript, Josef Albers Papers, Manuscripts and Archives, Yale University Library, MS 32, Box 27, Folder 251.

52. My discussion on potentiality is influenced by Daniel Heller-Roazen, "Editor's Introduction: 'To Read What Was Never Written,'" in *Potentialities: Collected Essays in Philosophy*, by Giorgio Agamben, ed. and trans. Daniel Heller-Roazen (Stanford, CA: Stanford University Press, 1999), 14–18.

53. Albers, "Concerning Art Instruction," *Black Mountain College Bulletin* 2 (1934): 1.

54. Anni Albers, "Work with Material," *Black Mountain College Bulletin* 5 (1938).

55. For more information about her collection of ancient textiles, see *Small-Great Objects: Anni and Josef Albers in the Americas* (New Haven: Yale University Press, 2017). See also Anni Albers, *On Weaving* (Middletown, CT: Wesleyan University Press, 1965).

56. Anni Albers, "Design: Anonymous and Timeless," *Magazine of Art* 40, no. 2 (February 1947). Reprinted in *Anni Albers: Selected Writings on Design*, ed. Brenda Danilowitz (Hanover, NH: University Press of New England, 2000), 39.

57. Clement Greenberg, "Necessity of 'Formalism,'" *New Literary History* 3, no. 1 (Autumn 1971): 171.

58. "Greenberg Scores Abstract Art Critics, Stresses Quality as Criterion of Judging," *Yale Daily News*, May 13, 1954.

59. The essay "Modernist Painting" first appeared in a 1960 pamphlet published by Voice of America after it was broadcast that spring. It was subsequently republished in slightly revised form in *Art and Literature* 4 (Spring 1965) and *The New Art: A Critical Anthology*, ed. Gregory Battcock (1966), and in several other anthologies. The citation is from *Modern Art and Modernism: A Critical Anthology*, ed. Francis Franscina and Charles Harrison (New York: Harper and Row, 1982), 9.

60. Anni Albers, "Early Techniques of Thread Interlacing," in *On Weaving*, 52.

61. Ibid.

62. See Gottfried Semper, *Style in the Technical and Tectonic Arts; Or, Practical Aesthetics* (1863; repr., Santa Monica, CA: Getty Research Institute, 2004).

63. Anni Albers, "Constructing Textiles," *Design* 47, no. 8 (1946): 22

**CHAPTER 5
LOUIS I. KAHN AND PAUL WEISS**

1. Charles H. Sawyer quoted in Robert A. M. Stern and Jimmy Stamp, *Pedagogy and Place: 100 Years of Architecture Education at Yale* (New Haven: Yale University Press, 2016), 78.

2. Ibid., 89.

3. Kahn got the job after the original architect, Philip L. Goodwin, resigned in 1951 due to poor health, and Eero Saarinen declined the commissions based on a recommendation by George Howe, then-chairman of the Department of Architecture. See Philip L. Goodwin, "Memorandum: The Yale Art Gallery, 1941–1953," January 26, 1953, School of Art and Architecture, Manuscripts and Archives, Yale University Library, RU 189, Box 1, Folder 1.

4. In the 1940s Kahn worked for the Resettlement Administration and George Howe, and he later formed a partnership with Oscar Stonorov.

5. Joseph Hudnut was the dean of the Harvard Graduate School of Design from 1936 until 1953. The American Society of Planners and Architects was active between 1943 and 1948. Eero Saarinen was also a member.

6. Lewis Mumford, *The Culture of Cities* (New York: Harcourt and Brace, 1938), 137. Sigfried Giedion, George Nelson, Philip L. Goodwin, and Ernest Fiene also spoke about the topic at the symposium.

7. Paul Zucker, "The Role of Architecture in Future Civilization," *Journal of Aesthetics and Art Criticism* 3, nos. 9/10 (1944): 30.

8. See Paul Zucker, "The Paradox of Architectural Theories at the Beginning of the 'Modern Movement,'" *Journal of the Society of Architectural Historians* 10, no. 3 (1951): 8–14.

9. Sarah Williams Goldhagen, *Louis Kahn's Situated Modernism* (New Haven: Yale University Press, 2001), 29.

10. Kahn, "Monumentality," in Paul Zucker, *New Architecture and City Planning* (New York: Philosophical Library, 1944), 578.

11. See Joan Ockman's introduction to Louis I. Kahn's 1944 essay "Monumentality," in *Architecture Culture, 1943–1968: A Documentary Anthology*, ed. Joan Ockman with Edward Eigen (New York: Rizzoli, 1993), 47.

12. Alois Riegl, "The Modern Cult of Monuments: Its Character and Its Origin" (1903), in *Oppositions* 25 (1982): 24.

13. Kahn, "Monumentality," in Zucker, *New Architecture and City Planning*, 579.

14. Walter Gropius, [extract from a speech delivered at] "What Is Happening to Modern Architecture?: A Symposium at the Museum of Modern Art," *Bulletin of the Museum of Modern Art* 15, no. 3 (1948): 11.

15. Lewis Mumford, [extract from a speech delivered at] ibid., 18.

16. Louis Kahn, "Advanced Design Problem II (Fall 1948), A Suburban Residence," undated manuscript, Louis I. Kahn Collection, University of Pennsylvania, Philadelphia, Folder 030.11.A.60.26.

17. Charles Sawyer, "Proposal for Collaborative Problem to Be Discussed at Meeting Saturday, July 9, 1949," copy of typescript with annotations by Louis I. Kahn, Louis I. Kahn Collection, University of Pennsylvania, Philadelphia, Folder 030.11.A.61.27.

18. Ibid.

19. Louis I. Kahn, "Collaborative Problem—1949: The Idea Center for Plastics," manuscript dated "8.11" [1949], School of Art and Architecture, Manuscripts and Archives, Yale University Library, RU 189, Acc 2002-A-099, Box 7.

20. Ibid.

21. Sarah Williams Goldhagen discusses Kahn's relationship to abstract art in *Situated Modernism*. See the chapter "Kahn and Presentational Aesthetic" in ibid., 49–50.

22. Katherine S. Dreier, "'Intrinsic Significance' in Modern Art" (lecture, Yale Art Gallery, March 5, 1948), Manuscripts and Archives, Yale University Library, RU 189, Acc 96-A-018, Box 3. Published in Katherine S. Dreier, *Three Lectures on Modern Art: Katherine S. Dreier, James J. Sweeney,*

*Naum Gabo,* ed. Charles Sawyer (New York: New York Philosophical Society, 1949), 1–30.

23. Kahn, "Collaborative Problem—1949."

24. Notes on the studio "An Idea Center for Plastics" in Louis I. Kahn Collection, University of Pennsylvania, Philadelphia, 030.11.A 60.26.

25. For more information about the exhibition, see "Gallery to Exhibit Plastics, Textiles; Display Shows Progress in Modern Art, Industry," *Yale Daily News,* December 6, 1949.

26. Josef Albers, "The Educational Value of Manual Work and Handicraft," in Zucker, *New Architecture and City Planning,* 694.

27. Saarinen had just received a commission to design the massive General Motors Tech Campus and felt the office did not have the capacity to take on another project at the time.

28. Goodwin, "Memorandum."

29. Anni Albers, "The Pliable Plane: Textiles in Architecture," *Perspecta* 4 (1957): 36.

30. Louis I. Kahn, "Order and Form," *Perspecta* 3 (1955): 47.

31. Anni Albers, "Work with Material," *Black Mountain College Bulletin* 5 (1938): 2. Italics in the original.

32. Josef Albers, "Design as Visual Organization," special issue, "Arts at Yale," *Yale Alumni Magazine* (April 1950), reprinted in *Search versus Re-Research* (Hartford, CT: Trinity College Press, 1969), 31.

33. Louis Kahn, "Order and Form," *Perspecta* 3 (1955): 59. Boldface and spacing in the original.

34. This paragraph is informed by Dwight L. Bolinger, "More on the Present Tense in English," *Language* 3, no. 4 (October–December 1947): 434–36.

35. Louis Kahn, "Architecture Is the Thoughtful Making of Spaces," *Perspecta* 4 (1957): 2–3.

36. Josef Albers, "Abstract—Presentational," in *American Abstract Artists* (New York: Ram, 1946), 240. Boldface in the original.

37. Louis Kahn, "Letter to 'Professor and Mrs. Josef Albers,'" December 27, 1957, Louis I. Kahn Collection, University of Pennsylvania, Philadelphia, 030.11.A.61.27.

38. Howe retired in 1954 and died the following year.

39. For more about the history of *Perspecta,* see Robert A. M. Stern, "Introduction," in [*Re*]*reading* Perspecta: *The First 50 Years of the Yale Architectural Journal* (Cambridge, MA: MIT Press, 1994); and Stern and Stamp, *Pedagogy and Place,* 130.

40. George Howe, "Training for the Practice of Architecture: A Speech Given before the Department in September 1951," *Perspecta* 1 (1952): 4. Italics in the original.

41. See A. Whitney Griswold, *Liberal Education and the Democratic Idea* (New Haven: Yale University Press, 1959), 121.

42. Howe, "Training for the Practice of Architecture," 2.

43. Ibid., 3.

44. Ibid., 4–5.

45. Alfred North Whitehead, "The Aims of Education" (1916), in *Daedalus* 88, no. 1 (Winter 1959): 192.

46. Ibid., 194.

47. Ibid.

48. One of Weiss's popular undergraduate courses was called "Nature, Man, and Society."

49. Paul Weiss, "Being, Essence and Existence," *Review of Metaphysics* 1, no. 1 (September 1947): 69.

50. Paul Weiss, "Time and the Absolute," *Journal of Philosophy* 32, no. 11 (November 23, 1935): 287.

51. Ibid., 288. Italics in the original.

52. "Weiss Lectures on Philosophy, Architecture; Asks Artists Understanding of Past, Future," *Yale Daily News,* October 3, 1951.

53. Introductory remarks to "On the Responsibility of the Architect; Roundtable Discussion with Philip Johnson, Louis Kahn, Vincent Scully, Pietro Belluschi and Paul Weiss," *Perspecta* 2 (1953): 45.

54. Paul Weiss cited in ibid., 51.

55. Ibid., 51–52.

56. Ibid., 52.

57. Ibid.

58. Ibid.

59. Louis Kahn, lecture given at the Aspen Design Conference, Aspen, CO, 1972, in Richard Saul Wurman, *What Will Be Has Always Been: The Words of Louis I. Kahn* (New York: Rizzoli, 1986), 157.

60. Paul Weiss, "History and the Historian," *Journal of Philosophy* 42 (March 29, 1945): 169.

61. "CIAM Meeting at Locust Valley, May 3, 1953." Quoted in Eric Mumford, *The CIAM Discourse on Architecture and Urbanism, 1928–1960* (Cambridge, MA: MIT Press, 2011), 226.

## CHAPTER 6
## EERO SAARINEN AND GEORGE KUBLER

1. Letter from Gilmore D. Clarke to William W. Wurster, February 24, 1948. Quoted in William Graebner, "Gateway to the Empire: An Interpretation of Eero Saarinen's 1948 Design for the St. Louis Arch," *Prospects* 18 (1993): 368.

2. See "St. Louis Arch for Memorial Called Fascist," *New York Herald Tribune,* February 26, 1948, Eero Saarinen Papers, Manuscripts and Archives, Yale University Library.

3. "Arch Argument: St. Louis Memorial Starts Architectural Squabble," *Life,* March 8, 1948, 113.

4. Letter from Eero Saarinen to William W. Wurster, March 1, 1948, Eero Saarinen Papers (MS 593), Manuscripts and Archives, Yale University Library. I thank Jessica Quagroli for bringing this letter to my attention.

5. "Jefferson and Mussolini," *New York Herald Tribune,* February 27, 1948.

6. "Statement by the Jury of Award on the Winning Design in the Jefferson National Expansion Memorial Competition," signed by Herbert Hare, Fiske Kimball, Louis La Beaume, Charles Nagel, Jr., Richard J. Neutra, Roland A. Wank, and William W. Wurster (chairman of the jury), n.d., Eero Saarinen Papers (MS 593), Manuscripts and Archives, Yale University Library.

7. Eero Saarinen, "Saarinen Tells How 'Gateway' Was Conceived," *St. Louis Post-Dispatch,* March 7, 1948.

8. "An Arch, Is an Arch, Architects Archly Agree," *New York Herald Tribune,* April 4, 1948.

9. Kenneth K. Stowell, "Precedents, Prototypes and Plagiarism," *Architectural Record* 103 (April 1948): 91.

10. The widely influential symposium drew some sixty speakers from across

disciplines to discuss proportional theories in September, among them keynote speakers Rudolf Wittkower and Le Corbusier, whose respective books, *Architectural Principles in the Age of Humanism* (1949) and *Le Modulor, essai sur une mesure harmonique à l'échelle humaine, applicable universellement à l'architecture et à la mécanique* (*The Modulor: A Harmonious Measure to the Human Scale Universally Applicable to Architecture and Mechanics*, 1950), had launched an interest among modern architects to search for a transhistorical and universally applicable formal principle that would moderate modern architecture's technological and functional imperative with a timeless mathematical formula.

11. See Eero Saarinen, "Golden Proportions" (1953), in *Eero Saarinen: Shaping the Future*, ed. Eeva-Liisa Pelkonen and Donald Albrecht (New Haven: Yale University Press, 2006), 342–43.

12. Focillon taught at the Sorbonne and Yale in alternating semesters. He was at Yale during the spring 1936 semester, which makes it likely he attended Eliel Saarinen's lecture.

13. Eliel Saarinen, *The Search for Form in Art and Architecture* (1948; repr., New York: Dover, 1985), 1.

14. Edward Herbert Thompson, *People of the Serpent* (London: Putnam, 1932).

15. Saarinen, *Search for Form in Art and Architecture*, 181.

16. Ibid., 174–75.

17. Ibid., 180. Boldface in the original.

18. Ibid., 181.

19. Ibid., 157. Boldface in the original.

20. Ibid.

21. Ibid., 157.

22. Eero Saarinen, "Saarinen," *Perspecta* 7 (1961): 30.

23. Ibid., 30–31.

24. The Saarinen family studio-home, Hvitträsk, was completed in 1901, and the Cranbrook campus in stages over a roughly fifteen-year period from 1925 through the early 1940s.

25. Saarinen designed gargoyles, iron gates, and custom-made furniture for various buildings on the Cranbrook campus.

26. Here I am referring to William Harlan Hale's article "Art vs. Yale University," *Harkness Hoot* (November 15, 1930),

and Henry-Russell Hitchcock's book *Modern Architecture: Romanticism and Reintegration* (New York: Payson and Clark, 1929). Saarinen took classes on Renaissance, Greek, and Roman architecture at Yale College. For further information about Saarinen's studies at Yale, see Pelkonen and Albrecht, *Shaping the Future*.

27. A letter from Eero Saarinen to Dean Everett Victor Meeks, written in 1936, makes his appreciation of Dudok evident. Quoted in Pelkonen and Albrecht, *Shaping the Future*, 235n10. For who was included in the category "new traditionalism," see Hitchcock, *Modern Architecture*, 127.

28. "Piety in Brick," *Time*, January 27, 1941, 39.

29. "Architecture for the Future: GM Constructs a 'Versailles of Industry,'" *Life*, May 21, 1956, 102–7.

30. Aline Louchheim, "The Maturing Modern," *Time*, July 2, 1956, 54.

31. "The Steady Hand," *Time*, June 11, 1951, 76–84.

32. "Uris Hall: An Opportunity Missed," *Columbia Daily Spectator*, May 8, 1964. The full quote reads: "What is wrong with architecture and planning at Columbia? Will it continue in the same vein, leaving Yale to become the veritable museum of buildings by contemporary architectural giants, and Harvard to furnish the United States with its first building by Le Corbusier?"

33. Letter from the Yale Department of Art History to Griswold advocating for Saarinen's design. Alfred Whitney Griswold, president of Yale, Manuscripts and Archives, Yale University Library, RU 22, YRG 2-A, Box 36, Folder 332.

34. "Rink Quotes," *Yale Hockey Letter*, December 1958, 5.

35. "At the Rink," *Yale Daily News*, September 18, 1958.

36. See David R. Finkle, "Saarinen's Designs for New Colleges Put Construction Cost at $6,200,000," *Yale Daily News*, November 12, 1959.

37. Saarinen quoted in ibid.

38. Eero Saarinen, "Individualism in a New Artistic Vocabulary," *Yale Daily News*, November 12, 1959.

39. See Sibyl Moholy-Nagy, "Double House, New Hope, Pennsylvania," in *Native Genius in Anonymous Architecture* (New York: Horizon, 1957), 178–79.

40. Reyner Banham and Walter McQuade, "New Yale Colleges," *Architectural Forum* (December 1962): 110.

41. I am grateful to Kubler's daughter, Cornelia Kubler Kavanagh, for this information. For more about Saarinen's involvement with Yale University, see "Chronology," in Pelkonen and Albrecht, *Shaping the Future*, 323–39.

42. George Kubler, Focillon Method, January 5, 1940, 1–2/2, George Alexander Kubler Papers (MS 843), Manuscripts and Archives, Yale University Library.

43. George Kubler, lecture notes, January 26, 1940, 2/3, George Alexander Kubler Papers (MS 843), Manuscripts and Archives, Yale University Library.

44. George Kubler, *The Shape of Time: Remarks on the History of Things* (New Haven: Yale University Press, 1962), 1.

45. Ibid., 72.

46. Ibid., 19. Italics in the original.

47. Ibid., 19.

48. See the chapter "Prime Objects and Replications" in ibid., 39–53.

49. Paul Weiss, "The Perception of Stars," *Review of Metaphysics* 6, no. 2 (December 1952): 238.

50. Kubler, *Shape of Time*, 2.

51. Ibid., 82.

52. Ibid., 124.

53. Ibid., 17.

54. Robert Smithson, "Ultramoderne," *Arts Magazine* 42, no. 1 (September 1967): 31–33. For more information about Kubler's influence on 1960s art, see Pamela M. Lee, "Ultramoderne: Or, How George Kubler Stole the Time in Sixties Art," in *Chronophobia: On Time in Art of the 1960s* (Cambridge, MA: MIT Press, 2004), 46–77.

55. "A Modern Architect's Own House: The Eero Saarinen Remade House, Victorian Outside, Modern Inside," *Vogue*, April 1, 1960, 174.

56. Robert Joseph Horvitz, "A Talk with George Kubler," *Art Forum* (October 1973): 32.

# CHAPTER 7
# PAUL RUDOLPH AND SIBYL MOHOLY-NAGY

1. George Kubler, *The Shape of Time: Remarks on the History of Things* (New Haven: Yale University Press, 1962), 6.

2. See Timothy M. Rohan, "Humanism, Yale, New Haven," in *The Architecture of Paul Rudolph* (New Haven: Yale University Press, 2014), 56–113.

3. Walter Gropius, "Blueprint of an Architect's Education" (1943). Quoted in Wilfried Nerdinger, "From Bauhaus to Harvard: Walter Gropius and the Use of History," in *The History of History in American Schools of Architecture 1865–1975*, ed. Gwendolyn Wright and Janet Parks (New York: Princeton Architectural Press, 1990), 89.

4. Paul Rudolph, "New Directions," *Perspecta* 1 (1952): 21.

5. Paul Rudolph quoted in Rohan, *Architecture of Paul Rudolph*, 14.

6. See Eeva-Liisa Pelkonen, "Reading Aalto through the Baroque," *AA Files* 65 (2012): 72–75.

7. Joseph Hudnut, "Architecture Discovers the Present," *American Scholar* 7, no. 1 (Winter 1938): 108.

8. Sibyl Moholy-Nagy, *The Architecture of Paul Rudolph* (New York: Praeger, 1970).

9. Sibyl Moholy-Nagy, "The Future of the Past," *Perspecta* 6 (1961): 66.

10. Rudolph, "New Directions," 21.

11. Scott's book was reprinted in 1947, 1952, and 1954 and again in 1961 and 1969. Rudolph probably owned a copy of the 1952 Doubleday edition. Alina A. Payne compares Wittkower to Scott in her article "Rudolf Wittkower and Architectural Principles in the Age of Modernism," *Journal of the Society of Architectural Historians* 53, no. 3 (1994): 322–42. For more discussion about Scott's impact, see Raúl Martínez, "Geoffrey Scott and Modern Architectural Thought," *Journal of the History of Ideas* 80, no. 4 (October 2019): 597–619.

12. See Payne, "Wittkower and Architectural Principles," 330.

13. See Paul Rudolph, "Architecture: The Unending Search" (1958), in *Paul Rudolph: Writings on Architecture*, ed. Nina Rappaport (New Haven: Yale School of Architecture, 2008), 39.

14. Geoffrey Scott, *The Architecture of Humanism: A Study in the History of Taste* (New York: Scribner, 1924), 60.

15. Ibid., 61.

16. Paul Rudolph, "The Changing Philosophy of Architecture" (*Architectural Forum*, July 1954), in Rappaport, *Writings on Architecture*, 17.

17. Le Corbusier, *Toward an Architecture* (1922), trans. John Goodman (Santa Monica, CA: Getty Research Institute, 2007), 212.

18. See the subhead "Down with the Tyranny of the Endless Streets" in Rudolph, "Changing Philosophy of Architecture," 16.

19. Rudolph, "Changing Philosophy of Architecture," 16.

20. Camillo Sitte, *The Art of Building Cities: City Building According to Its Artistic Fundamentals* (New York: Reinhold, 1945), 16–17. Quoted in Rudolph, "Changing Philosophy of Architecture," 17.

21. Rudolph, "Changing Philosophy of Architecture," 14.

22. Scott, *Architecture of Humanism*, 177.

23. Susanne K. Langer, *Feeling and Form* (New York: Scribner, 1953), 36.

24. In Robert E. Innis, *Susanne Langer in Focus: The Symbolic Mind* (Bloomington: Indiana University Press, 2009), 1. Innis defines Langer's take on art as a "continuous process of meaning-making effected through processes of symbolic transformation of experience."

25. Paul Rudolph, "Architecture: The Unending Search" (1958), in Rappaport, *Writings on Architecture*, 39.

26. Ibid., 41.

27. Paul Rudolph, "The Six Determinants of Architectural Form," *Architectural Record* 12 (October 1956): 186.

28. Paul Rudolph, "Enigmas of Architecture," special issue on Paul Rudolph, *Architecture and Urbanism* (July 1977), n.p.

29. For more on the reception of Wittkower's book among architects, see Henry A. Millon, "'Architectural Principles in the Age of Humanism': Its Influence on the Development and Interpretation of Modern Architecture," *Journal of the Society of Architectural Historians* 31, no. 2 (May 1972): 83–91.

30. Alison and Robert Smithson, "Report on a Debate . . . ," *RIBA Journal* 64 (1957): 460–61. Quoted in Millon, "'Architectural Principles,'" 86.

31. Rudolph, "Six Determinants of Architectural Form," 186.

32. Rudolph, "Changing Philosophy of Architecture," 14.

33. Payne, "Wittkower and Architectural Principles," 331.

34. Ibid., 324.

35. Andre Malraux, *The Voices of Silence* (New York: Doubleday and Company, 1953), 24. Many contemporaneous critics noted Malraux's indebtedness to Focillon. See, for example, a review by Francis Henry Taylor, "The Undying Life in the Work of Art," *New York Times*, November 22, 1953.

36. Geoffrey H. Hartman, "The Taming of History: A Comparison of Poetry with Painting Based on Malraux's *The Voices of Silence*," *Yale French Studies* 18 (1957): 114.

37. Rudolph, "Six Determinants of Architectural Form," 185, 187.

38. Matthew Nowicki quoted in ibid., 186.

39. J. M. Richards quoted in ibid.

40. Ibid., 188.

41. Ibid.

42. Sibyl Moholy-Nagy, "Style and Materials," *Progressive Architecture* 35 (October 1954): 97. Quoted in Judith Paine, "Sibyl Moholy-Nagy: A Complete Life," *Archives of American Art Journal* 15, no. 4 (1975): 11.

43. Sibyl Moholy-Nagy, *Matrix of Man: An Illustrated History of Urban Environment* (New York: Praeger, 1968), 12.

44. Sibyl Moholy-Nagy, "Environment and Anonymous Architecture," *Perspecta* 3 (1955): 77.

45. I borrow the expression "counter-image" from Hilde Heynen, "Anonymous Architecture as Counter-Image: Sibyl Moholy-Nagy's Perspective on American Vernacular," *Journal of Architecture* 13 (2008): 469–91.

46. Moholy-Nagy, "Environment and Anonymous Architecture," 3.

47. André Malraux, *The Twilight of the Absolute* (New York: Pantheon, 1950), 154.

48. Moholy-Nagy, "Environment and Anonymous Architecture," 77.

49. Ibid.

50. In his 1841 essay "History," Emerson wrote: "A man is the whole encyclopedia of facts. The creation of a thousand forests is in one acorn, and Egypt, Greece, Rome, Gaul, Britain, America, lie folded already in the first man."

Reprinted in Ralph Waldo Emerson, *Selected Essays* (New York: Penguin, 1981), 150.

51. Moholy-Nagy, *Native Genius in Anonymous Architecture*, 19.

52. Moholy-Nagy, "Future of the Past," 66.

53. Ibid., 76.

54. See Francesca Ammon, *Bulldozer: Demolition and Clearance of the Postwar Landscape* (New Haven: Yale University Press, 2016), which chronicles the tearing down of many of New Haven's urban neighborhoods during that time.

55. I thank Professor Emeritus Alexander Purves, who studied under Paul Rudolph during the late 1950s and early 1960s, for sharing this information. See also Allan Greenberg, "Introduction, Fragment of an Autobiography," in *Architecture of Democracy* (New York: Rizzoli, 2006), 18.

56. Rohan, *Architecture of Paul Rudolph*, 69.

57. Sibyl Moholy-Nagy, "Introduction," in *Architecture of Paul Rudolph*, 18.

58. Rudolph gained three commissions from Yale University: Greeley Memorial Laboratory (1957), Married Graduate Student Housing (1960), and the Art and Architecture Building (1963).

59. Rudolph, "Six Determinants of Architectural Form," 184.

60. Christopher S. Wood used this wonderful expression when discussing Focillon's historical schemata in *A History of Art History* (Princeton: Princeton University Press, 2019), 383.

61. Gillian Beer, "Mathematics: Alice in Time," *Nature* (November 2, 2011): 38.

62. Mari Lending, *Plaster Monuments: Architecture and the Power of Reproduction* (Princeton: Princeton University Press, 2017), 216.

63. Sibyl Moholy-Nagy, "Measure: Yale's Art and Architecture Building," *Architectural Forum* (February 1964): 77.

64. Ibid., 77–78.

65. Ibid., 79.

66. Ibid., 77.

## CHAPTER 8
## VINCENT SCULLY

1. Yehuda Safran and Daniel Sherer, "An Interview with Vincent Scully," *Potlatch*, 4 (Spring 2016): 2. I thank Daniel Sherer for gifting me a copy of this journal. Italics in the original.

2. James Stevenson, "Profiles: What Seas What Shores" (interview with Vincent Scully), *New Yorker*, February 18, 1980, 43.

3. Stevenson, "Profiles," 57.

4. Philip C. Johnson quoted in "Vincent Scully: An Artistic Showman," *Yale Daily News*, November 13, 1959.

5. Vincent Scully cited in "On the Responsibility of the Architect," *Perspecta* 2 (1953): 53.

6. Jacob A. Arlow, "Psychoanalysis and Time," *Journal of American Psychoanalytic Association* 34, no. 3 (June 1, 1986): 507–28.

7. The Mellons heard Jung speak at the Analytical Psychology Club of New York in 1937 and subsequently spent half a year studying with him in Switzerland. See William Hoffman, *Paul Mellon: Portrait of an Oil Baron* (Chicago: Follett, 1974), 106–7.

8. Andrew Causey, "Herbert Read and Contemporary Art," in *Herbert Read Reassessed*, ed. David Goodway (Liverpool: Liverpool University Press, 1998), 140. For more on Jung's take on art, see *Jung on Art: The Autonomy of the Creative Drive*, ed. Tjeu van den Berk (New York: Psychology, 2012).

9. Herbert Read, "Preface," in *Forty Thousand Years of Modern Art: A Comparison of Primitive and Modern*, ed. W. G. Archer, Robert Melville, and Herbert Read (London: Institute of Contemporary Arts, 1948). Quoted in Maria Stavrinaki, *Transfixed by Prehistory: An Inquiry into Modern Art and Time* (New York: Zone Books, 2022), 203. Italics in the original.

10. Herbert Read, inaugural speech "ICA: Forty Thousand Years of Modern Art Exhibition," quoted in Stavrinaki, *Transfixed by Prehistory*, 202–3.

11. Susanne K. Langer, *Philosophy in a New Key: A Study in the Symbolism of Reason, Rite and Art* (Cambridge, MA: Harvard University Press, 1942).

12. "Four Art Lectures Will Be Presented by English Writer; Herbert Read to Discuss Social Aspects of Art Beginning Next Week," *Yale Daily News*, March 15, 1946.

13. "Effect of Symbolism in Art Defined in Ryerson Lecture," *Yale Daily News*, May 7, 1954.

14. Vincent Scully, "Archetype and Order in Recent American Architecture," *Art in America* 42 (December 1954): 254.

15. Jason B. Jones, "The Time of Interpretation: Psychoanalysis and the Past," *Postmodern Culture* 14, no. 3 (May 2004): doi:10.1353/pmc.2004.0019.

16. Scully, "Archetype and Order," 252.

17. I adopted the concept of "pre-architecture" from Spyros Papapetros, "Pre/post/erous Histories," e-flux (November 2018), https://www.e-flux.com.

18. Scully, "Archetype and Order," 251.

19. Vincent Scully, "Modern Architecture: Toward a Redefinition of Style," *Perspecta* 4 (1957): 7.

20. See Bakhtin's 1937 essay "Forms of Time and of the Chronotope in the Novel," reprinted in English in Mikhail Bakhtin, *The Dialogic Imagination: Four Essays* (Austin: University of Texas Press, 1981), 84–258.

21. Scully, "Modern Architecture," 10.

22. "Scully Cites Time Element in Contemporary Architecture," *Yale Daily News*, October 28, 1955.

23. Vincent Scully, "Bibliographical Note," in *Modern Architecture: The Architecture of Democracy* (New York: George Braziller, 1961), 136.

24. Hannah Arendt quoted in "Dr. Arendt Compares History with Sciences in Address," *Yale Daily News*, January 14, 1955.

25. Siegfried Kracauer, *History: The Last Things before the Last* (New York: Oxford University Press, 1969), 6; Sibyl Moholy-Nagy, "The Future of the Past," *Perspecta* 7 (1961): 65–76.

26. See Hal Foster, "Archives of Modern Art," *October* 99 (Winter 2002): 81–90, for more discussion about the shift from historical to discursive contextualization of artistic practice.

27. Robert Venturi, *Complexity and Contradiction in Architecture*, 2nd ed. (New York: Museum of Modern Art, 1992), 16.

28. Robert Venturi, "Complexity and Contradiction in Architecture: Selections from a Forthcoming Book," *Perspecta* 9/10 (1965): 18.

29. The layout appears on page 63 of Venturi, *Complexity and Contradiction in Architecture*.

30. Vincent Scully, "Doldrums in the Suburbs," *Perspecta* 9/10 (1965): 290. Italics in the original.

31. Vincent Scully, *American Architecture and Urbanism* (New York: Praeger, 1969), 215.

32. George Kubler, "What Can Historians Do for Architects?," *Perspecta* 9/10 (1965): 300.

33. Ibid., 301.

34. Ibid., 300.

35. Harold Bloom, *The Anxiety of Influence: A Theory of Poetry* (New York: Oxford University Press, 1997), 5.

36. Vincent Scully, *The Shingle Style Today: Or, The Historian's Revenge* (New York: George Braziller, 1974), 4.

37. Ibid., 21.

38. Ibid., 2.

39. Ibid.

40. Ibid., 3.

41. James S. Ackerman, *Origins, Imitation, Conventions: Representation in the Visual Arts* (Cambridge, MA: MIT Press, 2002), 136.

42. Harold Bloom, "Freud, the Greatest Modern Writer," *New York Times*, March 23, 1986.

## POSTSCRIPT

1. Sigfried Giedion, *The Eternal Present: The Beginnings of Art. A Contribution on Constancy and Change* (New York: Bollingen, 1962), 7.

2. Ibid.

3. Cici Zhang, "The Country Building 'A New London' Every Year," BBC, June 11, 2020, https://www.bbc.com/future/article/20200610-how-china-can-cut-co2-emissions-with-sustainable-buildings.

4. See François Hartog's discussion of this issue of temporal confusion in "Presentism: Stopgap or New State?," in *Regimes of Historicity: Presentism and Experiences of Time* (New York: Columbia University Press, 2015), xiii–xix.

5. Melissa DelVecchio was in charge of the project at the New York–based Robert A. M. Stern Architects.

6. See Taylor Dafoe, "Yale Is Eliminating Its Art History Survey Course over Complaints That It Prioritizes a White, Western Canon over Other Narratives," *Artnet*, January 27, 2020, https://news.artnet.com/art-world/yale-art-history-eliminating-survey-course-1763082.

7. Frederick Cooper, *Colonialism in Question: Theory, Knowledge, History* (Berkeley: University of California Press, 2005), 149. Quoted in Lynn Hunt, "Globalization and Time," in *Breaking Up Time: Negotiating the Borders between Past, Present and Future*, ed. Chris Lorenz and Berber Bevernage (Göttingen: Vandenhoeck and Ruprecht, 2013), 211. I thank Änne Söll for bringing this article to my attention.

8. Nikole Hannah-Jones et al., "The 1619 Project," *New York Times Magazine*, August 14, 2019.

9. Ytasha L. Womack, *Afrofuturism: The World of Black Sci-Fi and Fantasy Culture* (Chicago: Lawrence Hill, 2013), 2.

10. "Before Yesterday We Could Fly: An Afrofuturist Period Room," Metropolitan Museum of Art, https://www.metmuseum.org/exhibitions/listings/2021/afrofuturist-period-room. I thank Änne Söll for bringing this project to my attention when it was still under construction.

# Index

Page numbers in *italics* indicate illustrations.

Aalto, Alvar, 2, 40, 80
Ackerman, James 182
Adams, Henry, 47
*aeon*, 77
*aesthēsis*, 97
Afrofuturism, 184–85
age value, 106
Albers, Anni, *82, 98*
    "Constructing Textiles," 101
    "Design: Anonymous and Timeless," 99
    "Early Techniques of Thread Interlacing," 100
    Museum of Modern Art, retrospective at, 81
    *On Weaving*, 97
    *Open Letter*, 98
    "Pliable Plane, The" 111–13
    "Work with Material," 97, 113–14
Albers, Josef, *82*
    "Art as Experience," 90–91
    Black Mountain School, 34, 81
    Collaborative Design Problem class, 108–10
    "Concerning Art Instruction," 97
    "Creative Education," 33, 91
    "Educational Value of Manual Work and Handicraft, The," 110–11
    "Historisch oder Jetzig?," 90
    "Homage to the Square," 147
    Metropolitan Museum of Art, 81
    photo-collages of, 93, *94*
    *Structural Constellation* series, 92, *92, 109, 109*
    *Vorkurs*, 33, 89
    "Werklicher Formunterricht," 33, 90, 91, 97
    Yale curriculum and, 88–90
American Institute of Architects, Boston conference of, 151–52
anti-materialism, 97
anti-modernism, 47
Archipenko, Alexander, 82, 110
Architects Committee of the National Council of American–Soviet Friendship, 86
Architectural Research Group, 105
Arendt, Hannah, 2, 176

Arlow, Jacob A., 170
art nouveau, 87
Arts and Crafts movement, 87
Ashbee, C. R., 37
Aspen Design Conference, 122–23
Asplund, Gunnar, 40
atavistic echo, 132
aura, 47, 73–74
Austin, Henry, 61, *61*
autotelic, 77

Bachelard, Gaston, 176
Badiou, Alain, 2–3
Bakhtin, Mikhail, 51, 174
Baldessari, John, 147
Banham, Reynar, 142–43
baroque, 76–80
Barr, Alfred H., Jr., 33, 82, 107
Baudelaire, Charles, 71–72
Bauhaus, 7, 81, 87, 90, 172
Beaux-Arts Institute of Design (BAID), 8
Beaux-Arts, 7, 12, 24, 27, 30, 33, 42, 68, 82, 104, 122
Bell, Clive, 116
Benjamin, Walter, 73, 76, 78
Bergson, Henri, 36, 48, 70, 72, 90, 96, 132
Betsky, Aaron, 59
Black Lives Matter, 184
Blake, Casey Nelson, 15
Bloch, Marc, 76
Bloom, Harold, 11–12, 179–81
Borromini, Francesco, 78–79
Brancusi, Constantin, 80
Breuer, Marcel, 88, 105
Brooks, Cleanth, 11, 177
Brooks, Turner, 181, *182*
Brooks, Van Wyck, 15
Brown, Denise Scott, *180*, 181
Bunshaft, Gordon, 153

Cassirer, Ernst, 2, 93–94
caves, 153, 158, 171, 174
Chicago pragmatists, 59
*Chicago Tribune* competition, 37, *38*, 47, 57
Chillman, Helen, 10
chronophobia, 16, 51, 118–19, 175–79
chronotopos, 51, 174
Clark, Michael D., 47
Clarke, Gilmore D., 125
cognitive architecture, 105–11

collective memory, 176
Collegiate Gothic style, 21, 43–44, 50–51, 55, 120, 149
Columbia University, 25, 35, 47–48, 50, 52–53, 88, 93, 105
Congrès Internationaux Architecture Moderne (CIAM), 123
constituent facts, 18, 41
contemporary history, 19
Corn, Wanda M., 14
Cram, Ralph Adams, 28, 32, 48, 63–65, 68, 137
Cranbrook, 7, 40, *133*

d'Ors, Eugenio, 77–78
*Daseinsform*, 93, 95
*Degenerate Art* exhibition, 83
*Denkkollektiv*, 2
*Denkstil*, 118
Dewey, John, 27–28, 59–60, 90
Dreier, Katherine S., 33, 82–83, *83*, 109–10
Duchamp, Marcel, 9, 82, 87
Dudok, W. M., 135–36
*durée*, 13, 36, 41, 72, 131–32

Einstein, Albert, 18–19, 72
élan vital, 48, 70
Eliot, T. S., 13–15, 100
Emerson, Ralph Waldo, 158, 27–28
eternity, 15, 73, 74, 106, 118

Federal style, 3, 5, 53
Floyd, George, 184
Focillon, Henri, 8, 47, 68–80, *69*, 72, *74*, 106
 "À nos amis d'Amérique," 74–75
 "Art Populaire," 70–71
 Department of the History of Art, 68
 *Embouchure de l'oder à quimper*, 73, *73*
 *La vie des forms*, 8, 68, 70
 USA, 74, 75
Fogg method, 31
formalism, 7–11
 art historical, 7–9, 14, 30, 130, 168–69
 literary, 11–12, 14, 179–80
form-migration, 131
form sense, 151
French, Robert Dudley, 4–6
French Annales school, 76
Freud, Sigmund, 16, 18, 74, 170, 172, 182
Freyssinet, Eugène, 34, 124, 127
Fuller, Buckminster, 42, 111, *112*

Gesamtkunstwerk, 85, 87, 133
*Gestalltungskraft*, 80

Giedion Sigfried
 "Art[,] a Fundamental Experience," 171
 *Eternal Present, The*, 183
 *Forty Thousand Years of Modern Art*, 170–71
 *Modern Exhibition—Painting and Architecture*, 85–86
 *Space, Time and Architecture*, 17–18, 19, 78, 85–86, 117, 150
 Trowbridge Lectures, 41
Goethe, Wolfgang von, 44–48, 152
Goldberger, Paul, 53
Goldhagen, Sarah Williams, 106
Gothic, 3–4, 20, 44–65
 *See also* Collegiate Gothic
Greenberg, Clement, 99–100, 177
Griswold, Alfred Whitney, 116, 138–39, 161–62
Gropius, Walter, 16, 88, 105, 107, 147, 149–50, 179

Hadrian, 138, 173, *173*, 175
Halbwachs, Maurice, 176
Hale, William Harlan, 62–63, *62*, *64*, 68, 134
Hamilton, George Heard, 82–83, 86
Hamlin, Talbot Faulkner, 47
Harkness, Edward S., 52
Harkness, Louise Hale, 139
*Harkness Hoot*, 21, 62–63, *62*, *64*
Hartman, Geoffrey, 155
Hartog, François, 3, 183
Harvard University, 13, 18–19, 31–32, 35, 88–89, 116–17, 130, 149–51
Hegel, Georg Wilhelm Friedrich, 12, 78
Heidegger, Martin, 176, 183
Hicks, Sheila, 81, 93, *94*
historical reflectivity, 8, 12–16
historicist architecture, 47, 69
historicism, 30, 134
historical facts, 15, 18–19, 65, 70–71, 75, 120, 131
historical imagination, 11–21
historical memory, 15–17, 138, 172
historical precedents, use of, 8, 15, 122, 127, 128, 156–57, 176
historical reflectivity, 8, 12–16
historical sense, 13–14
history writing, 154, 172
Hitchcock, Henry-Russell, 16–18, 20, 107, 37, 135, 154–55, 178
 "The Decline of Architecture," 17
 *Modern Architecture*, 16, 17, 37, 135
Hood, Raymond, 37–39, *38*
Howe, George, 11, 39, 105, *109*, 115–16
Howells, John Mead, 37, *38*
Hudnut, Joseph, 89, 105, 150
humanities, 8, 15, 25, 28, 91, 115. *See also* liberal arts

imagination, 30
imaginative beholding, 31
imitation, 35, 40
impurities of time, 1, 14
individuation, 174

James, William, 32
Jarzombek, Mark, 31
Jefferson, Thomas, 124–25
Johnson, Philip, 87, 119, 158, 167, 169, 172–73, *173*, 175
Jones, Jason B., 172
Jung, Carl, 170–76, 181

Kahn, Ely Jacques, 51–52, 63, 124
Kahn, Louis I., *108*, 109
 American Society of Planners and Architects, 105
 Architectural Research Group, 105
 "Architecture Is the Thoughtful Making of Spaces," 114
 *Art in America*, 173–74, *175*
 Aspen Design Conference, 122–23
 Collaborative Design Problem class, 108–9
 "Monumentality," 105–6, *106*
 National Center for UNESCO, 107–8, *108*
 "New Architecture and City Planning, The," 105
 "On the Responsibility of the Architect," 119
 "Order and Form," 114
 Trenton Bath House, 121
 Yale Center for British Art, 122, *122*
 Yale University Art Gallery annex to, 9, *10*, 105, 111–15, *112*, 112, *113*, 168, 173–74, *175*
Kant, Immanuel, 8, 28, 93, 95
Kracauer, Siegfried, 76, 176–77
Kubler, George, 124–48
 *The Shape of Time*, 8–9, 124, 145–48
 "What Can Historians Do for Architects?," 179
*Kunstwollen*, 106

Labatut, Jean, 11
Langer, Susanne, 94–96, *95*, 117, 153, 171
 "Art Symbol and Symbolism in Art," 94–95
 *Feeling and Form*, 96, 153
 Martin A. Ryerson lecture, 94–95
 *Philosophy in a New Key*, 94, 171
latency, 18, 77, 79
*Latenz*, 18
Latour, Bruno, 2
Lears, T. J. Jackson, 32

Index 201

Le Corbusier
    Columbia Lecture, drawing made during, 50
    Martin A. Ryerson Lecture on Modern Architecture, 39–40
    *Modern Exhibition—Painting and Architecture*, 84–85, *85*
    *Quand les cathédrales étaient blanches* (When the Cathedrals Were White), 15–16, 48, *49*, 51
    *Vers une architecture*, 14, 33, 40
    Ville Contemporaine, 13
Lee, Richard C., 159–60, *159*
Lending, Mari, 6, 167
Libera, Adalberto, 125
liberal arts, 8, 25, 28, 91, 116. *See also* humanities
*Life* magazine, 41, 125, *126*, 136
*longue durée*, 13, 131

Machu Picchu, 130
Malraux, André, 10, 155, 156, 158
Martin A. Ryerson Lectures on Modern Architecture, 39, 40, 94, 99
Mayan art, 130
McDonald, Gail, 7
McKim, Charles, *180*, 181
Medieval Academy of America, 28
medieval architecture, 30, 43, 46, 49. *See also* Gothic
medieval art, 45, 47, 68
medievalism, 13, 47, 167
medieval past, 16, 48, 52
medium specificity, 100
Meeks, Everett Victor, 8–9, 25, *29*
    *Architectural Forum*, 41
    Architectural League of New York, 34
    dual curriculum at Yale, 28–29, 33, 35
    "Foreign Influences in American Architecture," 34
    "Modern Art," 35
    "The Modern Trend in Architecture," 37
    "The Place of Art in Higher Education," 32, 33
    "The Responsibility of the College," 34
    Weir Hall, 29, *29*, 30
    World War I Memorial, 24, *26*
Mellon, Mary Conover, 170
Mellon, Paul, 140, 170
memory, vi, 15, 17, 21, 24, 75–76, 125, 137–38, 142–46, 172–76. *See also* historical memory
Middle Ages, 46–49
Mies van der Rohe, Ludwig
    Friedrichstrasse skyscraper project, 13
    IIT, 88

Lake Shore Drive Apartments, 153
*Modern Exhibition—Painting and Architecture*, 84–85
*Modern Architecture: International Exhibition*, 107
modern Gothic, 20, 47, 57
Moholy-Nagy, László, 2, 108
Moholy-Nagy, Sibyl
    *The Architecture of Paul Rudolph*, 159
    "Environment and Anonymous Architecture," 157
    "The Future of the Past," 122, *123*, 158
    *Matrix of Man*, 159
    *Native Genius in Anonymous Architecture*, 142, *143*, 158
montage, 13
Monuments Men, 86
Morse, Samuel F. B., 5
Mumford, Lewis, 105, 107
Museum of Modern Art, 9, 40, 81, 82, 84, 107, 110, 111
    *Modern Architecture: International Exhibition*, 107
    "What Is Happening to Modern Architecture?," 107

National Socialism, 8, 78, 83–84
Nelson, Paul, 84–85
New Criticism, 11, 177
new traditionalists, 17–18, 37
New York Five, 181
Nietzsche, Friedrich, 12–13, 49, 51, 77–78, 90, 93, 117, 155, 158
Norton, Charles Eliot, 14–15, 31

organic architecture, 39
Orr, Douglas, 9, 168, 173–74, *175*
Osborne, Peter, 3
Östberg, Ragnar, 37–39

Panofsky, Erwin, 20
*Paris Match*, 155
Payne, Alina, 7, 154–55
*Perspecta*, 11, *11*, 21, 111, *113*, 114–15, 119, *121*, 122–23, *123*, 132, 149, 158, 177
phenomenological approach, 75, 76, 79, 93
plagiarism, 125–31, 146, 157
plaster casts, 6, 10, 82, 89, 165
plastics, 108–10
Plato, 55, 157
Poelzig, Hans, 46
politics of time, 3, 184–85
polychronic, 6, 167
Pope, John Russell, 4, *4*, 140
Porter, A. Kingsley, 29
Pound, Ezra, 14–15

pre-Columbian art, 93, 130
prehistoric architecture, 179
prehistoric art, 130, 170, 171
prehistory, 41, 78, 168
presentism, 14, 30
Princeton University, 28, 48, 51, *52*
Proust, Marcel, 75
psychoanalysis, 170, 172, 179

Ray, Man, 82, 87
Read, Herbert, 170–71
Renaissance, 38, 49, 79, 129, 151
*Review of Metaphysics*, 118
Richards, J. M., 156–57
Robert A. M. Stern Architects, 184
Rogers, James Gamble
    Branford College Court, 53, *54*
    Butler Library, 53
    Columbia-Presbyterian Hospital, 52
    Harkness mansion, 52
    Harkness Memorial Quadrangle, 53, *54*
    Harkness Tower, *54*, 55, 57, 61
    Laboratory School, University of Chicago, 59
    Linonia and Brothers Reading Room, 57, *59*
    "Notes by the Architect," 57
    Pierson College, 5, *5*
    School of Education, University of Chicago, 59
    Sterling Law Building, 43, *44*, 53
    Sterling Memorial Library, 4, 53, 55–62, *55*, *56*, *58*, *59*, *64*
    Wrexham Tower, 53, *54*
    Yale campus, 31, 52–53, *53*
Rohan, Timothy, 160
Romanticism, 45
Rome, 2, 115, 139, 151–52, 167, 178
Rudolph, Paul
    "Architecture: The Unending Search," 153
    Art and Architecture Building, 10, 161–67, *164*, 167
    "The Changing Philosophy of Architecture," 151–52, 154
    Jewett Art Center, 149, *150*
    "The Six Determinants of Architectural Form," 154, 156, *156*, 162
    Temple Street Garage, 160, *161*, 162
Ruskin, John, 31, 45, 50, 116

Saarinen, Eero
    Beaux-Arts Institute of Design competition, *36*
    Berkshire Music Shed, 125
    Cranbrook Academy of Art and School for Boys, 133, *133*
    David S. Ingalls Hockey Rink, 5, 138–40, *139*

First Christian Church, 136, *136*
Gateway Arch, 9, *126*, *128*, *129*, 132–34, *134*, 139
General Motors Technical Center, 136–38, *137*
"Golden Proportions," 129
Jefferson National Expansion Memorial design competition, entry to, 124
MIT Chapel, 138
Samuel F. B. Morse and Ezra Stiles Colleges, 138–43, *140*, *141*, *142*
Victorian house, 147, *148*
Womb Chair, 136
Saarinen, Eliel
   *The Art of Building Cities*, 152
   *Chicago Tribune* competition, 37, *38*
   Cranbrook Academy of Art and School for Boys, 133
   First Christian Church, 136, *136*
   Martin A. Ryerson Lectures on Modern Architecture, 39, 40
   *The Search for Form in Art and Architecture*, 124, 130–32, *131*
Saarinen, Loja, 133
Sawyer, Charles H., 88, 104–5, 108
Scott, Geoffrey, 116, 151–53
Scully, Vincent, *169*
   "Archetype and Order in Recent American Architecture," 173–74, *173*, *175*
   "Doldrums in the Suburbs," 178
   "Four Kinds of Time in Contemporary Architecture," 175–76
   *Modern Architecture*, 176
   "On the Responsibility of the Architect," 119, 169
   *Shingle Style Today, The*, 180–81, *180*, *182*
Semper, Gottfried, 100
Seneca Village, 185
Shakespeare, William, 12–13
significant form, 116
Sitte, Camillo, 152
1619 Project, 184
Sixth International Congress for Drawing, Art Education, and Applied Arts, 33, 90
skyscrapers, 13, 15, 39, 47, 152, 157
Smithson, Alison and Peter, 154
Smithson, Robert, 147
Snead Standard Stack, *56*, 57
Société Anonyme, 9, 82–84, *84*, 87–88
space-time, 18, 72, 92, 96, 145
Stam, Mart, 14
Stamp, Jimmy, 20
Stern, Robert A. M., 20, 177–78, 184
Stierli, Martino, 13
Stowell, Kenneth K., 127–28

Strasbourg Cathedral, 44
Sullivan, Louis, 16, 37, 165, *167*
Swartwout, Edgerton, 29, *31*, *60*, 61

Taliesin Fellowship, 7
Team 10, 123
temporal constructs, 2, 20, 21, 27, 30, 90, 184, 185
temporal disorientation, 2, 51
temporal durée, 36, 41, 72, 131–32
temporal horizons, 12, 55, 69
temporal impurities, 2
temporal markers, 35, 61, 62, 76, 184
temporal registers, 11, 96
timelessness, 15, 99
*Time* magazine, 48, 136–38
time travel, vi, 5, 12
Tournikiotis, Panayotis, 17
Trowbridge Lectures, 40–41

usable past, 15, 20

Van Eyck, Aldo, 123
Venturi, Robert, 21, 177–78, *178*, *180*, 181
   *Complexity and Contradiction in Architecture*, 177, *178*
   Trubek and Wislocki houses, *180*, 181
*Vogue*, 147, *148*

Wagner, Otto, 16
Walker, Ralph Thomas, 39, 40
Weiss, Paul, *119*
   "Being, Essence and Existence," 118
   "Historic Time," 118–19
   "History and the Historian," 123
   "On the Difference between Actuality and Possibility," 118
   "On the Responsibility of the Architect," 119–21
   "The Past: Its Nature and Reality," 118
   "The Past: Recent Discussions," 118
   "The Perception of Stars," 145–46
   "Philosophy and Architecture," 118
   *Review of Metaphysics*, 118
   "Time and the Absolute," 118
Whitehead, Alfred North, 32, 116–17
*Wirkungsform*, 93, 95
Wittkower, Rudolf, 129, 151, 154–55, 178
Wölfflin, Heinrich, 10, 30–31
Womack, Ytasha L., 184
Wood, Christopher S., 16
Worringer, Wilhelm, 45–46
Wright, Frank Lloyd, 7, 39, 43, 132, 137, 174, 179, 276
   Larkin Building, 163, 179
   Martin A. Ryerson Lectures on Modern Architecture, 39–40, 43
Wright, Gwendolyn, 52

Yale Gallery of Fine Arts, 9, 29, *31*, 40, 82–84, *84*, 86
Yale University, campus of, 3, 4, 43, 52–53, *53*, 61, 68, 105, 138, 140, 159–61
Yale University Art Gallery, exhibitions at
   Modern Art from the Collection of the Société Anonyme, 83–84, *84*
   Modern Exhibition—Painting and Architecture, 85, 86
   The Modern House Comes Alive, 87
   Plastics in Art and Industry, 110, *110*
   See also Yale Gallery of Fine Arts
Yale University School of Fine Arts, 28, 29, 82, *83*, 88
Yaneva, Albena, 16
Yates, Frances, 176

Zucker, Paul, 105–6, 108, 110

# Illustration Credits

Manuscripts and Archives, Yale University Library, Digital Collections (figs. 1, 2, 10–12, 14, 15, 19, 20–24, 28, 29, 31–36, 42, 43, 57, 59, 61, 62, 70, 71, 77, 78, 80, 81, 83, 87, 88, 90, 94, 97, 99, 100)
Library of Congress / George Grantham Bain Photograph Collection (fig. 8)
© F.L.C. / ADAGP, Paris / Artists Rights Society (ARS), New York 2022 (figs. 16, 17)
Collection Baltrusaitis, Paris (figs. 37–40)
Yale University Art Gallery Archives (figs. 42, 43, 45–48)
Beinecke Rare Book and Manuscript Library, Yale Collection of American Literature, Katherine S. Dreier Papers / Société Anonyme Archive (fig. 44)
Josef and Anni Albers Foundation, Bethany, CT (figs. 49–51, 54, 55, 58)
North Carolina State Archives (fig. 53)
Architectural Archives, University of Pennsylvania (fig. 60)
New York Public Library, Life Magazine Digital Archive (fig. 69)
Cranbrook Archives (figs. 73, 74, 76)
Archives of American Art, Smithsonian Institution, Florence Knoll Bassett papers, 1932–2000 (fig. 75)
The Vogue Archive ProQuest (fig. 84)
Paul Rudolph Papers, Library of Congress (fig. 85)
© Ezra Stoller/Esto Photographics, Mamaroneck, NY (figs. 89, 95, 98)
© Wayne Andrews/Esto Photographics, Mamaroneck, NY (fig. 91)
Turner Brooks, New Haven (fig. 105)